SEEKING CHILDHOOD

STUDIES IN VISUAL CULTURE

SERIES EDITORS
Margaret Topping
Queen's University, Belfast
Rachael Langford
Cardiff Metropolitan University
Giuliana Pieri
Royal Holloway, University of London

EDITORIAL BOARD
Mieke Bal, University of Amsterdam
Paul Cooke, University of Leeds
Anne Freadman, University of Melbourne
Andrea Noble, University of Durham
María Pilar Rodríguez, Universidad de Deusto
Eric Thau, University of Hawai'i at Manoa

TITLES IN SERIES
Aimée Israel-Pelletier, *Rimbaud's Impressionist Poetics:
Vision and Visuality*

Nathalie Aubert (ed.), *Proust and the Visual*

Susan Harrow (ed.), *The Art of the Text: Visuality in nineteenth- and
twentieth-century literary and other media*

Alicia R. Zuese, *Baroque Spain and the Writing
of Visual and Material Culture*

Jean Andrews, Jeremy Roe and Oliver Noble Wood (eds),
On Art and Painting: Vicente Carducho and Baroque Spain

Jean Andrews, *Painting and Devotion in Golden Age Iberia:
Luis de Morales*

Eamon McCarthy, *Nora Borges: 'A smaller, more perfect world'*

Dafydd W. Jones, *The Reconciliation of Modernism:
Ceri Richards and the second generation, 1930–1945*

Studies in Visual Culture

Seeking Childhood
The Emergence of the Child in
the Visual and Literary Culture of
the French Long Nineteenth Century

Sophie Handler

University of Wales Press
2024

© Sophie Handler, 2024

All rights reserved. No part of this book may be reproduced in any material form (including photocopying or storing it in any medium by electronic means and whether or not transiently or incidentally to some other use of this publication) without the written permission of the copyright owner. Applications for the copyright owner's written permission to reproduce any part of this publication should be addressed to the University of Wales Press, University Registry, King Edward VII Avenue, Cardiff CF10 3NS.

www.uwp.co.uk

British Library CIP Data
A catalogue record for this book is available from the British Library

ISBN 978-1-83772-132-0
eISBN 978-1-83772-133-7

The right of Sophie Handler to be identified as author of this work has been asserted in accordance with sections 77 and 79 of the Copyright, Designs and Patents Act 1988.

Typeset by Marie Doherty
Printed by the University of Wales Press

To the child within each and every one of us.

Contents

Series Editors' Preface		ix
Acknowledgements		xi
Introduction: Elucidating Approaches to the Study		1
1	From the Twentieth Century to the Nineteenth Century: A Retrospective of Childhood	13
2	Romantic Enlightenment: The *Carte Blanche* of Childhood, c.1750–1850	39
3	Negotiating the Dark Underbelly: Children of the Poor, c.1830–1880	65
4	Searching for Solace: Children of the Bourgeoisie, c.1850–1920	91
5	Toy Town Theatre: Material Acculturation and the Child, c.1870–1900	121
6	Breaking the Mould: Burgeoning Cultural Emancipation of the Child, c.1880–1920	145
Conclusion: Finding the Child Within Us All		171
Notes		181
Bibliography		207
Index of Images		225
Index		233

Series Editors' Preface

Providing a forum for cutting-edge research into visual-cultural production in social, historical, cultural and political contexts, Studies in Visual Culture publishes ground-breaking critical studies that examine how visual cultures interact with a wide range of fields and discourses, including cultural history, literary criticism, philosophy, gender and sexuality studies, media studies, migration, and politics, as well as journalism and media studies.

A key objective of the series is to showcase critical engagements with visual media framed as social, cultural, and historical and theoretical constructs as well as aesthetic interventions. Publications in the series therefore pay particular attention to exchanges, transactions, and displacements shaping the visual. Through explorations of synergies between disciplines, concepts and theories, each publication tests and extends the disciplinary, theoretical and conceptual boundaries of understandings of the visual-cultural realm.

The series editors welcome proposals across the full range of visual cultural phenomena globally, including but not limited to visual aspects of architecture, interiors, urbanism, design, fashion, photography, film, landscape studies, garden design, fine art, art history, illustration and graphic communication.

Acknowledgements

There are many people who have had a part to play in the creation of this book, not least the many children, historical and contemporary, fictional and real, all grown up or still very small, whose abundant hues of inspiration colour its pages. Thanks must be expressed to Anthony Parton and Hazel Donkin, without whose support and advice as supervisors when this book began its life as a doctoral thesis, the text would not have grown as it has. I am further grateful to Anthony, whose abundant love for the history of art developed and encouraged my own intrinsic passion for the subject from my first formal encountering of it as an undergraduate. Enormous thanks must also be expressed to Chris Harris, for whose mentorship and kindness in both my emergence as a young academic and in the formulation of this book I will forever be grateful. I would also like to thank all those at the University of Wales Press for their hard work, and in particular, Sarah Lewis, for her patience and guidance. Finally, I would like to thank my family, especially my parents, Hilary and Stewart, and my husband, Charlie, for their continued love and support.

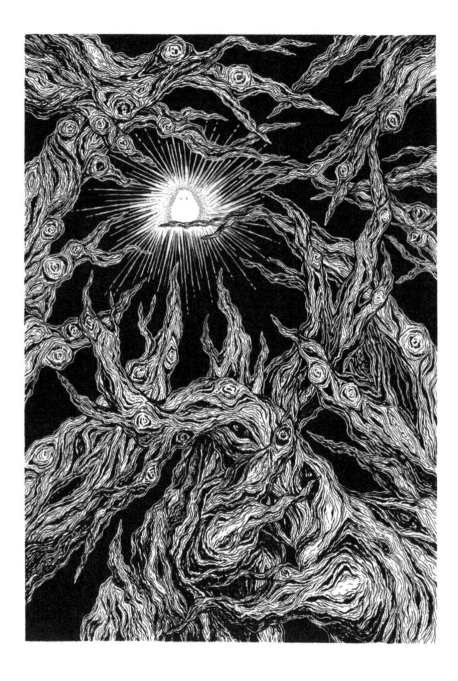

Introduction
Elucidating Approaches to the Study

Memories of the lost desert wastes, like the distant country of his childhood, became refuges in periods of corrupting melancholy.
Paul Webster, *Antoine de Saint-Exupéry*[1]

All grown-ups were children first. (But few of them remember it).
Antoine de Saint-Exupéry, *The Little Prince*[2]

It was in the post-Enlightenment context of nineteenth-century Europe that the study of children and childhood took on a particular resonance. This emerging bloom of childhood studies in many ways coincided with a sort of 'discovery' of children and childhood as entities and concepts separate from adults and adulthood and thus worthy of particular attention and interest. It was arguably the mid to late eighteenth-century clash between Enlightenment theory and Romantic thought that is credited as the turning point in the establishment of, and interest in, concepts of children and childhood. The study of children and childhood at this time advanced multifariously as intellectuals and cultural practitioners explored the relevance of these subjects at social, cultural and conceptual levels. While many intellectuals, writers, artists and educators across Europe began to retrieve the child and childhood from the confines of pre-Enlightenment thought and attempt to fathom and unfold childhood's intricacies for themselves thereafter, the

specific context of France in the long nineteenth century offers a particularly fruitful case study as a result of its positioning in the crossroads of tradition and modernity and its rich artistic and literary responses to this. As such, this text seeks to explore what can be learned from the visual and literary culture of the period about the transforming perceptions of children and childhood in France during the long nineteenth century.

Accordingly, this book focuses on the developmental period between two bookends central to cultural, creative, intellectual and social understandings of children and childhood in France. First, there is the aforementioned burgeoning acknowledgement of the child as an entity in its own right in the Enlightenment context of the late eighteenth century. Second, there is the modernist championing of perceived qualities of the childhood state as a blueprint for *avant-garde* expression in the early decades of the twentieth century. Therefore, in between, we find something of a social, historical, political and cultural stretch of no-man's-land. It is in this stretch that we find scholarly, literary and artistic outpourings that reflect the period's varied approach to and understanding of concepts and images of children and childhood. Moreover, it is these outpourings that exposed the ways in which children and childhood are harnessed by intellectual and creative endeavours for an array of personal, professional or collective aims.

This book will both demonstrate and account for the various ways in which artists and writers reflected on childhood in this context, sometimes consolidating and sometimes challenging the *status quo*, as well as studying their implications for art, society and individual life. The text comprises an exploration of the ways in which this process manifested itself in the discrete context of the French long nineteenth century. This work is consistently mindful of the complex and juxtaposing position of the child as both Self, evident for example in the beginnings of all of us, and also Other, represented multifariously by qualities both 'good' and 'bad' perceived as reserved to the childhood state. The pervasive and varied Otherisation of the child and its conceptual state is a notion perhaps first and most powerfully cemented by the reverence with which the medieval Church's attestation that 'children were not only conceived in sin, but born in utter corruption' was considered.[3] It is from this damning indictment, therefore, that the role, image and concept of the child and the condition of childhood struggled, grew,

Introduction

developed and was moulded throughout the period from the Enlightenment to modernism.

As such, an investigation into the rhetoric of the child and childhood, as both Self and Other, is established, reviewing their significant inspiration for the creative work of the arts and literature of France in this period. By beginning at the end, so to speak, the forthcoming chapters begin by making clear the result in the twentieth century that the rest of the book seeks to map through a series of thematic studies of concepts that developed over the course of the long nineteenth century. This process begins by unpacking historical and contemporary classifications of childhood, analysing efforts to classify neatly what is an innately unfixed concept. Discussion then turns to the ways in which this inherent ambiguity was distilled into a sort of malleability that gave rise to the deep-seated proclivity among adults to shape children and childhood as beings, images and concepts for their own ends.

When historians refer to the 'discovery' of childhood as a state and concept it is as though it is something akin to an archaeological excavation or attic-room unearthing of some mysterious never-before-seen gem; carefully dusting off its delicate features as it is brought out from its dark, shadowy enclave into the illuminated expanse of the outside world. Typically, this has taken the form of a most gradually increasing awareness of the differences between children and adults, 'of what was most essentially childlike about children [and] an increasingly compelling recognition of children as individuals, distinct from one another', a gradual emergence of which began, according to French historian Philippe Ariès, with 'a Renaissance "discovery" of childhood'.[4] While Larry Wolff argues that the Renaissance acknowledgement of the child 'corresponded to a proliferation in the cultural representations of children, in literary and artistic forms',[5] Peter Coveney contests that if cultural portrayals are to be our yardstick, it was not until the last decades of the eighteenth century that the child became firmly established as a thematic mainstay as opposed to 'a subsidiary element in an adult world'.[6]

Social historian Philippe Ariès's 1960 book *Centuries of Childhood: A Social History of Family Life* is widely considered the most influential catalyst in establishing the history of childhood and children as topics of social, cultural and scholarly interest. More specifically, Ariès's argument centres

on the attestation that childhood is chiefly a concept and state of modern creation and understanding, and that accordingly, ideas of childhood have changed with time. While Ariès's theories are not without criticism, especially with regard to his denouncing view of the role and treatment of the medieval child, his influence has remained steadfast, especially in the academic world.[7] For this text, not only has Ariès's contribution facilitated a study drawing from the literature that arose from his catapulting of the topic into the scholarly consciousness of the mid-twentieth century and beyond, but more specifically, his theory on the changing roles, concepts and images of the child and childhood throughout history proves a significant backdrop and framework to the current project.

This book builds on this approach, but with considerable weight placed on evidence to be found within various readings of literary and artistic culture of the period, as opposed to a more holistic and purely historical analysis of documents and artefacts. Accordingly, much of the text is underpinned by various theoretical approaches to understanding concepts and images of children and childhood in this context. Moreover, the method tends to focus on a close reading of materials of interest – namely, literature, artwork and other types of visual culture – within the context of the cultural history of both their creation and reception, thereby analysing the fluidity and evolution of thoughts and concepts alongside historical, social and political developments. Similarly, the text does not attempt to force or fabricate meanings in the past, but instead to offer visual and literary readings and understandings supported by contextual and scholarly scaffolds. As such, where appropriate, reference is made to and comprehension drawn from biographical anecdotes related to certain case studies. While disproportionate weight is not afforded to such inferences, it would nevertheless be imprudent to disregard the significance of the interplay between life and work. This is of particular significance given the inextricable link between the child and selfhood, as the book elucidates.

As an outgrowth of Ariès's pivotal text, and no doubt inspired by his interdisciplinary approach to research, there has since been some overlap between pedagogic and child-related scholarship, and that of an art historical focus, establishing a connection between the two fields. In the main, this link has been one that has surfaced in pockets and, rather symbolically of the

4

Introduction

attention typically afforded to children, as a rather incidental or secondary consideration. Essentially, scholarship on concepts and conditions of children and childhood has tended to include art historical analysis only in a handful of instances where such input appeared particularly significant and, similarly *vice versa*, art historical scholarship has only engaged with images of children and childhood on the sporadic occasions that their inclusion proved important. This is not to say that concerted considerations of children and childhood in an art historical context is missing altogether, but it has tended to exist in a sort of anthological format, typically a collection of essays that gathers a handful of prominent ideas.[8] Crucially, for the most part, these ideas and concepts have been addressed somewhat in isolation, or within a very limited contextual sphere, and thus not considered in a developmental fashion, and certainly not within the context of the French long nineteenth century.

The aforementioned mid to late eighteenth-century clash between Enlightenment theory and Romantic thought, considered a turning point in attention afforded to concepts of children and childhood,[9] has been matched in cultural and scholarly focus by interest in the context of the child and childhood in the modernist movement of the early twentieth century.[10] Consequently, a gap has been left without a developmental bridge by which to link these two important though nevertheless connected cultural milestones. This book seeks to address this issue, by constructing a bridge that offers an insight into the meandering journey experienced by the child, both conceptually and more literally, as evidenced in the literary and visual culture of the period that stretches between these two often-considered polar points of reference. In other words, the vast bulk of art historical scholarship on children and childhood has focused on two distinct fields. The first and most prominent is the modernist championing of the child that saw its position significantly elevated and exploited, and the second is the not uncommon reference to Enlightenment or Romantic anecdotes of interest. By contrast, this text examines the conceptual development of children and childhood in the era in between, exploring significant notions, theories and images that built on Enlightenment doctrine and Romantic rebukes and in turn laid the groundwork for the modernist explosion to come.

This book comprises six main chapters, followed by a final concluding chapter. While it adopts a broadly chronological format, by way of a

5

continuous circle emblematic of the cyclical development of the book's concepts, this lies underneath what is largely a thematic breakdown of chapters. The text does not profess to offer a comprehensive survey of the experiences of every child, the ways in which these contributed to every related concept, and in turn how this is reflected in all art and literature. It will, however, convey a complex range of ideas and theories at play during the French long nineteenth century, and endeavours to tackle a wide range of issues in an inclusive and exploratory approach, with the aim of providing a detailed and insightful journey comprising a pathway with many visitation points.

To begin, Chapter 1 functions as a comprehensive introduction to the topics and concepts featured in the book as a whole. As such, this chapter begins at the end, so to speak, with an assessment of the roles, concepts and images of the child and the childhood state in the modernist context of the early twentieth century. The remainder of the book explores the developmental process by which these views were reached and found expression in the decades before. The text elucidates this process through a sequence of thematic studies each addressing issues at play and concepts developed throughout the long nineteenth century. This process commences by explicating various classifications of childhood, both historical and contemporary, thereby beginning what will become an ongoing examination of the ways in which efforts were made to codify what is an intrinsically ungovernable concept. The chapter then explores how this ambiguity innate to the child and state of childhood was harnessed into a sort of pliability exploited by adults as a means to tailor children and their condition to their own designs, with particular attention paid in the context of early twentieth-century literary and visual culture to the modernist mobilisation of the child as a counter to the ills of modernity. The chapter considers the role of artists such as Paul Cézanne, Paul Klee and Pablo Picasso in the cementing of the child and its condition as something of a blueprint for modernist art practice, focusing in particular on the perceived connection between notions of childhood and Primitivism. The chapter concludes with analysis of the conflation of the child and the 'primitive' by looking to Blaise Cendrars's modernist text *Shadow*, to exemplify the ongoing Otherisation of the child, the process and effects of which climaxed with modernism.

Introduction

Chapter 2 marks a return to what is broadly considered the beginning of this process, analysing the emerging 'discovery' and acknowledgement of children and childhood as manifestations of both Self and Other and a vehicle of self-discovery, against the backdrop of the period that saw the crossover between the Enlightenment and Romanticism. This first comprises an exploration of the scholarship of prominent eighteenth-century academics, including Georges-Louis Leclerc Comte de Buffon, Étienne Bonnot de Condillac and Louis-François Jauffret, analysing their contribution to early concepts of children and childhood. The majority of the chapter is then dedicated to considering this literature alongside the work of Jean-Jacques Rousseau, investigating the complex and often contradictory philosophy of his seminal publication *Émile*. The chapter examines the origins and effects of Rousseau's particularly pervasive contribution to concepts and practices relating to children and childhood, and in particular the ways in which his doctrine speaks of a desire to start afresh indiscriminately, using the child as a means of almost vicariously carving out bright new beginnings for oneself and society. The chapter concludes with in-depth analysis of Gustave Courbet, his relationship with Rousseauian theory, and his potential reflections on the significance of children and childhood by engaging with *The Painter's Studio*, and particularly the little boy featured therein.

Moving away from Romanticism and using Courbet's realism of the previous chapter as a springboard, Chapter 3 turns its attention to the experiences of the poor and working-class child of nineteenth-century France, beginning with a short contextual exploration of the sociopolitical turmoil of the period. Alongside brief contributions from Émile Bayard and Charles Baudelaire, the bulk of the chapter focuses on two case studies engaging the work of Victor Hugo and Edgar Degas. Considering these two creative giants in novel ways, the chapter explores their works' overt and more discrete concerns with the darker realities of the vulnerable children in French society in this period. While Hugo's literature offers significant reference points, it is his engagement with dark worlds of fear and suffering in his artwork that takes centre stage in this study. Similarly, while Degas is perhaps best known for his depictions of the *haute bourgeois*, this chapter instead interrogates his equally thorough presentations of a darker and grittier underworld of urban poverty. Overall, the studies concentrate on the artists' use of *chiaroscuro* as

7

a means of highlighting society's extremes, and most particularly, analysing the various manifestations of the darkness that characterises the debasing Otherisation and plight of the poor child and their existence.

Moving to later in the period, Chapter 4, by contrast, considers the very personal though not uncommon experiences of middle class or bourgeois children through the dual case studies of Marcel Proust and Odilon Redon. Progressing from an examination of the contextual backdrop of French late nineteenth and early twentieth-century bourgeois family life, the chapter principally concerns itself with the lives and works of the two case studies. There is a particular focus on exploring the soothing relationships Proust and Redon seemed to share with exclusive and reclusive environments as a means of both escape from the harshness of modernity and a haven of creative freedom. Moreover, inspired by the similarities these two figures biographically and creatively share regarding a nostalgic yearning for mother, attention is duly given to the significance of visual and symbolic renderings of reclusive spaces as suggestive of a return to the womb, which itself offers poignant reflection on the familial and social dynamics of the period.

Covering the late decades of the nineteenth century, Chapter 5 operates under the pervasive metaphor of the toy-child, that is to say, the notion of the child as a commodified and fetishised ornament of adult design. As such, this chapter considers the extent to which various cultural apparatus, including Perraultian fairy tales and the popular *Jumeau* doll, were mobilised by adults as a means of acculturation, specifically in terms of sanctioning gendered notions of identity and social existence. Drawing on the child's natural existence beyond the stipulations of the adult world, this chapter examines how the adult-centricity of the French long nineteenth-century society at this time resulted in a debasement of the child through such determined efforts to codify them. The proclivity of artists such as Édouard Manet and Pierre-Auguste Renoir to depict domestic childhood through scenes of ornamental idyll contributed to the establishment of the image and concept of the toy-child in artistic and material culture, as well as the resulting degradation of the child to an empty shell of ideals.

Following a brief consideration of children in among the ripples of French feminism in late nineteenth-century art, Chapter 6 focuses on the emerging autonomy of the child, and acknowledgment of the wisdom thereof, by first

Introduction

exploring the creative possibilities offered in the magical world of child's play. This is developed by investigating the changing role and significance of the shadow in art, particularly that of Symbolists such as Pierre Bonnard, Maurice Denis and Félix Vallotton, as symbolic of not only personhood, but also the wistful and undulating ephemerality of childhood and life in general, as increasingly prominent in the collective conscience with the rapid onset of modernity. Drawing on the example of J. M. Barrie's *Peter Pan*, this chapter's case studies focus on artistic and literary representations and indeed fixations in the early twentieth century on the child as the symbol and embodiment of both the duality and ephemerality of modern life. This then develops further by investigating how such concepts and concerns brought about a fascination with what the condition of childhood may offer the modern man on creative and philosophical levels.

Finally, the Conclusion functions as a coming-together and reflection on the findings of previous chapters. This culminates in an understanding of the commonplace regression to one's childhood and sense of personhood as a sort of visitation of the child within us all, as a means of offsetting or coming to terms with the difficulties associated with the ephemeral human existence. The text highlights that while the peculiarity of the period of focus as a crossroads of tradition and modernity and an especially fruitful epoch of artistic and literary production makes for a particularly meaningful set of case studies, many of the emerging themes and conclusions can still be applied effectively to today's everyday experiences and concerns affecting most people.

It is worth clarifying at this point the chronological and geographical parameters of the book. The term 'long nineteenth century' is by its very nature not fixed strictly, but is probably most commonly understood, in line with Eric Hobsbawm's definition, to refer to the period between the French Revolution of 1789 and the beginning of the First World War in 1914.[11] Nevertheless, other prominent brackets exist, such as Peter N. Stearns's more generalised version of 1750 to 1914.[12] Religious contexts, specifically those within the realm of the Catholic Church, stipulate a stretch from the French Revolution in 1789 to the death of Pope Pius XII in 1958.[13] In the case of this book, the term 'long nineteenth century' is used not in a stringently fixed way, but in a general sense in order to encompass the years surrounding

the main century of focus. Broadly speaking, the long nineteenth century to which this book refers can be understood as ranging from around the mid to late eighteenth century to the mid to early twentieth century. Geographically speaking, while the book is located firmly in a French context, it nevertheless draws, when appropriate, from the wider European context, such as Britain and Germany, in order to obtain a fulsome grasp of certain wide-reaching concepts, influences and topics. All translations are by the author unless otherwise stated.

In summary, *Seeking Childhood* explores the commentary offered by visual and literary culture on the multifarious, undulating and transforming perceptions, concepts and manifestations of children and childhood within the discrete context of the French long nineteenth century. Developing from its scholarly acceleration in the Enlightenment and Romantic crossover to its popular championing in the midst of modernism, the 'emergence' of children and childhood is sought and traced against the culturally, socially and creatively turbulent and rich backdrop of the French long nineteenth century.

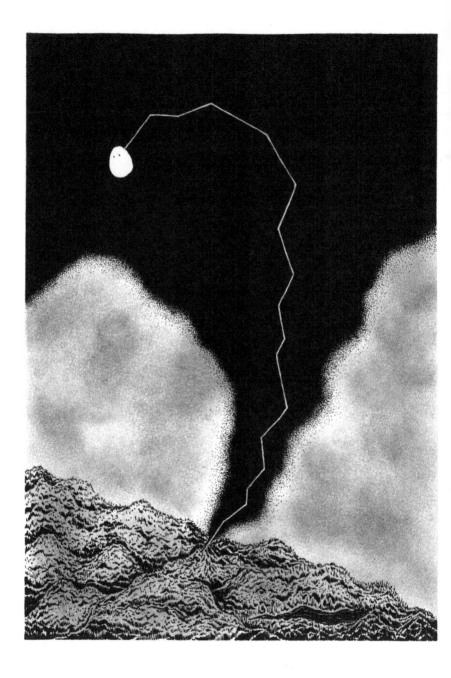

From the Twentieth Century to the Nineteenth Century: A Retrospective of Childhood

Children forget, and therefore childhood is forgotten.
Larry Wolff, 'When I Imagine a Child'[1]

People start out on express trains, but they no longer know what they're looking for.
Antoine de Saint-Exupéry, *The Little Prince*[2]

As intimated in the Introduction, the cultural 'discovery' of childhood is an unfixed and undulating concept in relation to which historians, sociologists and cultural practitioners rarely align neatly, both historically and today. Scientific corroboration has been even less forthcoming, with paediatrics established as a distinct field of medicine only during the late nineteenth century, by which time 'there likewise had emerged in France a new so-called science of child-rearing called puériculture'.[3] Michael Morpurgo maintains that even today 'prevalent still is the notion that childhood is simply a stage on the road to adulthood'.[4] More significant than these chronological land-marks of discovery, however, is the ongoing debate that ensued from the

topic's very advent, evidenced when English cleric Thomas Beccon mused in 1550, 'what is a child, or to be a child?'[5]

To explore this further, this chapter offers a backdrop and introduction to the topic of the book as a whole. It begins at the end, explicating the twentieth-century 'result' of the journey that the rest of the book charts through a series of thematic studies of concepts developed over the course of the long nineteenth century. This process begins by investigating historical and contemporary categorisations of childhood, and in so doing, casting a critical eye over endeavours to organise and codify what is an inherently variable notion. From here, the book seeks to analyse how the innate ambiguity of the concept of the child and its condition and culture was mobilised, by virtue of its pliability, by adults who sought to mould and reimagine children and childhood as beings, images and concepts for their own ends. Specifically in the context of twentieth-century artistic and literary culture, this took the form of a modernist harnessing of the child as an antidote to modernity. Accordingly, this chapter investigates the ways in which this manifested itself, considering the role of certain artists in the establishment of the child and childhood as the blueprint for modernist art practice, with a particular focus on the relationship between concepts of childhood and Primitivism.

Early attempts to delineate childhood adopted a very age-based focus, with scholars racing to offer age brackets or distinguishable milestones by which childhood could be precisely defined. For example, Paul Furfey understood childhood, or the 'forgotten age', to be between the ages of six and fourteen years – beyond infancy and before adolescence.[6] However, Bette Goldstone wrote that although 'seven was supposedly the age of reason' from the medieval period onwards, the benchmark invention of the printing press provided an additional dimension of cultural and educational clout (albeit often invalidated by compounding issues of class) by contributing to the characterisation of the child as not only a small person, but also someone who could not read, inviting characterisations of the child beyond those defined by age alone.[7]

In 1928, O. H. Benson proposed four 'ages' of childhood, known as the 'knee age', the 'me age', the 'we age' and the 'mating age'.[8] This notion of a phasic progression through childhood is one that has pervaded much of the

A Retrospective of Childhood

subject's contemporary discourse, not least in discussions of the increasingly popular and similarly indeterminable period of 'youth', broadly understood as 'a phase which post-dates childhood and precedes the period of "settling down".[9] Similarly of interest are the vital periods that encompass the composition and development of self and society, during which focus is placed on the construction and expression of identity.[10] From Arnold van Gennep's coining of the term 'rites of passage' in 1909 to describe the transitional stages of a person's life emerged the concept of liminality, and in turn the three distinct, principal liminal stages of separation, segregation (or liminality) and integration (or incorporation).[11] Separation is characterised by the splitting off of an individual from a given fixed and recognisable state or structure, a withdrawal from a status usually marked by some sort of symbolic behaviour or practice. Segregation (or liminality) comprises the period between the two polar states, during which one has left the previous but not yet gained entry to the next, and is thus innately ambiguous. Finally, integration (or incorporation) marks the completion of the particular rite, whereby the individual can assume their new identity and re-enter society with this status.

In other words, as a period during which 'initiates' – children not yet initiated into the 'proper' world of adulthood – are ostracised from the rest of society both physically and psychologically, they are thus rendered a hazy, shadowy sheath of a person barely visible to others. Accordingly, 'at the liminal stage [one] has nothing – no status, proper rank, or kinship position' and is afforded no tangible state of being that is stable and culturally recognised.[12] Definable as any period of transformation undertaken in response to changes big or small in one's life, the liminal stage is broadly the swathes of grey between two given points of black and white, and thus ultimately, perhaps, the 'movement of a man through his lifetime, from a fixed placental placement … to his death and ultimate fixed point of his tombstone'.[13]

This points to our tendency, as members of society, not only to see what we are conditioned to see, but also our blinkeredness in favour of the fixed and tangible over the fluid and transitional; that is to say, our inclination towards that which can be physically seen and understood over that which is abstract and theoretical. Victor Turner's likening of the transformational nature of the liminal stage to that of the pupa changing from grub to moth

exemplifies this, offering a symbolic link to the biological processes by which the conceptual processes of the liminal persona were characterised, giving easily identifiable outward manifestation to a more complex inward occurrence, in line with Claude Lévi-Strauss's theory on isomorphism.[14] This bias towards the concrete and palpable over the transitory and imperceptible, this preference for the grounded certitude of black-and-white posts over the floating undulations of grey in between, is archetypal of both scholarly and practical approaches to children and childhood. Through its determinedness to categorise ruthlessly, it is the root cause of the misperceptions and general erroneousness that consistently suffuses studies and understandings of childhood and children.

Among this palpable sense of 'tension between "beings" and "becomings"', the boundaries are as blurred as their adult creators are in disagreement about such definitions.[15] In the same way that there is no one fixed timescale or specific ritual by which we leave childhood and enter a new life stage, the issue of liminality proves equally ambiguous on a semantic level when we consider that we use the world 'child' in various senses, not least when we consider that 'a child can cease to be one with time, but we are always a child of our parents'.[16] This relationship-dynamic of the perpetual child provides some indication of the extent to which childhood is subject to the meandering dictatorship of adult control: 'it has always been adults (grown-up children, that is …) who have sought to define childhood, or more often to negate it, or to exploit it, and sometimes to idealise it'.[17]

Accordingly, 'if children themselves have in some ways changed over time, much more subject to change have been ideas about childhood', meaning that our perceptions thereof, historically and retrospectively, are invariably coloured in degrees by the lasting influence of the defining values and concepts of bio-psychological development in given social and institutional structures.[18] Childhood, Goldstone explains, is not a biological fact, but rather 'a socially contrived state of being' determined by culture and that shifts depending on the requirements of a given community.[19] These emerging indicators of the adult-centricity of the child's world highlight its malleability in the eyes of those who survey it, and yet also its simultaneous rigidity for those most afflicted but also least able to effect change: children. More contemporary scholars continued to explore such circumstances; while Simone

de Beauvoir frequently described a child's freedom as 'socially mediated',[20] Michel Foucault went so far as to underline the dogged lack of compromise inherent to adults when he queried 'if the child is born a monster ... should we regard the child as having been born or not?', pointing to the complete denial of manifestations beyond the defined mould.[21]

Foucault's comment can be understood to refer to a more acute practice in which childhood as a concept becomes a discovery and trope of adult convenience. Children, unlike adults, rarely leave behind neatly documented evidence from which we can gather unmistakable insights into their lives. While on the one hand, this can present what Stearns has described as a 'source problem' for historians of childhood, for others, it presents the perfect opportunity to take advantage of the ambiguity and write their own histories and the futures of others.[22] Convenient discovery or calculated invention, the adult pursuit of childhood culminates in the adult invention of childhood for the purposes of their own sense-making, leaving children to live with the consequences of becoming a trope in the modern adult's pursuit of resolution. In France particularly, this was buoyed by an obsession around the turn of the twentieth century with personal writings and exploratory artworks concerned with 'passing time, preserving time, recovering time, [and] reflecting on time'.[23] This habitual sense of introversion by which late nineteenth and early twentieth-century French artistic and literary culture was characterised can be viewed in tandem with what Andrew Graham-Dixon describes as a propensity to 'become culturally inward looking, [to adopt] a "petit France" mentality' in this period.[24] Such was the fixation with personhood, as well as the abundance of creative production that increasingly buttressed introspectiveness as opposed to artist-to-artist and artist-to-public conversation, 'art [was now] a person locked up in their own sense of being ... art of solipsism, art of the monologue'.[25] Furthermore, the various prongs that sprouted from this epoch's overflowing feeling of *fin-de-siècle* pessimism towards an increasingly unnatural and inhumane society, and simultaneously promoting a billowing sense of isolation and doubt, found themselves united by the antidote-like appeal of the child. Denied the opportunity to partake autonomously in their own experience and personhood, the child was susceptible to an array of interpretations courtesy of the melting pot of adult design, rendering the child 'so congenial an image, either of growth or regression,

of potency or regret'.[26] Referring to William Empson's notion of the 'tap-root' when describing the fashion among turn-of-the-century artists and writers to use the image and experiences of childhood as a means of both distraction and inspiration, Coveney summarised how childhood as a concept became a self-pitying and habitual vehicle of escape from a tired and confusing culture. Finding it increasingly difficult to grow up in such a world, to which regression into fantasy and nostalgia seemed the perfect antidotary protest, artists and writers used the child as 'a symbol of the greatest significance for the subjective investigation of the Self'.[27]

The latter decades of the nineteenth century saw a gradual glorification of regression, in France by Arthur Rimbaud's 'cult of childhood' and efforts to 'retain the "man-child" within',[28] and in Britain with John Ruskin's encouragement to recover 'the innocence of the eye' in order to produce artistic representations with the fresh vitality of the child.[29] This reached fever pitch by the turn of the century, when the inevitable decay of living could be thwarted by an artistic and literary return to one's youth. However, the self-serving origins of this particular adumbration of the child inevitably facilitated a self-indulgent embracing of the nescient self, for 'in writing of the child, their interest was continuously adult' and a means of both handily relinquishing responsibility while simultaneously creating an intellectual or artistic platform by which to elevate the perceived significance of one's own 'childish' musings.[30] It is thus unsurprising that the late nineteenth century and twentieth century brought 'a wealth of "ego documents"', swathes of literature imbued with personal memories, whose colouration of time and the author's own design distilled accounts warped by an unfathomable tangle of remembrance and imagining that can be understood by reference to Roland Barthes's notion of the 'death of the author'.[31] This propensity to distort autobiographical accounts, both literary and artistic, was amplified by what became a veritable competition among writers to record the earliest memory to demonstrate themselves as the most in touch with childhood. This was cemented further by the attribution of the melancholy of these pioneering archaeologists of childhood reminiscences to the sorrow associated with maternal loss or separation.[32]

And so, while 'the impulse towards self-gratification through literary confession' was palpable, with a perceived vividness of childhood memories so

A Retrospective of Childhood

strong that 'chronology is overturned and the adult becomes a child', this hedonism is matched by an eagerness to reshape the past according to one's needs or fancy.[33] Consequently, the mystery of childhood, combined with its loaded harnessing in artistic and literary circles, gave rise to something resembling a profitable trade in counterfeit memories. Through this, the adult search for 'self' (and indeed Self) was not only enabled, but it laid the foundations for a modern reworking of childhood in a conceptual, collective sense, as much as on a personal level:

> Introspective remembrance ... as an element in the history of childhood [produced] the child who waited to be discovered within each adult as an aspect of self ... Pursuing an empirical psychology of memory and a literary art of memoir, the *philosophes* sought to establish the remembered sense of self, which became the philosophical and sentimental cornerstone of the modern construction of childhood ... Writing on white paper ... gradually emerging from blankness, straddling the threshold of memory ... the force of [which] is such that the thing remembered 'can be made an actual perception again', an almost hallucinatory character qualified only by the 'consciousness that it had been there before'.[34]

Drawing from the significance of painful childhood experiences by which Carol Mavor's notion of 'umbilical indexicality' is bound, that is to say, the scar left behind by our physical and emotional connection to mother (as discussed at length in Chapter 4), is just one example of the way in which writers and artists of the French long nineteenth century sought to revisit and 'correct' experiences from infancy.[35] There is something to be said here for the significance of Freud's notion of the repetition complex, the need to re-enact painful experiences as a means of gaining mastery over them, in terms of its applicability to the modern adult approach to childhood, and specifically in relation to the adult reworking of difficult or inconvenient childhood memories. Roger Fry similarly refers to the notion of a double life comprising the actual and the imaginative, through the latter of which we may somehow re-envisage ourselves and our past for the ultimate amelioration or avoidance of the former.[36] Using their literature and art as vehicles of escape, practitioners of this period became fixated on 'what their experiences meant to them; his or her truth rather than the truth'.[37] While Barthes declared, 'my stories are a way of shutting my eyes',[38] J. M. Barrie went further,

attributing Peter Pan's otherworldly talent for flying as symbolic of 'escape artistry, childish flight ... being a bird, [and] not being a man'.[39]

This period's particular overflowing of nostalgia was characterised by the formation of 'an idealised past with an unsatisfactory present'.[40] Derived from the Greek terms *nóstos* ('homecoming') and *álgos* ('pain'), 'nostalgia, then, is a form of melancholy that wells up as a yearning for home', and considering its original seventeenth-century classification as a disease, alongside its cultural pervasiveness in the nineteenth and twentieth centuries, there is possibly some credence to be found in the query 'is nostalgia contagious?'.[41] Like a euthanasic disease whose acquisition offers deliverance from the pain of living a modern reality, nostalgia nevertheless inflicts the suffering of its symptoms and is ultimately derived from some misfortune in the first place, or indeed, the succession of losses experienced in life and that commence in childhood. It is in response to this loss felt in adulthood that we yearn to recover, or refill, what is lamented, coveted or resented from childhood by the oppressive onset of modernity. Moreover, the role of art in the recovery of selves lost must not be underestimated. Stendhal mused in around 1835 that 'next to the clearest mental pictures I find gaps in this memory, it's like a fresco, large parts of which have fallen away'.[42] Some 170 years later, contemporary artist Christian Boltanski declared that 'we make art to ... find childhood lost' reinforcing the significance of art and other creative processes in the practice of self-discovery and nostalgic re-imaginings of childhoods past.[43]

While the most common pathway to such deliverance seemed to be a re-engagement with childhood, Ernst Gombrich was eager to point out that this modernist regression was not to be achieved at will and by anyone, for many negated the seemingly prophetic philosophy of their endeavours when 'their frantic wish to become childlike drove [them] merely to exercises in calculated silliness'.[44] Some, however, managed to orchestrate such a practice to their advantage, transforming this propensity for aimless foolishness into a farce that sought to expose the incredulity of modern man that lay at the very heart of this modernist urge to retreat, reconsider and recompense. One such example is Alfred Jarry's controversial 1896 play *Ubu Roi*. Through layers of dualistic symbolism and simplistic woodblock illustrations, whose 'primitive' style pre-empts a connection with the modernist-child concept,

A Retrospective of Childhood

this work effectively embodies the appeal of and difficulty in the harnessing of the child and its conceptual state as key emblems representing the regressive yet reactionary ethos of the emerging modernist movement.

When Linda Nochlin defined realism as 'the demand for contemporaneity and nothing but contemporaneity', she consequently offered some insight into the movement that sought to rally against it: modernism.[45] In opposition to the acceptance of contemporary existence as seen and recorded by the realists, modernists rejected the notion of a fixed state of contemporaneity in favour of a process by which one is in a permanent flux of self-conscious revision and partaking in a progressive trend of thought that encourages and facilitates human capacity to create and reshape.[46] Accordingly, the modernist approach has more than once been likened to 'unlearning [as] a device that was supposed to unwrap the truth of things' all the while not forgetting that 'unlearning without relearning is meaningless'.[47] The modernist ethos affords a relinquishment of outdated values previously learned in favour of a persistent and ongoing replenishment of new, more self-consciously considered ones in what Colin Rhodes calls 'the act of undressing [through] the removal of the complex social masks imposed by modern urban culture', allowing for the garbing of oneself in any number of changing outfits.[48] This notion of undressing and a return to the physical and cultural beginnings of nakedness not only points to the major theme of the 'primitive' to be explored thoroughly later in this chapter, but also to the image of the child as a fresh and unadorned new-born as the very symbol of beginnings. This image, alongside the notion of unlearning, combines to furnish the notion that, not unlike aspects of Rousseauian theory, states that by virtue of its lack of educational sullying, the child houses unrivalled acumen: 'every level of learning begins with childhood [and] for that reason, the wisest man on earth so closely resembles a child'.[49] It seemed as though by regressing to the beginning, to unlearn all that modernity had encumbered on one, one could rediscover a state of infancy from which to commence the modernist process.

More generally though, this modernist excavation and rebuilding of oneself through childhood pointed to the gravitas by which the child was becoming characterised in the modern era, not least as a result of its universality and applicability to each and every one of us.[50] The emergence

of the modernist child was gradual and built on a plethora of foundation blocks that accumulated over the previous century or so. Testament to this, in anticipation of the impending modernist backlash against modernity, is Charles Baudelaire's positing of the concepts of *naïveté* and *curiosité* as early as 1846. Not only did he deem these ideas central to his conception of modern ways of seeing, but they established a grounding from which the modernist child would develop:

> *Naiveté* ... is primarily about the artist's self-expression, about his capacity to peel off the layers of academic learning and cultural condition in order to realise his own *tempérament* as fully as possible [and] *curiosité*, by contrast, is about a mode of engagement with the external world, and its corollary is ... *modernité*.[51]

Compelled by the twists and turns of the Parisian *avant-garde* in the early twentieth century, artist and critic Roger Fry was captivated not only by the growing presence in modern art and literature of themes related to childhood, but significantly also by the alternative vision offered by the child itself as a contributor to visual culture, especially its unfettered insight. Most particularly, Fry was struck by the child's capacity to use their imagination in a profoundly creative manner, bringing everyday objects and conjured figments to life through art and thus establishing a crucial link between the imaginative and creative spheres.[52] Fry accredits much of this ability to the child's propensity to form attachments to seemingly inanimate objects and environments as much as to other people.[53] While many scholars and artists believed in a link between children and nature, extending this to the assertion that it was from the latter that the former drew creative inspiration, Fry was more convinced by the idea of the inspiration of childhood and child art itself working in tandem with a reflection of the self. In other words, untaught artistic practice among children is demonstrative of the unrestricted personhood of its maker, as 'children, if left to themselves, never ... "draw from nature", but express, with a delightful freedom and sincerity, the mental images which make up their own imaginative lives'.[54]

Such focus on selfhood and individuality invites the philosophy of Friedrich Nietzsche, whose criticism of modern man's inclination towards what he termed the 'herd instinct' proved influential in the understanding

A Retrospective of Childhood

of late nineteenth-century and early twentieth-century *avant-garde* art and literature.[55] Infuriated by modern man's tendency to behave blindly and think like the majority, Nietzsche implored that one must instead liberate one's mind, ultimately giving rise to the sort of modernist output that found the individuality and perceived freshness of childhood an enormous creative influence, both as a conceptual theme and a blueprint for artistic practice. The establishment of the child as a symbolic trope of modernism, as well as the emergence of the childlike as a stylistic aim of the *avant-garde* manifested itself multifariously.[56] It is worth noting here that it often seems the case that, symptomatic of long-standing underestimations of the child, 'children's drawings are referred to as though they were a standardised product [when really their] output is almost as varied as that of adults'.[57] This is typical of the way adults not only generalised their understanding of children and childhood in a fashion that was neglectful of personhood and difference, but also their proclivity to make something of a fetishistic novelty of the perceived features and tendencies of children and their state. Although it is true that 'more than once in the history of Western art, there has been a return to fundamentals', to understand the modernist interest in children and child art solely within these terms would be ignorant of its many features and influences.[58]

Modernist champions of children and the childish rallied against the 'modern suspicion that playful, expressive art is intellectually shallow', instead showcasing that, contrary to the diligent and formalist rule-following of most adult art, children's artistic practice is natural and sincere.[59] While artistic production inspired by that of children often received the critical charge of childish incompetence, its proponents were instead struck by 'the power of the child's naïve vision to reveal truths closed to more sophisticated perception'.[60] Whereas adults tend to stereotype what they see, children, driven by the spontaneity of movement, draw precisely from life or imagination, producing a profoundly authentic rendering of personal vision unaffected by the constraints of convention or formalist training. Barbara Wörwag has written of the child's unique graphic language, which is typified by not only 'box people, [but general] distortions of form and ... ambiguous treatment of space'.[61] Not only do children entirely disregard structural rules that customarily restrict formal art production, but their styles and

processes afford the notion of a sort of 'folding out' in drawings whereby they adopt a sort of continuous picture formation that reflects the busy and unconstrained stream of consciousness that inspires it.[62] G. G. Pospelov agrees; firm in the belief that children's interests lie in the process and not the result, he remarks on the strength of the child's conceptual vision over the appeal of concrete reality.[63] Considered by Meyer Schapiro to be the ultimate source of creativity unabridged by convention, the child and his art becomes the most 'pure archetype of the "painter of modern life"', as coined by Baudelaire.[64] Accordingly, lamenting the long-standing process by which, in rather Nietzschean terms, 'most children abandoned artistic anarchy and idiosyncrasy to join the utilitarian herd' once educated and 'cultured', modern artists sought to subvert the denigration of this authentic artistic blueprint by channelling its themes, features and processes into their own work.[65] This collection of *avant-garde* figures, growing larger and more pervasive with time, dedicated their artistic production to this aim with such diligence that the increasingly common 'comparisons between modern abstraction and the symbolic work of children' were scarcely surprising.[66] While 'modern art was – and still is – dismissed with the cliché, "a child could have done it"', prominent members of the modernist *avant-garde* played up to this criticism, with figures such as Wassily Kandinsky, Paul Klee, Henri Matisse, Pablo Picasso, Joan Miró and Jean Dubuffet owning sizable collections of children's art, and others choosing to exhibit it.[67] These shared exhibitions of the work of modern artists and children provided a tangible scaffold to support the more conceptual connection between modernism and childhood, offering a concrete manifestation of the way in which artists 'studied and imitated the spontaneous and wilful distortions of children's pictures as though, like dreams, they offered a royal road to the unconscious' and the inner child in all of us.[68]

Such was the significance of this perceived connection between the child and the modern artist that James Sully proffered a semblance between play and creativity, a theory that proved a prominent mainstay in twentieth-century pedagogic study.[69] While key figures such as Picasso and Klee experimented with toys, making rudimentary playthings for their children, the simplistic shapes they fashioned soon became influential features of the *Cahiers d'Art* publication and Bauhaus shows respectively.[70] Similarly, while

A Retrospective of Childhood

in the 1960s John Berger disparagingly accused Picasso of being 'reduced to playing like a child,'[71] his pioneering Cubist style could instead be congratulated for 'taking the language of western art to pieces as if it were a jigsaw puzzle.'[72] These giant children at play, these giants of modernism, were changing the course of art production. Thus, their work unsurprisingly interacted; like children playing together, they shared and swapped, argued and stole. While Picasso acknowledged the influence that his great rival Matisse had on his own work, perhaps the greatest 'theft' among these childlike artists was that which they took from children themselves. When he declared that 'the more helpless they [children] are, the more instructive their examples', Klee revealed something of the exploitative nature of the modernist harnessing of the child.[73] From the practice among members of *Der Blaue Reiter* of rummaging about in children's nurseries for inspiration, to Klee's copying of his own son Felix's drawings into his own work, childhood was ransacked for its symbolic value and modernist gravitas.[74] Given that 'Picasso is supposed to have said that all children were born with artistic genius, but most of them forgot it', there seems to have been some degree of urgency among modernist figures to extract this wisdom before it was too late.[75]

The inspiration of child art went beyond mere 'child's play' and the appeal of just its *naïveté* and freshness of vision, however. In the formation of conceptual abstract styles, it would contribute what Kandinsky called 'the improvement and refinement of the human soul.'[76] Kandinsky's particular concerns about materialism pointed to the anxieties at the very heart of another artist, whose subtly foreboding work simultaneously warned of modernity's impending shifts and laid the foundations of the modernist deviation in artistic vision and perception: Paul Cézanne. When Cézanne declared to Émile Bernard in 1904, 'I would like to be a child', it provided some indication of the depth of this Post-Impressionist's significance in establishing the groundwork for the modernist uptake of the child and child-like.[77] For Cézanne, a painter whose subjects varied dramatically, it was not necessarily what he painted that mattered, but how he painted it. Painstakingly mulling over single brushstrokes for several hours, Cézanne reduced naturally occurring forms to their geometric essentials while simultaneously exploring new perspectival dimensions that rejected standard, single-point perspective in favour of a sort of binocular vision by which slightly different

though concurrent visual perceptions of the same image would present the depth and variation of what one truly sees. The phenomenological philosopher Maurice Merleau-Ponty understood Cézanne's renunciation of these traditional artistic elements as a bid to achieve a 'lived perspective' by effectuating all the complexities observed by the eye in a single moment.[78] Moreover, this perspective was forever changing for Cézanne, for not only when painting was he capturing a moment in time that once passed could never return, but it was subject to the vicissitudes of his own personal perception. By 'conveying a structured idea in paint of the sensory explosion of first sight', Cézanne was hoping to recreate something akin to the Damascus moment, producing a visual snapshot that captures the momentousness of one's exposure to the complexity of true vision and perception.[79] This visual epiphany can be understood alongside the extreme freshness of vision of which modernists believed the child to be in possession. To turn away, as modern artists increasingly did, from traditional compositions, structures, subjects, colours and perspectives in art, was to submit oneself to the visual and artistic clarity of the child untouched.

Cézanne, however, was an artist who resided on the very cusp of the modernist movement. In this way characterised by the *fin-de-siècle* pessimism that permeated the *avant-garde* consciousness at the turn of the twentieth century, Cézanne's glimpse at modernism was not only one that he took with trepidation, but one filled with the deeply anxious despondency that he felt for the future. This profound sense of oneself plummeting into the disconcerting pandemonium of modern life at such a helter-skelter pace, the modernist interest in the condition of the child can be seen to represent an earnest desire to 'retreat into a more innocent state untainted by the bad habits and values of the civilised mind'.[80] The *avant-garde* practice to embrace the image, influence and concept of the child emerged at a time when the 'adoption of otherness into the vocabulary of European thought' was steadily increasing alongside Freud's popularisation of 'the notion that the child is father to the man'.[81]

It was this context that also gave rise to Primitivism, a form of artistic expression that sought to contest the pessimism and corruption of modernity by engaging with the Other so as to effect a kind of creative and conceptual rebirth by which the example of the child serves as the seed from

which we grow. In many ways, Primitivism emerged from a cultural obsession with Otherness that had pervaded nineteenth-century intelligentsia. Given impetus by artists such as Paul Gauguin and Henri Rousseau, Primitivism had in the early years of the twentieth century become an established means by which the *avant-garde* could negotiate complex views regarding the supposed 'artificiality' of modern European society and a means of challenging what they considered the lifeless art of the academies and the bourgeois tastes to which it pandered. A far from simple concept, and built on a close relationship with nature, one's emotions, innate spontaneity and instinctive human condition, Primitivism worked to counter the regimented character of Western modernity and the artistic production that supported it. Primitivism thus often manifested itself as a wilful imitation by Western creatives of 'primitive' ideas and images as a staunch and deliberate subversion of classic, academic styles. Most prominently in the visual arts, Primitivist techniques and styles include exaggerated and flattened forms, unmodulated colour, crude contours, heavily stylised features, rough textures and perspectival distortion, all functioning as a rebuttal to the naturalistic forms, subtly blended tones, softly fluid contours, mimetic features, smooth surfaces and carefully structured illusions of depth found in academic art. To situate further their work, artists also frequently included specific cultural signifiers such as 'ethnographic' items. Awareness of and interest in such items (typically sculptures from various African cultures and tribes) reached a head around the turn of the twentieth century following the beginning of what became known as the 'Scramble for Africa' in approximately 1881. This process, comprising the competitive occupation, division and colonisation of African territory and peoples by European powers during the period of New Imperialism, replacing the earlier fascination with the 'Orient', saw the importation of wooden masks, statuettes and carved sculptures from across the continent.

In Europe, this *art nègre*, as it was known, was not exhibited as 'art' in galleries but rather as objects of material culture in world fairs and ethnographic museums, where they were used as a means of legitimising colonial intervention. Comparing the perceived crudeness of African sculpture to the apparent sophistication of European art, the West established African people and their cultures as the archetypal Other. Using the perceived

'savagery' and 'barbarism' of African art as evidence of their 'primitive' state, and by extension as a means of legitimising colonial enterprise as a moral responsibility, Europeans conveniently hid the true economic motives and disastrous effects of such a process on indigenous peoples and their cultures. Europeans either failed to realise or wilfully chose to ignore that instead of African art demonstrating its makers' 'primitivism' through their incompetence in accurate reproduction, African representational modes were conceptual and symbolic as opposed to mimetic. The African approaches to artistic representation was simply different from those of Europeans, but as a result of the mentality of Otherness, Europeans deduced only the 'primitive' in that which contrasted their own 'civilisation'.

In the early twentieth century, *avant-garde* artists and writers chiefly working in France (where Primitivism first emerged and developed), as well as in other European countries such as Britain and Germany, explored the features of African art and its connected themes as a particularly effective means of opposing traditional conventions of creative production. This manifested itself variously, for while figures such as German artist Emil Nolde and British author Joseph Conrad produced works that offered a very personal criticism of the destructive and acutely hypocritical actions of the European coloniser, others like Picasso referenced Africa and its art rather differently, harnessing its inspirational potential. Enticed by its unusual conceptual qualities, popular associations with superstitious exoticism and its capacity to provide a pathway back to our simple, 'primitive' roots, Picasso saw African art as an example of the creative freedom sought by those who felt oppressed by the constraints of modern 'civilisation'. These non-conventional sources of creative inspiration facilitated a sort of 'spontaneity' and 'authenticity' that did away with the supposed 'corruption' and 'decadence' that contributed to Western culture's characterisation among the *avant-garde* as something of a spent force.

In this way, the manner in which concepts and images of the 'primitive' were harnessed by *avant-garde* figures and the modernist movement mirrors the process by which children and the state of childhood were creatively commodified, providing just one of the key links between the two. From the specifics of their perceived features and the connected general symbolism of the unmediated, unspoiled and thus 'authentic', to the way in which these

A Retrospective of Childhood

characteristics were exposed, enhanced and mobilised, both the child and the 'primitive' ultimately served as a fascinating Other by which they were not only appropriated and exploited, but also conflated by virtue of their mutual Otherness. This conflation was constantly fuelled by the deluge of works inspired by and based on what became the perceived shared qualities of the child and the 'primitive', whose specifics varied depending on the particular interests and aims of each creator. In 1936, Erwin Panofsky provided a summary of man's perceptions of the 'primitive', offering a significant insight into the multifaceted nature of the term and thus the various ways in which it has become connected and conflated with the child and childhood. Writing of two contrasting views of the natural state of man, Panofsky discusses 'soft' primitivism as 'a golden age of plenty, innocence, and happiness ... a civilised life purged of its vices' as a contrast to 'hard' primitivism, which describes 'an almost subhuman existence full of terrible hardships and devoid of all comforts'.[82]

For some, it was as simple as drawing on the mutual parsimony of style, in particular a propensity for nakedness on the part of both the child and the 'primitive', often understood by the *avant-garde* to represent a relinquishment of the taboo-driven shackles of urban modernity in favour of the uninhibited innocence of paradise.[83] For others, the similarity was strongest in their respective artistic practice; where the tendency among children to produce artwork whose arguably grotesque 'exaggerations and distortions of body parts ... that express a spiritual life of which the child often is not conscious' resemble the style and potential symbolism of the art of 'primitive' peoples.[84] Fry stands out in the modernist conflation of the child and the 'primitive', chiefly in the powerful connection he found between the '*imprévu* quality of primitive art' and the comparable freshness of vision of the untaught child artist.[85] Fry exhibited a sense of regret at the loss as a self-conscious adult of modernity of the direct vision and capacity to create which still remained strong in the child. As such, he was convinced by a sort of deeply spiritual magic at play in both the child and 'primitive', whose proclivity for the transformation of seen or imagined objects into the most skilful of naturalistic illusion was not so accessible to 'normal' adults. Essentially, 'primitives ... are the "children" of social evolution' and vice versa, as 'one habitually invoked the other [for] the characteristics of both must be

regarded as projections stimulated by the modern European's sense of his own place in culture, history and evolutionary development'.[86]

It is possible that such ideas and comparisons developed from prevailing physiognomic theories that began to gain credence in the previous century. While child psychologist Milicent Shinn remarked in 1900 that 'babies sit like monkeys, with the soles of their feet facing each other', palaeontologist S. S. Buckman pushed this notion further in the years following.[87] By studying the growth of his children using the same processes he applied when working with ammonites and brachiopods, and influenced by Hyatt's law of acceleration, Buckman posited that there was a recapitulatory link between the characters of adult monkeys and human children, and sought to identify behavioural and physical evidence of this simian past by looking to potential shared characteristics, including flattened faces, chubby cheeks, and even the soothing effect of rocking and swaying alongside young children's urges to climb staircases as vestiges of an arboreal past.[88] Not only do these assertions offer some uncomfortable suggestion of perceived physiognomic links between the appearance of the ape, the child and the 'primitive' in a fashion reminiscent of pro-Caucasian race theory, but they also point to a long-standing relationship between ontogeny and phylogeny in the double-helix field of study of the child and the 'primitive'. In philosophical terms, the establishment of the child as the anthropological 'primitive' originates in the philosophy of Jean-Jacques Rousseau, as discussed in Chapter 2. The longevity of the concept, from the eighteenth century until the early twentieth century, is testament to the power the idea exerted on the European consciousness. Richard Shiff's succinct summary of the concept states that:

> primitives appear to be phylogenetic 'children' amongst the world's races, so the European child is ontogenetic 'primitive', an undeveloped being within its own race [and in turn] the racially advanced child recapitulates all previous stages of phylogenetic evolution, including that represented by the present-day primitive, man still living in the wild.[89]

To unpack this a little, the relationship between the child and the 'primitive' is galvanised further by the introduction of another twofold dynamic. It can be argued that the 'primitive', thanks to its perceived elementariness

A Retrospective of Childhood

and underdevelopment, is seen to represent the child on a global scale as though it were a race of peoples. In turn, the child serves to represent the 'primitive' stage of its own single-race development, with the progress from child to adult understood as akin to the advancement of the earliest and most 'primitive' human to its modern, 'civilised' version. Furthermore, it is pertinent to recognise that such a relationship had a profound effect on treatment and behaviours as much as classification and terminology. Although unlikely matched in systematicness, there is something to be said for the parallels between the experiences of children and colonised individuals. The demeaning of children by adults in the broadly modern era, manifesting itself as a denial or removal of personhood or culture in favour of the instilment of one's own ideals, often justified by the construction of collective moral responsibility, can be understood as reflective of the cultural and personal annihilation of 'primitives' and their societies by the steamrollering of Western colonial endeavours: 'children of industrialised society … suffered the fate of native peoples living in societies evolving towards the organised state'.[90] Accordingly, modernist efforts to return to an idealised 'before' through the child and the 'primitive', or some conflation thereof, often became a practice in exactly that which it sought to critique or subvert. An interest in and addressing of the Other almost inevitably resulted in an exploitation of its perceived symbols and values for the purposes of an *avant-garde* statement or ideal that ultimately encompassed counterproductive processes of fetishisation and appropriation arguably as shallow and inauthentic as those that they sought to expose and dismantle.

Paul Gauguin, ostracised from French middle-class society following the loss of his stockbroking job and thus disillusioned by 'civilised' modernity, fell victim to such a practice. Initially, Gauguin escaped to Brittany, where he misappropriated its deeply spiritual culture for his own purposes. When this proved exhausted, Gauguin sought out fresh inspiration on the French Polynesian island of Tahiti, only to be left further disappointed on finding it almost stripped bare of its indigenous culture as a result of colonial processes. Gauguin proceeded desperately to invent in painted form the paradisiacal escape he craved, ultimately producing works whose flat, inauthenticity simply became 'a long, drawn-out confession of the fraudulence of it all'.[91] Yet, as modernity continued to thunder, such appropriation of the

Other, or invention of its perceived yet absent qualities, persisted as a seemingly most effective method of some sort of modernist renaissance of self, an opportunity for rebirth, for:

> the sight of a child or a primitive will arouse certain longings in adult, civilised persons – longings which relate to the unfulfilled desires and needs of those parts of the personality which have been blotted out of the total picture in favour of the adopted persona.[92]

The emergence of the twofold concept of 'the childhood of man [and] children as home-grown savages' invites a confusing conflation that exacerbates the denigration of selfhood effected by adult concepts of children and childhood, modernist or otherwise, and the connected harnessing of the 'primitive'.[93] Victor Turner discusses the notion of the 'neophyte' as a particularly effective concept by which to understand the conflated and 'in-between' experience of the child and 'primitive'. Turner's symbol of the neophyte represents the acute maladjustment imposed on and felt by the child as they become synonymous with any number of tropes or constructions irrespective of their own individuality:

> likened to or treated as embryos ... neophytes are neither living or dead from one aspect, and both living and dead from another their condition is one of ambiguity and paradox, a confusion of all the customary categories ... they are neither one thing or another; or may be both; or neither here nor there; or may even be nowhere.[94]

Society's unflinching bias towards the fixed and codified over the transient and hazy is representative of the way in which children and childhood have been approached and treated, and thus misunderstood, in both scholarly and social circles. In turn, this has given rise to circumstances by which the child is seen as a sort of 'human *prima materia* [with] physical but not social "reality", thence they have to be hidden, since it is a paradox, a scandal, to see what ought not to be there!'[95] Indeed, while there is arguably a sense of veneration with which children are predominantly regarded these days, this a status that has been negotiated over many decades and, as such, gave rise to an extended period during which children and childhood were socially,

A Retrospective of Childhood

culturally and conceptually available and thus vulnerable to a plethora of external forces. Furthermore, this becomes a sort of self-fulfilling process, whereby the passivity and malleability of these neophytes to their instructors, which is only increased by their submission to torment and 'reduction to a uniform condition, are signs of the process [by which] they are ground down to be fashioned anew' and by which we can characterise the ongoing treatment of the child, and perhaps on a more recognisable level, of the 'primitive'.[96]

While the 'availability' of the child and the state of childhood invited attempts to regulate, codify and rebuild them afresh, as when crusading to 'civilise' the 'primitive', their apparent 'obscurity' also attracted efforts to explore and understand their true characteristics and condition. Like the voyages of discovery whose participants endeavoured to unearth the much-coveted secrets of the 'primitive' and his vast 'dark continent', there are arguably significant points of convergence with the not culturally and intellectually dissimilar processes of uncovering and colonising childhood. The process of discovery and understanding of so-called 'primitive' peoples and cultures was one that started at a very different place to where it currently is, beginning with economically motivated and racially fuelled colonial exploits from the fourteenth century onwards and developing into the ongoing efforts to understand and promote cultural difference we see today. Awareness, recognition and understanding of children and childhood has undergone a comparable journey, 'as if childhood were itself a dark continent that was completely "other"' to begin with.[97]

Modernist writer Blaise Cendrars offers an interesting interpretation of the relationship between the child and the 'primitive' in his poem *Shadow*. Part of his 1928 anthology *Little Black Stories for Little White Children*, the poem's original French title *La Féticheuse* literally translates to mean 'the charmer', which recalls both conceptually and visually the sort of mystic landscape and spiritualism of the so-called 'dark continent'. Cendrars, key to the formulation of a solid poetical synthesis of modernism, was also a keen historian and traveller, both hobbies proving a significant influence on his writing. *Shadow* is no exception, with Cendrars having accumulated an entire collection of fables from his travels around Africa that he then adapted in the style of a *griot*. Cendrars's Shadow character, a mysterious figure of African

spiritualism, whose story is one of disappearances and reappearances, of intrigue and mystery, can arguably be seen to reflect that of the child. The conceptual and representational journey of the child and the condition of childhood as explored by this text, as already intimated, is one of undulating experience whereby the childish game of hide and seek, imaginatively played out by Cendrars's Shadow, symbolises something of the negotiated role of backstage support versus centre stage focus that characterises the child's shifting position in society. Often hidden but increasingly sought, the child of the long nineteenth century, like Cendrars's Shadow, is a being on the periphery as its social and cultural significance unfolds.

Despite the literal translation of *La Féticheuse* as 'the charmer', Cendrars's text is most commonly known to Anglophone readers as *Shadow*, and was translated, illustrated and transformed into a children's picture book by Marcia Brown in 1982. Full of life and vigour in the daytime as it frolics with the jungle's animals, and heavy and fleeting by nightfall, bumbling about among the flickers of light emitted from the villagers' fire, the Shadow is a confusing and ephemeral presence. It is both in among yet separate from everyone else, and in all its sneaking and playing and prowling and dancing, it is in fact a full-bodied character, far more of a person than its seemingly sheath-like and transitory existence might first suggest. Judith Wynn Halsted offered a summary of this symbolism when she asserted that the Shadow 'evokes an image that goes far beyond that cast by an object between the earth and the sun … it incorporates the idea of spirit, both haunting and enchanting'.[98]

Perhaps reflected in its target audience of children, both Cendrars's Shadow and Brown's adaptation present a character whose symbolism speaks as much of the sense of the unknown and juxtaposed sense of both Self and Other, as that of the 'primitive', possibly first suggested by the African influences found in the text and illustrations. Reminiscent of the notion of the uncanny, a concept explored further in Chapter 5, the child, like the 'primitive', is both 'us' and 'not us'. Functioning as a sort of Self before our current Self, the child and the 'primitive' are both familiar yet not fully understood and assimilated yet. Valérie Meylan's succinct interpretation of the Shadow as 'a description but also a puzzle' adds to this, and could just as easily be applied to the child.[99] As much as the term 'child' is used as a categorising

A Retrospective of Childhood

and descriptive term, indicative of a whole host of biological and ontological understandings, it is also bound up in conceptually complex stories. It comprises many different fragments of cultural and creative representation that jostle for space across this period of exploration, from the advent of the Age of Enlightenment to the era of modernism and beyond, to take their place in forming the completed jigsaw of what childhood and children are. In a prelude to her translation, Brown mused, 'What is Shadow? ... The beliefs and ghosts of the past haunt the present as it stretches into the future. The eerie, shifting image of Shadow appears where there is light and fire and storyteller to bring it to life.'[100] Brown's brief preface, although ambiguous, is revelatory in terms of the connection between Cendrars's Shadow and the child, drawing on issues of memory, the passage of time, the relationship between histories and the future, both personal and collective, and the capacity to be both hidden and exposed, often depending on the interest and perception of others. Just like the child, the Shadow is 'seen and not heard', it seems 'it has no voice', and so becomes 'mute [for] it never speaks [and only] listens'; similarly it is reduced to 'follow[ing] man everywhere' during which 'it is always watching', fascinated by the world by which it feels simultaneously ostracised and absorbed; thus debased it finds an affiliation with 'all that crawls [and] all that squirms', and in so doing, 'breaking loose, unwinding, stretching, stirring [and] branching out', endlessly strives for emancipation.[101]

Brown's illustrations support this message both in form and content, born of artistic processes inspired by the creatively experimental child by bringing them to life using paper cut-outs and wood etchings. While some of Brown's illustrations offer a sort of nod to the 'primitive' culture and landscape of Africa from which Cendrars originally took inspiration, others adopt a far more symbolic approach. Her illustrations sporadically include those in which wispy, semi-translucent, yet beautifully detailed figures and shapes are shown in tandem with her solid black tribespeople. Seen either alongside their solid counterparts, mimicking their movements, or as a sort of ghostly, dream-like apparition floating above a stationary body, these filmy shadows represent the complexity and depth of character to be found within that which is ostensibly simple in appearance. Not only does this perhaps speak of the tendency among some adults to underestimate the child, but also of the connected issue of the significance that the shadow

had acquired by the late nineteenth century as a symbol and metaphor of the overlooked inner truth and selfhood of a person that was in full bloom in childhood but becoming extinguished by one's adult years. Woven to capacity with memories, thoughts and personhood, like the pattern of a most intricate lace, Brown's pale, delicate shadows are demonstrative of the histories, experiences and personalities that make up a person inside and that can be preserved should we resist the temptation to meddle and quash.

It is pertinent to note here that Blaise Cendrars was the author's pen name, carefully chosen as a further expression of his thoughts and creative message. Born Frédéric-Louis Sauser, the writer first signed his name as Blaise Cendrars in 1912 when writing *Easter in New York*, his first major contribution to modernist literature. 'Blaise', a sort of 'Frenchification' of the English word 'blaze', and Cendrars as a compound of *cendres*, the French for 'cinders', and *ars*, the Latin for 'art', this modernist figure's name became a sort of metaphorical echoing of the phoenix, capable of rising from its own ashes. This provides a conceptual link back to the central focus of this chapter, that is, the modernist championing in the early twentieth century of the child as a vehicle of cultural rebirth. It is this veneration of the child and state of childhood as a means of such rejuvenation, double-edged though the process proves, which marks the 'end result' whose development and negotiation is mapped and explored by the rest of the book.

As this chapter has demonstrated, the apparent capriciousness of ontological and biological definitions of children and childhood that emerged following the Enlightenment has given rise to a similar obscurity among social, cultural and creative understandings and representations thereof thereafter. In turn, this led to an association of children with the unfixed and liminal. As concepts and representations of children were variously negotiated, their lack of a clear role and status becomes a sort of affliction apportioned directly to the child and their condition in a manner that facilitated manipulation, reimagining and exploitation. Coinciding with an era in which the collision between tradition and modernity bore a widespread sense of both curiosity and despair, the cultural emergence and availability of the child and childhood in the long nineteenth century alongside their innate symbolism made them the perfect expedients of the cult of regression. Largely characterised, at least ostensibly, by a rejection of the ills of

A Retrospective of Childhood

onsetting modernity, the modernist fashion for revising the self that tumbled out of various nineteenth-century cultural dispensaries harnessed the child and childhood as its principal guide. Inspired by the perceived attributes of unaffected wisdom and freshness of vision, and as such, often conflated with the similarly fetishised image of the 'primitive', the image and condition of the child became the vehicle of collective rebirth modernists sought. The thinkers and practitioners discussed in this chapter, such as Fry, Klee, Picasso, Cézanne and Cendrars, although stylistically varied, can be united by their representational and conceptual colonisation of the child, childhood and their associated qualities for the purposes of fulfilling their own cultural rebirth, often to the detriment of their muses, whose truth of experience and individuality goes overlooked.

When Cendrars himself applied the aforementioned metaphor of the phoenix to the act of creation in writing, he asserted in his aptly entitled autobiography *The Man Struck Down* that 'to write is to be burned alive, but it is also to be born from one's ashes'.[102] Referring to the painful and destructive aspects of creative methods alongside their potential to offer eventual salvation and a sense of unearthly eternality, Cendrars could as well be speaking of this long nineteenth-century process by which children were harnessed by intellectual and creative endeavours for an array of personal, professional or collective aims, the complex journey of which will be explored and analysed in detail in the following chapters.

Romantic Enlightenment: The *Carte Blanche* of Childhood, c.1750–1850

Everything degenerates in the hands of man.
Jean-Jacques Rousseau, *Émile; or, On Education*[1]

Led astray by ambition, men trample upon naïveté ... Lovely child! It is only at your side that I regain the simplicity of the Golden Age.
Louis-François Jauffret, *Les Charmes de l'enfance* ('The Charms of Childhood')[2]

Charles Baudelaire once declared that 'genius is simply childhood recovered at will.'[3] Such a gentle and deft uncovering of the memories, experiences and perceptions of yesteryear, like the careful exposure of the yellowing pages of a dusty, attic-dwelling book to the bright daylight beyond, goes some way to describe the way in which childhood as a state and concept was being rediscovered and reconsidered in French culture and society from the mid-eighteenth century onwards. As explored in Chapter 1, debate concerning what constitutes and defines a child and the state of childhood has existed in some capacity for centuries. However, it was the cataclysmic clash between

Enlightenment doctrine and Romantic thought that is generally considered to have marked a shift in not only concepts of children and childhood, but in the degree of interest and importance afforded to them.[4]

Prior to this, children were relegated to the sub-category of man on a smaller scale, bereft of personhood and sociocultural significance. Moreover, their mistreatment was intensified by their often damning characterisation at the hands of the Church, whereby the extremeness of religious belief in the years encompassing the Middle Ages and the Renaissance prescribed popular assertions stating that 'children were not only conceived in sin, but born in utter corruption'.[5] Accordingly, early childhood became the designated period during which the child's innate evilness must be extinguished from its being through a harsh regime typified by stern moral instruction and threats of Hellish suffering for the disobedient.[6] Such was the distaste for children and childhood before the shift of the eighteenth century, that nostalgia, or anything resembling persistent sentimentality for one's past, was declared by seventeenth-century Swiss doctor Johannes Hofer to be a physical disease treatable with leeches, purges and opium.[7] This proves testament to both this era's reticence in relation to matters of the mind and emotional sphere, incidentally that which is often considered synonymous with the child's world, as well as the extent to which Enlightenment teaching and the subsequent Romantic rebuke marked a dramatic shift in both intellectual and popular thought.

Discourse on the newly considered significance of children and childhood in the Enlightenment period can be described as something of an entanglement of intertwining and clashing ideas. Inspired by writing from as early as René Descartes's 1637 treatise *Discours de la Méthode* ('*Discourse on Method*'), French scholarship of this epoch on the topic was heavily punctuated by some half a dozen key thinkers from France and beyond, often concurrently producing works that both challenged and consolidated the theories of their peers. Prominent French physician and writer Alphonse-Louis Leroy adopted a retrospective consideration of the period of the Enlightenment and its role in contemporary understandings of childhood, culminating in his desire to assemble 'a science of childhood'.[8] In 2004, Adriana Benzaquén deemed the Enlightenment to have been largely overlooked in terms of the significance of its scholarship on the study of childhood. While acknowledging

Romantic Enlightenment

the difficulties inherent to such research given the empirical impossibility of direct observation of ideas in the mind, Benzaquén nevertheless draws attention to what can be understood as the coinciding of the arrival of the child as a focus of scientific study and the emergence of ground-breaking notions of selfhood and identity: 'Childhood is entangled with the adult's present identity because the interiorised self ... is perceived as internalised memory of the past, the outcome of a personal history.'[9] In this sense, this era's apparent 'discovery of childhood' is perhaps as much a reference to 'the child who waited to be discovered within each adult as an aspect of self ... fully consummated with the introspective work of memory in the age of Enlightenment' as it was a realignment of what it meant to be a child in real time based on observation and representation *in situ*.[10] Accordingly, this gives credence to Leroy's assertion in 1803 that 'it is therefore the child who teaches man to know himself'.[11]

This chapter comprises an exploration of this particular notion, analysing the emerging discovery of childhood as a simultaneous embodiment of Self and Other and ultimately a means of self-discovery against the backdrop of the Enlightenment and Romantic periods. In the first instance, this begins with an investigation into the scholarship of various prominent academics of the eighteenth century, excavating from their literature the sometimes extensive though often forgotten or overshadowed study of children and childhood. The bulk of the chapter is then dedicated to reviewing its relationship alongside the work of the most widely recognised French scholar of childhood and pedagogy of the Enlightenment era, Jean-Jacques Rousseau. Considering Rousseau's position as arguably the founder of the notion of the 'Romantic child', this chapter focuses on analysing his complex and often contradictory philosophy, chiefly that found in his seminal work *Émile, ou De l'éducation* ('Emile; or, On Education') (1762), considering the origins behind, effects of, and reaction to his extensive contribution to concepts and practices relating to children and childhood.

With much Enlightenment philosophy arguably stemming from Cartesian seeds, it is interesting to note Descartes's inherent regret towards the period of childhood, remarking that because we have all been children and thus governed for a long time by the contradictory doctrines of the adults around us, our own judgements and convictions could never be 'as pure or as firm

as they would have been if we had had the full use of our reason from the moment we were born'.[12] While such views are reflected, if not regurgitated, by some of Descartes's contemporaries, it is more his advocacy of unyielding rationalism, his unrelenting method of doubt, and his development of the dualistic doctrine, more broadly defined by an overall scepticism, which proved especially influential to his academic descendants. John Locke's stringent spearheading of empiricism was in the first instance inspired by Cartesian rationalism, and in turn counselled his rejection of the notion of harbouring innate truths, in favour of embellishing the mind with observations, lessons, experiences and perceptions. In his works *An Essay Concerning Human Understanding* (1690) and *Some Thoughts Concerning Education* (1693), this was most famously denoted by his concept of the child's mind as a blank sheet, or *tabula rasa*, void of character and ideas, to which we gradually add the writings of experience and knowledge through learning and guidance. Moreover, Locke was convinced that the observation and study of children would open the doorway to a rationalist and evidence-based understanding of the mind overall.[13] In his *Treatise of Human Nature* (1739), David Hume expanded on strands of Locke's work, drawing on his assertions that memory had to be bound in past perceptions to buttress his own conclusions that personal identity was 'fictitious', based on perceptions, experiences and the influence of others, as opposed to originating as an innate human substance; in other words, like Locke's *tabula rasa*, identity as much as knowledge remains empty or non-existent without the epitaphs of education, experience and influence.[14]

Étienne Bonnot de Condillac's reflections are somewhat more sombre, rooted in his Cartesian belief that childhood was an impediment to rational human knowledge. Deeming its emptiness as not only a sign of its uselessness but also evidence of its inaccessibility, Condillac was frustrated by the very existence of childhood and the infuriating obtuseness he understood it to pose in his quest for rational answers and knowledge.[15] Condillac extended Locke's theory on the inexistence of innate ideas to the lack of innate abilities. To do this, he drew on the symbol of the statue to denote the physical being of man thus far unanimated by senses, which could similarly be attributed to the child, a person only in shape, who simply waits for time to tick by until he can awaken to the experience of mental

engagement that will only arrive in adulthood. Accordingly, in contrast to the advice of Locke and Hume on the advantages of returning to and observing childhood to locate the origins of knowledge, Condillac instead adopted a bitter 'philosophical repudiation of childhood, towards the envisioning of a world altogether without children'.[16] This contrasts quite dramatically with the standpoint of naturalist Georges-Louis Leclerc, Comte de Buffon, and his contemporary, educator Louis-François Jauffret, both of whose proximity to the burgeoning Romantic movement offers some explanation of their more sentimental approach. Buffon dedicated some forty years of his life to his thirty-six-volume encyclopaedic masterpiece of scientific, anthropological and pedagogic study entitled *Histoire Naturelle* ('*Natural History*') (1749–88), which he endeavoured to make accessible to both the learned and the simply curious, including children. While Buffon's expertise was drawn from his position as intendant of the Royal Botanical Gardens in Paris, a significant portion of his research was dedicated to the anatomical, physiological and psychological study of the child, culminating in his conclusion that children are born fragile and weak, and require constant care from parents and educators. Buffon advocated simple, country rearing in an affectionate and supportive atmosphere, remarking that the parent-child union should be strengthened, not diminished, for after all, it 'is natural, because it is necessary'.[17]

Buffon's favour for this process was largely supported by his establishment in his fourteenth volume, *Nomenclature des Singes* ('*Nomenclature of Apes*') (1766), of his dualistic theory of education.[18] In basic terms, Buffon posited that there are two types of education in existence: individual education (common to both man and animal) and species education (unique to man). Individual education is much slower for children than it is for animals, for the latter must learn very quickly how to be able to do most everything in order to survive, whereas human young are far less advanced at an early age and need the help of adults. In turn, such slowness in individual education allows for the gradual process of species education, affording the child time to become cultivated in a fashion inaccessible to animals. It is through such assertions that Buffon refuted the claims of Rousseau, for example, pointing out that if a child is born as wise and strong, as Rousseau suggested, their individual education would be far too quick as to facilitate the species

education required in order to awaken their minds.[19] Significantly, Buffon's reference here to what can be summarised as an innate animal or material principle in contrast to a decidedly spiritual and human one awakened and developed through education is as much about his moralistic outlook as it is his scientific one. Not only was he unconvinced by the staunch rationalism of Locke's loyalty to empirical observation, resolute in the impossibility of purely didactic research into childhood, but Buffon's focus on the inherent weakness of children and their consequential reliance on care from adults pointed to a greater issue about the importance of sociability and empathy as key elements of human nature more generally. Through this, Buffon formed 'a moral argument based on the belief that to care for the weak and vulnerable other is what comes to define a human being'.[20] Drawing on moralistic influences and theories relating to evolution, biogenetic law and even colonial issues, Buffon, befitting of his encyclopaedic roots and tendencies, establishes connections beyond the scientific sphere between the study of childhood and that of mankind and human nature as a whole.

It is perhaps the figure of Louis-François Jauffret who best represents the growing disharmony at the turn of the nineteenth century between what was now a well-established Enlightenment following and the emerging influence of Romantic opposition. This poet and educator's life and career was characterised by a constant tension between his interest in clinical studies and his inherent draw to sentimental writing for children. It was during the years following the French Revolution that Jauffret established his affinity with the natural world, retreating to a quiet existence in the countryside where he happily observed the innocent play of seemingly care-free children and wrote, as an antidote to the turmoil of his country's recent history, a sentimental four-volume collection of fables *Les charmes de l'enfance, et les plaisirs de l'amour maternel* ('*The Charms of Childhood and the Pleasures of Maternal Love*') (1791). Continuing this theme, Jauffret organised his annual *Promenades à la campagne* ('*Walks in the Countryside*') from 1801 onwards, consisting of walks and lectures through nature spots in Paris, designed to function in tandem with his engaging youth literature to provoke contemplative and reflective studies for children. These educational walks in many ways represented Jauffret's greatest success in trying to strike a balance between sentiment and science, as for the most part, his literary reputation as 'friend

of children' was in constant battle against his desire for scientific discovery as a founding member of the Society of Observers of Man. Jauffret's science did not remove him from the realm of childhood, for the motto of the Observers, 'know thyself', was a nod to the belief that 'the study of the child was the foundation of the knowledge of man'.[21] Rather, aborting and neglecting a good many scientific projects, Jauffret felt divided by his reticence to subject children to clinical scrutiny in the pursuit of scientific answers for which he nevertheless yearned. Jauffret's frequent distractions from his clinical studies were made permanent when the Observers society effectively collapsed under Napoleon's reconstruction of the National Institute in 1803. For Jauffret, the retreat to children's literature that this facilitated marked a relinquishment of the guilt that he associated with empirical endeavours, and a return to a soft and rosy world of romanticised storybooks.

However, the persistence of the cultural mainstay that 'all children's books are about ideals' offers some indication of the inconsistency by which such literature is characterised, and in particular, the theories and ideas promulgated by that of Jean-Jacques Rousseau.[22] Operating among the aforementioned scholars of childhood and related pedagogy of the Enlightenment era, Rousseau's far-reaching philosophy cemented his position as arguably the most popular and influential scholar in his field and of his time. Analysis in this chapter will chiefly comprise that of his pivotal 1762 treatise on education and civilisation entitled *Émile; or, On Education*, widely considered the 'best and most important' of all his literature, but will invite contributions from other relevant works of his extensive corpus in order to gauge an expansive grasp of his theories.[23] Certain aspects of *Émile*, considered to be rife with irreverence, resulted in a backlash that saw on publication its banning and public burning in Paris and Geneva. Nevertheless, its progressive appeal gained significant impetus during the French Revolution, after which its impact and popularity secured its position to some extent in dominating theory on pedagogy, subjectivity and introspection until the advent of Freudian thinking.[24]

It is perhaps the very dichotomy of Rousseau's work that secured his seemingly widespread appeal. His role in the creation of the concept of the Romantic child, forged in among the crux-like conflict between an abhorrence for Reason and its formalism, and a tentative reappraisal of feeling,

sealed his positive heralding among those similarly intrigued and perplexed by their epoch's grappling with old and new. In many ways, 'its sentiments had a universal influence on the cultivated mind'.[25] However, the longevity and significance of what were often such muddled 'Rousseauian' theories could be construed as a major factor in the ongoing cacophony of conflicting concepts and misapprehensions that have pervaded the study of children and childhood for centuries to follow. Psychoanalyst Melanie Klein once reflected that a child whose thoughts and anxieties remain unresolved in childhood will likely find 'its mental health in future years not planted in firm soil'.[26] Not only will the botanical basis of this metaphor prove pervasively symbolic, but its sentiment can be mirrored insofar as scholarship on children and childhood that tends to stem from a single, unsteady root (Rousseau) will likely also suffer from a similar frailty and inconsistency in the years that follow.

Before exploring the content of Rousseau's *Émile*, excavating the inconsistencies that run to its very core, it is worth noting the incongruity of its textual nature and form. While it is true that Rousseau's script was likely to straddle more than one genre by virtue of its complex intermingling of both Enlightenment and Romantic ideologies, his unabashed passion for the subject poured out dramatically onto the pages, forming what essentially became 'a pedagogic romance'.[27] In a style characteristic of his dogged obdurateness, Rousseau's *Émile* essentially comprises 'the pursuit of verisimilitude in fiction', disguising an extravagant and self-adulating exercise in sentimental introspection, rosy storytelling and scholarly shoehorning as an academically enlightening discourse delivered in a refreshingly modern, relatable and inspiring way.[28] It certainly proved an inspiration, functioning as a sort of catalyst in the production of introspective and non-realistic writing about and/or for childhood, personal or otherwise, resulting in what Peter Gay described as the late nineteenth century becoming 'swamped with unremarkable self-revelations [proceeding] in Rousseau's shadow'.[29]

Ultimately, Rousseau's text comes to operate, as many examples of literature in some way aimed towards children do, as an agent of control. Although some of this can of course be attributed to the fact that almost all such literature is written by and from the perspective of adults, it is nevertheless the case, both within literature and beyond, that 'it has always been

Romantic Enlightenment

adults ... who have sought to define childhood, or more often to negate it, or to exploit it, and sometimes to idealise it'.[30] In a tone reminiscent of Gay's critique of the nineteenth-century literary fashion for unwarranted self-indulgence, it has been said that Rousseau's initiation thereof through his planting of the seed of Original Innocence lends itself easily to irresponsible self-indulgence. It is an in-depth analysis of this in relation to Rousseau that forms the bulk of the rest of this chapter. Drawing from Locke's influential foundation of the *tabula rasa*, the notion of 'Original Innocence ... in the child had already won some currency as a retort to Original Sin', not least as part of the shift from religion that the waning power of the Church and beckoning gravitas of the Enlightenment facilitated.[31] Nevertheless, in a style characteristic of Rousseau's inconsistency, his discourse all the same fixated on a somewhat Romantic notion of the paradisiacal roots of childhood. While Original Innocence was a counter to the long-standing insistence on Original Sin and thus the inherent evilness of a new-born, it nevertheless pandered to the same doctrinal rhetoric of one's spiritual beginnings. The extreme level of purity associated with such notions is not only potentially ridiculous in its absoluteness, but in essentially deeming the child 'cleaner than Adam before he tasted the apple', it remains inextricably linked to biblical teaching.[32] In this way united, both Rousseau and Locke were convinced by the fundamental difference between children and adults, the former belonging to a sort of utopian land yet unsullied by the effects of later life.[33]

This concept contributes significantly to one of the cornerstones of Rousseau's pedagogic theory, regurgitated frequently by more modern figures such as Victor Hugo and Charles Dickens, that 'man is born good ... and society corrupts him'.[34] Although Rousseau was in accordance with Buffon's encouragement of a child's education based in nature, he disagreed with his assertions on the inherent weakness of the child, instead convinced by the natural strength of the child not yet impaired by the ills of experience and adulthood. Ironically, it was Rousseau's belief that the effects of man, including education (though of course not his own) were responsible for the ruin of the otherwise pure and whole beings of childhood by introducing them to all the evils of man's creation. For Rousseau, the pure state of nature is the stage in which 'that which is distinctive of human nature has not yet manifested itself ... Man – once he becomes truly man – is thus by his own

constitution condemned to endless dissatisfaction'.[35] Therein lies one of the most prominent paradoxes of Rousseau's treatise, around which rotates the ongoing defence of the author's own personal shortcomings. Utilising his theory to justify his actions, Rousseau simultaneously built on his opposition to Buffon's theory and defended his own notorious neglect of his own five children by using the apparent dependence of the child on the adult as merely a symptom of societal maltreatment as grounds for a relinquishment of persistent sociability or relations between the two. Confusingly, while Rousseau advocated education, he concurrently blamed it not only for the eventual corruption of the child, but also the future downfall of man as a whole:

> Finally, when this enslaved child, this little tyrant, full of learning and devoid of sense, enfeebled alike in mind and body, is cast upon the world, he there by his unfitness, by his pride, and by all his vices, makes us deplore human wretchedness and perversity.[36]

Moreover, while Rousseau was adamant in his belief in the ultimate goodness and strength of the child, he chose to send his own children away to a foundling school for the purposes of rendering them more robust, which, while contradicting the very basis of his argument of the naturally sturdy child, allowed his attention to remain focused not on his own adult-child relationships, but on the production in *Émile* of a most self-aggrandising and wildly unrealistic work of literature. This typifies the degree of Rousseau's quixotism, for the depth of his despair for adulthood is matched only by the extent of his idealisation of childhood. Buffon himself remarked on this, declaring Rousseau's concept of nature as merely 'an ideal, imaginary state which has never existed', giving rise to the idea of exotic deism with which he rather wistfully associated the child.[37] Such a concept has, like many of those associated with 'Rousseauian' philosophy, seeped into the discourse of more modern thinkers, with psychoanalyst Carl Jung referring to 'the paradise of childhood from which we imagine we have emerged'.[38] The tendency in the writings of academics of the twentieth century to fixate on the topic of nostalgia perhaps provides some indicator as to the root of not only Rousseau's unrealistic adulation

of childhood, but also his general difficulty or reticence to retain a single line of argument or instruction. Moreover, alongside Rousseau's contradictory implementation of an unrelenting system of controlled educational guidance, there is a tension felt in trying to admire and simultaneously conserve a condition or notion whose authenticity is not without influence or doubt in the first place.

This book's assertion that Rousseau's work is largely characterised by incessant conflict is by no means unchartered, nor is a general distaste for his ideas and processes little-known. From contemporary social historian Hugh Cunningham's scathing statement, "'We know nothing of childhood", says Rousseau. But of course, Rousseau thought he did',[39] to Voltaire's declaring the philosopher to be 'such a knave', Rousseau has succeeded in ruffling feathers for centuries.[40] Nevertheless, this tends to remain overshadowed by the precedence of his lofty reputation garnered over time. In spite of this, such paradoxes, discrepancies and irritations in his discourse prove numerous and complexly interconnected, and are thus best understood by first addressing some of the most prominent strands of his pedagogic theory. In summary, through *Émile*, Rousseau seeks to present a style or system of education whereby man may retain his innate goodness, his natural self, from childhood, while remaining a member of and indeed surviving in an otherwise corruptive collective of society. While this involves posing several fundamental philosophical and political questions regarding the interplay of individual and society, Rousseau tackles the task by introducing the fictional, novelistic format of Émile and his tutor by way of demonstrating how such an ideal citizen might be achieved through a very particular pedagogical programme. The extensive text was divided into five books, the first three of which are dedicated to the young child Émile, the fourth to his adolescent years, and the fifth to his domestic and civic life, drawing on his relationship with his female counterpart, Sophie, and in turn her own educative experience.

It is unsurprising that in his admiration for what he deemed the natural state of one's childhood, Rousseau prescribed education in a related environment, removing Émile from civilisation for an education isolated in nature, 'only to integrate him back into civil society, rejuvenated as a co-operative citizen'.[41] The authority afforded to nature is the central pivot

on which the majority of Émile's education centres. In the same way that Rousseau advised us not to tamper with the natural way of the child, this has been derived from his counsel for the utmost respect and acceptance of nature's truths.[42] Not only was Rousseau steadfast in his belief in nature as a provider and transmitter of wisdom, but he was also convinced of its enactment of wisdom: 'Nature intends that children shall be children before they are men. If we insist on reversing this order, we shall have fruit early indeed, but unripe, tasteless, and liable to decay.'[43] Accordingly, Rousseau's treatise is one that advocates the natural way of things, aiming to restore a liberating sense of self-sufficiency by theoretically propagating mental and physical strength through the exercising of a curious and investigatory mind. Essentially, Rousseau purports to sanction the imbuement of the child with a sense of being 'completely independent of the influence of other wills, to possess what later came to be called moral autonomy',[44] as opposed to subjecting them to doctrinal spoon-feeding, instead only putting what can be learned 'within his reach'.[45] However, this notion of the adult placing of material within the child's reach exposes the childhood independence of which he preaches as another of Rousseau's falsehoods. While the premise of his educative style proposes that Émile is barely aware that he is being taught at all, this very statement highlights the paradoxical nature of his thought and practice; is not directed tutelage masquerading as independent learning more devious than that which openly instructs and guides? It has been said that Rousseau advocated games in the dark for children, convinced of their benefit to sensory awareness, but it seems rather that he was playing his own such game, seeking to place the child in the proverbial dark as he looks on from his self-illuminated perch.

And so, while Rousseau claimed to pertain to an alternative view of and approach towards children, their literature and their pedagogy – a revolutionary view and approach, even – he in fact merely subscribes to the same self-serving manipulation of what was fast becoming a highly charged metaphor for public or personal harnessing, thereby exacerbating an already complex situation. Accordingly, while Rousseau's treatise ostensibly sought to promulgate independence from the influence of others and a preservation and encouragement of learning and experience based in nature, it was in practice simply control and manipulation of a different design. Rousseau's

programme of education becomes a sort of bargaining negotiation for the child to earn a sort of curtailed liberty, which, to those who have already lost it, cannot be allowed to flourish unchecked elsewhere: 'what appears natural is in fact indoctrination ... his is the apprenticeship to freedom'.[46]

A quotation from Rousseau's *Confessions* (1789), when speaking of childhood memories, is particularly revealing in this regard, exposing the desperate sense of his self-interest: 'It is as though already sensing life slipping away, I were trying to catch hold of it again at its beginnings.'[47] This kind of particular form of nostalgia, which can be seen as symptomatic of the Romantic following, became twisted into something far more potent, by which the freshness and purity of the child becomes sullied and muddied by attempts to harness it as antidote to the jealous and regretful malaise of adulthood. When Michel Foucault stated that 'children are precious because they replenish a population', he was most probably referring to their physical, biological replacement with newness of ageing, dying adults.[48] However, it can be equally construed as suggestive of the value associated with the child's capacity and propensity to be utilised in the machination of rejuvenating and buttressing adult spirit and standing on both personal and collective levels. While Rousseau's credo professes to be one that rues the day the child, bereft of his method of education, degenerates from his purest to his most corrupt, fulfilling a looming 'threat that they might ... maybe ... perhaps ... become us', it is as much a desperate attempt at reversing and regressing for oneself.[49]

When Rousseau, in castigating the practice of swaddling, instructs that new-born children need to stretch their limbs so as to free them from 'the torpor in which, rolled into a ball, they have so long remained ... we cripple them to prevent their laming themselves', he is ironically outlining his own wrongdoing.[50] Firm in the belief that introduction to logic should not occur too early, Rousseau endeavours to drip-feed the child, not only to 'unfold the powers of children in due proportion to their age', but to limit their exposure to the wisdom that he claims to possess, to control and administer knowledge dose by dose, as and when he chooses.[51] Instead of offering an educational liberation, a metaphorical and literal stretching of the limbs and mind in the space and fresh air of ungated nature, Rousseau simply presents another type of binding, tailoring his own paradoxical style

of 'well-regulated liberty'[52] to produce a system that consists in isolating the child from his family, friends and the rest of the world and:

> creating expressly for him a tutor, who is a phoenix among his kind … in surrounding him with a perpetual charlatanism, under the pretext of following nature; and in showing him only through the veil of a factitious atmosphere the society in which he is to live.[53]

In setting out his pedagogic treatise, awash with the endowments of expectation and duty on adults for the welfare of children, authentic or otherwise, that gained significant gravitas alongside the post-Revolution sense of responsibility towards human life, Rousseau conveniently heaped the bulk of the onus on women: 'if mothers are not real mothers, children are not real children'.[54] While 'Rousseau is very free in calling on Nature, on good old Mother Nature' for her innate and almighty wisdom, he is similarly hasty to charge her with the subjugation of her own sex through the example of 'Sophie, a woman who knows how to stay within the limits Nature has assigned to her'.[55] Perhaps inspired by the heavy memory of his own mother (as so many male figures featuring in this book seem to be), who died giving birth to him, Rousseau was convinced of the natural obligation of females to sacrifice themselves for the sake of their male counterparts. For Rousseau, while 'freedom is the greatest good … it is also highly gendered'.[56] Accordingly, in contrast to Émile's education, Sophie's education offers not even a chance of liberation as reward, but instead centres on a programme designed to instil constraint and subjection, to bury her opinions below his and live her life in childhood as in adulthood in the service of a male's love and happiness.[57] Rousseau's misogyny is twofold, for not only does he prescribe a civic, educational and social system built on the subservience of women, but he also holds women responsible for its implementation at almost every level, thereby leaving them open to blame and castigation for any failures. Although patriarchal schemes were by no means an innovation penned by Rousseau alone, his influence as a cultural and academic mainstay in Europe and beyond well into the twentieth century certainly proved a significant contributor to its endurance and veneration. Issues of gender will be explored in greater depth and complexity in later chapters, but from Thomas

Day's use of 'Rousseauian' logic as justification for the abuse of women and girls, to Simone de Beauvoir's comprehension of the infantilism of women who can 'exercise their freedom … only within the universe that has been set up before them [and] without them' as just two examples, it is plain to see the breadth and longevity of Rousseau's Émile and Sophie dynamic, as well as that of his theory in general.[58]

Jung once claimed that 'a characteristic of childhood is that, thanks to its naiveté and unconsciousness, it sketches a more complete picture of the self, of the whole man in his pure individuality, than adulthood'.[59] Within the context of twentieth-century meticulousness of consciousness and introspection, Jung was speaking of the condition of the child's pureness of individuality in a positive sense, celebrating the insight that it offers to the innocuous observer into a simpler though more complete state of being before the corrosive influence of age, experience and external influence on personhood. However, this concept of purity strikes a dangerous chord with Locke's notion of the child as *tabula rasa*, to which Rousseau found he could attach his theories in a most potent way. This concept of the child as a blank canvas is exactly that which facilitated Rousseau's complex indoctrination of the child, filling this untouched expanse with his own extensive scripture. As evidenced by many examples in history, and indeed in this book, children have tended to 'experience themselves as having being in the eyes of others', namely parents or adults, as opposed to feeling in possession of their own agency.[60] It is as though 'something deep inside the child resists being while the gaze of the adults around him works at inculcating in him the desire to be' in line with the designs chosen to furnish this particular vacuity.[61] While Jung's statement is one that is revealing of the championing of the 'wise child' prevalent from the advent of modernism, as examined in Chapter 1, Rousseau's 'take' on the freshness of the child is just that – a taking, a harnessing of its unmarked state for his own ends. The child not only represents newness but is an opportunity for the vicarious renewal of the self, to facilitate through the fresh purity of the child a cleansing of one's own experiences and errors with the advantage of hindsight and the promise of a rejuvenating regression to simpler times. An integral component of this theory was the assertion that 'children, according to Rousseau in Émile, have no "true memory"' and instead possess only 'the psychological

apparatus for receiving empirical impressions'.[62] For in much the same way that, for many, childhood was a state of not-knowing, this blankness allows one to render the child's brain so yielding that it is susceptible to all sorts of impressions, a welcoming sheet on which Rousseau can deliver his endless imprints. Drawing from a statement in his *Confessions* – 'if I am not better, at least I am different' – Rousseau sees in the child an opportunity for an undoing and redoing.[63] Erasing the marks of time and experience, of memory, the child serves as Rousseau's vessel to rewrite history on his own terms, both on a personal and collective level:

> The revolutionary modern art of autobiography, as inaugurated in Rousseau's *Confessions*, authorized an altogether new deployment of the art of memory in the service of literary self-fashioning. Taken together, the evolving perspectives of the Enlightenment on memory and on memoirs also exercised a profound effect on the cultural conception of childhood ... summed up in Rousseau's conviction that the child was always the object, never the subject, of memory, that children could not consciously remember anything of consequence, and yet childhood itself was recognized essentially in remembrance.[64]

Through the manipulation of the child, that is to say, both the child within ourselves and those external to us, 'memory is a reordering of the present: it can cast a shadow forwards', facilitating a reimagining of the self and one's potential through the manipulation of the Other; the child.[65] This objectification and Otherisation of the child – as non-adult, uneducated, sentimental and unempirical, ignorant and inexperienced, new and uncorrupted, fresh and empty, an impressionable vessel – serves to the advantages of the subject; that is, the adult. The notion of the child as an internalised and sentimentalised component of the adult not only points to its absorption as an object (as both a person and state) for the needs and purposes of the subject of the adult self,[66] but provides a more general indication of the status of children and childhood, culminating in literary and scholarly production whereby 'our accounts of the past are always fictions for the present, [and] all accounts of childhood are, in the end, accounts of ourselves'.[67]

This idea of returning to the beginning, this self-aggrandising appeal of 'starting again', combined with Rousseau's fixation with the role of nature

in education and society, gave rise to a connection between children, his discourse in particular, and the concept of the 'primitive'. Rousseau's writing has many times invited comments attributing his image of 'a prelapsarian paradise'[68] found in the natural world to his encouragement of a return to the 'primitive' state, to a championing of 'the cult of sensibility, the noble savage, *l'homme nouveau*'.[69] However, not only does the noble savage not actually appear in Rousseau's work, but any related claims of his propagation of a dramatic return to nature on social and cultural levels have largely been deemed mistaken at best.[70] Rousseau did not idolise the 'primitive' or his condition; inspired by the standpoints posited by much of the discourse of this period that championed Western colonial exploits, he considered them to be creatures of the lowest rung, morally and culturally destitute in the absence of the influences of 'civilisation'. However, he nevertheless did acknowledge the blissful ignorance by which such a being might live; this 'primeval *bête humaine*', devoid of any great thought or sentiment, lives from one day to the next without any concern beyond such a simple existence.[71] Furthermore, he posited that such an existence might contribute to what has been termed by more contemporary scholars as 'the good primitive', defined by an inherent benevolence by virtue of their ignorance of the mores susceptible to the ills of 'civilised' society, thereby establishing a link between the innocuousness of the 'savage' or 'primitive' and that of the child, and their mutual residence in the ambiguous 'state of nature'.[72] Some of the considerable erroneousness and confusion surrounding Rousseau's oft perceived connection and promulgation of Primitivist tendencies, and indeed the vast topic in general, lies in a distinct lack of clarity, both conceptually and in terminology. Arthur Lovejoy tapped the surface of this particular dilemma, querying what is meant by 'state of nature', postulating various possibilities including chronological primordiality, not being subject to political governance or authority, and lacking in cultural advancement in the arts and sciences.[73]

However, it is perhaps Rousseau's reckoning of childhood with cultural primitivism by comparing children to savages and by considering them representatives of the childhood of the human race as a whole that bears most significance and scrutiny here; that is to say, the establishment of the child as the anthropological 'primitive', as explored at length in Chapter 1.[74] In a

fashion likely to have proven influential to Ernst Haeckel's theory of recapitulation of 1866, Rousseau found himself persuaded by the notion whereby:

> Primitives appear to be phylogenetic 'children' amongst the world's races, so the European child is ontogenetic 'primitive', an undeveloped being within its own race [and in turn] the racially advanced child recapitulates all previous stages of phylogenetic evolution, including that represented by the present-day primitive, man still living in the wild.[75]

In other words, a twofold conjunction is established between the child and the 'primitive', in which the 'primitive', by virtue of its perceived simplicity and underdevelopment, is understood to represent the 'child' on a global scale as if it were a race of peoples, and in turn, the child comes to represent the 'primitive' stage of its own, single-race development, its advancement from child to adult recognised as comparable to that of the earliest and most 'primitive' and 'savage' human to the modern, 'civilised' version. While poignant in itself, this equation of the child and 'primitive' becomes imbued with metaphorically even darker hues when we consider the extent to which such a symbolic colouring permeates treatment and behaviours, as well as classification and terminology. In this way, the onset of the Age of Reason saw the degradation of the child by the adult, the systematic or individual denial of innate personhood or culture, or failing that, concerted efforts to uproot what exists in favour of cultivating from scratch a plant of perfect design under the guise of collective responsibility. This process can be construed, as discussed in Chapter 1, as symbolic of the personal destruction and cultural stripping of so-called 'primitive' societies by the colonial exploits of Western nations: 'regarding children of industrialised society; they suffered the fate of native peoples living in societies evolving towards the organised state'.[76]

Rousseau's efforts to 'begin again' through the child, his opportunistic chance of rebirth under the pretence of scholarly endeavour for the greater good becomes another example of those 'great intellectual journeys that effectively colonised the insane, the primitive, the debased and the intoxicated' for the purposes of self-preservation and self-elevation.[77] Indeed, for as much as the exploits of this period sought to advance human knowledge, to enlighten, they nevertheless could not resist the opportunity on

encountering the Other, to quell and smother, not absorb and consider, to extinguish in favour of creating an opportunity to have one's time again, and ultimately to replicate the very ills that inspired such a yearning for enlightenment in the first place.

A recurring metaphor that emerges from this practice of controlled reclaiming of the Other for the purposes of reimaging or reinvigorating the subjective self, collective or individual, combined with the ongoing role of the natural world, is that of the 'plant child'. Uprooted, its fragile pith is wrenched from the comfort of its dark soil to be exposed to the blindingly bright enlightenment of sunlight, before it is replanted in the confines of a small container, gradually re-potted in carefully considered stages, all the while cautiously watered and fed, fertilised and protected from external contamination or weeds, pruned and cut back by the hand of the diligent gardener. The allegory has not gone unearthed by academics in the field. Whereas Rousseau made direct reference to the metaphor, declaring in *Émile* that 'plants are improved by cultivation, and men by education',[78] Jauffret lamented that 'observers spy, during many years and await, with untiring patience, the blooming of a plant [yet] one does not yet see an attentive and truly philosophical gaze turned to a child's cradle'.[79] Of course, this particular cultivation is liable to the most extreme of modification, ultimately stunting the plant in its capacity to grow, blossom and bloom in its natural direction: 'it will take generations to weed out the bad training and cultivate new relations to children that encourage them to embrace their possibilities rather than solidify an oppressed identity'.[80]

Ultimately, in much the same way that many aspects of Enlightenment thought eventually sowed the seeds of their own destruction by insisting on an incessant process of doubt that would in time be invited upon itself, Rousseau's endeavours were a practice in self-destruction. His particular role in the *Siècle des Lumières* was in bringing childhood out of the murky existence it had endured throughout the aptly named Dark Ages, to proceed to enlighten the child and in turn be enlightened by the Romantic-inspired experience of returning to one's natural roots and beginnings. However, the self-led determination to succeed in such a feat ultimately resulted in blind pursuit, in the forcing of circumstances and manipulation of evidence facilitated by an erasing of history, memory, experience and personhood to

make way for the marks of a new 'truth'. Not only did this produce a tangle of contradictory doctrine in itself, but also a blazing legacy of pedagogic attitudes and discourses on children and childhood that has become lost and confused, blind to the hidden truth that existed before, and blinded by the dazzling brilliance by which they had been enlightened: 'deluded by a beautiful dream, and in pursuit of a shadow, [they] strive after immortality and fall into oblivion'.[81]

As with all prominent movements or figures in literature and the arts, the inclination for opposition is strong, and always seeks prominent manifestation. This becomes additionally complex in the case of Rousseau, unsurprisingly, not only as a result of his profoundly paradoxical and self-contradictory discourse, but from a historian's point of view, the unique durability of Rousseau's influence often rendered his critics somewhat buried beneath the swathes of supporters. With Rousseau's theory encompassing aspects of both Enlightenment and Romantic theory, the latter already largely a reaction to the former, it would take a significant shift to bring about a movement or style sufficient to undermine both. Aside from its ripple effect across Europe, France's 1848 Revolution bore a variety of cultural outcomes, one of which was realism, whose literary and artistic output was to dominate and inspire for decades to come. If realism is to be understood, as it often is, as a reaction against Romanticism, it can be equally considered a direct outgrowth of it,[82] and by extension from the Enlightenment as well, distilling from the former's fancy, convoluted over time, and the latter's dogmatic empiricism, engrained and hardened, the remnants of genuine reality and intrinsic truth to which both originally claimed to pertain.[83] The overwhelming sense of nostalgia that seemed to emerge in tandem with the acknowledgement of children and their childhood state in earnest, and that continued thereafter to hold sway and influence over a number of artistic and literary endeavours, did not disappear with the Realists. Although ostensibly it may have seemed too sentimental, too fanciful a consideration for a movement concerned with depicting ordinary life without artifice or 'that Heimweh which for the European Romantics became a central trope for both individual and national self-expression and identity', it was similarly absorbed by the Realists, whose sense of nostalgia lay in their yearning for a relinquishment of fantasy and a reclaiming of unembellished reality.[84]

Romantic Enlightenment

In France, the artistic strand of realism was led by Gustave Courbet, who became known for his depiction of decidedly ordinary scenes of contemporary life, and in particular those of workers or peasants. In producing such work, perceived as a deliberate pursuit of ugliness, Courbet was labelled by critics as both a 'terrible socialist' and a 'savage', an interesting reminder of the long-standing connection established between the natural and unremarkable and that of the 'primitive' or 'savage' world.[85] Arguably symbolic, perhaps, of the changing awareness or perception of children, childhood, and their qualities, it was not until well into the twentieth century that Courbet's emphasis on material reality was recognised as not only capable of enriching his often lowly subjects with a sort of quality and dignity from which they were previously excluded, but also highly influential in the development of future styles and techniques.[86] Courbet's favour for the everyday and unremarkable diminished somewhat when he produced his 1855 masterpiece *The Painter's Studio: A real allegory summing up seven years of my artistic and moral life*. Standing at over three-and-a-half metres in height and almost six metres wide, this 'real allegory', an oxymoronic term perhaps indicative of the artist's relationship with art and indeed the paradox of the piece, 'represents society at its best, its worst, and its average', depicting Courbet's real-life experiences and figures of influence through the medium of allegory.[87] Juxtaposing his friends and supporters with a summary of life under the Establishment, of 'the other world of trivial life, the people, misery, poverty, wealth, the exploited and the exploiters, the people who live off death', this unfinished work is nonetheless littered with individuals, signs and symbols of great significance and renown.[88] Most significant to this book, however, is the oft unnoticed image of the small boy drawing on the right of the canvas and that of the young child in the centre who observes the artist.

Studio has not escaped 'Rousseauian' reading from scholars. Courbet's inclusion of the landscape at the very centre of the canvas, engaging 'the *curiosité* of the savant' child, surrounded by tropes of contemporary, urban life, offers not only a pointed contrast between the harsh realities of urban civilisation and unsullied nature, but also presents the latter as the environment of the inquisitive and innocent child.[89] Not unaligned with Rousseau's reference to 'the abyss of the human species', Courbet's own method and mantra has been considered in tessellation with Rousseau's, in view of their

apparent shared emphasis on the value of drawing from direct, personal experience in nature.[90] Furthermore, it has been posited that the boy drawing on the floor embodies 'Rousseauian' education taking place.[91] Pertinent though this is, Courbet's *Studio* seems to go much further than merely regurgitate Rousseau's credo, not least in its portrayal of the child. During the Enlightenment and Romantic eras, childhood began to be discovered as something of a cache of wisdom, insight and sensitivity, a concept that inspired much of the retrospective study in the twentieth century of early sensory encounters, often with nature, as pivotal in the development of a creative or artistic mind. This association of childhood intuitiveness with a sort of creative vitality was gradual, and began in earnest early in the nineteenth century, when the innovative potential of the child emerged, unbound by habit or regulation, as an influence upon *avant-garde* endeavours. In light of this, we may consider the small boy scribbling away in Courbet's *Studio*, half submerged in shadow, emerging from the darkness around him, as symbolic of the capacity of the 'wise child', unencumbered by instruction or influence, to draw us out, in both senses, from the dark opacity of art defined by academic rigour, and genuinely enlighten us with the clarity of his unfettered, inner vision. Arguably a criticism of any form of education as the intervention of adults in the lives of children, Rousseau's included, perhaps Courbet sought in this painting to reveal the capacity of the child to create before the intrusion of adult influence, symbolised by the dwarfing of the child by the engulfment of dark adulthood, lamenting that as soon as they are initiated into the system of 'knowledge' and 'culture', 'most children abandon artistic anarchy and idiosyncrasy to join the utilitarian herd'.[92]

Considered reflective of free-drawing, a deeply liberating approach to artistic creation related to free-writing or even asemic writing, Courbet's child is demonstrative of the possibilities when one truly submits oneself to the impulses and direction of nature as opposed to the societal influences around him.[93] His obscurity beneath a trample of *avant-garde* feet symbolises the ongoing ignorance shown towards the child, irrespective to a certain extent of political or social standpoints. Rising determinedly, however, from his oppressive enclave of adult inception, the child nevertheless produces direct originality, simultaneously succeeding in embodying what Meyer Schapiro called 'the source of creativity, unobscured by convention',[94] and

Romantic Enlightenment

dismantling Rousseau's persistent erroneousness in attributing childhood creativity as a symptom of the desire to assimilate: 'all children, being natural imitators, try to draw'.[95] Resurfacing at the turn of the twentieth century, this sentiment pervaded modernist discourse concerned with the relationship between child art and 'primitivism', as Chapter 1 explored, not least in the work of Roger Fry, resolute in the significance of childhood potential for artistic creation and the importance of not stifling it. Courbet's spearheading of this manifested itself in the formal characteristics of his work as much as in the subject matter. From the childishness associated with the apparent frozenness of his figures, to Schapiro's recognising of simplified forms and arrangements as well as influences drawn from the life and art of folk culture,[96] 'Courbet's picture is a paradigm of the art of unlearning … neglect[ing] legibility and its spatial order principle [of] central perspective' to present an artwork that attempts to embody as much as allegorise his views.[97]

There is something to be said, therefore, for the significance and ongoing relationship between art and children. The constant re-emergence of the image of 'the child-messiah [who] belongs to the hopes of rejuvenation'[98] alongside the concept of 'art as society's salvation' galvanises a pre-existing connection between the two that strengthens the potential of art as a creative outpouring born of the insightfulness of childhood, boasting the capacity to enlighten, inspire and educate without the imbuing of design, motive or influence that experience and age carries.[99] The topic is not without debate and confusion, not least with regard to terminology, but is united by the central figure of the child, from whom the consolidating ideas and images originally sprout. Lovejoy's statement that 'this best condition of mankind was not primitive and was not, properly speaking, "of nature" but was the product of art' offers some indication of the extent to which grappling with theory, treatise, terminology and the ownership thereof had a propensity to overshadow the real essence of the matter.[100] With regard to the position of the child in this, Peter Coveney summarised the situation well when he declared 'the child so congenial an image, either of growth or regression, of potency or regret'.[101] Such is the danger negotiated by those scholars who endeavour, often in a nostalgic effort to reimagine their own beginnings, to box off in an orderly and pleasant way that which is by its very

Seeking Childhood

nature sometimes disorderly and unpleasant. Indeed, scholars too proceed, in the hurried and eager process of what claims to be an enlightenment of the dark ages of our mind, to erase arbitrarily any remnants of memory or personhood, without leaving the faintest mark of what once existed, ignorant of its significance and truth, albeit sometimes complex and difficult, in order to make way for the staining of new, carefully considered opinions and identities. Art theorist Ellen Handler Spitz perhaps encapsulated the fallout thereof for the child (and indeed for art) for many years to come, as the following chapters will explore, most effectively when she explained that 'By limiting ourselves to what [we think] a child obviously needs … we risk our child's growing less sensitive to ambient colours and sounds, to lights and shadows, to all the imaginative play and fantastic possibilities these phenomena awaken.'[102]

Functioning as an exploration of the beginning part of the journey, the starting point of the period and topic of study as elucidated in the previous chapter, this chapter has considered the immediate fallout of the catalytic collision of the Enlightenment period and the Romantic era in transforming perceptions of children and childhood in the French long nineteenth century. The chapter has established this crossroads, a period in which rebuttals to the old order of the Church and accepted concepts in general were thriving, as central to shifting notions of children and childhood. This chapter has laid the foundations for the rest of the book in the same way that the Enlightenment/Romanticism clash laid the foundations for the complex developments in perceptions and representations of children and childhood over the course of the next century or so. Straddling the progressing Age of Enlightenment and the burgeoning refutation of Romanticism, the seminal figure of Jean-Jacques Rousseau has been analysed for his pivotal role in both bringing to the fore a collective interest in the child and its condition, and the impact that his particular treatise had on social and cultural understandings of children and their condition thereafter. Through his creation of the idea of the Romantic child, Rousseau fashioned an unclear yet enormously influential and far-reaching concept of the child and its condition. As such, it was on this unstable creation and its fragile ground on which much future discourse and understanding of children and childhood was based, as explorations in the following chapter will reveal. Moreover, the innate

Romantic Enlightenment

ambiguity of this conception both enabled Rousseau's contrariness to thrive and paved an easy route by which others could similarly fashion the child for their own ends. Rousseau's contrariness, exemplified in his championing of Original Innocence while simultaneously promoting his own programme of carefully monitored education, culminates in the harnessing of the child as a vehicle of reinvention, seeking the opportunity through the child to reflect on oneself and vicariously live again. This vicarious reliving and reimagining of oneself, as previously discussed in Chapter 1, is a central concept of exploration in this book, and as such, it can be argued that Rousseau played a key role in its establishment.

The final sections of this chapter have begun the journey on the pathway laid out by Rousseau, focusing initially on realism as a response to Romanticism, and Courbet as the primary French proponent thereof within the visual arts. By arguably depicting the child as a curious savant and messiah of creativity in the midst of *Studio*, a work renowned for its allegorical criticism of modernity's ills yet perhaps blind to its own perpetuations thereof, Courbet points us with even greater focus in the direction that this book will take. The following chapters from this point map the nature of transforming perceptions of children and childhood throughout the French long nineteenth century. In so doing, they are all the while mindful of an emerging pattern, arguably first conceived by Rousseau, whereby the ambiguity of the child and its state enables a range of reconstructions, self-aware or otherwise, at the hands of those who seek explanation or a rejuvenating reimagining of the self in response to the bouleversement of their particular experience of the modernising world.

Negotiating the Dark Underbelly: Children of the Poor, c.1830–1880

I have begun to see a light cloudiness in front of my eyes.

Edgar Degas[1]

Piles of shadows covered the horizon. A strange shade, gradually drawing nearer, extended little by little over men, over things, over ideas; a shade which came from wraths and systems.

Victor Hugo, *Les Misérables*[2]

Intimated in the previous chapter by the disdain shown to Courbet's Realist depictions of ordinary, working people by the cultural establishment of mid-nineteenth century France, this period was both one of very clear social polarities and one whose divides its early *avant-garde* sought to question and muddy. This chapter is dedicated to perceptions of children confined to one of those polarities: children of the poor. As such, it analyses depictions of poor children and their lives, considering the ways in which their particular condition was harnessed and represented by key cultural practitioners of the epoch, with case studies focusing on Victor Hugo and Edgar Degas.

Chapter 3

Seeking Childhood

Accordingly, of particular note are the shadows, light, darkness and the interplay thereof which permeated the lives and works of both Hugo and Degas. In 1906, finally resigned to his failing eyesight putting a devastating end to his artistic career and practice, Degas wistfully and sombrely declared, 'if I could live my life again, I should do nothing but black and white'.[3] Following years of personal loss, finally succumbing to pneumonia in 1885, Hugo's final words on his deathbed were reported to be 'I see a black light'.[4] In many ways, the pervasiveness of shadow for Hugo and Degas is testament to its prevalence symbolically in the nineteenth-century French urban society that they so frequently depicted. It was, on the one hand, a world of great contrasts, of black and white, but also with a dogged propensity for a muddying thereof. This era was one of such social polarities, largely defined by 'a society which devoted so much energy to the creation of wealth, and was so especially blind to the privations of the poor'.[5]

In exploration of this particular theme, this chapter begins by briefly considering the context of the political and social upheaval that characterised French life at this time and gave rise to the establishment of an early welfare state. The bulk of the chapter is then dedicated to two ongoing case studies surrounding the works of Hugo and Degas. This focuses on their symbolic employment of *chiaroscuro*, and crucially the metaphorical significance of the grey shadows in between, as a means of highlighting the polarities of society. More specifically, this concentrates on the plight and very dark experiences of poor or working-class children and their 'shadowland' existence, analysing the various manifestations by which this contributed to a debasing Otherisation of society's most vulnerable. As such, we are to witness once again a process whereby the fashions, conditions and concerns of a period and environment give rise to transforming perceptions of the malleable condition of childhood by those in search of answers or remedies to the oftentimes bleak reality of modernity that they faced.

Ostensibly, the French long nineteenth century has been historically and politically characterised as rather radical, with its latter decades awash with legislative reform geared supposedly towards social and moral realignment. The turbulence of these years, built on foundations of military defeat, revolution and civil war, is evident in the tumbling flux of political turnover crammed into what is a comparatively short amount of time, comprising

some eight changes in power and leadership from the French Revolution in 1789 through to the end of the *Belle Époque* in 1914.[6] Accordingly, many French governments and leaders, especially in the latter half of the century, viewed moral reform as what historian Sylvia Schafer terms 'the antidote to the panoply of national travails'.[7] To alleviate the discord to which this country and many of its people were consistently subject and increasingly characterised, the state turned to a somewhat drastic system of social and moral reform, which began to take effect in earnest during the Third Republic, aiming to combat what was perceived as the very real 'threat of "depopulation" and … "degeneration of the race"'[8] and in so doing triggering the origin of the concept of the welfare state. It is in this way that France represented something of a dichotomous crossroads, as much praised for its 'peculiarly exemplary role' in enlightening modern reform as it was riddled with the murky streams of the seemingly archaic woes of 'pauperism, prisons, crime, illegitimacy, and illiteracy'.[9] Moreover, the precise focus of France's legislative reform in this period on its perceived 'demographic crisis' points not only to the weight of concern afforded to this particular social apprehension, but also to a metaphorical brightening of the future that it was hoped such reform would bring to what seemed a particularly gloomy issue.

This gloominess manifested itself twofold. First, it was characterised by something of a moral 'sullying' of the population as a result of a low birth-rate and increasing levels of prostitution, as well as racial tension following an influx of immigration arising from frantic French colonial expansion between 1880 and 1914, contributing to a perceived physical demographic 'darkening'. Second, a rather foreboding black cloud of child poverty that hung over nineteenth-century France exacerbated fears about the nation's future, for not only did children constitute more than half of those living in primary poverty in this period,[10] but infant mortality rates rose disturbingly in the years between 1850 and 1880.[11] Initially, efforts to counter these issues focused on a series of child protection laws introduced between 1874 and 1889 designed to combat parental neglect and abuse, alongside educational reform that effectively secularised education, including the establishment of ragged schools for pedagogic provision for the poor. The establishment of *écoles pour defavorisés* (ragged schools) in part points to an important preoccupation that prevailed across much governmental legislation in this

epoch; the notion of the risk of immorality and deviance associated with the poor spreading like a disease throughout the population. While state-implemented reform was likely to affect those positioned on all rungs of the social ladder, it was nevertheless the working class, and especially its youth, whose lifestyle, morals and general condition proved the focus. The tendency to locate a nation's problems in the circumstances and activities of the poor was not unusual, but the public hysteria spawned by France's demographic catastrophe coupled with the growing preoccupation among middle class philanthropists and social critics with the lives and morals of the urban poor delivered a new and desperate kind of urgency in answering this particularly troublesome social question.

It was perhaps the Paris Commune, with its long-lasting reputation for radical socialism and violent massacres, which triggered a resolve among the ruling classes that action needed to be taken to preserve both their own authority and a France of both international and moral standing. Symbolic of a black mark in France's history, whose memory threatened to splurge across the bright white pages of the nation's unwritten future like an inerasable ink stain, the Commune and its effects lingered like a dark cloud over the lofty heads of French Republicans. For many, the association of the Commune with the grubby agglomeration of the poor was derived in no small part from the breakdown of traditional family values over the preceding century, during which a lack of orderly community had given rise to both the exacerbation of the perceived natural cohesiveness of the 'unwashed', as well as the formation of ill-found togetherness of anarchy and anti-establishment discord. In much the same way that 'they assumed that one childhood was much like another', the state deemed one poor person as identical to the next, and in turn, the entire working-class population as a collective and unruly child in need of cleansing and guidance.[12] Indeed, there seemed to be the suggestion on multiple levels that 'for the French, all children are barbarians who must be tamed and moulded ruthlessly to adult standards'.[13] In line with Roger Fry's previously discussed concept of 'primitives, who are the "children" of social evolution', the poor child, much like the apparently 'dark' and 'unclean' native of a non-Western community, needed to be 'civilised', its dark and dusty coating of poverty and sin scrubbed away to reveal a shining beacon of hope for the state-prescribed future.[14] As such, all heads

were thus turned towards the future and, consequently, towards the child, resulting in the implementation of what became known as a paternalist state from the 1870s onwards. Formally recognising the benefits for a country in its children developing into healthy, productive and capable adults, child welfare became the principal focus for government in this period. It seemed that more than ever before 'the future of both society and nation hung in delicate balance with the fate of each and every French child'.[15]

Accordingly, the flavour for paternalism saw the French government essentially inaugurate itself as a sort of alternative mother or father, a supplementary parent for all in order to validate the 'assertion that the state might have a legitimate role in the drama of family life'.[16] Authoritative involvement in the collective upbringing of a nation's offspring was not foreign to the French; Henri Duval published a popular manual on child-rearing in 1840, for example.[17] However, efforts were significantly escalated in later decades. Many were gripped with the fear that, should the ill-advised practises of immoral parents go unchecked, their children would likely become afflicted with the same deficiency of moral decency, in turn threatening the future of France as an entirety. As such, the Republic sought to enforce 'the gradual relocation of parenthood away from the realm of naturalised right and toward the realm of social responsibility'.[18] Most prominently, paternalism saw the establishment of the *Service des Enfants Moralement Abandonnés* ('Service for Morally Abandoned Children') in the 1870s. Supported by an array of legislation and empowered to place children into state guardianship, this government department effectively sought via the concept of 'moral abandon' to protect children (and therefore France as a whole) from the damaging and corruptive influence of parents deemed morally deficient as evidenced by neglect or abuse. Although undoubtedly and profoundly effective in many cases in fulfilling its remit of protecting children from otherwise overlooked neglect and abuse, the innately skewed nature of France's paternalist outlook and aims inevitably dictated that 'moral abandon' was almost exclusively an ill of the poor, rendering the laws as little more than efficient tools of social and political control. Bearing all the typical marks of duplicitous tokens of appeasement geared towards placating the concerns of the working class, the establishment between 1882 and 1883 of five schools for state wards of 'moral abandon' indicated, on the surface

Seeking Childhood

at least, steps towards France's future policy of *tous à l'école et une école pour tous* ('everyone to school and school for everyone'). After all, it was in this period that childhood had become something of 'a political stake' by which to garner or forfeit support, especially from an increasingly conscious and militant working class.[19] However, the reality that these schools offered little more than a 'professional education', as well as presenting a convenient answer to the issue troubling many officials as to 'whether to place the morally abandoned (likely to have bad habits) alongside "normal" and presumably uncorrupted state wards' further underlines the extent to which France's paternalist state worked to contain the children of poverty as though in the watertight pen of a deep, dark well, as opposed to endeavouring to hoist them up and out and into the light.[20]

Such a siphoning off is perhaps reminiscent to modern readers of the racial segregation suffered by Black people in America, for example, born of divisive physiognomic beliefs and discriminatory racial theory developed during and following periods of slavery, or the arbitrary internment camp imprisonment of Japanese-Americans during the Second World War. The collation and separation of a given section of society, in this case particularly destitute children, points to a very basic fear on the part of the state of the threat of contamination of the rest of society by the moral, criminal and indeed biological deviance of the Other. Such a comparison, enabled by the temptation in light of their perceived degradation to 'equate the child with the savage of "primitive races" [who] grew up "like little animals",[21] establishes something of a 'parallelism between the total human conditions of being a savage and those of being a child' alongside that of a sub-human animal, essentially characterised by a patronising and ostracising sense of Otherness to which they are subject by those of the establishment norm.[22] In their perceived earthliness, simplicity and crudeness, these poor children fulfilled the very definition of 'primitive', and were seen as belonging to a cultural 'darkness' that threatened to stain irrevocably the purity of the norm if allowed to go unchecked. Penned off from the rest like unruly animals, these children of poverty, the most destitute of society, were essentially 'the *classes dangereuses* who filled social commentary', all the more threatening by their youth, an indicator of their generation's potential as the future of a nation.[23] Accordingly, it was not long before 'children from peasant backgrounds were

likely to discover the general contempt in which the rest of the population held them', by which the crushing stigmatisation of poverty and hardship results in a sort of social death that precedes the (usually premature) actual bodily one.[24]

The perception and depiction of the poor, working-class child as an animal in French nineteenth-century society, and in turn the reflection thereof in its artistic and literary creation, can be understood as manifesting itself twofold. On the one hand, this child-animal is a weak little pet in need of shepherding, a sweet and endearing commodity to be trained, admired and ultimately exploited under the glaring spotlight of popular public consumption. On the other, these are creatures of a grubby shadowland comprising an agglomerated mass of sub-human debasement, cowering in the cruel darkness of the underworld to which modern urbanity has confined them. Both halves are, of course, united in the commonality of sorrow and hardship by which their lives are characterised, which in turn accounts in a large part for the public interest in which the story and plight of the poor child was bathed, as Jacques Bonzon remarks, 'Happy children have no history … but poor children, abandoned children, they do'.[25] Equal as they are in their propensity to be harnessed and fetishised by the adult in search of meaning and expression, it is nevertheless important to acknowledge the two categories and analyse the existence and image of the poor child as such, differentiating between an embodiment of 'innocence [as] an eminently exploitable commodity'[26] and 'childhood [as] merely the life of a beast'.[27]

In many ways, the emergence of the child, commodified or merely destitute, as a mainstay of popular culture in this era, offered a new interest and focus on the lower classes in visual and literary culture. As one of the central tenets of this book, it was in this period that 'children [were] continually being commandeered as highly charged and volatile metaphors for any number of tangential causes and interests'.[28] It is no surprise, therefore, that this practice was hastily adopted by the ruling classes, whose fascination with the trope of the innocent and frail child of poverty played a significant role in the affording of its status as a principal motif of art and literature. For many, this functioned in a wholly condescending and self-gratifying manner, serving to appease their pride and consolidate their belief in traditional moral and social order. Consumable images of mournful children simply

Seeking Childhood

reinforced those adult-defined characteristics of childhood – dependence and powerlessness – which in turn confirmed the innocuousness of childhood in the face of adult control.[29] Crucially, however, this was not always so simply the case.

A renowned figure who stood at the very centre of the crossroads of popular culture and the suffering child of poverty in nineteenth-century France was Victor Hugo, who perhaps most famously disseminated his refreshing insight in his historical novel *Les Misérables* (1862). For Hugo, 'the representation of exceptional achievement or heroic grandeur became increasingly situated ... among lowly outcasts', and so his work manifested as an exploration of both the plight and the resilience of the marginalised poor, with a particular focus on that of the child.[30] In something of a Romantic turn, 'Hugo constitutes an exception amongst the men of his era'[31] as for him, 'children ... became a symbol of all that was good in the world before adult behaviour and institutions made their impact'.[32] While Hugo's presentation of the child varies, one of the chief devices he employs is that of 'the figure of the "child-redeemer"' to radiate goodness and love in a murky adult world by way of literary and pictorial *chiaroscuro*, which in some capacity lends itself to the notion of the child as an endearing victim to be commandeered by external forces.[33] Indeed, on the one hand, there is 'the prophetic function of Hugo', evidenced by his intentions as a broadcaster of the truth in the face of a cacophony of convenient similitudes, through his projection of such a symbolic role onto the child.[34] However, on the other hand, he nevertheless partook in a practice of 'reducing children to something near pathos [and thus] remains part of the adult-child relationship' of control and acquiescence with which we are familiar in this period.[35] In this way, Hugo nonetheless plays a role in the practice of perpetuating representations and perceptions of children and childhood characterised by inequivalence and tropification.

Particularly focusing on Hugo's character of Cosette, both in her depictions in the literature as well as the complimentary artwork of Émile Bayard, we can find evidence of Hugo's portrayal of children as possessing a uniquely angelic quality. The warming glow found at the heart of the child becomes a symbol of their inherent goodness and purity: 'the moral and metaphysical light which reveals the feelings hidden at the heart of the soul'.[36] Contrasting with the dark obscurity of the adult world, key representatives of youth, such

Negotiating the Dark Underbelly

as Cosette, are a perfect embodiment of 'naivety, gullibility, transparency, purity, integrity, sunbeam', her bright clarity in appearance functioning as a mirroring of her artlessness of character.[37] On occasion, the presence of light reveals the reality of this once neglected and abused child, for example the candlelight of the Thénardiers' home 'rendered her thinness frightfully visible',[38] producing something of an 'affecting tableau of an innocent child in the lair of wild beasts'.[39] However, ultimately, the illumination of the child as if under a spotlight emphasises her role as a shard of hope within a world that has otherwise become 'drowned in darkness'.[40] Like a shining beacon, a bright radiance thus far unsullied by the onset of adulthood, Cosette plays her Hugo-assigned role well.

This is extended further by the illustration of Cosette by Émile Bayard, whose popularity has soared since its use on a multitude of advertisements for subsequent musical adaptations of the classic story. In this way, the sole representative of the story, Cosette as the archetypal 'Hugolian' child becomes the 'face' of her kin's story, an attractive form of merchandise by which to promote the morbid consumption of her plight. Bayard's Cosette, originally a drawing but reproduced as an engraving, is poignantly entirely monochrome, and features the little girl at the very centre, dressed in rags and standing barefoot as she mournfully sweeps. Dwarfed by her surroundings, the broom, the bucket, the steps and the wooden gate are all proportionally enormous compared with little Cosette, her defencelessness is emphasised. The diminutiveness of the child offers a startling new slant on the notion of the 'authentic small world of the young child'; that is to say, one whose smallness serves as an indicator of her personal vulnerability and the lonely insignificance of her lot more than it does the endearing seclusion of the world of a happy childhood.[41] When we consider that nineteenth-century photography saw an obsession with beggar maids and street urchins, it is unsurprising that Cosette proved a memorable image, as well as a popular marketing ploy.[42] Although it lacks the drama of the sorts of emaciated children captured by political cartoonists such as Honoré Daumier and Camille Pissarro, Cosette is the very embodiment of the fragile and angelically naïve child so appealing to the middle and upper classes.

The majority of the image is a muddy grey in colour, with dark smudges of shadow, notably in the windows, reflecting the lack of warmth and solace

even to be found indoors. It is markedly Cosette's face and upper body that are highlighted by bright, unmodulated white. She is illuminated by what resembles a halo of light, a spotlight of focus on this angelic yet afflicted child who rises like a beam of celestial goodness, 'a condensation of the light of dawn' from the grunge of the puddle that surrounds her.[43] She is strikingly doll-like, her cherubim face, glowing against the dreary background, is characterised by the watchful gaze of her saucer-like eyes, to her left and away from her work, suggesting fear of an impending threat or some sinister adult surveillance to which she is all too accustomed. Cosette's commodification as the bourgeois trope of engaging, poverty-stricken girlhood, of innocence confronted with life, points to the habit in this period for the practice of what Valerie Walkerdine calls a 'ubiquitous fetishisation of girlhood which is at once innocent and erotic'.[44] The working-class girl thus becomes a multi-layered motif, for her depiction as the helpless, needy little girl cements her popularity within a patriarchal society that often centred on 'a middle-aged man's (sexual) longing for a young girl who was a mixture of childish innocence and ripening eroticism'.[45] Such a notion further cements the idea of the child as conceptually and representationally moulded according to the needs, wants and vision of those driving society and culture.

The paintings of Edgar Degas in which he focuses on 'the ballet, the modern locus of sexual exchange and public display' and for which he is most renowned, go some significant way to illustrate common perceptions of working-class girls, and especially their relationship with middle-class society; namely, the gendered gaze of the 'superior' adult male.[46] Degas's *The Rehearsal of the Ballet Onstage* (1874) is a work typical of the artist's paintings of ballet practices and rehearsals. The viewer looks out across the stage from one side, surveying ballerinas stretching, posing and pirouetting in full costumes of flouncy, tiered tutus, surrounded by a mixture of forest scenery and male instructors and patrons. The stereotypical interplay of the delicate femininity of the ballerinas, twirling like dainty woodland fairies, and the mysterious yet authoritative male, often partially obscured in the shadowy offstage nooks of licentious surveillance, is plethoric in symbolism. Not only does it represent the notion of the 'male license to stare openly at – and to touch and talk about – women's bodies and the fetishized commodities associated',[47] but it is also suggestive of 'rather orgiastic undertones [and] all icons

Negotiating the Dark Underbelly

of male desire and possession' inherent within the worlds of child-female dance and fairy-filled exoticism.[48] The popularity of fairy paintings as representative of the 'quintessential Other, allied with the occult, savage, bizarre, and also the child-like' in Victorian Britain is chronologically and thematically congruent with Degas's ballet paintings, for both offer for the (presumably) male viewer a 'retreat into secret, even taboo, sexual worlds and activities of little people, both fairies and the young'.[49] Consider, for example, Degas's 1879 monotype *The Client*, in which nude though decoratively adorned women, presumably prostitutes, are paraded before an obscured male client, moustached, dressed in black and wearing a lofty top hat, rendering him strikingly similar to one of the men seated offstage in the aforementioned *The Rehearsal of the Ballet Onstage*. By depicting the male in-artwork viewer almost identically, regardless of whether it is young dancing girls or prostitutes that he is observing, Degas creates a sense of assimilation, enhancing and generalising the sexualisation of the working woman or girl in a manner that offers a darkly foreboding social commentary that anticipates the commodified child's fate: 'in the half-grown ballet girl he shows already the future prostitute. He is like Nature, merciless, coldly sceptical.'[50]

Degas's most common and famous subject of the dancer, like the juxtaposed image of 'miniaturised *femme fatale* [alongside] vulnerable girlhood' of the fairy, both prepubescent yet sexualised, comes to represent a sort of mythical inhabitant of an exotic land.[51] The little girl dancer functions as a kind of 'cipher for an ethereal fantasy or a world transported from the tensions of modernity'.[52] Not only does she offer an escape from the mundaneness of *fin-de-siècle* urban life, but by attaching a sense of exotic otherworldliness to this dancer, who is precariously at once child-like and sexually enticing, patrons also found themselves conveniently absolved of any paedophilic disquiet by virtue of the sense of separation afforded by the apparent non-earthliness of this 'creature'. Moreover, this connection was buttressed by favouring floral and mythical roles for female dancers, for not only did they appear non-human and therefore exempt from the rules of the human world, but 'in their common guise as flowers and fauna, they reflected the popular image of Art Nouveau' in which females and nature were represented symbiotically.[53] Consider Degas's famous 1878 piece *The Star*, in which a prima ballerina is featured curtseying, her arms delicately aloft and her face

glowing beneath the spotlight under which she is thrust, as she is clad in a wispy tutu and bodice, elaborately decorated with russet flowers to match her ornate headdress. From the gentle arabesques of her corporeal shape and the poised singularity of her fingers to the ethereal semi-translucence of her gown and the warm blooms of flora, she closely resembles the angelic goddesses of nature depicted by pioneer of the Art Nouveau movement Alphonse Mucha. Dangerous and damaging though this conflation of the delicate dancing child with the otherworldly fairy undoubtedly is, it gives way to even darker hues of fetishisation and commodification of girlhood that renders the child an embodiment of ornamental and performative servitude. This aptly named 'star', brilliant white under the dazzling lights of the stage, is exploited for her unique appeal as both innocent and knowing, a fragile child at the mercy of bourgeois fancy, vulnerable yet somehow solemnly aware of her lot. By way of a link to the notion of the poor child as an animal, sweet but sub-human, and thus a simple pet in service of the amusement of social superiors, Degas's ballerina becomes a sort of dancing bear, a mere spectacle of public entertainment. In this way reminiscent of Baudelaire's notion of 'the living toy', the poor child becomes a commodified plaything of the rich.[54] The child of poverty becomes for the rich their very own living toy through which they can take a touristic participation in a world far removed from their own, perpetuating an ignorant sort of fascinating exoticism associated with the plight of the poor child, an exploitation of which results in a sort of bodily and emotional debasement so chronic that it ultimately leaves the observer ironically wondering, on consideration of the child, 'but where is the soul?'[55]

Degas's bipartite employment of *chiaroscuro* functions as both an indicator of his own rapidly darkening world due to the hasty onset of blindness and the subtle emotional and moral sullying undergone by the working child under the overbearing shadow of society's gaze. Degas's *Woman with Field Glasses* (*c*.1866) provides a disconcerting indication of the artist's relationship with vision, *chiaroscuro* and the gaze. The drawing consists of a single young woman staring intently out at the viewer through a pair of binoculars, offering both the artist and the spectator 'an almost disquieting sensation of the represented instant of and seeing … himself being seen'.[56] The work is dominated overall by white, rendering the black fixation of the binoculars

Negotiating the Dark Underbelly

all the more intense as a result of the value structure. This offers a deeper reading to the contention that 'just as the damage to his eyes created a "dull patch" and areas of light haze, it must also have left between them areas of relatively clear vision'.[57] That is to say, the visual darkness that blanketed Degas's sight, represented here by the concentration of ink around the persistence of the binocular eyes is offset by, and perhaps gives rise to, the clarity of vision, represented by the stark whiteness of the rest of the artwork, to which Degas afforded society and its severest woes.

Degas's *chiaroscuro* is of a deeply symbolic form, functioning not only as a pointer to his own failing eyesight, but also to a general darkening of the world and starkness of social polarity comparable with that of black and white. To this end, much of Degas's artwork is less suggestive of the paradisiacal and exotic world of the dancing female, and is instead arguably more representative of the harsh reality of the ballet girl's existence, exposing 'the sexually available, partially clothed, commodified corpus of the working woman [which] embodied the carnal materiality of modern metropolitan life'.[58] Far from the magical, floral land of plenty that the ballerinas seemingly advertise with the hypnotic and supple rhythms of their youthful bodies, aloof and exotically unattainable, Degas portrays many of these girls as in fact highly typical of the sordid degeneracy from which their viewers seek escape but to which the performer is depressingly confined. Degas's artwork predicates on the sexual promiscuity associated with the 'debased but highly desirable form of public entertainment' of ballet spectacles, and with urban and city life in general.[59]

As such, Degas produced a significant corpus of artwork that showed ballet dancers in more humanly raw circumstances, without the artfulness of performance. Degas's depiction of the dancer behind the scenes and without a formal audience exposes an arguably darker, seedier, more closeted and unchecked commodification and consumption of the young female form, perhaps even pointing to the concealment of 'juvenile prostitution [and] those dens of infamy into which young girls are decoyed'.[60] One of the most effective ways in which Degas achieves this notion of the working girl who is at once an object of both public and private consumption is his production of artworks in which the positions and viewpoints of resting and preparing ballet dancers are mimicked by those of nudes and bathers. That is to say,

Seeking Childhood

the livelihood of performance from which these exhausted dancing girls are ostensibly taking a break in fact lives on even in the would-be private realms of backstage and the home. Degas the artist functions as a symbol of the eternal watchful gaze of masculinity and bourgeois, patriarchal society in general, whose presence is everlasting as much in public as in private arenas, regardless of whether the girl is a dancer or not, and irrespective of her consent or lack thereof to be viewed, consumed and shared. In summary, whether the girl is a ballerina in mid-performance, a dancer at rest or in preparation, or simply bathing at home, her role and purpose as a working-class female and therefore a spectacle for the male gaze is almost identical.

Degas's 1880 pastel and chalk sketch *Dancer Fastening her Pump* and his 1886 pastel drawing *The Tub*, when considered together, illustrate this. In both works, the artist and viewer peer down at the young female subject, her exposed back demonstrative of her vulnerability. The similarity of the females, in the dimpled shape of their backs, the flexed arm, obscurity of their faces and the scraping of their hair into an untidy bun, which in itself 'served as an emblem of the transition from childhood to adulthood', all of which offer a lack of discernible identity and fixed age point, suggest little differentiation on the part of the viewer and consumer of the little girl ballerina and the nude bather.[61] The childish uncouthness of the 'bowed and spread-legged worker' in *Dancer Fastening her Pump* is a frequent image of Degas's work, appearing, for example, in *Dancers at the Barre*.[62] Not only is the ungainly awkwardness of these dancers' pose reflected, as before, in the intimate positioning of bathers, for example in *After the Bath*, but the peculiarity of their shapes and the apparent multiplicity of their limbs forms what Félix Fénéon terms 'a confusion of arms and legs [that resembled] an epileptic Hindu god'.[63] While a sort of mass of bumbling heads or a tangle of instruments crammed into the foreground was a common feature of Degas's ballet performance artworks, the bodily amalgamation of young dancers stretching or at rest points to a much deeper metaphorical understanding of their condition.[64]

On the one hand, the proximity and similarity of the two dancers renders them suggestive of the foggy blurring of shapes and individuals to be found in the early photographic experimentation that fascinated Degas, in which 'two shots [are] conflated into a single image [exposing] light phantoms

Negotiating the Dark Underbelly

[which] emerge into visibility through each other, ... transformed into a hallucinatory, spectral image'.[65] The ethereality of the image supports Stéphane Mallarmé's notion that the ballerina is 'not a girl, but rather a metaphor ... and she does not dance, but rather ... she suggests things'.[66] However, a more scrupulous reading might reject the apparent innocuousness of figures appearing under artistic licence as 'more akin to colour expression than human beings' in favour of understanding Degas's bodily amalgamation of working girlhood as indicative of their dwindling personhood before the shadow of the public gaze.[67] Like the fecundity, deformity and contagiousness associated with their general condition of poverty, these young girls are characterised by their crowd-like anonymity before the amusement, scorn and disregard of popular society: 'Grouped together with arms and legs that seem to multiply, long and supple like creepers [they] rise up like apparitions in the night, like passers-by whose lives are expressed in gestures and smiles that begin to take shape and rapidly disappear.'[68]

However, it is perhaps Degas's 1881 sculpture *Little Dancer Aged Fourteen* that best portrays the concept and role of the little girl dancer as the epitome of the working-class child as perceived by cultural practitioner and cultural consumer. Two-thirds life size, the particular diminutiveness of the work is indicative of both her youth and her vulnerability. Originally sculpted in wax, but boasting a wig of real hair and a fabric bodice, ballet shoes and tutu, and modelled on Marie van Goethem, a young student of the Paris Opera Ballet dance school, the sculpture has all the makings of a strikingly lifelike representation of French nineteenth-century modernity. Moreover, by virtue of being based on a real child and including human hair and real dancer's clothing, but posed and moulded by the artist for the viewer, Degas's sculpture perfectly embodies the role and value of the child, for she has all the appearance of life without any of the volition of a real person. This notion is enhanced yet further by the twenty-eight bronze casts made of the sculpture from 1920 onwards, which have since been distributed to various galleries and museums around the world. Not only does 'the fragmentation of the modern body into component parts' fetishise the female form of this young dancer as she is shipped off and reassembled worldwide, but it also contributes to a solidification of the material replicability and lack of individuality attributed to the child in general.[69] As a young student of the ballet school,

one of the many *petits rats* of Paris, this particular dancer will not have taken centre stage but instead formed part of the body, or *corps*, of supporting dancers, which is significant in itself: 'The corps did not go on pointe nor did they have any aerial movement; their vocabulary was earth-bound and mundane [and so] she appeared as far more amenable, more accessible, for the gaze of the audience.'[70]

This vocational degradation was matched by a personal one, specifically a debasement founded on the perceived sub-human condition of the poor child, reflected in Degas's sculpted portrayal of 'an infantilised, animalised working class, closer to their instincts [and] physically less well-developed'.[71] Her child poverty is shown in the awkward underdevelopment of her pos-tured body, further evidenced in Degas's preparatory bronze sculpture *Study in the Nude of Little Dancer Aged Fourteen* (1878–81), in which the nude body is disturbingly similar to that of a small infant, with the protruding stomach and mere bud-like beginnings of her breasts indicative of a girl far younger than fourteen, and thus potential malnourishment. More revealing still is the child's face, which, oddly jutting forward and upwards, has solicited much commentary for its apparent suggestion of animalistic immorality deemed symptomatic of the lowest classes. While more modern readings have been sympathetic, with art historian Tim Marlow declaring that the little girl per-haps bears 'the image of a sickly, gawky adolescent who is being made to do something she does not totally want to do' as opposed to being delib-erately ugly, reviews at the time of the sculpture's unveiling in 1881 were somewhat blunter, and thus revealing of the shape of popular opinion in that period.[72] Leading art historian Paul Mantz concluded that 'with bestial effrontery she thrusts forward her face, or rather her little muzzle – and this word is completely correct because this poor girl is the beginnings of a rat',[73] and Jules Claretie agreed, declaring that 'the vicious muzzle of this little, barely pubescent girl, this little flower of the gutter, is unforgettable'.[74] The language chosen by both of these critics is unmistakably pregnant with the scathing disdain that typically characterised a superior's opinion of the inferior, for as much as condescension often outwardly prevailed, a sense of lofty wariness often remained steadfast: 'the image of the street urchin has an uneasy presence in the imagery of childhood – combining pathos with a sense of resilience and engaging impudence'.[75] The likening of this

Negotiating the Dark Underbelly

particular girl to a sewer-dwelling beast not only points to the *petits rats* terminology, but also the severity of censure to which the working child is subject; she is considered nothing more than a dirty, scavenging, unwanted spreader of disease.

This, coupled with the constant undercurrent of fear on which the rich's mistreatment of the poor is often based, is reminiscent of a legend frequently recounted by Victor Hugo, in which the wicked Archbishop Hatto of ninth and tenth-century France locked the starving poor of his Rhineland parish in a barn, set it alight and exclaimed 'Can you hear the rats hiss?' after which 'the peasants all died, but from the ashes there emerged hordes of rats, who chased the evil Hatto ... gnawed their way into the fortress ... and ate him alive'.[76] Not only did such notions give new weight and significance to the assertion that 'nineteenth-century cities swarmed with children', but they contributed to the very ignorance and fear that ironically fuelled the perpetual debasement of the child in a bid to reiterate and restore a hierarchy of norms and a peaceful mind.[77] This degradation of the child increases when one considers the prevalence at this time of Johann Kaspar Lavater's theories on physiognomy (1775–8). One of Lavater's woodcut illustrations produced to accompany his written theory features four heads in profile, offering a precise depiction of the forehead, nose and chin in particular. While art historian Ernst Gombrich warned of 'physiognomical fallacy',[78] historian Ludmilla Jordanova has since reminded us of the contemporary relevance nevertheless of Lavater's theories, for we continue today to pass judgement on the basis of inferences from appearance.[79] Lavater's work endeavoured to present the 'science' of this particular theory, asserting that 'the natural and essential bony skull and its carefully measured proportions are the true indicators of the character of man, whereas the face and flesh are the accidentals', on the basis that the skull and bony structure of the nose is worked upon from within by the brain, the controller of mental activity, and from the other side by the muscles, which are governed by the faculties of emotion and passion; our facial structure, therefore, is essentially born of our very personhood and nature.[80] Degas's 1881 work *Criminal Physiognomy*, a sort of courtroom sketch, both resembles Lavater's book's illustrations and is demonstrative of Degas' awareness of such theories on physical attributes identified with the criminal and immoral.[81] Moreover, this was a sketch

produced in the same year as his little dancer sculpture, connecting and propagating judgements and opinions typical of the period, which attached a sense of animal immorality and even criminality to this adolescent ballerina on the basis of her facial appearance.

As Degas undergoes 'a relentless pursuit into the depths of ugliness', his lattermost works, fuelled by a mixture of his crippling photophobia and the connected depression of his spirits, continue to plumb the very lowest extremes of society.[82] This little girl of sculpture, illuminated and exploited by a perverted fascination with the glow of innocent hardship, is relegated to the darkest depths of society, to what Hugo termed the 'terrible tabernacle of the unknown'.[83] And it is within this enshrouding of nothingness that one's personhood slowly ebbs away, absorbed by the darkness like a cloak of invisibility under which one is nothing more than a mere shadow of a person: 'there is a level of poverty at which we are afflicted with a kind of indifferences which causes all things to seem unreal: those closest to us become no more than shadows'.[84] As such, this analysis of Degas's work reveals a reinforcement of that notion of the child as both Self and Other. As Self, its futurity represents the possibilities of a bright future for humankind, one unsullied by the ills of the present modern world to which man has largely fallen. As Other, it represents those very ills, with the poor child in particular representing a sort of emblematic, catch-all scapegoat for nineteenth-century society's problems of poverty, disease, licentious temptation and premature death. Crucially, as both Self and Other, its message is one that fuels and buttresses the period's preoccupation with the paternalist state and its significance for a brighter France.

Hugo's work, like his life, was 'a giant tension between light and darkness and it spilled out onto paper with thunderous impact'.[85] This manifested itself multifariously, not least in the constant battle and interplay of the light and goodness inherent within childhood and the dark evil of the world beyond, steadfast in the belief that life, experience and the actions of others sully the purity of the child: 'Man is born good … and society corrupts him'.[86] Evidenced in his literature and his artworks, Hugo 'sees life in black and white'.[87] This manifested itself equally in his general outlook on the distinctness and disparity between the two gulfs of society on which his conscience and work concentrated; for Hugo, like dark over light, evil engulfed like a

giant, spreading shadow over good and sullying society beyond repair. What is more, the vacuity of such a shadow, the narrow decumbence of its emptiness implies, in turn, an extreme banality that reflects the grave-like flatness of such a world.[88] As previously discussed, however, Hugo often looked to emphasise that even in the foreboding face of society's harsh and despotic treatment of children, their natural benevolence continued to break through, on occasion, like a ray of sunlight cutting through a rain-heavy cloud, in the adoption of a sort of fraternal togetherness and determination to survive against all the odds. The character of Gavroche in *Les Misérables* stands out as a particularly poignant example of such a child. In the absence of familial affection and shelter, Gavroche turns to a life on the street, during which he takes two small boys under his wing. Unaware that these boys are in fact his younger brothers, Gavroche is thus not motivated by blood links, but by a genuine concern for his fellow urchin, personifying 'the spirit of the child to survive, to cope, to forgive and always to reinvent'.[89] This notion of the hardier, sturdier child who territorially roamed the streets, enjoying 'partial autonomy from the world of adults', was often perceived as a potential threat to the elites.[90] Aforementioned connotations of primitivism and savagery gave rise to the notion of the 'tribal child' and a feared threat of mob mentality, which in turn arrived back to the pervading image of the child in poverty as a muddied composite of animalistic miscellany.

Kathryn Grossman's work on the dystopian environments of Hugo's novel goes some way to explore the ways in which the desolate and nebulous landscape of *Les Misérables* reflects the inchoateness and lacking sense of belonging of the ill-treated poor: 'the dislocation of the family, repeated in the dislocation of the self, is figured by the barren, dystopian landscapes'.[91] Instead of being considered as individuals with desperate human needs, the tendency to see 'the poor' as merely a problematic mass, a collective nuisance to be borne by the state, resulted in the dehumanising of working-class people on a dramatic scale. A cruel reflection of the low sense of self-worth suffered by the poor themselves, the state's sweeping pigeonholing of these people served to rid them of any individuality and identity, for the exacerbation of this 'destitution provides a hideous version of nothingness, an extreme mongrelisation [in which] they merge into an amorphous conglomerate'.[92] Far from warm-blooded human beings with discernible and identifiable

personalities, Hugo's characters, much like Degas's dancers, undergo a physical debasement that symbolises their emotional and moral degradation, likening them to some rudimentary species or alien form: 'How pale they are, those unfortunates, how cold they are! They might be the inhabitants of a planet far more distant from the sun than our own.'[93] Moreover, children and babies, naturally closer to their original embryonic state, begin to revert even more dramatically to a polyp-like existence. Resembling little more than a small, mucky grub, the children of Hugo's poverty become 'faceless larvae, the image of death itself, replac[ing] one's beloved offspring'.[94]

The symbolic *chiaroscuro* of Hugo's literature is buttressed by that of his lesser-known skills as an artist. From character portraits to darkly metaphorical landscapes, menacingly mystical designs and thoroughly abstract creations, Hugo excels in presenting a world that is in equal measure chillingly hostile and curiously infantile, embodying the child's perception of a terrifying reality in the Parisian underworld. In his 1850 portrait *Gavroche à 11 ans* ('*Gavroche at 11 years old*'), Hugo depicts the child in a fashion suggestive of both his stark humanity and his striking animalism. Contrary to Bayard's considerably more realistic illustrations, Hugo's Gavroche is something of a caricature. On the one hand, the naivety of style, the enormous grin stretching across the boy's animated face and his tousled hair suggest an impish child, a portrait of whom has been captured mid-adventure in the local outdoors or during a boisterous race up a tree. On the other hand, his darkened chin and mouth appear abnormally large, gaping and jutting uncannily. Moreover, his hair, a mass of erratic pen strokes, appears wild, spasmodic and out of control. Considered in this way, Hugo's Gavroche is an image of some sort of rabid, beast-like creature who, far from a human of popular society, scavenged among the rubble of the barricades like vermin in a rubbish tip: 'He crawled flat on his belly, galloped on all fours, took his basket in his teeth, twisted, glided, undulated, wound from one dead body to another, and emptied the cartridge-box or cartouche as a monkey opens a nut.'[95]

As such, Hugo's portrait of Gavroche appears to be an amalgamation of both the child inside and the animal as viewed externally by society. The frantic grubbiness of Gavroche and Hugo's style is reflected again in the artist's creative process. Experimenting with techniques that involved *pliage*

and Rorschach blots, stencils, finger painting and automatic drawing, as well as using materials ranging from ink and gouache to soot, squid ink, caramelised onion, saliva and even urine, Hugo produced images that consist of the same mucky mongrelisation (in appearance and smell) and psychological disturbance they depict.[96]

Heightened by his personal experiences of woe by which he was tormented during his political exile in Jersey, Hugo, like Degas, found himself 'forced ... to work in fragments, always contending with semi-darkness', to which his vision, literal or metaphorical, confined him.[97] Hugo, like Degas, was also touched by photographical concepts, and was similarly afflicted in his work by the boundaries of darkness inflicted by experience on his soul. Forever psychologically blighted by the intolerable fates of his children (all but one of whom died before he), and evidenced in his literature's foreboding philosophy, Hugo 'fell to pondering over what would be the result if the black submerged the white entirely, or the giant trampled on the dwarf'.[98] While his exile landscape of Jersey spilled out into the social and emotional claustrophobia suffered by his characters, it is more specifically 'Hugo's inner "forest" (and ours) [which] swarms with any number of half-seen, frightening creatures'.[99] In the same way that the condemning environment of the poor child becomes an all-consuming abyss, 'Hugo's forests became wild, living entities',[100] transgressing themselves like an unrelenting spread of black fog, leaving him in his depression, like a child constantly treading water in the endless cesspit of poverty, hopelessly 'groping in labyrinthine darkness'.[101] While on the one hand, as has been explored, children straddle the boundaries between Self and Other. They exist somewhat, as Hugo put it, in 'that amphibious world' of in-betweens.[102] However, Hugo also points to the continuous slippage of the poor child in particular to the realm of the Other. Hugo's employment of the ethereal and bestial, manifesting even more outwardly in ghoulish artworks such as *Octopus* (1866) and *The Snake* (1866), is a reminder of the dark and foreboding state and environment of Otherness to which children of poverty in nineteenth-century France were relegated. Hugo summarised such a notion as like observing 'crab-like souls which are continually retreating towards the darkness, retrograding in life rather than advancing ... their deformity, growing incessantly worse, and becoming more and more impregnated with an ever-augmenting blackness'.[103]

As such, the animalistic child is multifarious. It may refer to notions of Baudelaire's 'living toy', a sentient and appealing plaything of the wealthy, as reflected in more scrupulous readings of Degas's ballerina paintings. It can refer to notions of connections between physiognomic, social, and moral degeneration as reflected in reactions to and interpretations of Degas's sculpted dancer. It may, from such a child's perspective, reflect an instinctive determinedness to survive against the obstacles of a polarised and unwelcoming society. It can be in reference to fears among the ruling classes of tribal miscellany and the threat of a spreading peasant mass. It can in turn point to a homogenisation of the poor, and especially poor children, into a mongrelised and problematic subhuman conglomerate. Ultimately, the animalistic child in all its factions, as a key concept surrounding perceptions of poor children in this period of France's movement through the long nineteenth century, is one characterised by the pronounced inequivalence of a Self and Other dynamic. Through this particular perception of the child, poor children and their condition are once again fetishised and commodified according to the needs and wishes of those in control, debased to be built up anew, with the preoccupation with a paternalist remodelling of France's future through its population holding particular influence in this case.

In considering, as clearly so many did not, how such perceptions and behaviours may impact on children and their condition, Hugo's more abstract artwork offers an indication of the fear and isolation we might imagine. The obscurity and ambiguity of the subject matter and images, appearing like dark shadowy shapes partially illuminated by the moonlight, renders them reminiscent of the shifting, unidentifiable forms typically at play in a child's nightmares, and that characterise an environment of fear continuously suffered by those marginalised by society so acutely. *Fantastical Silhouette* (1854) depicts a relatively unmodulated black profile of a monster-like character. Created with the aid of his own children's stencils, the work exemplifies the very typical image of fear and danger of an abstruse monster, the sort that might appear before the eyes of a terror-stricken child when the undulating, kaleidoscopic forms of their surroundings merge to concoct what appears to be a foreboding beast. *Stains with Fingerprints* (1865) is still more ambiguous. On the one hand, this bizarre work resembles a child's artless finger painting, unstructured and clumsy, with ink splashed across

most of the page, yet on the other, we can gauge darker statements. The work could depict the upward view of a person trapped in a well or other cavernous hole, for example, with the white area representing the light of the sky above, and the fingerprints appearing as the obscured faces of curious onlookers peering down at the unfortunate pit-dweller. Perhaps through this artwork, Hugo sought to illustrate the sense suffered by many poor and urchin children of being trapped and enclosed in a dark, lowly and hostile world from which there is no escape, only to be observed and sneered at by those above.

When Halévy compared Degas, 'the painter who became blind [to] Beethoven ... the musician who became deaf', he remarked on the symbolic irony that this was the same painter who 'opened the eyes of his contemporaries'.[104] While there is little tangible evidence to suggest that the artistic and literary work discussed contributed significantly to any sort of official social reform during the time in which it was produced and disseminated, it nevertheless raised awareness among contemporary audiences if not contemporaneously of prominent social issues, and thus became an effective reflector of circumstances and concerns surrounding the working-class child of the French long nineteenth century. It is perhaps as a result of their warped vision, afflicted by a mixture of photophobia, blindness and depressive disorders, that the figures of Hugo and Degas removed the artifice of artistic invention. They exposed, like their photographic descendant, in the visually simpler though metaphorically more complex medium of light and dark, the extreme biformity of modern society and its treatment of the child of poverty. Forced by their own incapacities to help remove the shadowed veil of (wilful) ignorance that was draped over society, these individuals offered a clear and indisputable picture, a statement printed in black and white, of the technicolour palette of ills of which society was awash.

Reflecting on the polarities of nineteenth-century French society and the creative *chiaroscuro* that reflects this, especially that of an urban nature, this chapter has been dedicated specifically to perceptions of children of poverty. It has analysed artistic representations of poor children and their lives, focusing on the works of Degas and Hugo to investigate cultural consolidation and critical exposure of the ways in which the complex condition of children of poverty in this period was harnessed and projected by policy makers.

Seeking Childhood

Fuelled by a veritable obsession with social regeneration of the population as the only means to secure France's future, the poor child of this context was, as almost all perceptions covered in this book can be characterised, an emblem of both Self and Other. As Self, its youth is a poignant foreshadowing of man's downfall should ills go unchecked. As Other, it represents such ills, that is, the disease, poverty, disease, immoral seduction and infant mortality that plagued nineteenth-century French urban society. Through this particular perception of the child, poor children and their condition are harnessed to fit the needs and wants of the powerful, and, in rather Rousseauian fashion, whittled down only to be fashioned anew. As such, this chapter exemplifies the pervasiveness of this practice of reimagining the Self through the Other of the child, considering the specific manifestations thereof within the context of children of poverty. By contrast, the following chapter will turn to representations of children and childhood belonging to a class which arguably personified the attitudes responsible for the debasing of the poor child: the bourgeoisie.

Searching for Solace: Children of the Bourgeoisie, c.1850–1920

I seemed to see that this life that we live in half-darkness can be illumined, this life that at every moment we distort can be restored to its true pristine shape, that a life, in short, can be realised within the confines of a book!

Marcel Proust, *Time Regained*[1]

As a child I sought the shadows; I remember taking singular and profound joy in hiding among the great curtains in dark corners of the house.

Odilon Redon, *To Myself*[2]

Through this book's investigation into what we can learn from the visual and literary culture of the period about the transforming perceptions of children and childhood in France during the long nineteenth century, patterns have been established. It has become clear that as complexly representative of both Self and Other, creative and cultural manifestations of the child and its condition are ones enabled by its inequivalence to the powerful. Through a sense of ambiguity perceived to be innate to the child, a notion developed from contradictory yet influential Rousseauian theory, the malleability of

Seeking Childhood

children and their condition gave rise to their harnessing for an array of social, political, cultural, creative and personal aims. This exploitation of the child and its condition is something that has been enacted variously according to the needs and wants of individuals and circumstances but is always founded on and enabled by a reinforcement of its perceived liminality and thus inequivalence and adaptability.

This is perhaps overtly evident within the context of those subjected to Rousseauian theory and education or for children of poverty in the oppressive and unforgiving world of nineteenth-century urban France. However, how might the practice of such harnessing and the impacts thereof, founded on inequivalence, play out for those children not so obviously disenfranchised? In contrast to the previous chapter's focus on the plight of the working-class child, it is the focus of this chapter to unpack the very personal, though not altogether uncommon, experiences of middle-class or bourgeois children. The chapter begins with a brief exploration of the contextual background of bourgeois family life and associated approaches to children in the French long nineteenth century. Thereafter, the chapter is principally dedicated to two concurrent case studies of Marcel Proust and Odilon Redon, whose work offers a unique collision of life and creativity reflective once again of the introspective interrogation and re-imagining of the self afforded by the culture of the child in this turbulent period. Proust and Redon were strangers to one another, yet extraordinarily congruent in their experiences and semi-autobiographical reflections of bourgeois family life, the hostility of the modern world, the introspective awareness of the creative, and perhaps most poignantly, the child-mother relationship. As such, they present complexly intertwining case studies that offer uniquely personal yet far-reaching accounts of the impacts of the pervasive bourgeois culture and mentality in this period on those children most acutely subjected to it. Moreover, this chapter explores how the particular nature of such an upbringing revealed itself in the complexly introspective works of Proust and Redon, not only in their yearning for social and creative liberty, but perhaps most especially in literary and visual imagery produced in adulthood. Such works can be seen as highly representative of the comforting sanctum of the womb as a symbol of the eternal maternal warmth for which their childhoods left them forever yearning.

The weaving of one's childhood, life and work has probably few greater literary examples than Marcel Proust. It is in this way, namely through the imbuing of his magnum opus *In Search of Lost Time* (1912–27), with the convoluted experiences and hazy memories of his infancy and youth, that Proust helped to establish a new literary genre. Threading 'childhood memories in works that straddle the boundary between autobiography and fiction', Proust's intermingling of recovered memories and invented plots provides for a narrative in which truth and fiction becomes an unfathomable melange.[3] The indeterminable nature of Proust's genre is as much reflective of his own sense of doubt as it is the reader's when trying to differentiate between genuine memories and confounding embellishments in which one's past 'is so distant that its supposed revival is actually a new creation, from which a resurrected self arises'.[4] It is often the case that 'childhood memories ... compounded of adult nostalgias and anxieties, actual memories and the writer's artistic ambitions', can rarely be relied on as whole truths and often exist on paper as mere shadows of past events.[5] This is perhaps especially true of Proust. His particularly dense plait of writing combines his own youthful experiences with collective concepts of childhood by which his affinity in adulthood with the magical world of the child could be scaffolded. Gilles Deleuze adopted the term 'apprenticing' to describe the meshing of Proust's life and work, functioning as a never-ending bumbling through an obstacle course of signs, without much indication as to what is to be signified.[6] Accordingly, Proust's text not only functions as a personal revisiting of one's former years, an attempt to collate and make sense of past markers, but also as an invitation for the reader to do the same. Carol Mavor discerns that Proust wrote 'in a manner that relentlessly insists that we be *readers of ourselves*', in that his seven-volume novel is as much a study of all of us as children and adults as it is of himself.[7]

The bourgeois class of nineteenth-century France has been credited by both Philippe Ariès and Mark Poster as having given birth to the modern family, and by extension, the concept of the child as an entity in its own right.[8] Arguably, they did so by relinquishing the long-standing beliefs rooted in the medieval and early modern era that children were simply 'miniature adults',[9] perhaps in itself pointing to an age-old predication of the inclination of the large to control the small, for 'the appeal of [the] diminutive ... begins with

its capacity for instilling a feeling of omnipotence in the viewer'.[10] Far from just a ready-made adult on a small scale, it was recognised that the child needed to undergo a sort of period of quarantine and training before they would be permitted to join the world of adults, especially if they were going to fulfil their ultimate purpose: to develop into an adult capable of flourishing in a newly productive and unforgiving modern world.[11] The vigorous industrialisation of society undoubtedly contributed to the strictness of the regime undergone by these apprentice adults, subjecting them to a sort of mechanical whittling akin to the orderly functioning of a factory loom. However, it was as much an adaptation of 'Rousseauian' logic amounting to a system whereby every step in a child's development depended on 'the development of what people call its *raison* … the child is now considered to be *raisonnable* and is expected to remain *raisonnable*'.[12]

Far from being simply swaddled and indulged, the new role of the bourgeois child was that of the apprentice undergoing a particularly attentive training programme that sought to 'safeguard [childhood] against pollution by life … and strengthen it by developing character and reason'.[13] This rigorous apprenticeship programme was offset by a similarly intense application of (usually) motherly affection, developing a new depth of emotional attachment between mother and child, forging a parent-child bond so profound that 'the child's inner life could be shaped to moral perfection [by this] novel form of maternal love'.[14] In other words, care and fondness served as a sort of lubricating oil in the unfettered cog rotation of the bourgeois family machine, an enabling reward by which the necessary apprenticeship of bourgeois society may be more easily undertaken by its children. In this way, we can understand Deleuze's 'apprenticing' as not only etymologically suggestive of this bourgeois practice, but also providing a symbolic link between the idea of Proust's writing and the child's development; that is to say, both constitute a confusing and seemingly endless meandering through signs and stages with little indication of the signified end result.

The complexity of this can, quite paradoxically, be elucidated to us by a deeper burrowing into the tight folds of bourgeois society. While peer surveillance and competition were commonplace, socialising beyond the four walls of the family home existed strictly among adult members of society. This suffocating family enclosure meant that young children often

experienced no interaction beyond family and nannies, at least until school age. Firm in their belief of devolution from state to individual household, according to the bourgeoisie, 'the family was a private micro-world, a sanctum into whose hallowed chambers no outsider had right of entry'.[15] Accordingly, the family environment became for the child a sort of *mise en abyme* for bourgeois society as a whole; a world within a world, a house within a house, an enclosure within an enclosure. It is via this never-ending pathway of 'within' that we return to Proust, as the writer himself constantly does, adopting what Joseph Litvak calls a 'narrativising behindsight [that] insists preposterously on going back and staying back, dwelling on and in' every possible detail.[16] Proust's text, inextricably entangled among the knotted and fraying threads of his life, can never be unravelled into neat skeins: 'I perceived that life all this while had been weaving round person or thing a tissue of diverse threads which ended by covering them with the beautiful and inimitable velvety patina of the years'.[17]

Proust did not know how to do things simply, or how to do simple things. For example, despite having spent most of his life in bed, he did not even know how to make one: 'I found the bed hadn't been made up – there was just a pile of sheets and blankets ... I had never made a bed, and I got myself all entangled with the sheets'.[18] As in the bedclothes that most frequently formed his sanctum, Proust snarled himself up among the layers of life and work, autobiography and fiction, critique and philosophy. The exasperation that we glean from his inability to straighten things out, to make the bed and make his point, is reflected in his convoluted sentence structure, as Julia Kristeva explains:

> Unlike linear time, the [Proustian] sentence reproduces a giant breath through explanatory detours or backwards leaps that develop traces that had already been constructed, erased, and not absorbed ... a chronological progression, broken up and superimposed onto itself.[19]

These extremely long, twisting sentences provide the reader with a sense of breathlessness akin to that suffered by the asthma-riddled author; we too struggle to catch air as we meander through the paragraph-sentences, our lungs and minds cluttered with retrospective corrections, doubts and

Seeking Childhood

returns. In many ways, Proust's writing was facilitated by his invalid state, his acute form of asthma and the parental mollycoddling to which he was subject as a child, giving way in adulthood to a sort of cocoon of affliction in which he spun himself, cementing a lifelong habit of bed-bound convalescence. Moreover, it was also evident in his writing itself, not least in the hurried, self-questioning way in which his frail body struggled to pour out sensibly his addled mind's ruminations, his original manuscripts consisting of tiny concertinas of folded additions, each covered with miniscule scrawling afterthoughts. Proust's realisation in his novel of Henri Bergson's theory of *durée*, the subjective experience of time that transcends clockwork time as we know it, is a well-trodden topic in the scholarly world. To read Proust is to be absorbed into a topsy-turvy world, to be caught in a stop-clock motion that randomly resets, and to partake in a touristic, moseying perambulation of many layers, rendering the writer and reader alike a unique sort of 'Baudelarian armchair traveller, moving spatially and temporally'.[20] Considering the severity of such a displacement, it is as though Proust's long thread of narrative works in the same way that string does for one of paediatrician and psychoanalyst D. W. Winnicott's patients. This little boy, whose preoccupation with string had led him habitually to join various pieces of furniture together, was in this way dealing with a fear of separation in light of a growing family and thus reduced attention from his mother, 'attempting to deny separation by his use of string, as one would deny separation from a friend using the telephone'.[21] Similarly, conscious of his frequent liability to drift away in sleep or in the depths of creative focus, separated from reality or the beginning by streams and knots of storytelling, Proust weaves a never-ending narrative thread that allows him to retrace his thoughts. Just as children in fairy tales leave a trail of crumbs to find their way back home, Proust's narrative thread ensures he does not become lost. This becomes particularly important when we consider that Proust's search is for lost time, and that according to Deleuze, 'Lost Time is not simply "time past"; it is also time wasted, lost track of' until we find what we seek; the revelation of that lost time.[22]

Furthermore, the necessity of a woven, flowing and tactile linkage becomes all the more pressing when we consider the significance for Proust of darkness. As it was in the complex, shadowy confines of his bedroom, and

the even darker folds of his sleeping memory and inky dreams, that Proust's semi-autobiographical narrator found most of his creative inspiration, it is unsurprising that he and his art were as equally reliant on a plotted trail by which to find his way as he was on the very nature of the environment that made it so unnavigable. As Proust himself declared, 'what one has meant to do during the day, one accomplishes only in one's dreams'.[23] Nocturnal hours prove most imaginative and productive for both Proust and his child narrator of *In Search of Lost Time*, not only due to the innate potency of dreams, but also as a result of the confusion innate to darkness, which, muffling more external senses, serves to enhance one's awareness on a more internal level. Without the luxury of full and clear vision facilitated by light, our thoughts and sense of perception no longer follow a linear path. Walter Benjamin once said that 'the Latin word *textum* means "web" ... and no one's text is more tightly woven than Marcel Proust's'.[24] This offers some insight into the value of the darkness of an insulating sanctum for Proust and indeed Redon. Such is their urgency to maintain an environment whose impermeability both permits no outsider's entrance of light or interference and forbids the leakage of any vital sources of inspiration. Therein lies the paradoxical crux of the relationship of Proust (and his child narrator) and Redon with their dark existences; it is the very sense of confusion, insecurity and even fear innate to darkness that requires a level of contemplation, exploration and absorption, mental and otherwise, for it is the 'hard work in the darkroom of the mind' that ultimately offers both comfort and creative release.[25]

Such an existence and such behaviour were facilitated and exacerbated by the aforementioned arrangements peculiar to the bourgeois family. The *mise en abyme* condition of this 'behind-closed-doors' composition of the home constructed for the child a rather complex comprehension of the world, creating a claustrophobic flux by which they would be transported, as E. H. Erikson puts it, 'from a hostile innerworld, to an inner outerworld'.[26] Ergo, a highly pressured and private family life produced a child whose adulthood years would be characterised by a combination of a peculiarly secluded social circle and similarly cloistered state of mind. It is from this environment, both physical and mental, which a particularly exacting and unforgiving upbringing developed a child whose sense of introversion was

so acute that his passage into adulthood would prove plagued by anxiety, self-deprecation and a tendency to shy away from even the briefest exposure to the smallest chinks of light of the external world. The acuteness of such inwardness within Proust, his child narrator and Redon was exacerbated in no small part by their relationship with their mothers. Being that the new bourgeois teachings prescribed a model for motherhood that expected women to ensure not only the physical survival of their children, but also equip them for a respectable and successful place in society, it is scarcely surprising that such an intense relationship exacerbated the child's sense of dependency, especially if the child is already of a sensitive disposition. Such an attachment proved commonplace among creative individuals like Proust and Redon, with 'nineteenth-century artists' biographies invariably plac[ing] a graceful, nurturing mother' at their heart, as well as such a figure frequently seeping into their artistic and literary output.[27]

Despite bourgeois mothers' best efforts, child-rearing and training on such an unprecedented scale of parental involvement was something of an 'anthropological no-man's-land' at this time.[28] To negotiate this confusing, unplumbed terrain would prove problematic for mother and child alike. Such was the privacy of bourgeois society that mothers found themselves increasingly isolated and without a community of support from which to draw guidance on this new and burdensome role. Such apprehension transferred to the child as if through a symbolic umbilical cord from mother to infant, to such a degree that 'their anxieties fed on each other, forming an inextricable knot'.[29] And so we return to Proust's string, which, beyond that of the narrative thread, becomes symbolic in its notion of the never-ending link between mother and child, as felt by himself and his child narrator. While such a close bond could result in 'an emotional pooling which may multiply well-being in both, [it also could] endanger both partners when the communication becomes jammed and weakened', when the threads of the connective cord become taut and frayed, or tangled and knotted beyond unravelling.[30] We may ask ourselves, then, what happens when such a bond is thus damaged or destroyed. How does this important emotional and communicative breakdown manifest itself, most particularly in the child? Martens has remarked on the capacity of 'childhood experiences [to] indelibly stamp the adult spirit', thus suggesting the propensity for such intensity of feeling and emotional

turbulence during one's childhood accounting for insurmountable psychological issues in later years.[31]

It may seem difficult to accept that a social class so occupied with taking an obsessively diligent approach to their children's upbringings could succumb to an attitude of neglect or rejection. Yet we must remind ourselves of the paramount motive behind bourgeois parenting techniques; sculpting a human who is prepared to succeed in the modern adult world and worthy of representing the family. Therefore, a quiet, sickly or unusual child, isolated, misunderstood and burdened with inappropriate expectations is further saddled with the epithet of embarrassing disappointment. As playwright Molière declared in the seventeenth century, 'the infant who was too fragile ... to take part in the life of adults simply did not count'.[32] The existence of 'an unwanted child in a "superior" household' is unlikely ever to produce a thoroughly happy adult.[33] Then, to couple this situation with a particularly sensitive child with a peculiarity of spirit and interests in comparison to his peers, and the unsurprising result is one that creates a fearful and confused adult whose existence is one ridden with anxiety and depression. As Coveney puts it, 'for an intelligent and imaginative child to have affection and sympathy unaccountably withdrawn will cause a trauma from which he will suffer throughout his life'.[34]

Such a trauma, born of the bereavement of an absent mother, lies at the very heart of this chapter's focus. For both Proust (and his semi-autobiographical child-narrator of *In Search of Lost Time*, Marcel, who with some degree of trepidation we find ourselves considering as synonymous with the author) and Redon, it is the withdrawal of familial support and interaction, especially that of the mother, which not only forces them inwards to themselves, but also towards a dark sanctum that offered solace from the harshness of the outside world. For these two figures, the 'umbilical scar always pulls at the lost mother'; the source of pain, the ongoing irritation of a lifelong scar boring into one's centre is that of the tangible connection between mother and child, the physical manifestation of a more symbolic maternal lifeline that has been forever severed.[35] Such a profound attachment to the mother on a symbolically uterine level has been explored by both Evelyne Bloch-Dano and Mavor in relation to Proust. While the former has remarked upon the author's apparent 'inability to *exist* outside of his

mother',[36] Mavor's analysis of prominent sons' relationships with their mothers extends to an understanding of such an attachment as a 'covet[ing] [of] the mother's body as a home both lost and never lost, to desire her as only a son can, as only a body that longs for her, but will never become Mother, can'.[37] Although physically removed from the womb's sanctum, the finality of the cut umbilical cord cementing this, the symbolic join remains, albeit strained, tangled or hidden and continues to serve as a painful reminder of the thread-like pathway back to the maternal safe haven of the uterus, to which they feel they belong but will never gain access.

It is pertinent at this stage to provide some detail of the childhood experiences relating to the concept of 'Mother' of both Redon, Proust and his semi-autobiographical narrator, Marcel. Proust's early years growing up in a comfortable middle-class family were complicated, due mainly to his debilitating bouts of illness, specifically asthma, which prescribed a childhood often confined to the indoors, if not the bed. This insular and limiting lifestyle proved the root of the severity of his attachment to his mother and permeated the depicted experiences of the child narrator in *In Search of Lost Time*. The child narrator's desperate yearning for maternal attention is most famously reflected in the acute anxiety he feels at bedtime. Referred to as his *drame de coucher* ('sleep drama'), Marcel is afflicted with attacks of anxiety when trying to go to sleep at night unless pacified by the soothing comfort of his mother's goodnight kiss.[38] The psychoanalytical scholarship of Melanie Klein established general sleeplessness, and more specifically night terrors, as common among children, especially those of a more sensitive disposition, explaining that 'children and young people suffer from a more acute degree of anxiety than do adults'.[39] The comparative maturity of an adult to allow for a more logical approach to troubles contrasts starkly with that of the sensitive child, who is more likely to find themselves emotionally trapped by a situation for which they have neither the experience nor understanding to combat effectively. Klein's theory is exemplified in Proust's text. Not only is the child Marcel unusually sensitive to any potential peculiarities in his routine and surroundings, but adults seem especially numb to his anguish, operating, perhaps quite typically of their class, in a manner rather anaesthetised to emotional matters in general. Initially, this is characterised in Marcel's father's traditionally stoic treatment of his young son's sensitivity,

Searching for Solace

his abrasive bourgeois patriarchy evident in his irritation at his son's reticence to maternal separation. However, more revealing are the blinkered efforts made by his family to remedy his perceived fear of the dark during his *drame de coucher*, which will be further explored later in the chapter.

As an artist, Redon is most commonly associated with the Symbolists, and while in general their 'deep-seated pessimism derived … from a rejection of the world', the depth of Redon's determination to reject the world is testament to the intensity of the melancholy that he suffered at the hands of his family.[40] Born into a comfortable middle-class household, Redon's naturally introspective and melancholic personality left him enormously wanting in his parents' eyes, who patently preferred his more outgoing brother Gaston. A source of confusion and embarrassment for his family, Redon was abandoned in infancy and sent to live alongside a distant relation on the remote and dilapidated country estate of Peyrelebade, in the wilderness of the Médoc. Said to have 'felt the pain of this family exile for his whole life', Redon was forced, in the absence of familial love, to immerse himself in the rural culture and natural world surrounding him, allowing this alternative connection to living things to imprint permanently on his soul and artwork.[41] Consequently, Redon's childhood was one chiefly characterised by loneliness and self-deprecation, exacerbating an already well-established sense of scrupulous inward analysis and sensitivity. Just like Proust and his child narrator, although Redon's frailty was in part due to a sickly constitution, his depression resulted principally from the belief that he was something of a misfit and had let his family down. As such, 'his solitude and introspection, therefore, were stoic rejoinders to parental oppression' of a most complex nature, not least in the form of a sort of pleading infantilism.[42] Perhaps in some desperate response, a sense of infantilism dominated Proust's very core. His attachment to being his mother's little boy refused to allow him to mature to such an extent that he continued in adulthood to sign his letters to his mother 'your child Marcel'.[43] Edmund White's reading of Proust's famous statement 'in dying, Maman took with her her little Marcel'[44] reads that, with the emphasis placed on 'little', there is the suggestion that 'the ineffectual, dandified, immature Marcel died at her death, to be reborn as the determined, wise ascetic Proust' who produced literature of such sophistication and significance.[45] However, the extent to which this can be deemed true

remains dubious given the weight of maternal influences in Proust's magnum opus. Similarly, Redon's lifelong yearning for the mother figure he was denied at such a young age not only permeates his *oeuvre* but is reflected poignantly in his choice to adopt a name taken from his mother's nickname for him. Born Bertrand-Jean, Redon's moniker 'Odilon', coined by his mother and derived from her own name, Marie-Odile, is an indicator in itself of the artist's attachment to times when evidence of affection between the two existed.[46] In the same way that Proust will always be his mother's 'little Marcel', Redon will too always be his mother's 'little Odilon', literally formed from her identity, herself. With this in mind, it seems difficult to view Proust and Redon as anything other than what Benjamin termed 'that aged child'.[47]

These biographical anecdotes not only offer an informative backdrop to the personal backgrounds of these two figures, but also help reinforce the assertion that 'the boundaries between art and writing, or between autobiography and literary fiction, are never very clear'.[48] For both Proust and Redon, their lives and works interlock with a tightness impossible to prise apart. While in the case of Proust, he meticulously 'made use of everything he experienced or thought about during his lifetime',[49] Redon's 'satanic *noirs* act as a rejoinder to the solitude imposed on the artist by his family'.[50] Inspiration was found as a result of their banishing him, both in exacerbating his melancholy towards the world, and in its provision of a natural landscape overflowing with cavernous comfort and artistic stimuli. What also unites these two figures, the analysis of which will form the bulk of the rest of this chapter, is their search for solace in shadows and in the darkness as a remedy for their separation from Mother, a yearning that becomes apparent in the uterine imagery of their artistic and literary vision. For Proust and Redon, their upbringings were characterised by an understanding of childhood described by Mavor as 'innocent and pure, walled off from adult life (like a child's bedroom in the middle-class or bourgeois home, even the home itself)'.[51] It is perhaps unsurprising then that they took most comfort in the absence of maternal security to reclaim or manufacture a safe haven akin to that in which they resided alongside Mother for so long. Having only ever previously been exposed to a 'somewhat anaemic reality, [a] secluded life within four walls' as per the structures of their family and society, it is no surprise that in the face of difficulty, we find Proust and Redon's works to be

Searching for Solace

depictive of a return, nostalgic or therapeutic, to a uterine home, a dark and comforting sanctum in into which no interference from the outside shall be permitted.[52] For Proust and Redon, and indeed all of us, our mother was our first and forever home: 'I say Mother. And my thoughts are of you, oh, House. House of the lovely dark summers of my childhood.'[53]

Proust's womb, and that of his child narrator, is first and foremost the bed, but can be extended to the bedroom as a whole. While the bed is probably primarily considered a place of sleep, the significance of which (especially in relation to dreams) has already been discussed, the bed became far more for Proust, and in turn his narrator, child and otherwise. Proust's bed was his entire environment; often bound to it as a 'sickbed', its comforting folds became his accustomed place of refuge in which he produced his most successful writing. Functioning nocturnally, Proust slept throughout most daylight hours only to feel himself and his creative mind wake up with the onset of dusk, his brain filled with the visions of his dreams, and pouring himself out in ink onto his pages, 'from the honeycombs of memory he built a house for the swarm of his thoughts' without so much as moving an inch from his bed.[54] The bed is as much a symbol of Proust's memory and imagination as it is its home. Peter Stallybrass declared that 'wrinkles ... were called "memories"', and while Stallybrass was specifically referring to those wrinkles that cling like memories to our worn clothes, wrinkles can be equally attributed to the endless folds of the bedclothes that house in their dark crevices and billowing undulations Proust's weave of memories and imagination.[55] Proust's bed is, in this way, a sort of nest, a rounded snug, a uterine 'cloak of oblivion'.[56] His womb-like 'dwelling place which [he] had built up for [him]self in the darkness' like a nest whose twigs and moss and bracken is replaced by layer upon layer of memories, dreams and imaginings, becomes a place in which his creativity can thrive but also not escape or be polluted.[57] As such, Proust's uterine nest becomes a 'dark place, a "darkroom"', in which his memories, dreams and thoughts can be developed, like a photograph, from a single moment shot in a flash of brilliance to a rich and magical story forever preserved as picture or text.[58] Proust's uterine retreat is as much a place of creative abundance as it is of maternal solace. As Brassaï discerns, Proust is laden with 'images he had managed to wrest from light [which need] a dark place in order to bring them to visibility, [a place] withdrawn

Seeking Childhood

from the world in order to more vividly relive [them]'.[59] It is in this dark and private tabernacle of bedsheets that Proust feels safest, and thus where his mind is able to work at its fullest capacity.

Nonetheless, by playing host to these convoluted outpourings, by becoming a physical manifestation of the internal workings of the child and his childish adult writer, Proust's uterine bed is also a locus of turmoil, home to the psychological tribulations to which the child narrator's mind is subject in both a quest for literary autonomy as an adult, as well as the efforts of 'the child's psyche, claustrophobic, contained, gazing out upon the mysteries of adult life'.[60] It is perhaps in an effort both to engage with and battle against such an environment that the author expanded his womb to comprise his bedroom as a whole, blowing, as he did in his writing, the tiny and intricate into the enormous and all-encompassing. Proust as an adult famously covered his bedroom walls in cork, and while this was a popular style of the period, for Proust it proved far more than a mere fashion statement. The spongy, sequestering quality of the cork formed 'a placenta-like inner lining' to insulate him in his single, sealed room from the noisy interference of the outer world, allowing him physically to expand its capacity for contemplation while remaining sealed off from the outside world proper.[61] In much the same way that Proust's narrative grows and coils and tangles like an endless thread of thought that needs straightening, the space in which his dreams, thoughts and memories circulate, the mind beyond the mind, womb beyond the womb, needs to offer ample space for such an amalgamation to separate and be understood. It is as though, swaddled and entwined in the cocoon of his bedclothes, Proust stumbles into the extending darkness of his bedroom, and in bumbling around in the opacity, searching for a thread by which to find his way, he 'followed the stream of memory back towards its source', gradually disentangling himself from the sheets and his knotted thoughts until he emerges from his bedsheet cocoon, creatively inspired and free of psychological fetters.[62]

The extent to which Proust as an adult, reflected through his child narrator, felt as though he had mastered this absorbance of the bedroom into the self is perhaps made clearest when it is threatened most. In *In Search of Lost Time*, the introduction of the magic lantern to the child narrator's bedroom is the adults' response to the child's *drame de coucher*, assuming his anxieties

Searching for Solace

are rooted in a typical fear of the dark. The magic lantern, a lamp around which moving slides are fitted, projecting coloured, dancing shapes and characters about a dark room so as to depict fairy tales or folkloric legends, was installed in Marcel's room in a bid to cure him. His parents' ignorance as to the root of his woes not only arguably highlights their parental failings, but in fact exacerbates the problem, for this colourful kinesis distorts the child's impression of his room, ruining the familiarity he had established.[63] Presented with this warped version of his sanctum, a sanctum to which he had dedicated so much time and effort to render it a mere extension of himself and the maternal home, the child narrator is now forced to deal with a new environment. Instead of the shadowy haven of comfort and contemplation, this intrusion of colour, light and movement to the previous dark calmness threatened to impose a regime whereby his 'bedroom became the fixed point of which melancholy and anxious thoughts were centred'.[64] Like the narrative thread to which we cling being wrenched away from our grasp, and without the familiarity of the dark shapes to which we are comfortingly accustomed to guide and soothe us, the light of the magic lantern proves blindingly bright. This bright and unfamiliar light drives the child narrator towards 'a more than ordinarily scrupulous examination of [his] own existence', as if under the searing torchlight of interrogation.[65] The simple alteration afforded by the lantern renders him entirely lost within himself and his surroundings, as we might feel when we find ourselves transported by sleep and dreams, totally forsaken again in the apparent waking and very real disappearance of his maternal home. In one sense, the environment developed by the magic lantern concurrently frightens and enlightens the child narrator, for through its fantastical manifestations of the 'other' and the 'beyond', it depicts a new sort of landscape in the way that 'pictures offer both reality and illusion, [presenting] a window on the world, separating us from it, enabling us to observe and hence control it'.[66] In this way, the magic lantern's unfathomable images may expose Marcel to a fresh creative stimulant, functioning as more traditional images such as paintings or other artworks, as a way by which to broaden his visual perception both inwardly and outwardly. However, it may also demonstrate the potential damage of parental misgivings, not only as a reminder of the ways in which slapdash attempts to remedy childhood woes can result in

a malady far worse, but also as a symbol of the harmful effects of the adult world on that of the child in general. The magic lantern incident becomes symbolic of the significant notion of 'The sensitive child developing into an awareness of the complexities of life ... capable of receiving life to its fullest, capable too of finding it only to have it ruthlessly withdrawn by the plethora of powers that surround them.'[67] It is unsurprising, therefore, to find that Proust likened his life within four walls, his sickbed-cum-workbed-cum-sleepbed-cum-deathbed, to Noah in his ark.[68] In this way, Proust as both a child and adult exemplifies the childish satisfaction of shutting one-self away from the outer world, something like the sense of contentedness that we all feel watching a torrential downpour of rain from the safety and cosiness of indoors. Like a womb, an enclosed vessel at sea offers a capsule by which one can not only remain protected from the elements of a potentially stormy exterior, but also concealed and separate from any attempted entrance from outsiders. Accordingly, for Proust, his ark-like bed is not just a 'hermetically sealed compartment' in which he can hide, but also a vessel by which he can float away and leave the world behind, escaping both the harshness of adult influence and the creative-constraining reality of the modern world.[69]

The appeal of water and related vessels proved a significant influence in the life and work of Redon as well. Born in the port city of Bordeaux, on a bend of the expansive Garonne River, at one side accessible to large ships arriving from the Atlantic, and on the other home to low-lying marshy plains, Redon felt himself profoundly connected to waterscapes. Such a desire expressed in adult years, especially when coupled with the torturous experienced of having been wrenched from family life at a young age, points to a yearning for a sort of oceanic feeling that Freud considers a form of 'infantile regression'.[70] Redon's fascination with the sea is indicative of his wish to return to the comfort of the womb, or to create an environment that mimics its comfort and sense of the carefree:

> The oceanic feeling [is] to be regarded as repetition either of the very early mother-child relationship or of the still earlier intra-uterine existence, during which we were really one with our universe and were really floating in the amniotic fluid with practically no weight to carry.[71]

Searching for Solace

As Redon himself declared, 'to leave an accustomed place has always been a kind of death for me', and so it is scarcely surprising that throughout Redon's work we find evidence of not only the suffering that he underwent in light of his familial abandonment, but also the lifelong yearning he felt for the original, accustomed place from which he was pulled: his mother's womb.[72] Redon's banishment as a child rendered him not only bereft of familial interaction, but also that of people in general, forcing him instead to venture outdoors to nature, in search of what he had been denied by the human world. Consequently, this countryside estate became a trigger in Redon's imaginative and creative expression, for not only did it provide a landscape of endlessly inspiring flora and fauna, but it was his arrival there, exiled from his family, which provided the initial inner turmoil from which sprang artistic purpose. It so proved that, like a womb, sealed and insulating but filled with the buoyant fluid of thought, 'Peyrelebade was the child Redon's playground and prison cell, a place of physical confinement and imaginative liberation.'[73] Mavor's discussions of the ways in which Jules Michelet's 'love of Mother runs the gamut from *his* own mother to *our* earth as Mother'[74] rings true also of the great affinity Redon established with the natural world, for whom 'the biological mother is replaced by a mythical one – nature.'[75] And it is with this Mother Nature that he now shares everything, and within whom he finds all the comfort and inspiration he lacked beforehand: 'Nature, thus measured, and informed, becomes my source, my yeast, my ferment.'[76] And so in much the same way that the tiny folds of the sheets enveloping Proust's bed-nest-boat became his place of refuge and creativity, it was the shadowy crevices, nooks and crannies of the natural world that appealed to Redon and in which he immersed himself.

Whereas Proust ultimately found solace in the acceptance and absorbance of his bedroom, spending most of his time enshrouded in the cloak of his bedclothes, Redon did not suffer from the same fear of solitude and maternal abandonment that consumed Proust (he had, after all, already borne it). Consequently, while 'at night, Marcel sank into primordial anguish', it was the very qualities of the primordial of the outside world that opened Redon up to a new and liberating form of artistic expression.[77] Much like Proust, the trajectory of Redon's life had driven him decidedly inwards, but it was not until he met the little-known botanist Armand Clavaud when he

Seeking Childhood

was about twenty years old that he learned how to harness and effectively represent his visions and experiences. What began for Redon as a childhood interest in the infinite creatures and abundant plant life of the natural world around him, developed, under the tutelage of Clavaud, into a 'completely new perspective on the fantastic, on the multifarious morphological forms and figures that seem to unfold as simply as in a children's book' that had landed in his lap, serendipitously falling open on the most marvellous pages.[78] Clavaud's friendship and mentorship not only put an end to the artist's 'lifelong search for visual metaphors for sombre moods and haunting reveries ... introduc[ing] Redon to the revelatory experience of looking at nature through a microscope,'[79] but it provided him, for possibly the first time ever, with someone who seemed to understand his unique outlook: 'Clavaud shared with Redon a fierce pride and stubborn introspection as well as a sense of being unjustly ignored by his contemporaries.'[80]

Such is the variety in style, technique, media and subject matter of Redon's art that his association with the Symbolist movement is complex. Unlike many artistic groups and movements, banded together by their dedication to a single creative style or topic of interest, the Symbolists were united rather more ambiguously by their preference of the imaginary to the real, and their rejection of a contemptuously industrialising modernity in favour of sort of spiritual and mystical kingdom. For Redon, while his affiliation with the movement is linked in no small part to his embracing of what contemporaneous Parisian journalist Amédée Pigeon called a depiction of 'the world of dreams', it is perhaps chiefly due to his wholehearted participation in the Symbolist bitter rejection of the modern world.[81] Redon drew most of his inspiration from Clavaud's belief that 'even the earliest, rudimentary living organisms had a kind of soul through which they participated in the totality of the universe', taking personal comfort in the notion that even the most overlooked and seemingly insignificant beings can have an unexpectedly important role to play.[82] Drawing on this, Redon dedicated a large portion of his life and career to producing numerous portfolios and albums of monochrome lithographs and charcoal sketches known as his *noirs*, which, begun under the tutelage of Rodolphe Bresdin, continued to emerge in the 1870s following Redon's service in the army during the Franco-Prussian war. It was chiefly in these series of *noirs*, some of which were produced as

Searching for Solace

illustrative accompaniments to innovative literature, others simply on topics of the artist's own interest, that Redon created a gloomy and even spooky view of life 'emerging from dark, primordial slime where dwelt lethal bacteria', often including hybrid creatures and the peculiarities of nature, both frightening and intriguing, and thus suggestive of the influence of an equivalent comprehension of the world.[83] We may argue that Redon's familial abandonment, and especially his maternal separation, afforded him a connection to the Symbolist manifesto through his endeavours to discover, depict and champion a world far removed from that which had let him down on both a personal and ideological level. Furthermore, it forged a strong link between the artist and Clavaud, for their mutual feelings of hardship and curious fascination with the natural world provided the former with the environment and inspiration suited to the development and representation of that for which he longed; the dark, earthy comfort of Mother Nature's womb.

Redon's search for artistic representation of such an environment in the natural world began, in the first instance, in the world of monocellular deep-sea organisms. The peculiar lifeforms found in Clavaud's marshland investigations and the otherworldly fish at Redon's beloved aquarium at Arcachon provided him with a vision of a world in which one could retain the weightless, cleansing bath of the amnion. The appeal of such an existence is evident not least in the artworks in which Redon depicts what Barbara Larson calls 'mutating or hybrid forms that are informed by *transformisme*'.[84] Consider Redon's fifth plate to his first series of illustrations, published in 1888, to accompany Gustave Flaubert's *La Tentation de Saint Antoine* ('The Temptation of Saint Anthony') titled *Then There Appears a Singular Being, Having the Head of a Man on a Body of a Fish*, which features, as the title suggests, a fish with a human head. Calmly gazing on a scattering of barely discernible single-cell organisms, this unusual sea creature remains, like a tadpole part way through its metamorphosis of maturation, innocuously afloat his aquatic home. Informed by his attendance at various public lectures given at the Faculty of Medicine in Paris, as well as his own investigations of comparative anatomy at the city's Museum of Natural History in the mid-1870s, Redon was significantly influenced by prominent theories surrounding interspecies relationships.[85] French naturalist Geoffroy Saint-Hilaire, considered by many to be the 'father of embryology', believed, for example,

Seeking Childhood

in a single skeletal type that pervaded earthly species, which proved a foundation for works such as Ernst Haeckel's 1866 Theory of Recapitulation, positing that the development of advanced species underwent processes and stages reflected by adult organisms of more primitive species. Such scholarship boiled down to pre-eminent research of the period attesting to human embryos enduring a fish or animal stage, which was likely to have buttressed Redon's enthusiasm for a peaceful, uterine existence. Such bio-genetic theories fed into discourses on social degeneration popularised by *fin-de-siècle* pessimism that was imbued further with hues of national anxiety following the failures of the Franco-Prussian War. Concurrently, conjecture on evolution, such as Charles Darwin's concept of the 'survival of the fittest', was being harnessed as a means by which to rally the spirits of a defeated nation.

Although Redon's 1883 portfolio *Les Origines* ('Origins') participated in a satirical critique of scientific notions of progression, presenting an *ad hoc* assortment of monsters, representative of man's retrogressive moral evolution, his interest in evolutionary theory lies chiefly in its relationship with notions of hybridity, and especially that of the natatorial human residing within Mother Nature's womb. Inspired by Clavaud's perception of what he termed a 'universal harmony', Redon yearned for a return to a world in which man, animal and plant lived in and around each other, unfettered by the arbitrary divides of scientific dogma.[86] The striking frontispiece for *Les Origines* includes a splurging amalgamation of indeterminable creatures and species, light and dark, detailed and sketchy, emanating and skulking, a per-plexing melange of human, plant and animal. Forever pained by his familial exile due to his perceived inadequacy for the modern world, Redon sought, through his artwork, the renewal of the basic, organic linkage between cul-ture, nature and society that had existed long before modernity severed it. Like Clavaud, who 'was not interested in banal listings of characteristics [and instead] fascinated by individual attributes of plants – each having its own living personality', Redon's lithographs combined animal, human and plant, merging forms to create those he envisaged existing on the cusp of that invisible and unknown world that straddles plant and animal, and with which he felt an affinity in their tiny, marginalised though nevertheless enclosed, unexposed environment far preferable to him than that of the harsh, extra-uterine one.[87]

Searching for Solace

Redon's aching search for entrance by which to retreat into Mother Nature's womb is perhaps most evident in his depiction of polyps, which, taking shape as 'a sort of organic crystallography – or, organic stereometry', not only offer circular and ovular forms suggestive of the spherical or egg-shaped space of the womb, but also a unique vision of embryonic beings indicative of the human foetus afloat the amniotic fluid of its swaddling sack.[88] Redon's thirteenth plate from his third series of *Tentation* illustrations, entitled *Et que des yeux sans tête flottaient comme des mollusques* ('*And the eyes without heads were floating like molluscs*') depicts an ambiguous scape peppered with various cellular creatures, who, boasting little more than eyes and the sweeping arabesque of a partially formed fishtail, resemble something of the mid-cycle tadpole, the archetypal creature of amphibious metamorphosis to which Redon may have considered himself akin. It is in these sorts of Redon's works in which we can clearly detect evidence of Clavaud's influence, down to the precise similarity of the natural peculiarities of the artist's embryonic polyps and the botanist's scientific diagrams of minute marsh life. Redon's lithograph *N'y a-t-il pas un monde invisible?* ('*Is there not an Invisible World?*') (1896), in which a dark and obscured coral stands abundant in pale, sprouting micro polyps, whose tiny faces, representative in their various expressions of a myriad of moods, offer 'an extraordinary sense of being transported to another scale', one in which Redon can shrink himself down to a foetus again and return to the soothing confines of the womb.[89]

It is often said that 'a particular affinity exists between childhood and nature', and it is such a connection that aids one's passage back to youth when immersed in the natural world.[90] It is in this way that Redon's deeply personal artwork also strikes a particularly poignant chord with the collective voice of society, and his contribution is twofold. First, his fascination with and championing of the hidden peculiarities of the natural world emphasises the 'stark contrast between the harsh realities of civil society and unsullied nature'.[91] Second, Redon's depiction and channelling of the child becomes a symbol of rejection of the modern world, serving as a 'means of escape from the pressures of adult adjustment, a means of regression towards the irresponsibility of youth, childhood, infancy and ultimately nescience itself'.[92] Given the bouleversement of social and political life in the rapidly

modernising environment of nineteenth-century France, such a notion was not uncommon, as previous chapters have already indicated. Indeed, for the re-imagining of the self enacted through the child is arguably as much a relinquishment of the pressures of responsibility and awareness as it is a nostalgic perambulation.

It was arguably the 'primitive' surroundings and culture of Redon's own childhood in the Médoc that informed not only his interest in folk art and that of children, but also his sociopolitical outlook, using the autonomy of art to condemn implicitly the vulgarity of modernity. Redon's journal, written from the age of twenty-seven until his death, goes some considerable way to revealing the depth to which Redon felt, like other artists towards the end of the nineteenth century, 'very much abroad in an alien world'.[93] Save for his own personal tribulations as both a child and adult, which indelibly coloured his every outlook in life, Redon seemed most affected by the moral descent of man that he perceived among the middle and upper classes especially. Fed in part by his own sense of injustice, Redon felt fixated by the apparent polarity between the greedy modern man of urbanity and the marginalised simplicity of the natural and the innocent. This reinforced the artist's will to exist in a world that combined human, plant and animal in a harmonious, non-discriminatory fashion, as Jodi Hauptman observes:

> Redon's entire career consisted in finding ways to represent nature's surplus. His monsters unwittingly came to symbolize the staunchly idiosyncratic nature of his artistic trajectory: art, like the monster itself, would prove us wrong in our will to distinguish between human and nonhuman, ugly and beautiful.[94]

Redon's personal sense of *fin-de-siècle* sorrow is reflected in the lamenting expressions bestowed by his embryonic, womb-residing creatures. Redon's lithograph *Éclosion* ('*Blossoming*'), from his 1879 album *Dans le rêve* ('*In the Dream*'), demonstrates this. The print features the profile view of a floating face that is peering out with a sense of hopelessness at the world external to his spherical abode. Notoriously fixated with the notion of vision, especially in relation to the idea of the insightful view of the philosophical inner eye, Redon's imagery is often peppered with optical bodies. While this typically takes the form of an enormous, discernible eyeball, he also engaged with

Searching for Solace

more subtle representations, such as that of *Éclosion*, in which the plentiful and scratchy strokes that detail the upper part of the sphere suggest eyelashes, and the pale face, his own eye unnaturally large and skyward, forms a patch of bright light within the darkness of the pupil. This eye-creature, hovering above a calm body of water, like a foetal embryo within the amnion, appears to harbour a pessimistic inner-eye vision of the world, gazing out on an environment he dreads having to join. Redon's works by their very nature are deliberately ambiguous. In the same way that all of these tiny creatures retain a sort of mystery, by extension, so do Redon's artistic portrayals of them, for they pertain to a shadowy world in which not everything is quite as it seems, and in which mystery and truth remains enshrouded until discovery by those who endeavour to search.[95] In keeping with Mallarmé's discernment that 'to describe an object is to eliminate three quarters of the pleasure', Redon's art is one of suggestion, inspiring the viewer to engage with and ponder the image in a way that quashes the blinkered acceptance of spoon-fed doctrine symptomatic of the era.[96] This is perhaps indicative also of Redon's own fervour for contemplation, his 'tendency towards scrupulous and somewhat masochistic analyses of every aspect of existence, often manifest[ing] in aesthetic introspection', which informed his every stroke.[97]

Bound by this feverish introspection, Redon can only find relief in the all-consuming and impenetrable envelopment of Mother Nature's womb. His 1880 work *Le puits* ('*The Well*') depicts this. Unclear as to whether the viewpoint is from inside the well looking up, or from outside looking in, its appearance is typically ambiguous. The composition can be understood as that of a baby sleeping peacefully within the padded confines of the placenta, itself within the womb. The face at the centre of the image, baby-like in its soft shape and downy hair, appears contentedly asleep as it floats in the perfect blackness of the well's amniotic fluid. Instead of an encirclement of cold, solid stones forming the rim of the well, the wedge shapes that surround the baby seem like spongey segments of placenta lining, softened by their rounded edges, providing a protective, cushiony layer to the uterine haven. Beyond that, the endless and ambiguous opaqueness of patchy darkness implies the expansive but contained space of the womb, the seemingly infinite though nevertheless secure world of the tiny child. Although this image is not an overly fantastical one filled with otherworldly creatures and

Seeking Childhood

mesmerising intricacy, it is nevertheless suggestive of a need to soothe and heal an overwhelming sense of disquiet. It thus participates in 'Symbolism's anxiety to be protected from the outside world with scenes which have no connection with everyday life', in this case, through a relinquishment of the self back to the life before life as we know it, through a 'little door through which [Redon's] own imagination escaped to travel far down the black paths of lithography' and into the inky pool of the womb.[98]

Redon was probably never so in line with his artistic affiliation than in his echoing of the statement that 'Symbolists were people who loved intimate relationships and shrank from bright lights', reflected most poignantly in his lifelong endeavour to retreat to Mother Nature's womb.[99] While this most frequently manifested itself in his embryonic, encircled beings of the minuscule extremes of the universe, Redon was equally enamoured by the giants of the natural world: trees. Steadfast in the notion that 'trees and all the inanimate nature of the countryside live in the life of man' and influenced by beliefs among local Médoc communities that trees are possessive of supernatural qualities, Redon depicts trees in a way that emphasises not only their imposing grandeur, but also their unique anthropomorphism.[100] Redon's ninth plate from his third *Tentation* series, titled *Je me suis enfoncé dans la solitude. J'habitais l'arbre derrière moi* ('*I plunged into solitude. I dwelt in the tree behind me*') exemplifies this. The lithograph depicts a thick-trunked tree standing in the very centre of a dense, dark forest, the plentiful outreaching branches of the tree and its surrounding shrubbery filling almost the entire space with a tangle of shadowy leaves and twigs. Boasting patches of shaded bark serving as dark, squinty eyes and a large hole of broken tree trunk representing a sort of gaping mouth, both threatening and welcoming, the anthropomorphism of the tree mixes the human and natural worlds. Taking into consideration the title of this particular print, it is as though the child Redon, alone in the savage forests of Peyrelebade, longs to retreat into the cavernous protection of the hollow tree, not only similar to what Roland Barthes called a childish desire to be 'primitive, without culture', but also to be encased and safeguarded by that primitiveness from the very culture with which he feels at odds.[101] Similar to the 'effect of shutting childhood eyes [to] wall off the world [for] as little children, many of us believed that if we shut our eyes, we couldn't be seen', Redon wished to be swallowed up by this

tree-mouth, to be consumed by the grandeur of nature, never again to have to face the painful injustices and deafening solitude of the human world.[102] Just like his beloved region of Bordeaux, described as 'a mouth without a stomach', Redon desired to be swallowed by its landscape's tree, swallowed down not into the stomach, but into the comfort of the womb again, to be consumed and harboured within the dark, safe confines of Mother.[103]

The notion of a recluse's haven within a tree is reminiscent of Proust's proclivity for a nest as a cosy, encircling encasement made up by and of the Mother; for as a mother bird uses her saliva to bind her structure, and plucks out her own feathers to provide a soft, cushiony lining, the nest becomes as much a home of the mother's body as the womb is. This 'nostalgic return to the womb' that characterises both Proust and Redon's propensity for a secluded existence, this desire to shy away from life's hardships, to be hidden away in the peaceful, comforting darkness of Mother, highlights an infantile mind-set at the heart of both figures even as adults.[104] As Gaston Bachelard confirms, 'the nest image is generally childish', for not only is it suggestive of the womb environment, but also, in the case of Proust and Redon, of an adult yearning for a relinquishment of reality and reclusion to such an environment.[105] In many ways, their lives and works of Proust and Redon exemplify Ellen Handler Spitz's notion that 'unusually creative individuals may dwell precariously on the edge of this divide', that is to say, the divide between the human and natural worlds, between real and imaginary, adult and child, outer and inner.[106] Yet in both instances, this is not just as a result of their heightened creativity, but also in no small part due to an upbringing in which familial affection is significantly lacking. This manifests itself in a longing to return to the womb, to the very essence of infancy in order to reclaim what is perceived as 'the loss of childhood through the death of a mother',[107] whose death is not necessarily literal, but rather metaphorical; namely, in her failing, wilful or accidental, to be what Winnicott terms the 'good enough mother'.[108] A troubled beginning in life most often results in an adult life of turmoil. As Klein has clarified, if a child is not sufficiently guided by their parents or guardians and therefore struggles in 'mastering its anxieties ... its mental health in future years is not planted in firm soil'.[109] Just like Redon's wilting plants and miniscule organisms, cowering in the darkness of earthly nooks starved of attention, and Proust's tangle of a nest-boat-bed,

awash a turbulent sea, the troubled child whose sensitivity is ignored or misunderstood can develop an enhanced sense of internalisation, for although they are ultimately places of comfort, beds, deep sea dwellings, nests and wombs are nevertheless dark places. As Barthes once said, 'to be excluded is not to be outside, it is to be alone in the hole', and the hole of the womb to which Proust and Redon yearn to return is, after all, only necessary because of the inhospitability of the outside world.[110]

Continuing the theme of the natural and the botanical, it is as though these children of the bourgeois system suffer an abrupt sort of uprooting at the hands of their parents, leaving their wispy and weak roots exposed to the harshness of the elements and the surrounding weeds, unlikely ever again to find hospitable ground. Redon's 1880 work *Tête à la tige* ('*Strange Flower*') goes some way to illustrate this point. The charcoal sketch features a large moon-like human face tilted to one side, which, relatively unmodulated, boasts two heavily shaded eyes that gaze out at the viewer with a watchful solemnity. The face becomes somewhat egg-shaped by the addition of dark crescent petals at the top that form a sort of hat. The embryonic head is supported by a single, spindly stem that is planted in the centre of the landscape, which, save for a few sparse leaves in the foreground, is bleakly barren, an ambiguous white cloud-like shape on the right suggestive of a foreboding storm. This image perhaps altogether mirrors Redon's own sense of belonging, or lack thereof; the soft, bright ambivalence of this baby face against the backdrop of a dreary sky, feebly propped up by a scaffold whose strength is doubtful, is thoroughly suggestive of a delicate child lost in the harshness of the world, all too aware of his vulnerability, bereft of familial aid.

The works of Proust and Redon go some way to exemplifying the experiences of children whose societal and thus familial structure had all the markings of a comfortable and supportive upbringing, but that failed, for it became 'an ethos undermined in a culture that is debased with debris from neglected and abandoned objects. Unmothered. Stillborn.'[111] Feeling wholly rejected and lost in a world to which it seems most others considered themselves akin, these creative individuals conducted themselves in a manner that believed in the 'superiority of art over reality'; they chose to view their own existence as not confined to the parameters laid out by others.[112] For the average adult, comfortable in the society to which they have been

prescribed, the inner world and the external world in which we live, like art and reality, exist as two separate, though perhaps complementing, entities. For children, however, the disambiguation is considerably less precise. 'Spaces, as we like to think, can be inner or outer, but for children, the gates swing back and forth', in much the same way that for Proust and Redon the womb space need not be off-limits and re-admission from the outer to the inner seems an enviable possibility; the gate to the womb is not firmly shut.[113] Forever troubled by the query that haunted their childhoods, 'how can one be oneself and still be likable?' Proust and Redon as adults remained as they were as children.[114] They refused the opportunity as they matured to follow suit and 'distinguish clearly between dreams, fantasies and waking states, between the self and others, between a picture and the thing pictured'.[115] While in many instances of this ilk, 'mutism and parental withdrawal into abysses of self beget the annihilation of children', perhaps it is the case on this occasion that Redon, just like Proust, remained something of a child in an adult's body, using their painful childhood experiences to reflect on and possibly reimagine a youth that was never allowed to flourish, thus, simultaneously basking in a warm and calming pool of nostalgia for what might have been and wading through a tortuous swamp of why it was not.[116]

As such, through the lives and works of Proust and Redon, this chapter has accounted for perceptions and representations of children and childhood from within the bourgeoisie, whose far-reaching social and cultural structures proved a significant influence on French life in the long nineteenth century. As simultaneously members by birth of this social class yet shunned from its favour due to perceived inadequacy and deviancy, Proust and Redon are particularly emblematic of the recurring motif of child as both Self and Other. Moreover, it is from the inequivalence felt by these individuals, both as actual children and as creatively regressive adults, when faced with the demands and expectations of modern society, that their creative expression is generated. Driven by their natural introspection, Proust and Redon vicariously reflected on their childhoods through their literature and artwork. In so doing, they produced works that both criticised society's treatment of those perceived as ineffectual and liminal, and, perhaps most poignantly, revealed a desire to return to the original safe haven from which this society had wrenched them: Mother. In this way, unlike previous case studies in

Seeking Childhood

this book, Proust and Redon perhaps offer a more personal reflection on perceptions and representations of children and childhood in this period, allowing us to appreciate the impacts on children from a more child-like perspective of the strictures laid out by society's ruling classes. Arguably extreme versions of the intellectuals and creative practitioners of this epoch who harnessed the child as a malleable vehicle of re-imagining and reinventing oneself, Proust and Redon seemed never really to grow up in the first place. Bereft of the familial affection needed for such a transition, they remain children in the bodies of adults, thereby offering a unique insight into perceptions of their own condition.

Toy Town Theatre: Material Acculturation and the Child, c.1870–1900

[R]oles can be peeled away like layers of an onion to reveal a repressed core, a true self, which has been inhibited, clouded by the layers of social conditioning which obscure it.

Valerie Walkerdine, *Femininity as Performance*[1]

[S]urface and surface alone [for] she was nothing in herself ... Beyond the projected fantasies of her admirers, there lay a vacuum, a void ... an empty shell which needed to be cloaked and adorned in the style of the moment.

Tamar Garb, *The Body in Time*[2]

It has already been established by now that for a long time, existing in a world disinterested in the seemingly ineffectual, 'children were seen as miniature adults', and thus simply a person in the making, on its way to being someone.[3] In another sense, however, we can view this semblance of a human on a reduced scale as something of a plaything or toy in the adult world, a pocket-sized novelty for grown-up amusement. This concept is not new to this text; it was perhaps most prominent in Chapter 3 and its

Chapter 5

Seeking Childhood

analyses of fetishised children of poverty. However, the concept of the toy-child is not confined to discussions of children of poverty, and is far more ubiquitous a notion, representing on a more far-reaching scale the sense of inequivalence and cultural harnessing to which the child is subject. In the same way that 'play acting … is a child's instinctive need for enlarging his world of experiences',[4] often offering 'the impression of a giant at play', surrounded by a vast array of tiny replicas of recognisable members of the real world which offer some semblance of interaction and control, adults can be seen to replicate this scenario in their treatment of children.[5] It is through the notion of the child as an adult's toy that we can conceptualise not only the multifariousness of this power dynamic, but also its potential and gravity in a context characterised by an urgency to control and maintain recognisable order. The *Oxford English Dictionary*'s description of the toy as 'often an imitation of some familiar object'[6] points to just 'how important the exact portraiture of real-life form and function had become in defining a … toy' in this period.[7] And what greater likeness to real life than the child, who, not quite a fully formed human, but, in its diminutive similitude, has all the veneer, novelty and potential of a small-scale version of its puppeteer: both Self and Other. This points not only to the resounding popularity of humanoid toys such as dolls, puppets and automata at this time, but also the great weight afforded to appearance, recognisability and conformity, on which cultural and social norms were founded. As such, with little regard for the actual person within, children were moulded and adorned according to the latest ideals of the prevailing adult population, the turning out of these hollow replicas into society shadowing that of modernity's accelerating pro-duction line and thus giving rise to a compelling toy-child coalescence in the late nineteenth century.

Scaffolded by sociological theory throughout and operating under the ongoing concept of the toy-child, this chapter examines the ways in which various apparatus were harnessed by adults as powerful tools of accultura-tion to instil from birth a very gendered, socially contrived and sanctioned pattern of existence by which to transmit personal, collective and national ideals. Drawing on the child's natural existence outside the strictly governed demarcations of the adult world, this chapter considers the ways in which the adult-centricity of French long nineteenth-century society sought to

Toy Town Theatre

combat non-conformity, contributing to the formulation of the toy-child image and concept in artistic and material culture, and in turn the reduction of the child, socially and conceptually, into a soulless veneer of ideals. In so doing, this chapter focuses particularly on the instilment of normative gender roles and is sociologically informed according to this. While the moulding of children in this period incorporates various fashions and influences, it is important to recognise that there was no marker more profound or widespread than that of the sex-gender conflation. Even social class could not escape it. This was due largely to the prevalence of patriarchal models and the central position that they occupied in upholding established cultural and family values and roles deemed key to national stability in turbulent nineteenth-century French society. While France's future rested in the hands of its children, those children needed to fulfil roles that would guarantee established concepts and ideals of success and stability, and patriarchal norms signified this unquestioningly for most. This process is carefully examined through the ubiquitous tools of acculturation central to the upbringing of children in nineteenth-century France: fairy tales and toys. It is through these key transmitters that children see, hear and do in their carefully walled-off lives that we can gauge an understanding of the parameters by which children existed, and against which they subsequently fought, as explored in the following chapter.

To frame understandings of the concepts on which patriarchal systems relied in this period, the current chapter investigates the prevalence and impact of oppositional theories through the lens of Perraultian fairy tales and accompanying illustrations. Such a focus allows for analysis of the discrete ways in which such ideology infiltrated the culture of childhood, producing for children a very narrow version of a carefully controlled and gendered reality to which no likely alternative exists. From this, and overarchingly informed by Ann Oakley's theories on canalisation, the chapter then explores such concepts of social existence by analysing their further cultural reinforcement in play through highly gendered and adult-designed toys, considering the ways in which specific ideals are instilled within children through the toys that they are given to play with.[8] The social and cultural prevalence of these ideas is then exemplified through an investigation into the reflection thereof in Impressionist artworks, where 'impressions' of modern children

are those that eerily mirror the image and behaviours of their adult-made toys and thus lack authenticity and personhood. Therefore inviting considerations of the uncanny, the chapter then returns to the central idea of the toy-child conflation by looking to the *Jumeau* doll. This case study demonstrates society's preoccupation with idealistic appearances and a neglect of personhood, whereby children become debased by their harnessing at the hands of those who seek salvation in the modern era.

As outlined above, contemporary theories of child development conclude that central to this unyielding emphasis on outward aspect alongside both the ongoing formulation of a legitimate person from child to adult, and the connected symbol of the toy, is the creation and maintenance of normative gender roles. It is never really the case that 'a child' simply becomes 'an adult', but rather, that boys are apprentice men and girls are apprentice women.[9] Such a distinction not only proves a lifelong focus and vocation by virtue of its perceived natural status, but also in its complex role as a cultural and social mainstay in an environment of ongoing fluctuation, for notions and constitutions of femininity and masculinity are not secure but rather '*struggled over* in a complex relational dynamic'.[10] Similarly, while gender ideologies, as with all ideologies, are not fixed but instead share a dynamic relationship with reality, the same can be said of toys.[11] It is no coincidence that an accelerated interest in these interconnecting issues in late nineteenth-century France occurred during a period marked by a growing preoccupation with all that was seen to characterise the future: children, industry and concepts of the Other. As previous chapters have indicated, the French long nineteenth century was a time both marred and lifted by a cacophony of political earthquakes, constantly shifting the social tectonics and accelerating the urgency for stability. Not only do toys 'serve as temporal markers, reflecting undercurrents of popular attitudes' of a given society, but they play a significant role in shaping the key constituents of this society's future: children.[12] Accordingly, given that it was the latter decades of the nineteenth century that saw the burgeoning of a sincere interest in the related fields of child development and gender ideology, it comes as no surprise that this coincided with the publication of preliminary works on the study of toys by figures such as Édouard Fournier, Gaston Tissandier, Léo Claretie and Henry-René d'Allemagne.

Concepts of gender and toys, therefore, exist in a sort of flux, an undulating continuum of intersecting helixes of time, place and experience. In much the same way that toys can be seen to correspond generally to the development of society, Judith Butler has asserted that 'gender is an identity tenuously constituted in time, instituted in an exterior space through a *stylised repetition of acts* ... a constituted *social temporality*'.[13] This constant metamorphosis to which notions of gender and toys are subject is composed of layers. Like constantly overlapping leaves of parchment, these socially and historically articulated concepts develop like a multi-mantled ink-wash comprising thick cloaks of opaque black adorned with flimsy veils. Like the imbricating swathes of shadows that move in and among each other, there never exists one singly discernible and solid silhouette by which to trace a replicable model outline. Somewhat paradoxical, then, is the dogmatism by which these two concepts were predominantly treated in the French long nineteenth century, constraining their relationship to a double-pronged formula corresponding to the perceived strict biformity of gender. Far from acknowledging the opacity that characterises gender and toys as constituted in time and experience, French nineteenth-century society adopted a stark black-and-white approach that entertained no mixture of viewpoints. This gives new reason to the assertion that 'toys mould generations', for far more than functioning as a mere yardstick of society's evolution, toys became a significant and active tool by which gender particulars were shaped, a model that every child must strive to replicate, thereby giving rise to the conflating concept of the toy-child.[14]

The immoveable rigidity of society's binary understanding of gender, and the resultant role and symbolism of the toy, lies chiefly in the conflation of the former, in terminology, concept and content, with sex. The trepidation with which gender has been treated for many years in scholarly circles is testament to the precariousness of its relationship with sex, and more specifically, the obstinate amalgamation thereof by any society prescribing to the patriarchal standard. Simply put, sex is the term given to the physical, bodily division of boy or girl, male or female, and while there is some ambiguity (e.g. hermaphroditism and transsexuality), sex is a fairly inflexible dichotomy. Gender, on the other hand, both in nineteenth-century French society and today, is a far more complicated and nuanced concept. Defined

by Joan W. Scott as 'a constitutive element of social relationships based on perceived differences between the sexes [and] a primary way of signifying relationships of power', gender represents a code by which social functioning is regulated.[15] Gender constitutes an ongoing enactment and fulfilment of learned behaviours and identities as stipulated by a given social environment, and is thus naturally at odds but forcibly aligned with a biological truth to which it is perceived to correspond, much like the creation of toys that aim to mimic human life, but that then contribute to a conflation of the toy with the child, resulting in an increasing moulding of the latter into the ideals of the former. To confound the matter further, the adjectival descriptors of 'masculine' and 'feminine' are automatically understood to correlate with the perceived typical attributions of males and females, creating a sort of social dichotomy that places two genders parallel to and correspondingly alongside two sexes, wholly based on assumptions and ideals and irrespective of an individual's traits, thereby creating a norm that prohibits deviation. This in itself is riddled with contradictions, for as Carrie Paechter notes, 'a person's masculinity or femininity is not innate, is not natural, but instead is something that is learned, constantly reworked and reconfigured, and enacted to the self and others', yet it is nevertheless founded on and absorbed from teachings that draw their counsel from the perceived normal attributes that are considered as natural as the biological sex with which they are associated.[16]

The very existence of a norm in society is perplexing, for its entire basis is one of self-fulfilment. As Butler puts it, 'the very attribution of femininity to female bodies as if it were a natural or necessary property takes place within a normative framework in which the assignment of femininity to femaleness is one mechanism for the production of gender itself'.[17] In other words, while norms strive to become the only reality by which we can exist comfortably in a given society, they are active agents in their own affirmation, becoming norms only because they are constantly repeated as such. Once again, we encounter a prong of this debate in which habit, reinforcement and repetition betray the very lack of 'naturalness' on which the entire ideology of normative gender is mistakenly based. This automatic assignment of gender to a seemingly corresponding sex carries numerous issues, chiefly in the unwavering expectation bestowed by society on a boy or girl,

man or woman, to behave stereotypically 'boyishly' or 'girlishly', 'manly' or 'womanly'. We are born, quite unknowingly, into an environment that has laid out appropriate behaviours for us from birth, basing these stipulations wholly on our sex, what society deems suitable a manner by which to operate, and with complete disregard for the individual characteristics of that person, which may or may not fall within the allowed boundaries of their sex-gender mould. As Butler put it, 'I am constituted by a social world I never chose' and yet 'I am someone who cannot *be* without *doing*' and thus in order to be accepted and validated as a legitimate person, one must corroborate one's existence as a male or female by constantly maintaining an exacting masculine or feminine role.[18] Accordingly, community acceptance is founded on the 'coercive exclusion of others and a claiming of superiority for members', thereby galvanising the necessity to mould oneself like a beautiful bisque doll, forcibly if necessary, to fit the carefully sculpted shape laid out by society.[19] Failing to do so can lead to a sense of detachment, apathy and loss of constituted identity from which it is difficult to escape.

Because of the inextricable conflation of sex and gender, the determining of the former at birth automatically implies the latter, meaning that when we assign a sex to a baby, it immediately places that individual within a clear category on which we base an innumerable range of expectations and designs, all of which hinge on biologically determined but socially articulated 'systems of classification, regulation and normalisation'.[20] By introducing from birth a model that is then ceaselessly reinforced thereafter, the result is a child for whom no alternative to the prescribed norm realistically exists. Valerie Walkerdine refers to 'a kind of greenhouse ... a "natural" place where childhood could progress untrammelled, and children would become the self-regulating and democratic citizens, the hope for the world'.[21] This greenhouse, essentially a uniquely artificial yet natural environment, exists to enhance and safeguard the growth and cultivation of living organisms in an environment that resembles the natural world in everything but its exclusion of external forces and factors, much like the supposed 'normal' upbringing of a child in nineteenth-century France. In this way, the proverbial plant, accustomed only to its greenhouse surroundings, knows nothing of the wider world outside its encasement and so can exist only on the knowledge that it has been drip-fed. By providing a regimented and shielded upbringing

based on normative gender roles, children 'are presented with, and inserted into, ideological and discursive positions by practices which locate them in meaning and in regimes of truth'.[22] However, as Butler comments, and in correspondence with the ongoing magnification of appearance over depth and façade over truth, 'sometimes a normative conception of gender can undo one's personhood'.[23] The common converging of the child with the doll, for example, in a social, cultural and artistic sense makes for a society comprising clusters of eerily manicured automatous children, unyieldingly bright-eyed, polished to a high shine and decoratively clad in ornamental fabrics. Moreover, it produces a society whose attention to such detail translates to a neglect for anything beyond the deftly lacquered shell, for 'with so much emphasis on the signifier, the signified tends to vanish'.[24]

This concerted pattern of fashion overshadowing personality was epitomised by the popularity of Charles Perrault's adaptations of various traditional and pre-existing folktales into what became the new and powerful literary genre of the fairy tale, which placed traditional gender-orientated values central to its message. Not only were tales that fixated on feminine beauty far more popular and long-standing by virtue of the incessant normalisation of such superficial values, but they were invariably characterised by the featuring of ineffectual females whose survival depended on males.[25] As Andrea Dworkin attested, 'for a woman to be good, she must be dead, or as close to it as possible', and so like Snow White, encased in a glass coffin through which her evergreen beauty could still be admired, ideas of female agency had no place when her greatest asset was as evident in death as in life, and whose state could and would only change on the deliverance of true love's kiss.[26] Not only is she reliant on the action of a male in order to 'save' her, reinforcing his strength and agency in contrast with her delicate passivity, but the only way in which this can be affected by her is through the allure of her feminine beauty. Not only do such stories replicate and legitimise gender statuses for the little girls and boys at whom they are aimed, but the frequent weaving of make-believe in among recognisable features of everyday life serves to imbue a child's understanding of reality with discourses of fantasy, especially when accompanied by illustrations. Reminiscent of Proust's semi-autobiography, for children, and adults to some extent, the words and pictures of our favourite books become so tightly interchangeable with our

Toy Town Theatre

perceptions of the real world that the former becomes as much of a truth as the latter, functioning in a reciprocal dynamic that supports the norms that have created it. Patricia Holland usefully defines such norms as:

> Patterns of expectation which sediment into a broader set of public meanings and become an active part of the mapping of social and political worlds, [producing] a set of narratives about childhood which are threaded through different cultural forms, drawing on every possible source to construct stories that become part of cultural competence [so that] these pictures become our pictures, these stories our stories.[27]

Fairy tales, by their very nature, adopt a timeless and moveable quality, the synonymously notable phrase of 'once upon a time' proving testament to their innate historical and geographical vagueness, which is then built on with similarly ambiguous references throughout. Such rootlessness of origin and setting suits the multi-century popularity they have enjoyed, and facilitates the ongoing cultural dissemination of their traditional, normative ideals. They are both appealingly steeped in tradition but somehow endlessly and conveniently applicable to the present day. While Jack Zipes considers such longevity of popularity a result of Perrault's unique style in bringing a modern approach to literature that combined comedy, adventure, romance and morality, such powerful and steadfast acceptance was expedited somewhat further in nineteenth-century France by the accompaniment of illustrations, most prominently those of Gustave Doré.[28] Doré's various engravings and prints produced between 1862 and 1883 to accompany multiple publications of Perrault's beloved 1697 collection of fairy tales *Histoires ou contes du temps passé* ('*Stories or Fairy Tales from Times Past*'), proved a catalyst in the revival that these traditional folktales enjoyed from this period onwards, both in literature as well as in formats as wide-ranging as pantomimes, live action films, musicals and anime. While an innocuous reading of fairy tales might praise their nostalgic escapism as whimsical antidotes to the travails of modernity, and a feminist reading understands them as indicative 'a major crisis of phallotocracy', modern scholarly interpretation seems nonetheless united in its acknowledgement of the fairy tale's significance as an extremely powerful tool of acculturation of some

sort.[29] Not only did illustrations naturally appeal to our human yearning for visual stimulus, especially for children not yet literate, but their accessibility and thus memorability arguably rendered them more effective still, operating as a 'pictorial attempt to buttonhole the viewer ... and trap them within a restricted field of meaning'.[30]

One of the major visual apparatuses by which such singular and readable messages were achieved was the use of *chiaroscuro*. Characterised by the exposure of stark contrast between light and shade in an artwork, Doré's manipulation of *chiaroscuro* can be understood to function, both on literal and metaphorical levels, as a means by which to present the child with a black-and-white world comprising easily identifiable 'rights and wrongs' by which to live. Doré's 1862 illustration for *Le petit chaperon rouge* ('*Little Red Riding Hood*') exemplifies this, depicting a diminutive little girl, glowing bright white with the purity of her innocent goodness, her skirt bathed in the shadow of the wolf, dark in colour and enormous in size by comparison, trapping her between his beastly body and the dense and mysterious darkness of the woods from whence he came. Little Red Riding Hood's restriction in her environment is mirrored by the child viewer. Drawn to the wide-eyed fear of the small child's illuminated face, the child viewer can clearly differentiate between the unsullied purity of her world, representative of 'ours', and the gnarly tangle of opacity that surrounds her, a muddied and unclear world separate and outside of hers and ours; the Other. Such focus on difference is central to both fairy tales and normative concepts of gender. In many ways, fairy tales function on polarity, frequently adopting binary classifications of 'good' versus 'evil' in order to impart simplistic views on far more complex issues, maximising on black-and-white notions of opposition in stories as 'a way to characterise elements in their lives as being either "good" (we) or "evil" (them), as well as trying to justify their actions'.[31] In tandem with an ongoing preoccupation for oversimplifying more multifaceted issues surrounding gender, fairy tales offer an imaginatively appealing and visually captivating means by which to reinforce somewhat arbitrary and otherwise ungrounded 'truths' of society by virtue of their roots in the unquestionable rigidity of tradition.

Concepts of positioning and Otherness in general have proved pivotal to the establishment and bolstering of normative gender roles and difference. It

Toy Town Theatre

was the nineteenth century in particular that witnessed a growing emphasis of sexual dimorphism, an observation that was then worked on and aggrandised by the perception of specific behaviours and habits as accentuating of these stated differences. Modern scholarship has endeavoured to underscore the arbitrariness of such distinctions; while Butler draws attention to the 'anxiety about the truth of gender which seizes on this or that toy, this or that proclivity of dress, the size of the shoulder, the leanness of the body',[32] Mary Holmes goes further, offering an alternative binary of 'big ears' and 'small ears' as an example, for her, as similarly ridiculous and without foundation as our sex-gender standard.[33] Nevertheless, it remains the case that 'it is the meaning of *difference* which is a central feature in the production of any sign system',[34] and that gives rise to a patriarchal positioning that Paechter describes as 'the dualistic division between male as subject and female as negated Other'.[35] This typical elevation of the male and masculine to the detriment of the female and feminine is betrayed by its innate reciprocity. Just like colonial standpoints relied on a relational dynamic of 'we are good, and they are different so they must be bad' that allowed Europeans to be 'civilised' when presented with a world full of the 'uncivilised', sex-gender models are much the same in that 'masculinity' does not exist except in contrast to 'femininity'. In turn, the prevalence of such oppositional theory at this time relies on its period's preoccupation with appearance. While this was rooted in emphasis on sexual dimorphism, it petered out and manifested itself most prominently in a focus on more general physical differences that then contributed to a collection of behaviours and practices born of what is perceived to be a tightly bound sex-gender dynamic. As with other complex issues, emphasis is placed firmly not on what occurs within and can be articulated with varying success, but on what can be seen clearly and thus deemed absolute, allowing these observations to colour understandings of the whole. Accordingly, compounded by the inextricable relational dynamic of gender, an outside-in approach is adopted, allowing normative perceptions of the outermost veneer to soak through to the very core, and never the other way round.

It seems particularly apt, therefore, that such a practice permeated the work of leading Impressionist artists. While this was a movement perhaps most typically characterised by paintings produced *en plein air*, unusual and

Seeking Childhood

non-academic interpretations of the natural world, it was similarly prolific in its creation of domestic and urban scenes, a number of which represent young children. What unified these works lay in their group name, for their rejection of naturalistic and mimetic depictions in favour of imbued perceptions provided for a collection of pictorial *impressions* perhaps surprisingly akin to the preoccupation with the visual that was characteristic of the period in general. It is germane, here, to make clear that in the discussion and analysis of these *impressions* of little boys and girls, of masculinity and femininity as embodied in the toy-child, that I, like feminist art historian Norma Broude, 'use the terms "masculinist" and "feminist" in this context to describe modes of thought that, in the first case derive from, and in the second case respond to, a patriarchal social structure'.[36] In a fashion symbolic of nineteenth-century gender hierarchy, this exploration of visual representations of toy-children shall commence by first looking to the little boy, a cast with all the potential to become the perfect ambassador of manhood and masculinity. Poignantly, despite the establishment of sex-gender distinctions from birth, the subjugation of any child by adults meant that the outstanding advantages of 'maleness' and 'masculinity' were not necessarily immediately bestowed and felt. Not only did fashions of the period mean that boys commonly dressed in styles more broadly associated with girls until the age of around five, offering some suggestion of an age by which gendered considerations on appearance began to take effect in earnest, but young males were at risk of becoming 'feminised' by virtue of their subordinate position before adult male power, and were therefore in danger of forfeiting their claims to 'masculinity'. Accordingly, little boys were operating in yet another field of no-man's land that characterised childhood, for the tightness of the relational dynamic of male and female, masculine and feminine, hinged on a reciprocity that dictated that any Other to the masculine/male must be feminine/female. Such was the haste, therefore, to ensure the efficient insertion of the little boy into his normative masculinist role well in time for adulthood. Beginning from a young age, boys were initiated into the 'valuable masculine world, [from] which … women are excluded' through a careful alignment of the child with his toy ideal.[37]

While dolls in their typical sense are generally associated with little girls, they existed too, although alternatively, in the little boy's toy chest.

Toy Town Theatre

Pierre-August Renoir's 1875 work *Garçon avec un petit soldat* ('*Boy with a Toy Soldier*') demonstrates this. This simple portrait features a young boy dressed in a smart white suit, decorated with blue trim and buttons, his richly dark eyes strikingly illuminated as he gazes out of the frame, bright-eyed and rosy-cheeked, just as he should be. The little boy is gripping a toy soldier, an archetypal signifier of both masculinity and patriotism. Boasting a clear, easily identifiable outfit of red, black, white and gold, the miniature military man stands out as an unmistakable symbol of masculine dominance and patriotic might against an otherwise largely softened painting, the combination of the soldier's red and the little boy's blue and white suggestive of the French *tricolore*. A focus on military roles had plethoric effects; not only did it lend itself well to the regimented process by which little boys were to be transformed into men, but it offered a dualistic dimension to the vision for a modern France, symbolic of both the global prowess for which the nation yearned, as well as the mechanical uniformity to which this increasingly industrial world had become accustomed and against whose standards of efficiency and order it was measured.

It is poignant that the rise of the machine that is synonymous with both burgeoning modernity and the resultant decline of the 'person' is reflected as much in toys as it was in industry on a larger scale: 'the eighteenth and nineteenth centuries mark the heyday of the automaton, just as they mark the mechanisation of labour'.[38] The paradoxical nature of automata is too reflected in its industrial cousins. The design of the automaton as an imitation of the human is a flattering nod to humanity's capacities and functions, yet through both its uncanny mimicry and operative rigidity, it simultaneously renders people obsolete, removing the need for the actual human touch that drives most toys, in much the same way that the industrial revolution's drive for mechanised labour begot mass unemployment. Furthermore, the replacement of man with machine pointed to a wider problem of a neglect of feeling and personhood by which the gendered upbringing of children was constituted. While France's acceleration in the production and marketing of toys in the nineteenth century was purported to be in service of 'the reign of children', during which every frivolity of each prince and princess is dutifully satiated, it was in reality part of a much grander scheme of national elevation against global competition.[39] Pressure from

Seeking Childhood

Japanese technological advancements and the cheap efficiency of German toy production saw France position itself at the very forefront of the quality end of the market, establishing bespoke, independent toy shops, as well as regional toy fairs inspired by the spectacles of the Expositions. In contrast to Émile Zola's judgement of the French toy industry functioning as a means by which 'to conquer the mother by the child', it seems the converse was true.[40] Far more than mere playthings, toys constitute a constant and identifiable part of the material culture and record of society. Instead of knick-knacks of childish whim, toys are artefacts by which we glean an insight into parental behaviours, for they function as 'by-products of parents' attempts to instil values into their children'.[41]

Accordingly, not only did the popularity of automata and similar toys reflect the adult-centricity of the period, but also the enormous appeal of toys that afforded greater control to adults. This was a consumer culture respecting history, innovation and utility, and consequently, adult concepts of what a toy should be, thereby operating as both a self-gratifying celebration of man's industrial achievements, and a particularly effective means by which adult authority over children could be exercised.[42] Such was the worship of artifice and spectacle that consumed adults, and not the fascination with the intrinsic nature of things by which children were enamoured, that attention was 'focused on the instruments or accessories of games much more than on their nature, their character, their laws, the instincts that they involve, the satisfactions that they secure', contributing to a veneer-deep vision of society that perpetuated the toy-child model.[43] The child was restricted by adult design as to the availability of a certain type of toy; namely, a humanoid sort to which the child could be moulded, transformed into the toy soldier, constrained by his mechanisms or the linear woodenness of his polished limbs. Moreover, the inflexible functionality of such a toy contributed to the upbringing of unyielding regimentation to which the child would be subjected: 'there could be no room for alternative forms of play facilitated by the child's imagination ... no other action or output besides that intended by the manufacturer was possible.'[44] Above all, the popularity and success of such a toy rested on its ability to reflect and model the prescribed reality. Such toys were produced in droves, their eventual ubiquity reflecting an obsession in this period with both novelty

Toy Town Theatre

and mechanical innovation. The fetishisation of the toy-child, the aspiration to create the perfect miniature, both inspired and was facilitated by the technological developments of the day. Correspondingly, they were as equal in celebration as they were in responsibility, for this unquenchable desire in the nineteenth century to 'stimulate life by mechanical means' ultimately led to a blurring of the distinctions thereof, producing an unfathomable entanglement of the two, a commonly and positively received conflation of life and machine that gave rise to the popular image and concept of the toy-child.[45]

Jean-Marie Apostolidès has entertained a similar concept, characterising in his 1988 essay the process of upbringing as one that almost forcibly transformed young boys, like puppets, into the toys with which they obediently played: 'this metamorphosis is not a natural one; it is an acknowledgement by society and depends partially on the marionette's will to behave like a "regular little boy"'.[46] In some sort of twisted version of Carlo Collodi's classic tale in which the wooden puppet of Pinocchio dreams of becoming a real boy, the little boy of French society is rendered a peculiar amalgamation of the two, his woodenness and unsteadiness, guided only by the strings of the adult puppeteer, are slowly worked on and eased into the smooth and proper movements of a real little boy, a carefully whittled version of his former self. Apostolidès's specific choice of Pinocchio by which to compare the toy-child is particularly poignant given the character's famous propensity to tell lies; he is, in this way, exposing the falsehood by which these performing puppet children were forced to live. Edouard Manet's work *Le Fifre* ('The Fifer') (1866) offers a product of this marionette-boy transformation, for it is almost as though Renoir's *Garçon* has become a humanoid version of the toy soldier that he is holding. Manet's *Fifre*, this uniformed, regimental flautist, is presented against a plain background whose indistinguishable planes prevent the viewer from making any accurate estimation of his size. This boy, poised to play, has no discernible surroundings in which to situate him, allowing the viewer maximum freedom in anticipating his story and personhood, or lack thereof. The ambiguity of his dimensions contributes to this, offering a figure that is at once a child, a soldier, a puppet and a toy. His small, dimpled hands combined with his soft, ruddy complexion betray his youth as he stands clad in military regalia. Unlike the *impasto* technique

Seeking Childhood

popular with artists of the period, Manet has opted for clear, often rather flat, bold colour, with dark, emphatic outlines, generating a rather decorative quality, his eyes steadfast not with emotive intensity but the vacant glassiness of a polished toy. Add to this the boy's anonymity, and we are presented not with an individual, but with what seems to be a model, a sort of ornamental advertisement for patriotic boyhood. The dark solidity of the torso and waxy, bisque-like pallor of the face and hands, contrasting against the soft drapes of the fulsome trousers combine to suggest a typical marionette with a sturdy core and floppy limbs, the classic image not only of the childish puerility of the enormously popular Guignol show, but also the embodiment of the in-between, a halfway-house between the static doll and the automaton, a Pinocchio-esque half-toy-half-child. In some capacity demonstrative of Susan Stewart's concept of the 'juxtaposition of microcosmic and macrocosmic images' in the world of children and toys, this refers back to the notion of the child functioning as a miniature version in the adult world, and then in turn the toy as a smaller version within the child's.[47] While the adult-centricity of the toy-child existence does not afford the autonomy that Stewart recognises as central to her models of the anterior, interior and exterior worlds of play, it nevertheless points to the complex structure and relationship of 'within within within' characteristic of the toy-child dynamic.[48]

While founded on and constructive of almost identical principles and effects, the specifics of the toy-child model implementation by their very nature were defined by normative gender stipulations. Accordingly, even as toys, females were to be 'the Other for the male Subject', that is to say, exalt and exhibit the sort of passivity, dependency and weakness considered inherently feminine by virtue of its antibook to the unquestionable masculine traits of agency, independence and strength.[49] Unlike the hardy, mobile and purposeful boy toy-child, the little girl would become a delicate and ornamental doll of bisque, porcelain or china, an ideal version of this 'frail and fragile object of wardship'.[50] In his 1884 painting *L'après-midi des enfants à Wargemont* ('*Children's Afternoon at Wargemont*'), Renoir constructs the masculinist voyeur's dream, an idyllic arrangement of three sisters of varying ages, like dolls in a choice of three sizes. Renoir emphasises the peaceful insignificance of these toy-children, these girl-dolls, by camouflaging them in the safe, internal environment of the room. The girl on the left of

the artwork in particular virtually becomes part of the décor and furniture of the room; dressed in shades of blue and white and holding a blue book, she becomes absorbed by the settee on which she is propped, her chambray skirt fanning out into the navy stripes of the upholstery, which in turn blends into the painted woodwork behind her. Like a lampshade or cushion, she has been selected as an accessory to match the room. Far from individuals in their own right, these girl-dolls are a decorative, ornamental feature of a blissful home, a perfect commodity of bourgeois domestic culture. Like a collector's doll too precious and delicate to be played with or taken outdoors, the entire existence of the little girl was not only limited to the familial home but founded on 'a generic cuteness that helps code the entire realm of the domestic as a feminine complement to the masculine world of labour, culture and ownership.'[51]

It is, however, perhaps the youngest sister in the centre of the image who is most significant and who 'gazes aside with a blankness, a reflective shield of prettiness, that makes her appear more an ideal type than a living individual', a child-toy, a girl-doll with mould-cast face carefully painted.[52] In another manifestation of Stewart's notion of the 'real world miniaturised or giganticised', this youngest sister, the smallest of the three dolls, is in fact holding a doll even more diminutive than she, whose general appearance is startlingly similar to her own, and whose similarity of face in particular serves convincingly to conflate the pair.[53] Not only did 'dolls [have] a powerful influence in helping to internalise, on an unprecedented scale, stereotyped role models', but they became synonymous with the child herself, whereby no discernible distinction, neither in visual nor material culture, could be made between the two.[54] In this way, Renoir's painting may be understood as if one were looking into a doll's house, a giant's eye-view through the pane of a tiny window into the perfect idyll of the miniature. Drawing on the literature of Henrik Ibsen, Stewart has studied in length the popular motif of nostalgia that dominates adult preoccupation with doll's houses, contributing to the theme of adult-centricity which pervades this chapter, and indeed this book, with such a notion of the adult surveillance and control and even destruction of the child's world giving rise again to the image of the 'dollhouse … consumed by the eye' of the giant.[55] While Stewart's argument explores the significance of the doll's house in perceptions of inner and outer spheres

of experience, a concept unpacked in the following chapter, it is pertinent too to acknowledge that if the toy world indeed reflects that of everyday life, the static ornament of the doll's house, a toy so often accompanied by exclamations of 'be careful!' and 'don't touch that!', serves to represent not only the miniaturised novelty of the toy-child world, but also one that, like real life, is completely under adult design and control.

This steadfast conflation of real and model, original and miniature, child and toy, resulted in the amplification around lifelike toys of Freud's concept of the 'uncanny', hinging on the crux that 'the uncanny is that species of the frightening that goes back to what was once well known and had long been familiar', which when encountered on some sort of revelatory return, has since being subtly warped.[56] Being that 'its otherness was once sameness, its strangeness disguising its primordial familiarity', the uncanny relies on a return to the familiar, a familiar that has been inexplicably distorted.[57] Like the toy-child who is remarkably human yet also strikingly toy-like, this eerie loitering of the familiar was exemplified by Freud's exploration of Jentschian uncanny, the concept of 'doubt as to whether an apparently animate object is alive and, conversely, whether a lifeless object might not perhaps be animate' through E. T. A. Hoffmann's 1817 text *Der Sandmann* ('*The Sandman*'), and in particular, the figure of the apparently animate doll, Olimpia, who in turn gives rise to a most profound girl-doll motif in this period.[58]

It is during this period that French toy manufacturer *Jumeau* was at its height of success with its eponymous bisque doll, having begun production in the early 1840s and enjoyed its heyday between the 1870s and 1890s. This perfect miniature, costumed to match the most fashionable Parisian ladies, became the perfect model of the female toy-child. Immaculately coiffed, stylishly adorned, with bright, unflinching eyes, soothing mutism and reassuring stillness, the early *Jumeau* doll was 'as placid and perfect as the parent wished the child to be'.[59] Similarly, the porcelain complexion, delicate rosy cheeks and alert glassy eyes of Renoir's infant models, combined with their lifeless, ornamental positioning in the home, their static embodiment of the 'prevalence of the doll type as a visual standard of children shows that children – girls especially – were being commodified as an essential element of bourgeois spectacle'.[60] This was enhanced by the connotations carried by the *Jumeau* name, which, translating from French to mean 'twin',

suggested not only the degree of imitation between the doll and the child, but a strong sense of novelty that not only appealed to a commercial buyer, but also to adults with the propensity to view and treat their children as miniature collectables.

Renoir's 1881 painting *Pink and Blue*, a portrait of Alice and Elisabeth, the daughters of Jewish French banker Louis Raphaël Cahen d'Anvers, depicts such connotations. While the unique *Jumeau* design made it possible for the doll to be freestanding, it was an unnaturalistic posture, much like the awkward and stiff positioning of the Cahen d'Anvers sisters, as if balanced according to their peculiar weighting, the unyielding moulding of their hands locked together to bind the doll girls in place, their heads turned on an unnatural angle, their eyes fixed yet unfocused. Although not twins, the resemblance between the two girls is palpable, and emphasised by their complimentary outfits. Like a pair of little *Jumeau* dolls, the sisters are presented to the spectator in matching outfits, differentiated only by the pink or blue embellishments, as if to offer the consumer a choice of colour, or indeed the complete set of two: 'a kind of fetish-like luxury item ... these children are like commodities on a store shelf, the shiniest of many luxury goods.'[61] Like on a swatch of different colour ways, or a display of various size options, these sisters are presented as if from the very same mould, their core identically formed and vacuous, their glazed faces from the very same paint pot, the twin-set a veritable collector's item. Their duplicative form betrayed their falseness, for in this way they bore little resemblance to real people, and instead reflect the idealised child of French bourgeois culture. Accordingly, no allowance was made for the potential for peculiarities of inner workings, so to speak, for just as the 'female body [was] physically constrained, moulded and shaped into forms considered appropriately feminine'[62] this girl-doll was herself similarly contrived, for with 'concentration on a purely superficial effect ... the French child was herself something of a curiosity', not least by virtue of her complex conflation with the likes of the *Jumeau* doll model.[63] This conflation and confusion was magnified as a result of the ongoing developments in toy production afforded to *Jumeau*'s constant torrent of new styles and versions of doll from the 1870s onwards. Technological developments were particularly prominent, with their moving eyes and surprisingly effective speaking mechanism offering what was sometimes an

alarming affinity to the living. Such was the apparent authenticity of the *Jumeau* doll towards which the little girl strived, ironically moulding herself to the perceived perfect form of a figure celebrated for its own comparability to human life, that the child often became 'convinced that her dolls were bound to come to life if she looked at them in a certain way, as intently as possible'; like a pair of inseparable sisters of friends, they had become one and the same.[64]

This was augmented both in realism and eeriness with the introduction of the *Jumeau Triste*, whose 'hauntingly mysterious face' offered a pretence of emotion darkly suggestive of the melancholy child trapped within the pristine shell of the doll they have been forced to become.[65] This particular doll's popularity is perhaps testament to the ubiquitous acceptance of the toy-child conflation. Treasured by customers and collectors alike for its perceived aesthetic delicacy and naturalistic beauty, there was no regard for the forlornness and sorrow that its expression suggests lies within. While poet Rainer Maria Rilke has commented on the profound anxiety suffered by the child who encounters with much confusion the 'terrible unresponsiveness of the child's doll to the efforts its owner makes', this can instead be contested as indicative of the toy-child's own deep-rooted agency and feeling, as evidence of the unhappy child within whose transformation and encasement in impossibly unfaltering polished bisque remains a person not always eager to play along.[66]

This marks a return again, like the uncanny, to the 'twin' symbolism of the *Jumeau* terminology; namely, in its connection to Freud's idea of the 'double'.[67] This concept of doubling points to the power of conflation central to the toy-child concept; such is the extent to which these boy-marionettes and girl-dolls are both child and toy, they become one and the same. The bright shininess of the toy-child exterior hides a darkness within. Beneath the magnificently humanoid exterior of the talking *Jumeau Bébé Phonographe* lies a troublingly cold and robotic mechanism where her heart should be, a perfectly rectangular doorway into a mysteriously dark orifice of artifice. Similarly, in place of the toy-child's colourful mind lies a soulless vacuity housing only a large, central stringing coil, which, symbolic of the strain to conform under which the performing toy-child is placed, holds in place 'a series of hooks and springs that put the figure under continual pressure'.[68]

Not only did this creation and maintenance of the toy-child, in concept, image and reality, produce a soulless being ridded of personhood, a figure existing as a mere shadow of its former self, but it also served to augment a sort of pseudo-reality in which reality and fiction, truth and fallacy, can no longer be clearly distinguished.

The combination of the uncanny repetition and difference of a warped reality alongside the intermingling of the human with the otherworldly establishes a profound sense of doubt and ambiguity that can be found mirrored in and buttressed by the bones of Freud's own work on the subject: 'There's an uncertainty about the very form of the essay itself ... it is a strange amalgam of different genres. It cannot quite make up its mind what it is.'[69] Just as Hoffmann's *Sandman* creeps into bedrooms and steals the eyes of watchful children, the depth of confusion born of the toy-child conflation rids the child of 'normal vision' and replaces it instead with an unfathomable pseudo-reality: 'such liability between fantasy and reality [that] fantasy has invaded reality'.[70] While this is a notion at the very heart of the theory of the uncanny, it extends beyond those parameters and into the realm of imagination and perception in the world of child's play. Ironically therefore, it is through the most profound efforts of acculturation and enforcement of normative gender roles that adults have, not without first debasing the child's very soul, unknowingly exposed him or her to a new and transformational site of experience. The adult has unwittingly facilitated their own usurpation, releasing the child into a field of experimentation previously untrammelled, in which they will find the means to an autonomy never before grasped.

Scaffolded throughout by key sociological theory and through the lens of the ongoing metaphor of the toy-child conflation, this chapter has accounted for the ways in which the intertwined use of literary and material culture allowed for the harnessing and control of children by the powerful with a view to reinforcing established cultural and social norms as a stabilising influence in the turbulent French long nineteenth century. Through the use of carefully contrived transmitters of culture and mainstays of nineteenth-century child-rearing, fairy tales and toys, patriarchal systems based on oppositional theory are instilled into children from birth, ensuring that they perform their assigned, gendered role, giving way to the idea of conformity, mimicry and puppetry. From this, the image of the

Seeking Childhood

toy-child emerges, a metaphor variously reflective of the child's position and role as a miniature apprentice woman or man, passive actor, both Self and Other, and fashionable adornment encapsulating the ideals of the epoch. This chapter has illustrated how the pervasiveness of such a notion is not only demonstrated through its reflection in Impressionist artworks but is emblemised by the popularity of the *Jumeau* doll. This object's lacquered shell becomes the uncanny embodiment of the 'perfect child', with all the outward appearance of idealist conformity without the inner personhood to deviate. As such, this chapter exemplifies how the toy-child image not only represents another example of the ways in which children and the liminality of their condition are moulded by society, intellectuals and cultural practitioners, but elucidates the detrimental impacts of such practices on the child. Moving forward, the following chapter seeks to unearth the child's subversion of this control. Like a spring wound so tightly that it bursts from its form, the following chapter considers how restrictive toy-making, both literally and metaphorically, led to a most revelatory rebellion in the world of play, charting the beginning of the child's cultural emancipation in the early twentieth century.

Breaking the Mould: Burgeoning Cultural Emancipation of the Child, c.1880–1920

Shadows ... show us a world more real than reality itself.

Jules Lemaître[1]

'Real isn't how you are made,' said the Skin Horse. 'It's a thing that happens to you. When a child loves you for a long, long time, not just to play with, but REALLY loves you, then you become Real.'

Margery Williams, *The Velveteen Rabbit*[2]

This book thus far has constituted a multifarious exploration of what can be learned from the visual and literary culture of the period about transforming perceptions of children and childhood in France during the long nineteenth century. Specific time periods have ranged from the initial Enlightenment-Romanticism crossover in the late eighteenth century and France's wrestling with Republicanism in the early decades of the nineteenth century, to the rapid onset of modernity in the century's latter decades and the *fin-de-siècle* pessimism to which it gave birth. Case studies and topics of consideration have been similarly diverse, including child-rearing, education

Chapter 6

and pedagogy, family roles and structures, impacts of colonialism, issues of class, poverty and wealth, and material culture, as well as the interactions thereof with intellectual, cultural and creative output across the period. Despite this variety, a clear pattern by which perceptions and representations of children and childhood in this period can be characterised has been established, running like a single golden thread through each of its pages.

It has become evident that as complexly representative of both Self and Other, intellectual, creative and cultural manifestations of the child and its condition are ones facilitated by its inequivalence to the powerful. Through a quality of obscurity perceived to be inherent to the child, a concept born out of paradoxical yet highly prominent Rousseauian theory, the apparent acquiescence and pliability of children and their condition gave rise to their exploitation for various social, political, cultural, creative and personal aims. Evidenced by the wide range of themes and case studies explored, this harnessing of the child and its condition is something that was carried out variously according to the needs and wants of individuals and circumstances. However, crucially, it is always founded on and enabled by a reinforcement of the child's perceived liminality and thus the inequivalence and adaptability of its condition.

In much the same way that the persistence of anything arguably extreme can often result in oppositional resistance, such as the previously explored Romantic reaction to the Enlightenment and Realist response to Romanticism, it is unsurprising that the oppressive exploitation of children led to their subversion. This rebellion has manifested itself diversely, such is the variety of the harnessing of the child and its condition. However, this sense of *fin-de-siècle* autonomy brewing within the child to which the closing sentiments of the previous chapter alluded, arguably arose initially, as indicated by Chapter 5's themes, within the realm of play. As an arena that could be reclaimed by children and childhood, play offers an insight into the ways in which the child's reaction against normative socialisation, control and exploitation found expression in the modern era.

As such, this final chapter constitutes an exploration of what might be understood as a gradual but more pronounced emancipation of the child culturally, socially and psychologically from the confines of adult structures, which began to be reflected intellectually and creatively around the turn

of the twentieth century. Crucially, this is a process that sprouts in the first instance from the experience of play as a key arena of possible autonomy for children. This is not to say that play did not present for children in previous decades and centuries a territory of freedom, but rather that a burgeoning awareness and reflection of such in intellectual, creative and cultural output did not surface so prominently until the modernist era. As will be explored, this awareness compounds the issue further, as it gave rise to renewed interest in the perceived qualities of unfettered imagination and creative wisdom within the child to be harnessed as a blueprint for modernist creative practice.

In investigation of these themes and issues, this chapter will begin with a brief exploration of feminism in both political and artistic circles in late nineteenth-century France, specifically considering Berthe Morisot and Mary Cassatt. This will focus on their role in arguably laying the conceptual groundwork for greater receptiveness to change in established, largely patriarchal, norms. As explored in the previous chapter, this is significant to the study of children and childhood chiefly because of the patriarchal foundations to which highly gendered upbringings of children were fixed. Thus, not only does it play a key role in the nature of the oppression experienced by children and therefore the means by which children subvert this, but its significance is buttressed by a sense of allyship that often forms in female cultural practitioners who empathise with the oppression of the child. Moreover, the emerging traction gained by feminist thought towards the end of the nineteenth century can be considered central to a growing appetite for subversion against traditional strictures that had previously been for so long followed dogmatically. Leading on from this exploration, the bulk of the chapter then concentrates on the significance of play as a space and practice for independent experimentation and self-expression; in other words, it becomes a place where children can be their own Self without the danger of this condition or that of their perceived Otherness becoming exploited. Considering the messages of *The Velveteen Rabbit* as a poignant literary reflection on both play and modernity, this analysis considers the notion of 'toyless' play and the rejection of inauthentic, regimented games and modern, purpose-made objects as a practice affording the most freedom. This then culminates in an exploration of shadow play as the ultimate

example of such authentic play. The study into shadow play is not only significant because of its ubiquity across cultures, genders and classes both during the period of study as well as before and after, but also because of its connection around the turn of the twentieth century with the shifting symbolism and significance of the shadow in artistic circles. Accordingly, by considering the work of key Symbolist artists such as Pierre Bonnard, Maurice Denis and Félix Vallotton, this chapter explores the significance of the shadow as emblematic of both personhood and ephemerality, such were the concerns prominent in the collective conscience at this time. It is from this notion, operating through the cohesive case study of J. M. Barrie's *Peter Pan*, that the chapter explores the connection between the troubled fixation among modernist intellectuals and cultural practitioners with the ephemerality of life in the modern world, and their own preoccupation with what the perceived condition of childhood has to offer as an antidote to such anxieties. Indeed, for as both Self and Other, the child is both a reminder of the transience of one's youth and life more generally, as well as a pointer of that which is yet to come and is unfamiliar, whose futurity carries the promise of hope and rejuvenation.

As previously indicated, the environment in which the burgeoning autonomy of the child in the latter decades of the nineteenth century made tracks can be traced in part to the impact of early feminist discourse and creative output in France. As 'for the most part of history, the bourgeois has definitely been a "he"', it was unlikely to experience a decisive revolution in this regard, but tentative steps in society nevertheless initiated ripples in cultural circles.[3] Feminism in France in the late nineteenth century was generally more muted than that of Britain and America, for example, and focused chiefly on legislative reform, as opposed to suffrage. Campaigners of a principally bourgeois or republican background, such as Léon Richer and Maria Deraismes, worked in the 1880s to ally and regrettably sometimes subordinate feminism to the endurance of the fledgling Third Republic by rendering it a more respectable political concept and position.[4] Despite the efforts of more radical feminists, such as Hubertine Auclert, who campaigned tirelessly for the vote for women from 1879 onwards, feminism in France was limited and to a certain extent characterised by the popular school of thought of the period. Fed in part by the misogynist writings of anarchist politician Pierre-Joseph Proudhon

and historian Jules Michelet, it was generally accepted that the maintenance of the familial role and status of women in France by limiting their options and rights was integral to the moral and material renaissance on which the preserving of the patriarchal family of France depended.

Nevertheless, inspired by and in reaction to this was the artistic production of figures such as Berthe Morisot and Mary Cassatt, who, creating artwork that was as much Realist as it was Impressionist, endeavoured to show life as it was, without artifice and without inviting sympathy or promulgating moral instruction. In contrast to the majority of their male counterparts, Morisot and Cassatt gave agency instead of fallacy to previously null and void subjects. Chiefly, this consisted of subverting inauthentic or stereotypical images of femininity and, perhaps through a sense of allyship carved out in their shared oppression, childhood. Tackling a conventional image in a new way, they composed work in which the children that they depicted are human as opposed to idealised, emanating a beauty only of reality. Hailed by Griselda Pollock as one of the most radical images of childhood of its period, Cassatt's 1878 painting *Petite fille dans un fauteuil bleu* ('*Little Girl in a Blue Armchair*') exemplifies this potential shift in depictions of childhood.[5] The composition features a little girl slumped, neglectful of the deportment expected of her, in a bright blue armchair, open-legged before the viewer, with one arm leisurely laid on the armrest and the other placed behind her drooped head. Her facial expression is one of bored disgruntlement, and suggestive of the maddening unfairness of simultaneously being controlled and ignored by adults, 'the flopping immaturity of her body, and her wilful, boyish pout' capture a sense of huffing and puffing, a brewing or thrown tantrum by a child who has flung herself down in protest to the imprisonment to which she is subject by the social constraints of the world of grown-ups; for her, 'the enactment of class and gender seems a burden that she bears reluctantly'.[6] Interpretations of this painting are plentiful, such is its renown in the realms of not only early feminist artwork and historical markers of cultural production, but also in modern and changing concepts and conceptions of childhood and children. It is known, for example, that Edgar Degas influenced this artwork (he and Cassatt were good friends), evident in its asymmetrical composition and cropped pictorial space akin to the Japanese prints to which he had introduced Cassatt. Pollock, however,

chose instead to focus on the low perspectival construction of the image as evidence of Cassatt and Morisot's subversion of the sexualised male bourgeois gaze by depicting alternative examples of feminine identity.[7] Although some readings of the portrayal of a sulky, arguably naughty little girl, with parted legs almost at the viewer's eye level, might offer suggestions of a sort of masculinist hypersexualisation of a prepubescent child typical of patriarchal concepts, Harriet Chessman argued instead that Cassatt's use of the child's body functions as a way of actually encoding and concealing female sexuality.[8]

While Cassatt herself declared that 'women should be "someone", not "something"', this can be equally applied to the position and role of the child given the parallels in inequivalence to the powerful.[9] In contrast to the fashion for tailoring the child from the outside inwards, allowing the careful indentations of the delicately moulded shell to press into the soulless vacuity of its interior, Cassatt's blue-armchair girl bears an exterior shaped by the multiformity of within. She is from the inside outwards an embodiment of her personhood, not her mould, and thus in possession of the depth of which her toy-child counterparts are bereft. In this way, Cassatt was one of the few artists ever to 'invest children with the full range and depth of human character'.[10] However, to elevate the position of the child most effectively, not only did efforts need to move beyond those just concerned with debunking long-standing gender myths, but crucially, they needed to come from the children themselves. While the likes of Cassatt and Morisot sought to remove the veil of distortion draped over concepts and depictions of women and children, their works and thus depictions of children and childhood remain imbued with feminist agency. Moreover, even without such a gendered focus, their images are nevertheless those of adult concoction.

Acknowledging the key connection on which later sections of this chapter with focus, key individuals such as André Gide commented on the deep relationship between play and art,[11] alluding perhaps to Baudelaire's account of the child's initiation to art through toys.[12] However, this only gathers true meaning and impetus when the child is able to effect this relationship and experience on their own terms and under their own steam. In other words, while toys often served as a means by which adults could exert further control and influence over children, as the previous chapter explored, this could

be subverted on many levels through the child's rejection of mainstream toys and their functions in favour of a more imaginative and freer approach to play.

For many scholars of child psychology, play is not only a basic constituent of the child's life, but it occupies a significant position in the developing psyche of the child. Moreover, Melanie Klein has acknowledged the cathartic qualities of such a practice, during which anxieties and misapprehensions are resolved by transforming passively undergone experiences into active performances that facilitate a mastery of fears and dangers.[13] Consequently, it is unsurprising that 'play and experiment can be intimately connected', for the former becomes a practice in the latter as a child develops an understanding of the surrounding world, on both smaller and more expansive scales.[14] As referred to in the previous chapter, play offers the child the opportunity to experience relationships and occurrences akin to those encountered in the adult world, and by presenting this within the miniature realm of play, in the shrunken yet seemingly whole environment of the bedroom or nursery, the child is able to gain an impression of mastery over their world, a world that is now subjected to their will and control, living and reliving experiences within more comfortable boundaries. As such, academics have increasingly viewed toys, both 'official' and 'unofficial', as not only cultural markers, providing something of a guide to the nature and character of a nation, but also as an outgrowth of childhoods gone by and thus a means of studying children's mental worlds.[15]

This crossover between fantasy and reality, imagination and experience, as facilitated by play, is joined by the apparent juxtaposition of the very natural, timeless and innate practice of play with the modern artificiality of technological invention. While the connection between invention and toys, and therefore children, is palpable and well-traversed, children themselves have contributed considerably to the transpiration of other technological inventions and developments. The tendency within the child to experiment, to *toy* with that beyond the adult-prescribed novelty, and to allow this experience to become imbued with a whimsical freedom that evades the procedural empiricism of adults, exposed them to discoveries hidden to blinkered adults. An example of evidence of 'the influence of childhood experiences on the great discoveries of man' can be found in the story of

optician Jacob Metius, whose young son's habitual playing with all sorts of different types of glass, observing the ways in which one's view was warped and distorted by the various thicknesses and shapes, led to the eventual discovery of the telescope in 1608, a tool that has since not only expanded the astronomer's field immeasurably, but also opened up the world of space to the masses.[16] This therefore invites exploration when we consider how a discarded piece of bric-a-brac or some bauble drawn from the dark and dusty confines of the toy box is saturated and transformed by the imagination and investment of the child. While adults 'nevertheless displace their own childishness onto their children, manufacturing toys as much to serve their own needs as those of their offspring', as the previous chapter discovered, this became increasingly overturned by the propensity of the child to seek alternatives, not only endeavouring to manipulate adult-designed toys beyond their intended purposes, but producing their own playtime creations, composed of material or imagination, or some magical combination thereof.[17]

This capacity and propensity of the child to practise 'toyless' play, to fashion their own world in which imagination overrules adult-prescribed regimentation facilitates a precious sort of freedom for the child. Comparable symbolically and conceptually to 'the emancipation of the doll, too long restricted by horrible limbs', the static and rigid doll by which play and indeed the child was characterised was disintegrating.[18] Furthermore, and not dissimilar to the effects of Marcel Proust's magic lantern as discussed in Chapter 4, the free sinuosity of imaginative and 'toyless' play exposes a whole new world of sensory and material experience, for as the child 'challenges norms … the kaleidoscope patterns all around him start to shift'.[19] The mysteriousness by which this is all characterised is symptomatic of and contributory towards the equivocality, freedom and secretiveness at the heart of the child's unique concept of and attitude towards toys and play, for 'this rather dark apprehension of the origins of toys and of their fundamental ambiguity [means] toys elude any precise positioning in terms of our inner and outer worlds'.[20] The fluidity by which the child's understanding of toys is characterised is matched by that of the nature of their world of play. Private and magical, an unyielding flux between inner and outer worlds, a complex amalgamation of experience, perception and imagination, the world of play

for the child is akin to the dark, cellular privacy of the toy chest, an enclave in which both joy and uncertainty reside, but crucially, an environment in which the child possesses the freedom to operate on their own terms. It is perhaps unsurprising, then, that children more often favour toys, or peculiar and unofficial manifestations thereof, of a basic and malleable nature, than those of adult design. While it is often true that 'in a toy store, a child can find a miniature of life far more colourful, cleaner and shinier than real life', such a vivid glow is potentially far more pronounced when it is born of the limitless folds of imagination.[21]

While Chapter 4, for example, addressed the powerful capacity of imagination to reshape memories, its instrumentality in the here and now proves just as significant, and especially in the realm of play, in which the child sets about forging a personal, magical inner world in which no outer laws hold sway. In this secret society of whispered conversations and elaborate scenarios, there is unsurprisingly no place for the rigid superficiality of the modern, mechanical toy. Not only does the mechanical toy, unlike that fuelled by imagination, rely on the hardihood of solid form by which to render itself 'truth', but by its very nature, it fails to return the feeling advanced by the child. In contrast to the apparent 'living' personality of the toy or plaything imagined or invested in by the child, the mechanical or modern toy fails to match its physical tangibility with an emotional or spiritual equivalent, for it 'threatens an infinite pleasure: it does not tire or feel, it simply works or doesn't work'.[22]

Such frustration is exacerbated by the arrogance and ignorance that adults often present in the creation of such soulless toys, and is in turn parodied in sections of Margery Williams's famous children's book *The Velveteen Rabbit* (1922). Suggestive of the despondence of the child when faced with the dogmatism of the adult, this seminal text describes how 'the mechanical toys were very superior, and looked down upon everyone else; they were full of modern ideas, and pretended they were real'.[23] Like the child who becomes the giant at play, the master of his microsphere of toys, the world in miniature, Williams harnesses the *mise en abyme* of the toy world. This is achieved by mirroring the perceived inadequacies of the poor, basic or antiquated in the eyes of the self-aggrandising, modern bourgeoisie through the relationships between the traditional, old and well-loved toys, and the

brand-new technological ones. Significantly, the moral of the story lies in the rejection of such modern fallacy, for as the Skin Horse elucidates to the Velveteen Rabbit, it is only the love and affection of a child that reveals the pathway to becoming 'Real'. Indeed, for while the most impressive toys can never compete with life itself, this is in turn dwarfed by the extraordinary capacity of the child to effectively create and instil life of its own accord and merely by virtue of their powerful imagination, for 'when make-believe fails, the vitality of toys vanishes'.[24]

As already intimated, alongside investing simple and often seemingly tired toys with affection and imagination, children also excel in their ability to, as Baudelaire marvelled, 'play without playthings'.[25] Marina Warner has discussed at length the child's capacity to collate trinkets and inanimate knickknacks, to enliven with imagination, to form landscapes and stories of technicolour fantasy.[26] Perhaps even more significant is the intimacy that characterises the relationships that children forge with toys or indeed apparently random objects:

> The most useful doll I ever saw was a large cucumber in the hands of a little Amazonian-Indian girl; she nursed it and washed it and rocked it to sleep in a hammock, and talked to it all day long – there was no part in life which the cucumber did not play.[27]

Not only does this buttress the notion that a 'primitive plaything can turn into a thing of beauty', with the semantic connotations of colonial misperceptions and ignorance here reminiscent of adult obtuseness when faced with the wisdom of the child, but it points to the significance of D. W. Winnicott's concept of the transitional object.[28] This first 'not me' possession of the child's creation helps ease the transition from attachment to coexistence with the mother, and is thus often a source of pacification during bouts of anxiety and loneliness. As such, it need not be a most shiny product of adult conception, and instead often takes form of a most rudimentary plaything with which the child is most familiar. Add to this the affection and depth of imagination invested into toys and play by children, and it is easy to anticipate how such an object or plaything becomes a most special friend, a seemingly living entity within this secret and magical world. Bernd Brunner cites, for

example, the baby-like appearance of teddy bears as a significant draw in appeal for the enamoured adult buyer, detailing that the generalised image of a 'diminutive, toothless bear with a snub nose, fat cheeks ... and a cuddly body ... possesses all the traits that awaken sympathy in humans' and motivate their purchase.[29] But it is reasonable also to propose that this physical similarity enhances the strong sense of kinship between a child and their bear, this comforting shape of squidgy softness becoming far more than its fabric and stuffing might at first suggest.

This sense of underestimation of the toy or plaything, especially when subject to the emotional and imaginative investment of the child, is reflective of the much larger issues of the widespread misplaced scepticism that characterises adult understandings of children and the reality of their heightened perception, ingenuity and vision. Winnicott has detailed the emotional and developmental damage that adults can inflict on children, when, 'requiring your child to be grown-up whilst still a child', they do not play along in seeing and acknowledging the creatures and friends of their child's imaginative meanderings.[30] Moreover, there is something to be said for significance of the role undertaken by the child, often facilitated through play practice, in opening the collective mind to less rigid ways of thinking. Contrary to the blinkered dogmatism and selfishness typical of the adult-centricity of society, the child has a capacity and propensity to engage with a far broader spectrum of notions and reject long-standing obstinacy. While it has been established that children take a far more fluid approach to toys than adults, this is poignantly indicative of the flux-like cursiveness of their outlook in general, and thus their innate sense of mindfulness and its contribution to a shift at the turn of the twentieth century towards exploratory free-thinking and a more independent yet cohesive outlook on relationships and experience.

The expression of free thought and imagination among children in the realm of play is perhaps best represented by shadow play. Contextually, shadow puppet shows, often known as 'Chinese shadows' by virtue of their Tang Dynasty origins, enjoyed widespread popularity in France throughout the eighteenth and nineteenth centuries. This was in thanks not least to individuals such as François Dominique Séraphin, Félicien Trewey and Henri Rivière, the latter of whom created a genre of shadow theatre at the famous

Montmartre cabaret bar Le Chat Noir. Collaborating with various artists and writers, developing both aesthetic and technical innovations, Rivière helped to influence the art and production of future theatricals, especially phantasmagoria, for years to come.[31] Shadowgraphy, or *ombremanie*, as it was known in France, worked best with the concentrated brightness of candlelight, and so the prevalence of electric light towards the end of the nineteenth century caused the art form's popularity on a public scale to dwindle dramatically in favour of new favourites such as cinema. However, no such waning of favour occurred in the home, not least because candles and other similar forms of lamplight remained commonplace in households for years to come. Moreover, miniaturised, simplified domestic versions of the shadowgraphic spectacle were easily rendered with aids such as cardboard cut-out versions of Séraphin's shows made available for purchase to compliment children's makeshift theatres, as well as Trewey's 1919 illustrated book of hand shadow instruction, *The Art of Shadowgraphy: How It Is Done*.[32]

More significant still is the general ease by which any child could partake in such a game. Unlike gendered toys of adult design, shadow puppets are by and for everyone, unlimited by gender, class and other oppressive constraints. Moreover, their innate malleability affords a greater freedom of both interpretation and creation; uninhibited by the rigidity of form and function instilled within the modern, manufactured toy, shadow puppets and shadow play bestow seemingly unlimited options on the child, allowing them to create shapes and characters of their own invention, inflating them with personalities and stories contrived of their own unrestrained imagination. This points to the propensity among children in general to operate in far freer a sphere of imagination, experience and cognisance, compared with that of adults. Far from the black-and-white concept of the world typically held by adults, both that of play and in general, the child's understanding falls in among the shadowy grey in between, where previously distinct and demarcated notions begin to morph and blend, creating an obscure melange resistant to the intransigence of adult ideals, and akin to both the undulating changeability and wispy effervescence of the elusive shadow we find lurking in and among the polar planes of black and white.

This connection between the imaginative, expressive and liberating world of child's play and the symbolism of the shadow can be explored further

by looking to the shifting role of the shadow in art in this period. There is something to be said here for a correlation between the autonomy that freer forms of play, such as shadow play, afforded the child and an increasing cultural and intellectual awareness thereof around the turn of the century, and the new sense of agency with which the shadow was endowed as an artistic metaphor of the *fin-de-siècle avant-garde*. Moreover, such is the association of the child and its condition with both Self and Other, at once an embodiment of the ephemerality of youth and life as well as the promise of antidotal futurity, the significance of the child's relationship with the shadow is buttressed by the latter's additional association with transience in artistic circles. The following analyses will elucidate these complex but revelatory connections.

The changing role and view of the shadow as a symbolic and powerful entity at this time, in this way metaphorical of the burgeoning emergence of childhood autonomy, can be charted by looking to its new position in art towards the end of the nineteenth century. While solid black silhouettes had become stylistically popular in decorative art and poster design, as well as in miniature profile portraits both in Europe and Asia, their aesthetic appeal began to extend much further. Far from functioning, as it did traditionally, as a sort of supplementary *trompe l'oeil*, the shadow and silhouette were, by the late nineteenth century in France especially, establishing themselves as powerful and metaphorical artistic entities in their own right. Although varying in its specifics, much of the sense of agency now afforded to shadows and silhouettes was founded on a somewhat mythological belief that shadows are 'the souls, life essence, or strength of the individual' that was receiving renewed support from *avant-garde* groups.[33]

It was arguably the Symbolist movement that spearheaded this concept most enthusiastically, emphasising the equation of the shadow with the inner self as opposed to external descriptors, aligning it with the Mallarméan inclination among many late nineteenth-century artists to suggest rather than to describe.[34] Symbolist artists, and the many other members of the *avant-garde* of nineteenth-century France for whom they provided copious inspiration, considered the shadow and silhouette in their minimal and unmodulated forms as pictorial elements more powerful than their embellished counterparts. For these artists, by dispensing with unnecessary

Seeking Childhood

detail, one is more able to effectively capture and appreciate the intrinsic nature of things. French writer Édouard Dujardin cited the silhouette for the Symbolists as helping to 'give the sensation of things', emphasising the new preference for feeling over the physical.[35] This not only supported the notion that the new value afforded to the shadow implied the new focus on imparting the truth behind appearances, but also that the thematisation of the shadow in the art of this period partook in a greater propensity to explore and champion the less material aspects of existence.

Accordingly, the shadow and silhouette began to be recognised as an entirely separate entity to the subject to which it was previously considered as belonging, offering instead far more in-depth and emotional a message than outward aesthetics could hope to. By relinquishing the fallacy of external artifice, the shadow represented the most essential substance of deeper truth. These connotations reinforce the connection with the child and its condition. First, there is a correlation between the idea of the shadow as establishing itself as independent from the subject it was previously attached and the notion of the child's emancipation from the normative social and cultural structures and patterns that have contained them and ensured their secondary status and persistent inequivalence to the powerful. Second, parallels can be drawn between the shadow's rejection of fallacy and outward appearance in favour of inner truths, and the natural opposition represented by the child and its condition to society's preoccupation with pretence.

To further the appreciation of the stylistic and symbolic role of the silhouette and shadow in French art at this time and thus its relationship with the condition of the child, we must look to the work of the *avant-garde*. Félix Vallotton's work, for example, often depicts the relationship between the shadow and play. His 1899 painting *Le Ballon* ('*The Ball*') depicts a sort of aerial view of a middle-class park scene comprising roughly two halves: the green foliage of the background featuring two adults in the distance, and a little girl running about on the dirt or gravel of the foreground, playing with her bright red ball. This image of the child at play can be understood on face value as a rare example of a child freely being a child; uninhibited, she is racing about in the fresh air, at liberty to play with a relatively rudimentary toy of her choosing. A more symbolic reading looks to the diagonal splitting

of the frame and perspectival distortion that points to the stylistic features of the Japanese woodblock prints that would prove so influential to Symbolism. Moreover, the curving slant of the scene suggests something of an ongoing movement or shift akin to that innate to the constantly undulating world of the child at play. Furthermore, the work is dominated by shadow, both that which spreads across the ground as if playfully to chase the little girl, and the billowing shapes of the bushes and trees that seem to tumble like clouds of smoke and shadow on top of the landscape. In turn, Vallotton's *La Lingère, Chambre Bleue* (*'The Laundress, Blue Room'*) (1900) situates the three elements of children, play and the shadow in an interior setting. In a blue-coloured bedroom are seated two laundresses busy at work, the foremost of which has become little more than a silhouette in profile as she works in the dim light mending a section of sheet. The fabric of this enormous expanse of sheet concertinas from her lap onto the floor, spreading in its crumpled and billowed form across the majority of the room where two children find themselves huddled in its folds. Their little den among the cavernous, shadowy creases of this 'tabernacle of old sheets', reminiscent of that haven in which Proust's seclusion and creativity resided and churned, is exactly the seemingly ordinary environment in which the imagination of the child thrives during play, their unrestrained minds swirling and undulating like the shadows that characterise their dusky and secretive setting.[36]

However, it is perhaps the case that more pervasive among the *avant-garde* and their interest in the image of the child, the shadow and related metaphors, was a propensity to adopt, in line with their fancy for suggestion, a less literal and more representative rendering of this particular relationship and symbol. This is perhaps most poignant in the influence of the Japanese *ukiyo-e* genre. While the influx of *japonisme* and *japonaiserie* was unyielding in the latter decades of the French nineteenth century, the impact of *ukiyo-e* aesthetics and symbolism proved especially significant for leading artists of the *avant-garde*. A common feature of Japanese art of this style and period is the apparent rootlessness of its subjects, a notion that in itself points to the image of both the newfound freedom and autonomy associated with the child, as well as the ephemerality of childhood as a precious stage so easily lost sight of and left to drift away. Miyagawa Chōshun's *Ryukyuan Dancer and Musicians* (c.1718) depicts a total of eight brightly dressed figures against

Seeking Childhood

an unmodulated background in which floor and wall are impossible to discern. Indeterminate in location and dimension, and lacking pictorial depth in their block colour decoration, the figures of this artwork seem little more than silhouettes. Like a well-loved toy or seemingly inconsequential object of the household elevated by the child's imagination, confounded into little more than elusive and ephemeral shadows, these painted figures appear, in fact, to be floating. What is more, the rootlessness of these colourful silhouettes against the plain background is reminiscent of the sorts of flat shapes suspended on strings or sticks and used in shadow puppetry, weightlessly bobbing along the picture frame as in the miniature theatre of the bedroom or our mind. Vallotton's 1893 work *Le bain au soir d'été* ('*The Summer Evening Bath*') bears many stylistic and compositional similarities. While offering a more detailed background and a more perspective-clear composition, *Le bain au soir d'été* is nevertheless an artwork built on simple shapes and block colour. The frame is dominated by a selection of female bathers, whose pale skin and bright white shapes of clothing contrast beautifully with the stark black of their hair and removed stockings. Vallotton's work participates in the fashion popular among his peers for embracing silhouettes in white and colour as much as in their traditional black. His calmly posed bathers with their largely monochrome plainness and sickled arabesques appear as flat and potentially foldable as the crumpled outfits left scattered on the ground like shed skins. The distinct sections of silhouetted colour, particularly when coupled by angelic females dressed in white, is reminiscent of 'stained glass, [which] with its unmodulated, discrete segments of rich colour bounded by distinct outlines, served as one model for the Synthetist style of painting', emphasising the significance of aesthetics and lack of realism, as opposed to physically accurate representations.[37] Moreover, the bathers are without shadows, and therefore function almost as the shadows themselves, for their forms are like carefully positioned silhouettes, perhaps even cut-outs or flat puppets to be moved about the frame by a child building its own imagined picture of reality.

While individual styles and subjects of *ukiyo-e* could vary dramatically, what is arguably the steadfast feature of these 'pictures of the floating world' is an ephemerality and somewhat intangible quality of time, space and existence. Painter and printmaker Pierre Bonnard is famous for his employment

of the simple silhouette, evidenced, for example, in his 1896 lithograph *La Petite Blanchisseuse* ('*The Little Laundry Girl*'), which depicts the black, silhouetted form of a little girl making her way along a street carrying a basket full of laundry and an umbrella. From the unmodulated surroundings to the peculiar stooping angle of the little girl's position on the road, Bonnard has embraced not only the warped spatial awareness of Japanese art, but also the *ukiyo-e* style of presenting ambiguous, anonymous people carrying out everyday activities. Utagawa Hiroshige's woodblock print *Evening Snow at Kambara*, the sixteenth in his series entitled *Fifty-Three Stations of the Tokaido* (1833–4) offers a composition akin to Bonnard's. From the expansive white and grey in both artworks and the spattering of snow in Hiroshige's and perhaps cobbles or debris in Bonnard's, to the weary diagonal progress of the figures and the eerie quietude implied by the emptiness of the frame, these artworks offer shadowy people. The presence of these shadowy people is at once standout, either by splashes of colour or perfect blackness, as well as momentary, captured while passing by. The depiction in this French *avant-garde* art of the transitory moment of the passing, transcendent person is arguably reflective of the burgeoning awareness among creative individuals of the transience of life, of youth and thus of one's childhood years, the shadow child floating away with the wind. This again invites the recurring concept of the child and its conditions as representative of both Self and Other. The child is simultaneously an emblem of our essence as people, as someone we all once were and to an extent retain within us in memories and experiences, but then also part of us that is gone forever, a stage in our life from which we have progressed and can never return.

Furthermore, this sense of duality characterises the very nature of childhood and being a child when we consider again the liminality with which the state of childhood is associated by those removed from it. The child's experience is one of being neither here nor there, between birth and becoming a fully recognised person in adulthood, of residing in a constant flux of the in-between. This is fed by both the condescension towards the 'incompleteness' and indefiniteness of the child in an overtly demarcated and adult-centric society, as well as the growing propensity of the child to voluntarily frequent the in-between world as a locus of autonomy and self-determination with the onset of modernity. Symbolised by the notion of a rootless shadow as

depicted and popularised by France's *avant-garde*, unweighted and free-moving, the experience of the child is one of bodily, psychological, social and cultural 'betwixt-ness', constantly shifting and undulating as per the whims and designs of the powerful, and increasingly by the turn of the twentieth century, thanks to their own autonomous rebellion.

The notion of the shadow as an autonomous figure in its own right, a very tangible yet rootless image that symbolises the child, was reflected in J. M. Barrie's famous character Peter Pan. On the one hand, Peter's shadow functions as both an extension of his childish impishness and, frequently slipping away to cause mischief on its own, as an additional character full of personality in its own right. On the other hand, Peter's shadow can be understood as a component of a deeper metaphor at play in Barrie's novel. Sarah Gilead has analysed in some detail what she perceives to be Peter's embodiment of not only repressed adult wishes over the absence or loss of childhood, but often in a deeply tragic way, the seductiveness and dangers of fantasy.[38] Viewing Peter through a Freudian lens, he becomes something of a paradox, for not only is he a celebration of the 'adult's romantic view of childhood as the liberated imagination itself', but through his demonstration of the Freudian compulsion to repeat, he functions as a reminder of the ephemerality of childhood and life in general.[39] That is to say, in rather sombre terms, 'the existence of the next generation guarantees the expendability of the present'.[40] Consequently, by quite decisively being the boy who *would not* grow up, the highly symbolic character of Peter lays his own trap. Embodying the adult preoccupation with time and death, Gilead envisages Peter as both the 'idealised child and the regressive, impotent adult', compelled like most all of the adults explored in this book to hijack the very notion of childhood in order to assuage adulthood's burdens to such an extent that he becomes incarcerated by his own designs.[41] Representative in this way of the adult of modernity, Peter is suspended in a perpetual flux that is free of responsibility and in which he thus cannot grow up, whereby he desperately attaches himself to each new generation in the hope of renewal.[42] In this way, 'Never-Never Land' is not, as it ostensibly appears, the antibook of the adult world, but rather an eerie extension of it.[43] Like a fairy tale, Peter Pan and his world seem to offer an escape from the burdens and limitations of reality, but are actually laced with magnetising reminders of this reality

Breaking the Mould

that inevitability entices our return, an uncanny reappearance again of the prevalent Self and Other dynamic central to this book.

This cycle of returns is applicable also to Peter's shadow. In many ways, Peter's shadow can be understood as symbolic of the ephemerality of childhood and the associated qualities of freedom, imagination and mischief. On occasion, it quite literally overshadows the character himself, dictating activities by misbehaving and disappearing. The eventual necessity of the shadow to return to Peter is symbolic of the inevitable return to reality that we must accept either when maturing into an adult or when having regressed to an earlier stage of one's life. This free and whimsical shadow, dancing about with weightless liberty, will ultimately find itself recaptured and tethered to real life on Earth. The repetitive return by which Peter enjoys seemingly ceaseless youth is mirrored and in fact facilitated tragically by the inevitable return to reality by which everyone is bound to some degree or another: 'only after childhood ends can the adult reconstitute it as the object of desire, so that the concept originates in loss'.[44] In part, this may have been influenced by Barrie's own personal acknowledgement of the power of imagination, not only a child's ability to exist in a fantasy world largely of their own construction, and indeed the everlasting appeal this presents to adults faced with an often grimmer reality, but also in instances when trauma and loss trigger nostalgic obsession. When Barrie's brother David died in an ice-skating accident aged thirteen, the six-year-old Barrie quickly learned from his mother's obsession with his dead brother, her well-established favourite, that it is often things that have no physical existence in reality that take centre stage in our minds over the very real things before our eyes. Not only does this point to that crossover between reality and fantasy to which many concepts of the ephemeral child subscribe, but it marks a return to the prevalence of that adult-centric propensity to control the truth.

It was Barrie who also once described the nightly practice of all good mothers to encounter the unruly musings of their children's sleeping minds and tidy them for the following morning; it is like organising drawers, making sure that naughtiness is folded small and tucked away to make way for good behaviour freshly aired.[45] Not only does this point to the general sense of control, dressed in a garb of nurturance, of the parent over the child that characterises most behaviours in the household realm and

beyond in this period, but it is more specifically indicative of adult attempts to govern specific childhood environments, and by extension the psychological and mental annexes to these physical arenas. While children, as symbolised by the whimsical and free-moving shadow of toyless play and *avant-garde* art, prove as much products of the art that they inspire, they in turn become artistic creators in their own right. In much the same way that for the Symbolists, the shadows produce the forms, children can produce art. In these instances and at this stage, this refers to the unofficial and often rather unfathomable production or creation at the hands of the child, often manifesting itself during play or at rest, in an environment composed of imagination and experimentation, as opposed to the well-documented child art spearheaded by modernists. Indeed, for unlike the supposed 'free-drawing' of the child embraced and perhaps a little guided by adults in the twentieth century, these early manifestations of artistic creation are as flimsy, unrestrained and ineffable as the shadow itself.

Returning to Barrie's image of the rummaging, reorganising mother, much artistic creation on the part of the child, mental or otherwise, takes place in the dual site of play and rest: the bedroom. In both play and rest, children seek spaces of comfort and security, but also of interiority and concealment in order to practice an art unassailable by adult interference. While Winnicott has stated that 'the playing child inhabits an area that cannot be easily left, nor can it easily admit intrusion', this applies as much to its seclusion and privacy on a mental level as it does the physical boundaries often erected by the creative child at play.[46] This may in part be an attempt to prevent further muddying of what is already the very complex arena of behaviours, experiences and emotions for the playing and creating child. In many ways, the child at play is immersed in a separate temporal space entirely, which, straddling private and external spheres, functions as a sort of interweave founded on the fluidity of children's inner and outer lives that permit them to 'slip back and forth between their private worlds of imagination and the domain of shared cultural experience'.[47] Accordingly, the child's world of play, rest and creative production is not impermeable to external factors and influences; in fact, the shadowiness of its very nature is defined by free-movement between inner and outer, creating a melange of experience, perception, imagination and creation. Rather, its reticence to

adult intrusion is less in aid of reducing a muddying influence, but on the contrary, to prohibit the tidy arrangement of thoughts and ideas, toys and creations, into the neat, black-and-white compartments of the adult world. In much the same way that adults do not understand the emotional significance of the physical 'aesthetic of mess' that must be allowed to flourish for the sake of externalising otherwise interior clutter, they also wish to firmly separate inner from outer, fantasy and reality, in order to cleanly reiterate a grounded and sensible outlook.[48] Perhaps inspired by Jung's cohesive view of intermingling interior and exterior worlds having '"dividing walls" [which] are transparent', art theorist Ellen Handler Spitz's analogy of the window goes some way to illustrate the translucency and fluid permeability of worlds central to the experience and environment of play.[49] A ubiquitous symbol of every child's playroom or bedroom, the window opens up a space between inside and outside, but also comes to represent a flimsy veil to be negotiated during play, 'a translucent membrane suspended between fantasy and reality, a membrane that thickens and darkens as we grow older but never becomes entirely opaque.[50] Such an image presents the transparency that characterises this the fantastical dyad and ongoing flux of imagination, perception and experience in the mind of the playing and creating child.

While we have to some extent established the role of the bedroom as a vehicle for explorations and expressions of a child's perceptions and imaginings, it becomes apparent on a more profound level 'how like an artist's studio is the bedroom of a small child ... filled with highly invested possessions, a dual locus of security and discovery, of work and of rest.[51] In turn this points to Guillaume Apollinaire's assertion that art derives 'not from the reality of sight, but from the reality of insight', which we have come to realise resides so prominently within the searching mind of the child.[52] In the same way that a child does not rely on official toys with which to play, their creativity is similarly unbound. While their eyesight may offer a survey of their surroundings from which they yield 'a stock of images for [their] mental museums', they then rely on *insight*, employing the camera obscura of their mind to piece together these dimensions to create a merging combination of perception and imagination.[53] The advantages of such liberty to imagine, perceive and create is symbolised by the elusive shadow of both body and soul. The foundations of the catapulting of the child into

the realm of modern art in the twentieth century can be seen in the gradual relinquishment in the latter years of the previous century of the linear and monochromatic stipulations of the adult-controlled world in favour of the shadowy in-between to be found in among such polarities. These often shaded-out children re-emerge as the autonomous shadow, ephemeral yet seemingly never-ending as they transcend their prescribed outlines, reacting to produce in this way an 'art of modernity' that pre-empts their theme in the art of modernism.[54] Thinking on the singular joy of the child to contemplate and create in peace beneath their own veil of childish secrecy, it seems difficult to disagree with Baudelaire's assertion that such modern art was some sort of 'evocative magic', in which the mysteries of the adult-free environment of child's play and experimentation bubbled and stewed in the unfathomable depths of the cauldron.[55] This then calls one to ponder, in view of the impending illumination and indeed harnessing of the soul and intrinsic truth of the child and the state of childhood by modernist artists and writers, 'will all the magic dissipate in stark daylight?'[56]

This chapter began with a brief consolidation of the chief messages arising from the book's multifarious investigations so far. In so doing, the establishment of the child as culturally representative of both Self and Other was reinforced, a process and role that was consistently enabled and manufactured by the child's perceived and perpetuated sense inequivalence, liminality and malleability. Reflecting on the various ways in which this exploitation of the child and its condition manifested itself across the epoch, themes and case studies covered by the previous chapters, this chapter has considered how such oppression ultimately gives rise to rebellion among children towards the end of the period of study, with a specific focus on the initiation thereof in the realm of play. After considering the role of feminism in the late nineteenth century in France in laying the groundwork for a society likely to be more receptive to cultural ruptures that subverted normative structures, this chapter's focus derives from an in-depth analysis of play. A site and practice of mental growth, imagination and experimentation, crucially, play is the arena in which children are able to act for themselves, to enact mastery of their own world and emancipate themselves against the restraints of adult-imposed rules and dogma. As this chapter has highlighted through theoretical debate and an engagement with key literary

manifestations in *The Velveteen Rabbit*, this is perhaps most evident in toyless play, in which the child enjoys shedding the shackles of adult-designed toys and allowing their imagination to dominate. This is exemplified by shadow play as the most accessible and emancipating form of play, as well as enduringly popular, which in turn points to the significance of the shadow on symbolic and conceptual levels within *avant-garde* art of the period, looking to the *japoniste* artworks of figures such as Vallotton and Bonnard.

As such, a clear connection has been established between the independence that looser forms of play, such as shadow play, offered the child and an increasing cultural and intellectual awareness thereof around the turn of the century, and the new sense of autonomy and cultural significance with which the shadow was enriched as a creative metaphor of essence, truth and ephemerality among the *fin-de-siècle avant-garde*. Moreover, the association of the child and its nature with both Self and Other, simultaneously the personification of the ephemerality of youth and life as well as the symbol of a hopeful future, the significance of the child's relationship with the shadow is extended further by the latter's additional synonymy with transience in prominent artistic circles at the turn of the century. Further still, the child's duality has been elucidated through its position as a symbol of both our essence as people, as the person we all once were and partially retain through memory and experience, as well as that of the part forever lost to the passage from childhood to adulthood. Accordingly, by the turn of the twentieth century, the child and all it seemed to represent began to gain autonomy, not least in the artistic world, where, like the shadow, it had for so long seemed supplementary and shaded out, but was now emerging as a powerful symbol of insightfulness previously overlooked. This culminated in a reflection of the duality of the child, as per its perceived representation of Self and Other and its liminality, pointing to its changeability both as a result of its various harnessing by the powerful and the free-moving transience afforded by the self-agency discovered later on.

This chapter concluded with a consideration of Peter Pan as demonstrative through the key images of the child and the shadow, of the adult obsession with youth to which this book has been essentially wed. The self-destructive process of harnessing the child and its condition as an antidote to the ills of modernity, as a means of reimagining oneself and reshaping

one's memories is one tethered by its uncanny and inevitable return to reality. Dedication, conscious or otherwise, to such a process is a reminder of the adult preoccupation with control, but also points to their limitations. It is the acceptance of the disorganised, of the flux between inner and outer worlds, which renders the insight of the child so special and so particularly enticing to the introspective and experimental practitioners of modernism. And so having come full circle, this chapter closes with a foreboding question. Pointing to the considerations of the Conclusion, it queries what this eventual achievement on some level of autonomy and freedom had in store for children and their condition when it came to the attention of another movement of intellectuals and creatives for whom such qualities presented an irresistible font of inspiration to be harnessed.

Conclusion
Finding the Child Within Us All

All accounts of childhood are, in the end, accounts of ourselves.
Anne Higonnet, *What Do You Want To Know About Children?*[1]

Life has always seemed to me like a plant that lives on its rhizome. Its true life is invisible, hidden in the rhizome. The part that appears above ground lasts only a single summer. Then it withers away – an ephemeral apparition.
Carl Jung, *Memories, Dreams, Reflections*[2]

The artists and writers discussed in this book, varied as they are in their individual experiences, aims and ideas, are united in their fulfilment in some capacity of a role that might be described as that of 'an ancient little boy'.[3] This oxymoron points to a process represented by these artistic and literary figures and their work, one that is assumed both consciously and subconsciously, by which a return to childhood and a child-like state is made by the adult. Manifesting itself variously and for numerous reasons, this return affords an array of opportunities for the adult, coloured by age, hindsight and nostalgia, to enact on their memories, concepts and images of childhood, both personally and collectively. Appearing as a sort of renaissance, this return provides an occasion once again to participate in the past, to revisit, re-evaluate and peace-make, to demystify, elucidate and unpack, to embellish, exaggerate and sensationalise, to remodel, distort and conflate.

Seeking Childhood

It is in exploration and analysis of this process to which this book has been dedicated, and against whose procedures and conclusions it can now be further understood. By investigating how experiences, images and the journey of the child and childhood on conceptual levels have been represented by intellectuals and cultural practitioners throughout the course of the French long nineteenth century, this book has established a pervasive practice of harnessing of the child and its condition. The perceived liminality and thus inequivalence and malleability of child and of childhood in the eyes of the powerful, has given rise to a fervent propensity among scholars and creatives to both explore and define. It is the processes and results of such endeavours that this book has investigated, examining the rhetoric of the child and childhood in how it has inspired and been reflected in the arts and literature of the French long nineteenth century. By studying the scholarly, literary and artistic output reflecting this period's varied approach towards and grasp of concepts and images of children and childhood, as well as the ways in which children and childhood were intellectually and creatively mobilised for a variety of personal, professional or collective aims, this book has demonstrated and accounted for how artists and writers have reflected on children and their condition, and the implications thereof on social, cultural, intellectual and personal levels. The book has been conscious throughout of the complex and juxtaposing position of the child as both Self, present for example in the origins of us all, and also Other, represented variously by qualities both 'good' and 'bad' perceived as innate to the childhood state. It is this contradictory yet pervasive positioning of the child and its liminal condition that has enabled an Otherising exploitation of its representative possibilities by the intellectual and creative practitioners of a period addled with queries of both the self and Self.

Coveney argues that the long nineteenth century was an age in which 'it became increasingly difficult to grow up, to find valid bearings in an adult world' and as a result, there was a tendency, to 'take the line of least emotional resistance, and to regress, quite literally, into a world of fantasy and nostalgia for childhood'.[4] This is particularly true of the French context. Wedged in the constantly fluctuating chasm between tradition and modernity, convention and progression, the French long nineteenth century was a period characterised by writers and artists who, out of place and out of sorts,

Conclusion

sought a 'regressive escape into the emotional prison of self-limiting nostalgia' via the cult of the child, in whatever form, style or expression they may have taken or might have been assigned.[5] For as many causes, reasons and designs as there were behind these figures' return or regression to the childhood state, there emerged a twofold manifestation of this peculiar affliction of nostalgia comprising those who wanted to go back to the beginning in order to start afresh, and those who simply just wanted to go back, such was the often bleak complexity of the rapidly modernising world.

In many ways, the undulating cross-over between old and new that characterised the French long nineteenth century served as a backdrop that mirrored the child's condition and experiences in this period. Between the poles of the pre-Enlightenment 'Dark Ages' and the perceived 'enlightened' epoch of twentieth-century modernity, between the markers of birth and adulthood, endures an existence characterised by liminality. This period is one whose ambiguity between tradition and modernity proper comes to reflect the multifaceted concepts, roles, images and experiences of the Otherised child negotiating such an epoch. The perceived liminality, ambiguity and malleability of the child is characterised not only by the contradictory embodiment of both Self and Other of which they were seen to represent, but also by their role and experience in negotiating an in-between world, straddling the crossroads of modernity and nature, fallacy and truth, imagination and reality, and the constant merging thereof in among the hurly-burly of a world caught between tradition and modernisation.

As established in the Introduction, while Philippe Ariès is credited as the catalyst in bringing to the fore in the twentieth century the topic of children and childhood in the scholarly arena, and his interdisciplinary approach inviting future connections between pedagogy and art history, these have remained few and far between. Furthermore, the inclusion of children or concepts of childhood in art historical studies, and *vice versa*, have remained somewhat incidental, occasionally addressing seemingly ancillary ideas and concepts in isolation or within a very limited contextual sphere. More specifically, attention has focused chiefly on two often-considered polar points of significance and reference. The first is the mid to late eighteenth-century clash between the Enlightenment and Romanticism, credited as a turning point in the establishment of scholarly and creative interest in children and

Seeking Childhood

childhood. The second is the cementing of the child and its condition and blueprint of modernist creative practice in the early twentieth century. The period in between these two junctures, the long nineteenth century, has attracted interest relating to this topic only in pockets; that is to say, crucially, not in a fashion that examines the developmental process between these two points, and not within the specific context of France, whose turbulent political, social and cultural history at this time offers a particularly interesting and revealing contextual focus. This book has drawn on and addressed this scholarly chasm, bridging the gap by analysing the journey of the child and the concept of childhood through the literary and visual culture of the French long nineteenth century. By exploring the significant concepts, theories and images that built on post-Enlightenment thought and worked to pave the way for key modernist philosophies, this book offers an investigation into how these cultural milestones were connected throughout the changing environment of the era in between. By combining not only the study of children and childhood with that of art history, but also within the specific context of the French long nineteenth century, this book provides an examination of both the developments leading up to the ground-breaking emergence of modernism and the social and cultural history of children and childhood, but more crucially still, the complex and revelatory relationship between the two. By beginning with the perceived 'enlightened' thought of twentieth-century modernism, the book has adopted a retrospective analysis of how and in what ways these views were established and developed throughout the course of the previous century, drawing at all on times on the pervasive perception of the child as a liminal and inequivalent being representative of both Self and Other.

As intimated above, Chapter 1 functioned as a comprehensive introduction to the themes and concepts of the book, beginning at the end to elucidate the modernist championing of the child in the early twentieth century as the 'result' whose journey the rest of the book mapped. The process began with an explication of various historical and contemporary classifications of childhood, pointing from the outset to the propensity among the powerful to codify and control what the essentially ungovernable condition of childhood. The chapter then investigated how the previously discussed liminality and ambiguity seen as innate to the child and state of childhood

Conclusion

were harnessed into a sort of pliability exploited by adults and the powerful as a means of moulding children, their condition and their perceived qualities for their own ends. In the specific context of this chapter, this amounted to a modernist mobilisation of the child and its creative insight as a particularly potent counter to the ills of modernity. The chapter considered the role of artists such as Paul Cézanne, Paul Klee and Pablo Picasso in the cementing of the child and its condition as something of a blueprint for modernist art practice, focusing in particular on the perceived connection between notions of childhood and Primitivism as creative taproots for an *avant-garde* tired of existing symbols and hungry for a new and plentiful source of counter-culture inspiration. The chapter concluded with analysis of the conflation of the child and the 'primitive' as reflective of the key concept of inequivalence and liminality to which much of the book's discourse is wed, considering Blaise Cendrars's modernist text *Shadow* as an exemplification of the connected process of ongoing Otherisation of the child.

As such, having made clear the end point towards which the result of the book would journey, Chapter 2 marked a return to what is broadly considered the beginning of the process. Its focus was an analysis of the emerging 'discovery' and acknowledgement of children and childhood as representative of both Self and Other and a vehicle of self-discovery, against the backdrop of the period that saw the crossover between the Enlightenment and Romanticism. Following a brief exploration of the scholarship of prominent eighteenth-century academics, including Georges-Louis Leclerc Comte de Buffon, Étienne Bonnot de Condillac and Louis-François Jauffret, the majority of the chapter was dedicated to the work of Jean Jacques Rousseau, unpacking the complex and often contradictory treatise of *Émile*. As such, Chapter 2 explored the origins and effects of Rousseau's paradoxical yet highly pervasive contribution to concepts and practices relating to children and childhood, and in particular his notion of harnessing the child as a means of reimagining oneself and starting afresh for oneself and society. The chapter then concluded by considering responses to such doctrine through an analysis of realism's Gustave Courbet, thereby charting the initial development from Rousseau of perceptions and representations of children and childhood.

Moving away from the Enlightenment/Romanticism crossover and using Courbet's realism of the previous chapter as something of a springboard,

175

Chapter 3 addressed the experiences of children of poverty in nineteenth-century France. Alongside brief contributions from Émile Bayard and Charles Baudelaire, the bulk of the chapter was dedicated to two concurrent case studies engaging the work of Victor Hugo and Edgar Degas as reflective of urban French society in the decades following the Revolution. Imbued with a pervasive consideration of *chiaroscuro* and its symbolic capabilities, Chapter 3's examination of Hugo and Degas deals with their depictions of the Otherising debasement of poor children, with a focus on their various animalistic conditions and the vulnerability to which this gave rise. Framed by French society's preoccupation in this period with a regeneration of the race and rejuvenation of society, this chapter exposed the extent to which children and their condition were involuntarily bound up in this.

Moving to slightly later in the period, Chapter 4, by contrast, considered the very personal though not uncommon experiences of middle-class or bourgeois children through the dual case studies of Marcel Proust and Odilon Redon. Drawing from an investigation into the peculiarities of French nineteenth-century bourgeois family life and the associated expectations and relationships, the chapter engaged principally with the lives and works of the two case studies. Inspired by these two figures' shared nostalgic yearning for mother, both biographically and creatively, Chapter 4 comprised an in-depth exploration of Proust and Redon's visual and symbolic renderings of reclusive spaces as suggestive of a return to the womb, reflecting poignant messages about familial and social dynamics of their period and class. Perhaps unique to this chapter is the way in which the harnessing of the culture of childhood is carried out most reflexively by two figures whose upbringing arguably prevented an emotional maturation to match their bodily one.

Covering the later decades of the nineteenth century and under the ongoing metaphor of the toy-child, Chapter 5 considered the extent to which various cultural apparatus, including Perraultian fairy tales and the popular *Jumeau* doll, were mobilised by the powerful as a means of acculturation and social control of children, particularly regarding normative gendered notions of identity and social existence. Reflecting again on the preoccupation with fabricating a society fit for the twentieth century, this chapter investigated how the adult-centricity of French long nineteenth-century society at this

Conclusion

time resulted in a debasement of the child through such determined efforts to codify them. By analysing the ornamental idyll that characterises depictions of domestic childhood by prominent Impressionist artists, Chapter 5 addressed society's preoccupation with pretence and image through establishment of the image and concept of toy-child. Present in both artistic and material culture, this notion is highlighted as not only demonstrative of stereotypical underestimations of children's capabilities, but as responsible for the emotional, social and cultural degradation of the child to an empty shell of ideals. It is off the back of this extremeness of treatment of the child that the book began to consider the inevitable retaliation.

As such, the final chapter led on from this consideration. Following a brief discussion of anti-patriarchal foundations of social and cultural change laid by French feminism in the late nineteenth-century art, Chapter 6 investigated the emerging autonomy of the child, and burgeoning acknowledgement of the wisdom thereof chiefly through an exploration of the world of play. With a focus on the significance of toyless play as facilitating imagination and experimentation emancipated from adult control, the chapter uses shadow play as the ultimate exemplification of this as a segue into the changing symbolism and role of the shadow in art among the *avant-garde*. Through the *japoniste* artwork of Symbolists such as Pierre Bonnard and Félix Vallotton, Chapter 6 unpacked the shadow's new role in art at the turn of the twentieth century as comparative to the status of children and childhood at the same point. Reflective of both increased agency and a reminder of the ephemerality of life, the child-shadow connection is cemented through the case study of J. M. Barrie's *Peter Pan*, which elucidates most poignantly both the Self/Other duality by which the child and its condition is characterised, as well as the obsession with which they have been treated by generations of adults desperate to come to terms with the ephemerality of their own existence as highlighted by the transition to modernity. Finally, coming full circle, Chapter 6 considered how this twentieth-century recognition of the real liminality of childhood, of the child's ability to straddle autonomously the in-between world of imagination and creative insight of which we lose our grasp as adults, ultimately too fell prey to the outreached hands of a new *avant-garde* in search of prolonged inspiration: the modernists.

Seeking Childhood

As such, there is a well-established pattern here that, aside from the various specifics of each theme, period and case study, unites the book's premise as one that has charted through its art and literature a process of coming to terms in the French long nineteenth century of a rapidly changing world through efforts to somehow reclaim and preserve 'the child we once were, but shall never be again'.[6] These notions are further reflected in the experiences and fate of the famed writer of childhood, Antoine de Saint-Exupéry. A trained pilot and great lover of aviation, Saint-Exupéry disappeared during a reconnaissance mission in 1944, and presumably lost his life when the plane he was flying was shot down over the sea. This notorious ancient little boy, whose own life comprised a drawn-out battle between the nostalgic joy of childhood and the corrosive melancholy of adulthood, was shot in mid-air, between earth and sky, forever paralysed in the in-between. Furthermore, this lethal shot, like a single moment captured in time, is suggestive of the photograph, an increasingly popular medium throughout the period of study. Both Saint-Exupéry's sudden departure from earthly life, and the apparent momentariness of childhood can be understood through the symbol of the photograph, a monochrome rendering of a life before it withers and disintegrates with light. In this way, like the child and the state of childhood, 'a photograph is but a shadow of what once was there, but is now gone'.[7] This idea of the child as a sort of photograph, a 'weightless, transparent envelope' in which personhood and memories can be carried seems to account quite significantly for the adult artists' or writers' focus on the child.[8] In 2002, Christian Boltanski explained, 'I began to work as an artist when I began to be an adult, when I understood that my childhood was finished, and was dead. I think we all have somebody who is dead inside of us. A dead child.'[9] This idea of a child that remains inside us serves not only as a reminder of what once was but no longer exists, but also as a sort of warning and appeal to preserve and cherish the child, its condition and its memory before it fades and drifts away with time.

As Larry Wolff mused, 'if memory was the "source" of personal identity … then childhood was the delta into which its river irreversibly ran', affording the opportunity to immerse oneself in one's past or those imagined of others, until one loses oneself in 'the unremembered sediment of personal alluvial deposits [thus] becoming a child again'.[10] This exploration of the truth

Conclusion

through the past, this discovery of one's personhood in the little child within, is subject to colouration. In the same way that 'the memory of childhood was not a piece of vestigial mental matter, but rather [some of the] first strokes that marked the mind's white paper', this rediscovery could be compared to the process by which an old black-and-white photograph dug out from a dusty album becomes colourised by the techniques and styles acquired by the passage of time.[11] Similarly, this exploration of fragments of childhoods past is in itself subject to the effects of a shadowing, a sort of 'translucent membrane suspended between fantasy and reality, a membrane that thickens and darkens as we grow older but never becomes entirely opaque', and thus permits re-entrance at the right moment.[12] This re-entrance offers a doorway into a realm that seems infinitely deep, comprising the countless leagues of our experiences, memories and personality within the thousands of planes of the human mind.

With the rapid, destabilising and psychologically corrosive onset of modernity, during which empty priorities and long-standing falsehoods were slowly called into question, a search for truth and genuine sense of selfhood was never so pressing. Such considerations and endeavours have been exemplified in the study of figures such as Charles Baudelaire, Paul Cézanne and Roger Fry. Given that 'children remember when men forget, and their games speak when history keeps quiet', there emerged a melancholic reflection on one's relinquishment of the magic and wisdom of childhood to gain admission into the empty world of adulthood symbolised by the metaphorical covering of the kaleidoscopic wonder of childhood with a dreary cloak thick with ignorance and obstinacy.[13] Accordingly, a re-immersion into the kaleidoscopic depths of childhood as a means of reliving and reclaiming what adulthood had served to whitewash, seemed the most effective and revelatory way of unpacking the past and finding the truth.

Of course, this process often proved as destructive, conflating and counterproductive as other more prominent voyages of discovery, both historical and ongoing. Indeed, for as we wrap ourselves in these blankets of the past, encumbering our own histories and the fate of a new generation with the notion that 'children become the pattern and promise of futurity ... for society as a whole',[14] we tend to lose sight in that 'not all children are "our" future because not all children are "ours" and because not all children promise or

Seeking Childhood

portend a desired future'.[15] Our intentions, processes and, thus, findings can become muddied by a knot too rashly untangled. While it is often the case that 'childhood is a mirror in which we can see ourselves young and old at the same time', it is not nearly so often so clear a reflection as the metaphor suggests.[16]

When Ellen Handler Spitz remarked on the similarities between the artist's studio and the bedroom of a small child as explored in Chapter 6, she went some way to elucidating not only the innate and profound connection between childhood experiences and perceptions and the creative process, between the pursuit of truth and 'making sense' inherent to both the curious child and the disillusioned creative practitioner, but also the untidiness and complexity intrinsic to both.[17] And so as with all endeavours of great worth and revelation, the pursuit of truth found in the child within, through the journey into childhoods past, is an art that requires patience and delicacy. It is a careful lifting of each layer of one's childhood, of each aspect of one's past, memory, experience and personhood so as to reveal that which lies buried further beneath without damaging it, like the gradual rummaging of a child in the darkest nooks and crannies of a chest containing their most precious treasures. Indeed, for as Walter Benjamin once reflected, if 'there exists for each individual an image around which the entire world appears to founder, for how many does that image not rise out of an old toy chest?'[18]

Notes

Introduction

[1] Paul Webster, *Antoine de Saint-Exupéry: The Life and Death of the Little Prince* (London: Papermac, 1994), p. 110.

[2] Antoine de Saint-Exupéry, *The Little Prince*, trans. by Richard Howard (London: Egmont UK Ltd, 2013), 'Dedication'.

[3] Gary K. Clabaugh, 'Perspectives on Childhood', *Educational Horizons*, 70/1 (1991), 7.

[4] Larry Wolff, 'When I Imagine a Child: The Idea of Childhood and the Philosophy of Memory in the Enlightenment', *Eighteenth-Century Studies*, 31/4 (1998), 380.

[5] Wolff, 'Imagine a Child', 380.

[6] Peter Coveney, *The Image of Childhood* (Harmondsworth: Penguin Books, 1967), p. 29.

[7] Nicholas Orme, *Medieval Children* (New Haven CT: Yale University Press, 2003).

[8] Prominent examples include Marilyn R. Brown, *Picturing Children: Constructions of Childhood between Rousseau and Freud* (Aldershot: Ashgate Publishing Company, 2002); Jonathan Fineberg (ed.), *Discovering Child Art: Essays on Childhood, Primitivism and Modernism* (Princeton NJ: Princeton University Press, 1998); Richard Hobbs (ed.), *Impressions of French Modernity: Art and Literature in France 1850–1900* (Manchester: Manchester University Press, 1998); and Patricia Holland, *Picturing Childhood: The Myth of the Child in Popular Imagery* (London: I. B. Tauris & Co. Ltd, 2006).

[9] Elizabeth Foyster and James Marten (eds), *A Cultural History of Childhood and Family in the Age of Enlightenment* (London: Bloomsbury, 2014).

[10] M. R. Higonnet, 'Modernism and Childhood', *The Comparatist*, 33 (2009), 86–108; and Fineberg, *Discovering Child Art*.

Notes

[11] Hobsbawm's analysis of the long nineteenth century spans three books: Eric Hobsbawm, *The Age of Revolution: Europe 1789–1848* (London: Weidenfeld & Nicolson, 1962); Eric Hobsbawm, *The Age of Capital: 1848–1875* (London: Weidenfeld & Nicolson, 1975); and Eric Hobsbawm, *The Age of Empire: 1875–1914* (London: Weidenfeld & Nicolson, 1987).

[12] Peter N. Stearns, Michael Adas, Stuart B. Schwartz and Jason Gilbert (eds), *World Civilisations: The Global Experience* (Upper Saddle River NJ: Longman, 2011).

[13] John W. O'Malley, *What Happened at Vatican II* (Cambridge: Harvard University Press, 2010).

Chapter 1

[1] Larry Wolff, 'When I Imagine a Child: The Idea of Childhood and the Philosophy of Memory in the Enlightenment', *Eighteenth-Century Studies*, 31/4 (1998), 384.

[2] Antoine de Saint-Exupéry, *The Little Prince*, trans. by Richard Howard (London: Egmont UK Ltd, 2013), p. 69.

[3] Marilyn R. Brown, 'Introduction: Baudelaire between Rousseau and Freud', in Marilyn R. Brown (ed.), *Picturing Children: Construction of Childhood between Rousseau and Freud* (Aldershot: Ashgate Publishing Company, 2002), p. 3.

[4] Michael Morpurgo, 'Foreword', in Hugh Cunningham, *The Invention of Childhood* (London: BBC Books, 2006), p. 10.

[5] Cunningham, *Invention of Childhood*, p. 12.

[6] P. H. Furfey, 'The Forgotten Age of Childhood', *The Scientific Monthly*, 40/5 (1935), 458.

[7] Bette P. Goldstone, 'Views of Childhood in Children's Literature Over Time', *Language Arts*, 63/8 (1986), 792–3.

[8] O. H. Benson, 'Four Ages of Childhood', *The Journal of Education*, 107/16 (1928), 470–1.

[9] A. McRobbie, 'Dance and Social Fantasy', in A. McRobbie and M. Nava (eds), *Gender and Generation* (London: Macmillan, 1984), p. 146.

[10] C. Duff, 'Drugs and Youth Culture: Is Australia Experiencing the "Normalisation" of Adolescent Drug Use?', *Journal of Youth Studies*, 6/4 (2003), 442.

[11] J. Northcote, 'Nightclubbing and the Search for Identity: Making the Transition from Childhood to Adulthood in an Urban Milieu', *Journal of Youth Studies*, 9/1 (2006), 5.

[12] Arthur C. Lehmann and James E. Myers (eds), *Magic, Witchcraft, and Religion: An Anthropological Study of the Supernatural* (Palo Alto CA: Mayfield Publishing Company, 1985), p. 46.

Notes

[13] William Lloyd Warner, *The Living and the Dead: A Study of the Symbolic Life of Americans* (New Haven CT: Yale University Press, 1959), p. 303.

[14] Victor W. Turner, 'Betwixt and Between: The Liminal Period in *Rites de Passage*', in Lehmann and Myers (eds), *Magic, Witchcraft, and Religion*, pp. 47–8.

[15] Daniel Thomas Cook, 'A Politics of Becoming: When "Child" is Not Enough', *Childhood*, 22/1 (2015), 3.

[16] Cunningham, *Invention of Childhood*, p. 14.

[17] Morpurgo, 'Foreword', p. 10.

[18] Cunningham, *Invention of Childhood*, p. 13.

[19] Goldstone, 'Views of Childhood', 792.

[20] Simone de Beauvoir in Sally J. Scholz, 'That All Children Should Be Free: Beauvoir, Rousseau, and Childhood', *Hypatia*, 25/2 (2010), 400.

[21] Michel Foucault, *Abnormal: Lectures at the Collège de France 1974–1975*, trans. by Graham Burchell (London: Verso Publishing, 2003), p. 65.

[22] Peter N. Stearns, 'Challenges in the History of Childhood', *The Journal of the History of Childhood and Youth*, 1/1 (2008), 35–42.

[23] Michèle Hannoosh, 'A Painter's Impression of Modernity: Delacroix, Citizen of the Nineteenth Century', in Richard Hobbs (ed.), *Impressions of French Modernity: Art and Literature in France 1850–1900* (Manchester: Manchester University Press, 1998), p. 9.

[24] Andrew Graham-Dixon, *Art in France: This is the Modern World*, BBC Four (2017).

[25] Graham-Dixon, *Art in France*.

[26] Coveney, *Image of Childhood*, p. 35.

[27] Coveney, *Image of Childhood*, p. 32.

[28] Alessandra Comini, 'Toys in Freud's Attic: Torment and Taboo in the Child and Adolescent Themes of Vienna's Image-makers', in Brown (ed.), *Picturing Children*, p. 173.

[29] John Ruskin in Christopher Turner, 'Art Toys: Through the Eyes of a Child', *Tate Etc.*, 19 (2010), *www.tate.org.uk/tate-etc/issue-19-summer-2010/through-eyes-child* (last accessed 9 October 2023).

[30] Coveney, *Image of Childhood*, pp. 240–2.

[31] Colin Heywood, *Growing Up in France: From the Ancien Régime to the Third Republic* (Cambridge: Cambridge University Press, 2007), p. 17.

[32] Heywood, *Growing Up*, pp. 91–4.

[33] Wolff, 'Imagine a Child', 378.

[34] Wolff, 'Imagine a Child', 381–3.

[35] Carol Mavor, *Reading Boyishly* (Durham NC: Duke University Press, 2007), p. 254.

Notes

36 Roger Fry, 'An Essay in Aesthetics', in Roger Fry, *Vision and Design* (London: Chatto & Windus, 1920), p. 12.

37 Richard N. Coe, *When the Grass was Taller: Autobiography and the Experience of Childhood* (New Haven CT: Yale University Press, 1984), pp. 79–80.

38 Roland Barthes, *Camera Lucida: Reflections on Photography*, trans. by Richard Howard (New York: Hill and Wang, 1981), p. 53.

39 Peter Hollindale (ed.), *J. M. Barrie: Peter Pan and Other Plays* (Oxford: Oxford University Press, 1995), p. 92.

40 George K. Behlmer and Fred M. Leventhal (eds), *Singular Continuities: Transition, Nostalgia, and Identity in Modern British Culture* (Stanford CA: Stanford University Press, 2000), p. 7.

41 Mavor, *Reading Boyishly*, p. 42, p. 434.

42 Stendhal, *The Life of Henry Brulard*, trans. by John Sturrock (New York: New York Review Books, 2002), p. 128.

43 Christian Boltanski, 'Studio's Visit: Christian Boltanski', *Tate Magazine*, 2 (2002).

44 E. H. Gombrich, *The Story of Art* (London: Phaidon Press Limited, 2007), p. 598.

45 Linda Nochlin, *Realism* (London: Penguin, 1971), p. 25.

46 Marshall Berman, *All That Is Solid Melts Into Air: The Experience of Modernity* (New York: Penguin Books, 1988), p. 16.

47 Werner Hofmann, 'The Art of Unlearning', in Jonathan Fineberg (ed.), *Discovering Child Art: Essays on Childhood, Primitivism and Modernism* (Princeton NJ: Princeton University Press, 1998), p. 13.

48 Colin Rhodes, *Primitivism and Modern Art* (London: Thames & Hudson, 1997), p. 38.

49 Novalis, 'Blutenstaub', in Gerhard Schulz (ed.), *Novalis Werke* (Munich: Beck Verlag, 1969), p. 333.

50 Jonathan Fineberg, 'Foreword', in Fineberg (ed.), *Discovering Child Art*, p. xxii.

51 John House, 'Curiosité', in Richard Hobbs (ed.), *Impressions of French Modernity: Art and Literature in France 1850–1900* (Manchester: Manchester University Press, 1998), pp. 33–4.

52 Fry, 'Essay in Aesthetics', p. 16.

53 Roger Fry, 'Children's Drawings', *The Burlington Magazine for Connoisseurs*, 30/171 (1917), 226.

54 Fry, 'Essay in Aesthetics', p. 20.

55 Friedrich Nietzsche, *The Gay Science: With a Prelude in Rhymes and an Appendix of Songs*, trans. by Walter Kaufmann (New York: Vintage Books, 1973), p. 116.

56 Josef Helfenstein, 'The Issue of Childhood in Klee's Late Work', in Fineberg (ed.), *Discovering Child Art*, p.138.

Notes

57 Rudolf Arnheim, 'Beginning with the Child', in Fineberg (ed.), *Discovering Child Art*, p. 16.

58 Arnheim, 'Beginning with the Child', p. 15.

59 Richard Shiff, 'From Primitivist Phylogeny to Formalist Ontogeny: Roger Fry and Children's Drawings', in Fineberg (ed.), *Discovering Child Art*, pp. 160–1.

60 Marcel Franciscono, 'Paul Klee and Children's Art', in Fineberg (ed.), *Discovering Child Art*, p. 96, p. 109.

61 Barbara Wörwag, 'There is Unconscious, Vast Power in the Child: Notes on Kandinsky, Münter and Children's Drawings', in Fineberg (ed.), *Discovering Child Art*, p. 75.

62 Wörwag, 'Unconscious, Vast Power', p. 80.

63 G. G. Pospelov, 'Larionov and Children's Drawings', in Fineberg (ed.), *Discovering Child Art*, pp. 44–9.

64 Meyer Schapiro, 'Courbet and Popular Imagery: An Essay on Realism and Naiveté', *Journal of the Warburg and Courtauld Institutes*, 4/3–4 (1941), 180.

65 Shiff, 'Primitivist Phylogeny', p. 180.

66 Franciscono, 'Klee and Children's Art', p. 103.

67 Turner, 'Art Toys'.

68 Turner, 'Art Toys'.

69 James Sully, *Studies of Childhood*, in Christopher Turner, 'Art Toys'.

70 Turner, 'Art Toys'.

71 Turner, 'Art Toys'.

72 Graham-Dixon, *Art in France*.

73 Paul Klee, *Tagebucher von Paul Klee 1898–1918* (Cologne: Verlag M. DuMont Schauberg, 1957), p. 276.

74 Turner, 'Art Toys'.

75 Anne Higonnet, 'What Do You Want To Know About Children?', in Marilyn R. Brown (ed.), *Picturing Children: Construction of Childhood between Rousseau and Freud* (Aldershot: Ashgate Publishing Company, 2002), p. 202.

76 Wassily Kandinsky, *Concerning the Spiritual in Art*, trans. by Michael T. H. Sadler (Munich: Reinhard Piper, 1911), p. 4.

77 Paul Cézanne in Turner, 'Art Toys'.

78 Maurice Merleau-Ponty, 'Cézanne's Doubt', trans. by M. Smith, in G. Johnson (ed) *The Merleau-Ponty Aesthetics Reader: Philosophy and Painting* (Evanston IL: Northwestern University Press, 1993), p. 64.

79 Turner, 'Art Toys'.

80 John Carlin, 'From Wonder to Blunder: The Child is Mother to the Man', in Fineberg (ed.), *Discovering Child Art*, p. 242.

Notes

81 Carlin, 'Wonder to Blunder', p. 242.

82 Erwin Panofsky, '*Et in Arcadia Ego*: Poussin and the Elegiac Tradition', in Donald Preziosi, *The Art of Art History: A Critical Anthology* (Oxford: Oxford University Press, 2009), pp. 257–62.

83 Arnheim, 'Beginning with the Child', p. 23.

84 Wörwag, 'Unconscious, Vast Power', p. 81.

85 Fry, 'Children's Drawings', 226.

86 Shiff, 'Primitivist Phylogeny', p. 160, p. 177.

87 Milicent Washburn Shinn, *The Biography of a Baby* (Boston MA: Houghton, 1900), p. 7.

88 Stephen Jay Gould, *Ontogeny and Phylogeny* (Cambridge MA: Harvard University Press, 1977), p. 137.

89 Shiff, 'Primitivist Phylogeny', p. 162.

90 Shiff, 'Primitivist Phylogeny', p. 180.

91 Graham-Dixon, *Art in France*.

92 C. G. Jung, *Memories, Dreams, Reflections* (Waukegan IL: Fontana Press, 1995), p. 273.

93 Turner, 'Art Toys'.

94 Turner, 'Betwixt and Between', p. 48.

95 Turner, 'Betwixt and Between', p. 49.

96 Turner, 'Betwixt and Between', pp. 50–1.

97 Turner, 'Art Toys'.

98 Judith Wynn Halsted, *Some of My Best Friends are Books: Guiding Gifted Readers from Preschool to High School* (Scottsdale AZ: Great Potential Press Inc., 2009), p. 280.

99 Valérie Meylan, 'La Féticheuse', *Ricochet* (2014), *www.ricochet-jeunes.org/livres/livre/52966-la-feticheuse* (last accessed 4 April 2023).

100 Blaise Cendrars, *Shadow*, trans. by Marcia Brown (New York: Aladdin Paperbacks, 1995), p. 6.

101 Cendrars, *Shadow*, pp. 14–31.

102 Blaise Cendrars, *L'homme foudroyé* (Paris: Denoël, 1945), p. 13.

Chapter 2

1 Jean-Jacques Rousseau, *Émile; or, On Education*, trans. by Allan Bloom (New York: Basic Books, 1979), p. 37.

2 Louis-François Jauffret, *Les Charmes de l'enfance, et les Plaisirs de l'amour maternel*, vol. 1 (Paris: Didot jeune, 1801), pp. 2–8. Translations for this text are all derived from Adriana S. Benzaquén, 'Childhood, Identity and Human Science in the Enlightenment', *History Workshop Journal*, 57 (2004), 34–57.

Notes

3 John House, 'Curiosité', in Richard Hobbs (ed.), *Impressions of French Modernity: Art and Literature in France 1850–1900* (Manchester: Manchester University Press, 1998), p. 33.

4 Adriana S. Benzaquén, 'Childhood, Identity and Human Science in the Enlightenment', *History Workshop Journal*, 57 (2004), 53.

5 Gary K. Clabaugh, 'Perspectives on Childhood', *Educational Horizons*, 70/1 (1991), 7.

6 Bette P. Goldstone, 'Views of Childhood in Children's Literature Over Time', *Language Arts*, 63/8 (1986), 793; Humphrey Carpenter, *Secret Gardens: A Study of the Golden Age of Children's Literature* (London: Allen and Unwin, 1985), p. 2.

7 Dennis Walder, 'Remembering Rousseau: Nostalgia and the Responsibilities of the Self', *Third World Quarterly*, 26/3 (2005), 424.

8 Alphonse-Louis Leroy in Benzaquén, 'Childhood, Identity', 35.

9 Benzaquén, 'Childhood, Identity', 36–8.

10 Larry Wolff, 'When I Imagine a Child: The Idea of Childhood and the Philosophy of Memory in the Enlightenment', *Eighteenth-Century Studies*, 31/4 (1998), 381.

11 Alphonse-Louis Leroy, *Médicine Maternelle, ou l'art d'élever et de conserver les enfants* (Paris: Méquignon, 1803), p. xxii.

12 René Descartes, *Discours de la méthode*, ed. by J. M. Fataud (Paris: Dessain et Tolra, 1984), p. 64.

13 John Locke, *An Essay Concerning Human Understanding*, ed. by John Yolton (London: J. M. Dent, 1993), p. 56.

14 David Hume in Wolff, 'Imagine a Child', 379.

15 Étienne Bonnot Abbé de Condillac, *Treatise on the Sensations*, in Wolff, 'Imagine a Child', 386.

16 Wolff, 'Imagine a Child', 379.

17 Georges-Louis Leclerc Comte de Buffon, *Histoire Naturelle (Vol. 7: Discours sur la nature des animaux)*, (Paris: Imprimerie royale, 1753), p. 29.

18 Benzaquén, 'Childhood, Identity', 53.

19 Georges-Louis Leclerc Comte de Buffon, *Histoire Naturelle (Vol. 14: Nomenclature des Singes)*, (Paris: Imprimerie royale, 1766), pp. 33–4.

20 Benzaquén, 'Childhood Identity', 43.

21 Benzaquén, 'Childhood Identity', 48.

22 Carpenter, *Secret Gardens*, p. 1.

23 Jean-Jacques Rousseau, *The Confessions*, trans. by J. M. Cohen (New York: Penguin, 1953), pp. 529–30.

24 Peter Coveney, *The Image of Childhood* (Harmondsworth: Penguin Books, 1967), p. 46.

Notes

[25] Johann Wolfgang von Goethe in Ariel Durant and Will Durant, *The Story of Civilisation, Volume 10: Rousseau and Revolution* (New York: Simon & Schuster, 1968), p. 889.

[26] Melanie Klein, *The Psychoanalysis of Children*, trans. by Alix Strachey (New York: Grove Press Inc., 1960), p. 259.

[27] Jules Steeg, 'Introduction', in Jean-Jacques Rousseau, *Emile; or, Concerning Education*, trans. by Eleanor Worthington (Boston MA: D. C. Heath & Company, 1889), p. 1.

[28] Benzaquén, 'Childhood, Identity', 44.

[29] Peter Gay, *The Naked Heart* (New York: W. W. Norton, 1995), pp. 106–9.

[30] Michael Morpurgo, 'Foreword', in Hugh Cunningham, *The Invention of Childhood* (London: BBC Books, 2006), p. 10.

[31] F. R. Leavis, 'Introduction', in Coveney, *Image of Childhood*, p. 17.

[32] Alice Law, *The Cult of the Child-Spirit in Modern Literature*, in Goldstone, 'Views of Childhood', 793.

[33] Clabaugh, 'Perspectives on Childhood', 7.

[34] Jean-Jacques Rousseau in Raymond Trousson, 'Victor Hugo juge de Jean-Jacques Rousseau', *Revue d'Histoire littéraire de la France*, 86/6 (1986), 982.

[35] Arthur O. Lovejoy, 'The Supposed Primitivism of Rousseau's Discourse on Inequality', *Modern Philology*, 21/2 (1923), pp. 177–8.

[36] Wolff, 'Imagine a Child', 391; Rousseau, *Emile*, trans. by Worthington, p. 60, p. 22.

[37] Buffon, *Nomenclature des Singes*, p. 36.

[38] C. G. Jung, *Memories, Dreams, Reflections* (Waukegan IL: Fontana Press, 1995), p. 272.

[39] Cunningham, *Invention of Childhood*, p. 113.

[40] Durant and Durant, *Story of Civilisation*, p. 191.

[41] Daniel R. Guernsey, 'Childhood and Aesthetic Education: The Role of *Émile* in the Formation of Gustave Courbet's *The Painter's Studio*', in Marilyn R. Brown (ed.), *Picturing Children: Construction of Childhood between Rousseau and Freud* (Aldershot: Ashgate Publishing Company, 2002), p. 73.

[42] Rousseau, *Emile*, trans. by Worthington, p. 19.

[43] Rousseau, *Emile*, trans. by Worthington, p. 52.

[44] Mary Nichols, 'Rousseau's Novel Education in the *Emile*', *Political Theory*, 13/4 (1985), 536.

[45] Jean-Jacques Rousseau, *Emile*, trans. by Barbara Foxley (London: J. M. Dent, 1993), p. 170.

[46] Sally J. Scholz, 'That All Children Should Be Free: Beauvoir, Rousseau, and Childhood', *Hypatia*, 25/2 (2010), 405.

Notes

47 Rousseau, *Confessions*, trans. by Cohen, p. 20.

48 Michel Foucault, *Abnormal: Lectures at the Collège de France 1974–1975*, trans. by Graham Burchell (London: Verso Publishing, 2003), p. 70.

49 Daniel Thomas Cook, 'A Politics of Becoming: When "Child" is Not Enough', *Childhood*, 22/1 (2015), 5.

50 Rousseau, *Emile*, trans. by Worthington, pp. 15–16.

51 Steeg, 'Introduction', p. 6.

52 Rousseau, *Emile*, trans. by Worthington, p. 54.

53 Steeg, 'Introduction', p. 6.

54 Rousseau, *Emile*, trans. by Worthington, p. 18.

55 Sarah Kofman and Mara Dukats, 'Rousseau's Phallocratic Ends', *Hypatia*, 3/3 (1989), 123–5.

56 Scholz, 'Children Should Be Free', 396.

57 Rousseau, *Emile*, trans. by Foxley, p. 393.

58 Simone de Beauvoir, *The Ethics of Ambiguity*, trans. by Bernard Frechtman (Secaucus NJ: Citadel Press, 1948), p. 37.

59 Jung, *Memories, Dreams, Reflections*, p. 272.

60 Fredrika Scarth, *The Other Within* (Lanham MD: Rowman and Littlefield, 2004), p. 73.

61 Scholz, 'Children Should Be Free', 402.

62 Wolff, 'Imagine a Child', 377–8.

63 Leavis, 'Introduction', p. 16.

64 Wolff, 'Imagine a Child', 377–8.

65 Justin Cartwright, *White Lightening* (London: Sceptre, 2002), p. 200.

66 Benzaquén, 'Childhood, Identity', 36.

67 Anne Higonnet, 'What Do You Want To Know About Children?', in Brown (ed.), *Picturing Children*, p. 205.

68 Linda A. Pollock, 'Foreword', In Brown (ed.), *Picturing Children*, p xix.

69 Coveney, *Image of Childhood*, p. 41.

70 Lovejoy, 'Supposed Primitivism', 165.

71 Lovejoy, 'Supposed Primitivism', 170–1.

72 Richard Shiff, 'From Primitivist Phylogeny to Formalist Ontogeny: Roger Fry and Children's Drawings', in Jonathan Fineberg (ed.), *Discovering Child Art: Essays on Childhood, Primitivism and Modernism* (Princeton NJ: Princeton University Press, 1998), p. 176.

73 Lovejoy, 'Supposed Primitivism', 165–6.

74 Marilyn R. Brown, 'Introduction: Baudelaire between Rousseau and Freud', in Brown (ed.), *Picturing Children*, p. 3.

75 Shiff, 'Primitivist Phylogeny', p. 162.

Notes

[76] Shiff, 'Primitivist Phylogeny', p. 180.

[77] John Carlin, 'From Wonder to Blunder: The Child is Mother to the Man', in Fineberg (ed.), *Discovering Child Art*, p. 242.

[78] Rousseau, *Emile*, trans. by Worthington, p. 12.

[79] Louis-François Jauffret, 'Prix proposé par la Société des Observateurs de l'homme, pour l'an 11', *Magasin encyclopédique*, 4/16 (1801–2), 541.

[80] Scholz, 'Children Should Be Free', 410.

[81] Benzaquén, 'Childhood, Identity', 50.

[82] Linda Nochlin, *Realism* (London: Penguin, 1971).

[83] George R. Havens, 'Romanticism in France', *PMLA*, 55/1 (1940), 19.

[84] Walder, 'Remembering Rousseau', 424.

[85] Sarah Faunce and Linda Nochlin, *Courbet Reconsidered* (New York: Brooklyn Museum Press, 1988), pp. 4–6.

[86] John Berger, *The Success and Failure of Picasso* (London: Penguin Books Ltd, 1965), p. 52–3.

[87] Benedict Nicolson, *Courbet: The Studio of the Painter* (London: Allen Lane, 1973), p. 60.

[88] Gustave Courbet, in Fabrice Masanès, *Gustave Courbet* (Cologne: Taschen, 2006), p. 48.

[89] House, 'Curiosité', p. 41.

[90] Jean-Jacques Rousseau, in Guernsey, 'Aesthetic Education', p. 77.

[91] Guernsey, 'Aesthetic Education', p. 80.

[92] Shiff, 'Primitivist Phylogeny', p. 180.

[93] Shiff, 'Primitivist Phylogeny', p. 181.

[94] Meyer Schapiro, 'Courbet and Popular Imagery: An Essay on Realism and Naiveté', *Journal of the Warburg and Courtauld Institutes*, 4/3–4 (1941), 164.

[95] Rousseau, *Emile*, trans. by Worthington, p. 103.

[96] Schapiro, 'Popular Imagery', 166, 171.

[97] Werner Hoffman, 'The Art of Unlearning', in Fineberg (ed.), *Discovering Child Art*, p. 9.

[98] Hoffman, 'Art of Unlearning', p. 3.

[99] Richard Shiff, 'To Move the Eyes: Impressionism, Symbolism and Well-Being, *c.*1891', in Richard Hobbs (ed.), *Impressions of French Modernity: Art and Literature in France 1850–1900* (Manchester: Manchester University Press, 1998), p. 204.

[100] Lovejoy, 'Supposed Primitivism', 180.

[101] Coveney, *Image of Childhood*, p. 35.

[102] Ellen Handler Spitz, *The Brightening Glance: Imagination and Childhood* (New York: Random House, 2007), pp. 13–14.

Notes

Chapter 3

1 Edgar Degas, in Jeanne Fevre, *Mon oncle Degas: souvenirs et document inédits* (Geneva: P. Cailler, 1949), p. 138.

2 Victor Hugo, *Les Misérables*, vol. 4, trans. by Isabel F. Hapgood (New York: Thomas Y. Crowell & Co., 1987) (Project Gutenberg eBook), book 1, ch. 4.

3 Douglas Crimp, 'Positive/Negative: A Note on Degas's Photographs', *October*, 5 (1978), 100.

4 John Andrew Frey, *A Victor Hugo Encyclopedia* (Santa Barbara CA: Greenwood Publishing Group, 1999).

5 Peter Coveney, *The Image of Childhood* (Harmondsworth: Penguin Books, 1967), p. 119.

6 William Fortescue, *The Third Republic in France 1870–1940: Conflicts and Continuities* (London: Routledge, 2000), p. 1.

7 Sylvia Schafer, *Children in Moral Danger and the Problem of Government in Third Republic France* (Princeton NJ: Princeton University Press, 1997), p. 8.

8 Colin Heywood, *Growing Up in France: From the* Ancien Régime *to the Third Republic* (Cambridge: Cambridge University Press, 2007), p. 3.

9 Stephen Bann, *The Clothing of Clio: A Study of the Representation of History in Nineteenth-Century Britain and France* (Cambridge: Cambridge University Press, 1984), p. 53.

10 Hugh Cunningham, *The Invention of Childhood* (London: BBC Books, 2006), p. 187.

11 Heywood, *Growing Up in France*, p. 177.

12 Philip Stewart, 'The Child Comes of Age', in Heywood, *Growing Up in France*, p. 1.

13 Jesse R. Pitts, in Stacy Schiff, *Saint-Exupéry: A Biography* (London: Pimlico, 1996), p. 31.

14 Richard Shiff, 'Roger Fry and Children's Drawings', in Jonathan Fineberg (ed.), *Discovering Child Art: Essays on Childhood, Primitivism and Modernism* (Princeton NJ: Princeton University Press, 1998), p. 160.

15 Sylvia Schafer, 'When the Child is the Father of the Man: Work, Sexual Difference and the Guardian State in Third Republic France', *History and Theory*, 31/4 (1992), 99.

16 Schafer, *Children in Moral Danger*, p. 43.

17 Henri Duval, *Manuel de l'enfance, ou Petit cours d'éducation physique et morale, suivi d'une nouvelle méthode de lecture* (Paris: Johanneau, 1840).

18 Schafer, *Children in Moral Danger*, p. 25.

19 Michelle Perrot, 'Sur la segregation de l'enfance au XIX siècle', *La Psychiatrie de l'enfant*, 25/1 (1989), 204.

Notes

[20] Linda L. Clark, 'Review of Sylvia Schafer's *Children in Moral Danger and the Problem of Government in Third Republic France*', *The American History Review*, 104/10 (1999), 252.

[21] Heywood, *Growing Up in France*, p. 286.

[22] E. H. Erikson, *Childhood and Society* (New York: Vintage Publishing, 1995), p. 99.

[23] Raymond Grew, 'Picturing the People: Images of the Lower Orders in Nineteenth-Century French Art', *The Journal of Interdisciplinary History*, 17/1 (1996), 203.

[24] Heywood, *Growing Up in France*, pp. 261–2.

[25] Jacques Bonzon, *La Réforme du service des enfants assistés* (Paris: Berger-Levrault, 1901), p. 3.

[26] Patricia Holland, *Picturing Childhood: The Myth of the Child in Popular Imagery* (London: I. B. Tauris & Co. Ltd, 2006), p. 12.

[27] Heywood, *Growing Up in France*, p. 1.

[28] George Dimock, 'Children's Studies and the Romantic Child', in Marilyn R. Brown (ed.), *Picturing Children: Constructions of Childhood between Rousseau and Freud* (Aldershot: Ashgate Publishing Company, 2002), p. 192.

[29] Holland, *Picturing Childhood*, p. 143.

[30] Edward Ousselin, 'Victor Hugo's European Utopia', *Nineteenth-Century French Studies*, 34/1 (2006), 37.

[31] Raymond Trousson, 'Victor Hugo juge de Jean-Jacques Rousseau', *Revue d'Histoire littéraire de la France*, 86/6 (1986), 979–80.

[32] Cunningham, *Invention of Childhood*, p. 149.

[33] Heywood, *Growing Up in France*, p. 60.

[34] Ousselin, 'Hugo's European Utopia', 32.

[35] Holland, *Picturing Childhood*, p. 143.

[36] Guy F. Imhoff, 'Jeux d'ombre et de lumière dans *Les Misérables* de Victor Hugo', *Nineteenth-Century French Studies*, 29/1 (2001), 65.

[37] Victor Hugo, *Les Misérables*, ed. by Maurice Allem (Paris: Edition de la Pléaide, 1951), p. 1030.

[38] Hugo, *Les Misérables*, ed. by Allem, p. 415.

[39] Joakim Reinhard, 'Victor Hugo's Novels I', *The Sewanee Review*, 7/1 (1899), 42.

[40] Hugo, *Les Misérables*, ed. by Allem, p. 1202.

[41] Richard N. Coe, *When the Grass was Taller: Autobiography and the Experience of Childhood*, (New Haven CT: Yale University Press, 1984), pp. 35–6.

[42] Holland, *Picturing Childhood*, p. 158

[43] Victor Hugo, in Reinhard, 'Victor Hugo's Novels I', 40.

[44] Valerie Walkerdine, *Daddy's Girl: Young Girls and Popular Culture* (Cambridge MA: Harvard University Press, 1997), p. 9.

Notes

[45] Walkerdine, *Daddy's Girl*, p. 140.

[46] Tamar Garb, *The Body in Time: Figures of Femininity in Late Nineteenth-Century France*, (Seattle WA: University of Washington Press, 2008), p. 8.

[47] Gail Reekie, 'Decently Dressed? Sexualised Consumerism and the Working Woman's Wardrobe 1918–1923', *Labour History*, 61 (1991), 55.

[48] Susan P. Casteras, 'Winged Fantasies: Constructions of Childhood, Innocence, Adolescence, and Sexuality in Victorian Fairy Painting', in Brown (ed.), *Picturing Children*, p. 130.

[49] Casteras, 'Winged Fantasies', p. 127.

[50] Max Liebermann and Adrian Stokes, 'Degas', *The Artist: An Illustrated Monthly Record of Arts, Crafts and Industries*, 28/247 (1900), 118.

[51] Casteras, 'Winged Fantasies', p. 130.

[52] Garb, *Body in Time*, p. 20.

[53] Alexandra Carter, 'Blonde, Bewigged and Winged with Gold: Ballet Girls in the Music Halls of Late Victorian and Edwardian England', *Dance Research: The Journal of the Society for Dance Research*, 13/2 (1995), 38.

[54] Charles Baudelaire, 'Morale du joujou (et du pauvre)', *Le Monde littéraire*, (1853) (Bibliothèque Municipale de Lisieux electronic collection), *www.bmlisieux.com/litterature/baudelaire/moraljou.htm* (last accessed 9 October 2023). This concept first appeared in Baudelaire's *Le joujou de pauvre* ('The Plaything of the Poor'), which, written as part of some fifty-one prose poems constituting his famous posthumously published *Paris Spleen* (1869), remains frequently linked to the separate short prose piece titled *Morale du joujou* ('Moral of the Plaything') (1853). In one revelatory moment of the story, a poor beggar child shows his curious middle-class equivalent his own most cherished toy: a living rat. The rich child's captivation with the poor child's living toy points to the inevitable dissatisfaction with the manufactured toy's lifelessness and points to the fascination instead, therefore, with the idea of the 'living toy'.

[55] Baudelaire, 'Morale du joujou'.

[56] R. McMullen, *Degas: His Life, Times and Work* (Boston MA: Houghton Mifflin, 1985), p. 134.

[57] Richard Kendall, 'Degas and the Contingency of Vision', *The Burlington Magazine*, 130/1020 (1988), 191.

[58] Garb, *Body in Time*, p. 4.

[59] Garb, *Body in Time*, p. 4.

[60] 'Protection of Young Girls', *The British Medical Journal*, 1/1209 (1884), 430.

[61] Diane Waggoner, 'Photographing Childhood – Lewis Carroll and Alice', in Brown (ed.), *Picturing Children*, p. 153.

Notes

[62] Garb, *Body in Time*, p. 38.

[63] Félix Fénéon, in Joan Halperin, *Felix Fénéon: Oeuvres plus que completes* (Geneva: Librairie Droz, 1970), p. 6.

[64] Colta Ives, 'French Prints in the Era of Impressionism and Symbolism', *The Metropolitan Museum of Art Bulletin*, 46/1 (1988), 16.

[65] Douglas Crimp, 'Positive/Negative: A Note on Degas's Photographs', *October*, 5 (1978), 91.

[66] Stéphane Mallarmé, 'Ballets', in Stéphane Mallarmé, *Selected Prose, Poems, Essays, and Letters*, trans. Branford Cook (Baltimore MD: Johns Hopkins Press, 1956), p. 62.

[67] James Huneker, *Promenades of an Impressionist* (New York: Charles Scribner's Sons, 1910), p. 82.

[68] Gustave Geffroy, *La Vie Artistique* (Paris: E. Dentu, 1894), p. 173.

[69] Garb, *Body in Time*, p. 21.

[70] Carter, 'Blonde, Bewigged', 38.

[71] Walkerdine, *Daddy's Girl*, p. 44.

[72] Tim Marlow, 'Tim Marlow on … Degas, Sicket & Toulouse-Lautrec' (television programme), Channel 5 (2005).

[73] Paul Mantz, 'L'Exposition des oeuvres des artistes indépendants', *Le Temps*, (1881), 3.

[74] Jules Claretie, *La Vie à Paris, 1881* (Paris: Victor Harvard, 1882), p. 150.

[75] Holland, *Picturing Childhood*, p. 158.

[76] Richard B. Grant, 'Victor's Hugo's "Le Rhin" and the Search for Identity', *Nineteenth-Century French Studies*, 23/3 (1995), 328.

[77] Cunningham, *Invention of Childhood*, p. 168.

[78] Joan K. Stemmler, 'The Physiognomical Portraits of Johann Caspar Lavater', *The Art Bulletin*, 75/1 (1993), 151.

[79] Ludmilla Jordanova, 'Reading Faces in the Nineteenth Century', *Art History*, 13/4 (1990), 571.

[80] Stemmler, 'Physiognomical Portraits', 157.

[81] Lisa Bixenstine Safford, 'Mallarmé's Influence on Degas' Aesthetic of Dance in his Late Period', *Nineteenth-Century French Studies*, 21/3–4 (1993), 426.

[82] Daniel Halévy, *Pays Parisiens*, trans. by Mina Curtiss (London: Vintage Books, 1966), p. 114.

[83] Victor Hugo, in David Gervais, 'Hugo and Victor Hugo', *The Cambridge Quarterly*, 28/2 (1999), 117.

[84] Victor Hugo, *Les Misérables*, vol. 2, trans. by Norman Denny (Harmondsworth: Penguin, 1980), p. 117.

[85] Theodore Nottingham, *Hugo: The Strange Life and Visions of Victor Hugo* (Indianapolis IN: Theosis Books, 2011), p. 6.

Notes

86 Trousson, 'Victor Hugo', 982.

87 Joanna Richardson, *Victor Hugo* (New York: St Martin's Press, 1976), p. 171.

88 Kathryn M. Grossman, 'Homelessness, Wastelands, and Barricades: Transforming Dystopian Spaces in Les Misérables', *Utopian Studies*, 4 (1991), 30.

89 Michael Morpurgo, in Cunningham, *Invention of Childhood*, p. 11.

90 Heywood, *Growing Up in France*, p. 196.

91 Grossman, 'Homelessness, Wastelands, and Barricades', 30.

92 Grossman, 'Homelessness, Wastelands, and Barricades', 30.

93 Hugo, *Les Misérables*, vol. 1, trans. by Denny, p. 639.

94 Grossman, 'Homelessness, Wastelands, and Barricades', 30.

95 Hugo, *Les Misérables*, vol. 5, trans. by Hapgood, book 1, ch. 15.

96 Nathan Kernan, 'Review: *Shadows of a Hand: The Drawings of Victor Hugo*', *On Paper*, 2/6 (1998), 40–1.

97 Halévy, *Pays Parisiens*, p. 116.

98 Reinhard, 'Victor Hugo's Novels I', 38.

99 Grant, 'Victor's Hugo's "Le Rhin"', 325.

100 Richard B. Grant, 'Victor Hugo's "Le Deux Archers": Patterns of Disguise and Revelation', *Romance Notes*, 32/3 (1992), 217.

101 Grant, 'Victor Hugo's "Le Rhin"', 326.

102 Hugo, *Les Misérables*, vol. 1, trans. by Denny, p. 498.

103 Hugo, *Les Misérables*, vol. 1, trans. by Hapgood, book 4, ch. 2.

104 Halévy, *Pays Parisiens*, p. 10.

Chapter 4

1 Marcel Proust, *In Search of Lost Time, Volume VII: Time Regained*, trans. by C. K. Scott Moncrieff and Terence Kilmartin (London: Vintage Books, 2005), p 431.

2 Odilon Redon, *To Myself: Notes on Life, Art, and Artists*, trans. by Jacob Mira and Jeanne L. Wasserman (New York: George Braziller, 1996), p. 10.

3 Lorna Martens, *The Promise of Memory, Childhood Recollection and its Objects in Literary Modernism* (Cambridge MA: Harvard University Press, 2011), p. 2.

4 Ronald Bogue, 'Difference and Repetition in Deleuze's Proustian Sign and Time Machine', *Concentric: Studies in English Literature and Language*, 27/1 (2001), 20.

5 Martens, *Promise of Memory*, p. 19.

6 Gilles Deleuze, *Proust and Signs*, trans. by Richard Howard (New York: Continuum Publishing, 2000), pp. 18–25.

7 Carol Mavor, *Reading Boyishly*, (Durham NC: Duke University Press, 2007), p. 317.

Notes

8 Philippe Ariès, *Centuries of Childhood: A Social History of Family Life*, trans. by Robert Baldick (London: Jonathan Cape Ltd, 1962); Mark Poster, *Critical Theory of the Family* (New York: Continuum Publishing, 1988).

9 Linda A. Pollock, in Marilyn R. Brown (ed.), *Picturing Children: Constructions of Childhood between Rousseau and Freud* (Aldershot: Ashgate Publishing Company, 2002), p. xv.

10 Ralph Rugoff, *The Eye of the Needle: The Unique World of Micro-Miniatures of Hagop Sandaldjian* (Los Angeles CA: Museum of Jurassic Technology and the Society for the Diffusion of Useful Information, 1996), p. 31.

11 Ariès, *Centuries of Childhood*, p. 412.

12 L. Wylie, in Ariès, *Centuries of Childhood*, p. 118.

13 Ariès, *Centuries of Childhood*, p. 119.

14 Poster, *Critical Theory*, p. 170.

15 Poster, *Critical Theory*, p. 170.

16 Joseph Litvak, 'Taste, Waste, Proust', in Joseph Litvak, *Strange Gourmets: Sophistication, Theory, and the Novel* (Durham NC: Duke University Press, 1997), p. 108.

17 Proust, *Time Regained*, p. 354.

18 Marcel Proust, in Céleste Albaret, *Monsieur Proust*, trans. by Barbara Bray (New York: New York Review of Books, 2003), p. 148.

19 Julia Kristeva, *Time and Sense: Proust and the Experience of Literature*, trans. by Ross Guberman (New York: Columbia University Press, 1996), p. 304.

20 Mavor, *Reading Boyishly*, p. 112.

21 D. W. Winnicott, *Playing and Reality* (London: Routledge, 2005), p. 23.

22 Deleuze, *Proust and Signs*, p. 3.

23 Marcel Proust, in W. L. Werner, 'The Psychology of Marcel Proust', *The Sewanee Review*, 39/3 (1931), 277.

24 Walter Benjamin, *Illuminations: Essays and Reflections*, trans. by Harry Zohn, ed. by Hannah Arendt (New York: Schocken Books, 1968), p. 202.

25 Martens, *Promise of Memory*, p. 60.

26 E. H. Erikson, *Childhood and Society* (New York: Vintage Publishing, 1995), p. 270.

27 Petra Ten-Doesschate Chu, 'Family Matters: The Construction of Childhood in Nineteenth-Century Artists' Biographies', in Brown (ed.), *Picturing Children*, p. 62.

28 Erikson, *Childhood and Society*, p. 99.

29 Evelyne, Bloch-Dano, *Madame Proust: A Biography*, trans. by Alice Kaplan (Chicago IL: University of Chicago Press, 2007), p. 62.

30 Erikson, *Childhood and Society*, p. 187.

31 Martens, *Promise of Memory*, p. 3.

32 Molière, in Ariès, *Centuries of Childhood*, p. 128.

Notes

[33] Peter Coveney, *The Image of Childhood* (Harmondsworth: Penguin Books, 1967), p. 106.

[34] Coveney, *Image of Childhood*, p.118.

[35] Mavor, *Reading Boyishly*, p. 150.

[36] Bloch-Dano, *Madame Proust*, p. 111.

[37] Mavor, *Reading Boyishly*, p. 32.

[38] Marcel Proust, *In Search of Lost Time, Volume I: Swann's Way*, trans. by C. K. Scott Moncrieff and Terence Kilmartin (London: Vintage Books, 2005), p. 12.

[39] Melanie Klein, *The Psychoanalysis of Children*, trans. by Alix Strachey (New York: Grove Press Inc., 1960), p. 37.

[40] Philippe Jullian, *The Symbolists* (London: Phaidon Press Limited, 1977), p. 19.

[41] Stephen Eisenman, *The Temptation of Saint Redon: Biology, Ideology and Style in the Noirs* (Chicago IL: University of Chicago Press, 1992), p. 10.

[42] Eisenman, *Saint Redon*, p. 10.

[43] Edmund White, *Marcel Proust: A Life* (New York: Penguin Books, 2009), p. 64.

[44] Marcel Proust, in White, *Marcel Proust*, p. 89.

[45] White, *Marcel Proust*, p. 89.

[46] Russell T. Clement, *Four French Symbolists: A Sourcebook on Pierre Puvis de Chavannes, Gustave Moreau, Odilon Redon and Maurice Denis* (Westport CT: Greenwood Press, 1996), p. 220.

[47] Benjamin, *Illuminations*, p. 213.

[48] Eisenman, *Saint Redon*, p. 186.

[49] Jean Yves Tadié, *Marcel Proust: A Life*, trans. by Euan Cameron (New York: Penguin Books Ltd, 2001), p. xvi.

[50] Eisenman, *Saint Redon*, p. 79.

[51] Mavor, *Reading Boyishly*, p. 78.

[52] G. G. Pospelov, 'Larionov and Children's Drawing', in Jonathan Fineberg (ed.), *Discovering Child Art: Essays on Childhood, Primitivism and Modernism* (Princeton NJ: Princeton University Press, 1998), p. 51.

[53] Oscar Milosz, in Gaston Bachelard, *The Poetics of Space*, trans. by Maria Jolas (Boston MA: Beacon Press, 1994), p. 45.

[54] Benjamin, *Illuminations*, p. 203.

[55] Peter Stallybrass, 'Marx's Coat', in Patricia Spyer (ed.), *Border Fetishisms: Material Objects in Unstable Spaces* (London: Routledge, 1998), p. 196.

[56] Marcel Proust, *In Search of Lost Time, Volume IV: Sodom and Gomorrah*, trans. by C. K. Scott Moncrieff and Terence Kilmartin (London: Vintage Books, 2005), p. 440.

[57] Proust, *Swann's Way*, p. 224.

[58] Mavor, *Reading Boyishly*, p. 301.

Notes

59 Brassaï, *Proust in the Power of Photography*, trans. by Richard Howard (Chicago IL: Chicago University Press, 1997), p. 140.
60 Coveney, *Image of Childhood*, p. 198.
61 Diana Fuss, *The Sense of the Interior: Four Writers and the Rooms that Shaped Them* (London: Routledge, 2005), p. 152.
62 Proust, *Time Regained*, p. 350.
63 Proust, *Swann's Way*, p. 8.
64 Proust, *Swann's Way*, p. 8.
65 Proust, *Swann's Way*, p. 10.
66 Patricia Holland, *Picturing Childhood: The Myth of the Child in Popular Imagery* (London: I. B. Tauris & Co. Ltd, 2006), p. 6.
67 Coveney, *Image of Childhood*, p. 194.
68 Marcel Proust, 'A mon ami Willie Heath: mort à Paris le 3 octobre 1893', in *Les Plaisirs et les jours* (Paris: Librairie Gallimard, 1924), pp. 13–14.
69 Marcel Proust, in Werner, 'Psychology', 277.
70 Ranjana Khanna, *Dark Continents: Psychoanalysis and Colonialism* (Durham NC: Duke University Press, 2003), pp. 91–5.
71 Michael Balint, *Thrills and Regressions* (New York: International Universities Press, 1959), p. 75.
72 Redon, *To Myself*, p. 97.
73 Eisenman, *Saint Redon*, p. 10.
74 Mavor, *Reading Boyishly*, p. 32.
75 Ten-Doesschate Chu, 'Family matters', p. 66.
76 Redon, *To Myself*, p. 24.
77 Bloch-Dano, *Madame Proust*, p. 70.
78 Olaf Breidbach and Irenäus Eibl-Eibesfeldt (eds), *Art Forms in Nature: Prints of Ernst Haeckel* (Munich: Prestel Publishing, 1998), p. 7.
79 Lynn Gamwell, 'Beyond the Visible: Microscopy, Nature and Art', *Science*, 299 (2003), 49–50.
80 Eisenman, *Saint Redon*, p. 20.
81 Amédée Pigeon, 'Le Courrier Républicain', in Eisenman, *Saint Redon*, p. 102.
82 Max Hollein and Margaret Stuffmann (eds), *Odilon Redon: As in a Dream* (Stuttgart: Hatje Cantz, 2007), p. 17.
83 Gamwell, 'Beyond the Visible', 50.
84 Barbara Larson, 'Evolution and Degeneration in the Early Work of Odilon Redon', *Nineteenth-Century Art Worldwide*, 2/1 (2003), 1.
85 André Mellerio, 'Interview with Odilon Redon', 30 November 1891, Mellerio Archive, Art Institute of Chicago.

Notes

86 H. D. Schotsman, 'Clavaud: Sa vie – son œuvre', *Bulletin du Centre Recherches Scientifiques de Biarritz*, 8/4 (1971), 755.

87 'Actes de la Société linnéenne de Bordeaux', in Larson, 'Evolution', 2.

88 Breidbach and Eibl-Eibesfeldt, *Art Forms*, p. 9.

89 Gamwell, 'Beyond the Visible', 49.

90 Martens, *Promise of Memory*, p. 21.

91 Daniel R. Guernsey, 'Childhood and Aesthetic Education: The Role of *Emile* in the Formation of Gustave Courbet's *The Painter's Studio*', in Brown (ed.), *Picturing Children*, p. 72.

92 Coveney, *Image of Childhood*, p. 240.

93 Coveney, *Image of Childhood*, p. 241.

94 Jodi Hauptman, *Beyond the Visible: The Art of Odilon Redon* (New York: Museum of Modern Art, 2005), p. 59.

95 Redon, *To Myself*, p. 105.

96 Stéphane Mallarmé, in Jullian, *The Symbolists*, p. 16.

97 Sophie Handler, 'Redon, Odilon (1840–1916)', *The Routledge Encyclopedia of Modernism* (Oxford: Taylor and Francis, 2016), *www.rem.routledge.com/articles/redon-odilon-1840-1916* (last accessed 4 April 2023).

98 Jullian, *The Symbolists*, p. 51, p. 42.

99 Jullian, *The Symbolists*, p. 22.

100 Redon, *To Myself*, p. 121.

101 Roland Barthes, *Camera Lucida: Reflections on Photography*, trans. by Richard Howard (New York: Hill and Wang, 1981) p. 7.

102 Carol Mavor, 'Introduction: The Unmaking of Children', in Brown (ed.), *Picturing Children*, p. 28.

103 Albert Charles, *La Révolution de 1848 et la seconde République à Bordeaux et dans le département de la Gironde* (Bordeaux: Editions Delmas, 1945), p. 37

104 Mavor, 'Unmaking of Children', p. 32.

105 Bachelard, *Poetics of Space*, p. 126.

106 Ellen Handler Spitz, *The Brightening Glance: Imagination and Childhood* (New York: Random House, 2007), p. 138.

107 Mavor, *Reading Boyishly*, p. 54.

108 Winnicott, *Playing and Reality*, p. 10.

109 Klein, *Psychoanalysis of Children*, p. 259.

110 Roland Barthes, *Roland Barthes by Roland Barthes*, trans. by Richard Howard (New York: Hill and Wang, 1977), p. 121.

111 Spitz, *Illuminating Childhood*, p. 18.

Notes

[112] Randi Marie Birn, 'The Windows of Imagination in "A la recherche du temps perdu"', *Pacific Coast Philology*, 5 (1970), 8.

[113] Spitz, *Brightening Glance*, p. 133.

[114] Louise Bourgeois, in Spitz, *Illuminating Childhood*, p. 50.

[115] Ellen Handler Spitz, *Inside Picture Books* (New Haven CT: Yale University Press, 2000), p. 1.

[116] Spitz, *Illuminating Childhood*, p. 96.

Chapter 5

[1] Valerie Walkerdine, 'Femininity as Performance', *Oxford Review of Education*, 15/3 (1989), 267.

[2] Tamar Garb, *The Body in Time: Figures of Femininity in Late Nineteenth-Century France* (Seattle WA: University of Washington Press, 2008), pp. 46–51.

[3] Linda A. Pollock, 'Foreword', in Marilyn R. Brown (ed.) *Picturing Children: Constructions of Childhood between Rousseau and Freud* (Aldershot: Ashgate Publishing Company, 2002), p. xv.

[4] Winifred H. Mills, 'Creative Work with Children in the Field of Puppets', *Junior-Senior High School Clearing House*, 5/8 (1931), 471.

[5] David Hopkins, *Childish Things* (Edinburgh: The Fruitmarket Gallery, 2010), p. 30.

[6] *Oxford English Dictionary*, 'toy' (noun), *www.oed.com/view/Entry/204133?rskey=51 4W0Y&result=1&isAdvanced=false#eid* (last accessed 4 April 2023)

[7] Anika Schleinzer, 'Rehearsed Technology: The Definition of Technical Toys in the Early 20th Century', *Icon*, 20/2 (2014), 28–9.

[8] Ann Oakley, *Sex, Gender and Society* (Aldershot: Arena Publishing, 1974).

[9] Carrie Paechter, *Being Boys; Being Girls: Learning Masculinities and Femininities* (New York: McGraw Hill Education: 2007), p. 7.

[10] Valerie Walkerdine, *Schoolgirl Fictions* (New York: Verso Publishing, 1990), p. 105.

[11] Paul Smith. *Impressionism: Beneath the Surface* (Upper Saddle River NJ: Prentice Hall, 1995), pp. 62–3.

[12] Christopher P. Barton and Kyle Somerville, 'Play Things: Children's Radicalised Mechanical Banks and Toys, 1880–1930', *International Journal of Historical Archaeology*, 16/1 (2012), 53.

[13] Judith Butler, *Gender Trouble: Feminism and the Subversion of Identity* (London: Routledge, 1990), pp. 140–1.

[14] Joseph Wachelder, 'Toys as Mediators', *Icon*, 13 (2007), 136.

Notes

15 Joan W. Scott, 'Gender: A Useful Category of Historical Analysis', in Annette F. Timm and Joshua A. Sanborn, *Gender, Sex and the Shaping of Modern Europe: A History from the French Revolution to the Present Day* (Oxford, Berg: 2007), pp. 8–9.

16 Paechter, *Being Boys; Being Girls*, p. 14.

17 Judith Butler, *Undoing Gender* (New York: Routledge, 2004), p. 10

18 Paechter, *Being Boys; Being Girls*, p. 3.

19 Paechter, *Being Boys, Being Girls*, p. 36.

20 Walkerdine, 'Femininity as Performance', p. 271.

21 Walkerdine, *Schoolgirl Fictions*, p. 117.

22 Walkerdine, *Schoolgirl Fictions*, p. 87.

23 Butler, *Undoing Gender*, p. 1.

24 R. W. Connell, *Masculinities* (Cambridge: Polity Press, 2005), p. 45.

25 Lori Baker-Sperry and Liz Grauerholz, 'The Pervasiveness and Persistence of the Feminine Beauty Ideal in Children's Fairy Tales', *Gender and Society*, 17/5 (2003), 711.

26 Andrea Dworkin, *Woman Hating* (New York: Penguin Books, 1974), p. 42.

27 Patricia Holland, *Picturing Childhood: The Myth of the Child in Popular Imagery* (London: I. B. Tauris & Co. Ltd, 2006), p. 3.

28 Jack Zipes (ed.), *The Oxford Companion to Fairy Tales* (New York: Oxford University Press, 2000), p. 282.

29 Jack Zipes, *Why Fairy Tales Stick* (New York: Routledge, 2006), p. 163.

30 Holland, *Picturing Childhood*, p. 5.

31 Denise M. Osborne, 'Bluebeard and its Multiple Layers of Meaning', *Revista Alpha*, 12 (2014), 130.

32 Butler, *Undoing Gender*, p. 70.

33 Mary Holmes, *Gender and Everyday Life* (Oxford: Routledge, 2009), pp. 15–16.

34 Walkerdine, 'Femininity as Performance', 271.

35 Paechter, *Being Boys; Being Girls*, p. 2.

36 Norma Broude, 'Degas and French Feminism, ca. 1880: "The Young Spartans", the Brothel Monotypes, and the Bathers Revisited', *The Art Bulletin*, 70/4 (1988), 651.

37 Richard Drake Mohr, 'Knights, Young Men, Boys: Masculine Worlds and Democratic Values', *Noûs*, 25/2 (1991), 202.

38 Susan Stewart, *On Longing: Narratives of the Miniature, the Gigantic, the Souvenir, the Collection* (Durham NC: Duke University Press, 1993), p. 57.

39 Edouard Fournier, *Histoire des Jouets et des Jeux d'Enfants* (Paris: E. Dentu, 1889), p. 1.

40 Émile Zola, *Au Bonheur des dames* (Montreal: La Bibliothèque Électronique de Québec, 1998), p. 491.

Notes

[41] L. A. Wilkie, 'Not Merely Child's Play: Creating a Historical Archaeology of Children and Childhood', in J. S. Derevenski (ed.), *Children and Material Culture* (New York: Routledge, 2000), p. 10.

[42] G. Cross. *Kid's Stuff: Toys and the Changing World of American Childhood* (Cambridge MA: Harvard University Press, 1997), pp. 25–6.

[43] Roger Caillois, in Anthony Burton, 'Design History and the History of Toys: Defining a Discipline for the Bethnal Green Museum of Childhood', *Journal of Design History*, 10/1 (1997), 5.

[44] Barton and Somerville, 'Play Things', 53.

[45] S. A. Bedini, 'The Role of Automata in the History of Technology', *Technology and Culture*, 5 (1964), 24.

[46] Jean-Marie Apostolidès, 'Pinocchio, or a Masculine Upbringing', *Merveilles & contes*, 2/2 (1988), 75.

[47] Stewart, *On Longing*, p. 64.

[48] Stewart, *On Longing*, p. 61.

[49] Karen E. Rowe, 'Feminism and Fairy Tales', in Jack Zipes, *Don't Bet on the Prince* (New York: Routledge, 1986), p. 209.

[50] Walkerdine, *Schoolgirl Fictions*, p. 147.

[51] Greg M. Thomas, 'Impressionist Dolls: on the commodification of girlhood in Impressionist painting', in Brown (ed.), *Picturing Children*, p. 109.

[52] Thomas, 'Impressionist Dolls', p. 107.

[53] Stewart, *On Longing*, p. 57.

[54] Thomas, 'Impressionist Dolls', p. 105.

[55] Stewart, *On Longing*, p. 62.

[56] Sigmund Freud, *The Uncanny*, trans. by David McLintock (London: Penguin, 2003), p. 124.

[57] Jeffrey Gray, '"It's Not Natural": Freud's "Uncanny" and O'Connor's "Wise Blood"', *The Southern Literary Journal*, 29/1 (1996), 67.

[58] Freud, *The Uncanny*, p. 135.

[59] Constance Eileen King, *Jumeau* (Atiglen: Schiffer Publishing, 1983), p. 92.

[60] Thomas, 'Impressionist Dolls', p. 104.

[61] Thomas, 'Impressionist Dolls', pp. 107–8.

[62] Gail Reekie, 'Decently Dressed? Sexualised Consumerism and the Working Woman's Wardrobe 1918–1923', *Labour History*, 61 (1991), 48.

[63] King, *Jumeau*, p. 72.

[64] Freud, *The Uncanny*, p. 141.

[65] King. *Jumeau*, p. 14.

[66] Rainer Maria Rilke, in Hopkins, *Childish Things*, p. 11.

Notes

67 Freud, *The Uncanny*, p. 141.

68 King. *Jumeau*, p. 40.

69 Hugh Haughton, 'Introduction', in Freud, *The Uncanny*, p. xliii.

70 Ellen Handler Spitz, *Inside Picture Books* (New Haven CT: Yale University Press, 2000), p. 16.

Chapter 6

1 Jules Lemaître, in Nancy Forgione, '"The Shadow Only": Shadow and Silhouette in the Late Nineteenth-Century Paris', *The Art Bulletin*, 81/3 (1999), 502.

2 Margery Williams, *The Velveteen Rabbit: Or How Toys Become Real* (Scotts Valley CA: CreateSpace Independent Publishing Platform, 2013), p. 8.

3 Franco Moretti, *The Bourgeois: Between History and Literature* (New York: Verso Books, 2013), p. 2.

4 Norma Broude, 'Degas and French Feminism, ca. 1880: "The Young Spartans"', the Brothel Monotypes, and the Bathers Revisited', *The Art Bulletin*, 70/4 (1988), 644.

5 Griselda Pollock, *Mary Cassatt: Painter of Modern Women* (London: Thames & Hudson, 1998), p. 2129.

6 Greg M. Thomas, 'Impressionist Dolls: on the commodification of girlhood in Impressionist painting', in Marilyn R. Brown, *Picturing Children: Constructions of Childhood between Rousseau and Freud* (Aldershot: Ashgate Publishing Company, 2002), pp. 110–11.

7 Griselda Pollock, *Vision and Difference: Feminism, Femininity and Histories of Art* (London: Routledge, 1988), p. 65.

8 Harriet Chessman, 'Mary Cassatt and the Maternal Body', in David C. Miller (ed.), *American Iconology* (New Haven CT: Yale University Press, 1993), pp. 239–58.

9 Mary Cassatt, in Frederick A. Sweet, *Miss Mary Cassatt: Impressionist from Pennsylvania* (Norman OK: University of Oklahoma Press, 1967), p. 136.

10 Thomas, 'Impressionist Dolls', p. 110.

11 René Galand, 'Baudelaire's Psychology of Play', *The French Review*, 44 (1971), 12.

12 Marilyn R. Brown, 'Introduction: Baudelaire between Rousseau and Freud', in Brown (ed.), *Picturing Children*, p. 8.

13 Melanie Klein, *The Psychoanalysis of Children*, trans. by Alix Strachey (New York: Grove Press Inc., 1960), p. 246.

14 Joseph Wachelder, 'Toys as Mediators', *Icon*, 13 (2007), 165.

15 Beatrice E. Lewis, 'Antique Toys: Vestiges of Childhoods Past', *Children's Environments Quarterly*, 1/1 (1984), 3–6.

Notes

16 Edouard Fournier, *Histoire des Jouets et des Jeux d'Enfants* (Paris: E. Dentu, 1889), pp. 98–101.

17 David Hopkins, *Childish Things* (Edinburgh: The Fruitmarket Gallery, 2010), p. 12.

18 Fournier, *Histoire des Jouets*, p. 4.

19 Ellen Handler Spitz, *Illuminating Childhood: Portraits in Fiction, Film, and Drama* (Ann Arbor MI: University of Michigan Press, 2011), p. 49.

20 Hopkins, *Childish Things*, p. 11.

21 Galand, 'Baudelaire's Psychology', 14.

22 Susan Stewart, *On Longing: Narratives of the Miniature, the Gigantic, the Souvenir, the Collection* (Durham NC: Duke University Press, 1993), p. 57.

23 Williams, *Velveteen Rabbit*, pp. 6–7.

24 Marina Warner, 'Out of an Old Toy Chest', *Journal of Aesthetic Education*, 43/2 (2009), 4.

25 Charles Baudelaire, in Warner, 'Old Toy Chest', 4.

26 Warner, 'Old Toy Chest', 9.

27 William James, *The Principles of Psychology* (Cambridge MA: Harvard University Press, 1890) (Project Gutenberg eBook) *www.gutenberg.org/cache/epub/57628/pg57628-images.html* (last accessed 9 October 2023)

28 Galand, 'Baudelaire's Psychology', 15.

29 Bernd Brunner, *Bears: A Brief History*, trans. by Lori Lantz (New Haven CT: Yale University Press, 2007), p. 43.

30 D. W. Winnicott, *The Child, the Family and the Outside World* (London: Penguin, 2000), p. 130.

31 Phillip Dennis Cate and Mary Shaw (eds), *The Spirit of Montmartre: Cabarets, Humor and the Avant-Garde, 1875–1905* (New Brunswick NJ: Rutgers University Press, 1996), pp. 55–8.

32 Barbara Stafford and Frances Terpak, *Devices of Wonder: From the World in a Box to Images on a Screen* (Los Angeles CA: Getty Research Institute, 2002), p. 77.

33 Maria Leach (ed.), *Funk and Wagnalls Standard Dictionary of Folklore, Mythology and Legend* (New York: Funk and Wagnalls, 1950), p. 1000.

34 Jules Huret, *Enquête sur l'évolution littéraire* (Paris: Fasquelle, 1913), pp. 55–65.

35 Édouard Dujardin, 'Aux XX et aux Indépendants: Le cloisonisme', *La Revue Indépendante* (1888), 489. Translation by Nancy Forgione.

36 Ellen Handler Spitz, *The Brightening Glance: Imagination and Childhood* (New York: Random House, 2007), p. 151.

37 Nancy Forgione, '"The Shadow Only": Shadow and Silhouette in the Late Nineteenth-Century Paris', *The Art Bulletin*, 81/3 (1999), 498.

Notes

[38] Sarah Gilead, 'Magic Abjured: Closure in Children's Fantasy Fiction', *PMLA*, 106/2 (1991), 278.

[39] Gilead, 'Magic Abjured', 285.

[40] Gilead, 'Magic Abjured', 286.

[41] Gilead, 'Magic Abjured', 285.

[42] Gilead, 'Magic Abjured', 285.

[43] Simon M. Elliott, 'The Problem Play in British Drama, 1890–1914', in James Hogg (ed.), *Salzburg Studies in English Literature: Poetic Drama and Poetic Theory* (Salzburg: University of Salzburg Press, 1978), pp. 227–9.

[44] Gilead, 'Magic Abjured', 286.

[45] J. M. Barrie, *Peter Pan: The Story of Peter and Wendy* (New York: Grosset & Dunlap, 1911), p. 12.

[46] Winnicott, *Playing and Reality*, p. 69.

[47] Spitz, *Brightening Glance*, p. 6.

[48] Spitz, *Brightening Glance*, p. 148.

[49] C. G. Jung, *Memories, Dreams, Reflections* (Waukegan IL: Fontana Press, 1995), p. 389.

[50] Ellen Handler Spitz, *Inside Picture Books* (New Haven CT: Yale University Press, 2000), p. 58.

[51] Spitz, *Inside Picture Books*, p. 31.

[52] Guillaume Apollinaire, *The Cubist Painters, Aesthetic Meditations* (Berkeley CA: University of California Press, 2004), p. 227.

[53] Spitz, *Inside Picture Books*, p. 14.

[54] Beryl Schlossman, 'Baudelaire's place in literary and cultural history', in Rosemary Lloyd (ed.), *Cambridge Companion to Baudelaire*, ed. by Rosemary Lloyd (Cambridge: Cambridge University Press, 1997), p. 185.

[55] Spitz, *Brightening Glance*, p. 153.

[56] Spitz, *Illuminating Childhood*, p. 192.

Conclusion

[1] Anne Higonnet, 'What Do You Want To Know About Children?', in Marilyn R. Brown (ed), *Picturing Children: Construction of Childhood between Rousseau and Freud* (Aldershot: Ashgate Publishing Company, 2002), p. 205.

[2] C. G. Jung, *Memories, Dreams, Reflections* (Waukegan IL: Fontana Press, 1995), p. 18.

[3] Carol Mavor, *Reading Boyishly* (Durham NC: Duke University Press, 2007), p. 213.

[4] Peter Coveney, *The Image of Childhood* (Harmondsworth: Penguin Books, 1967), p. 32.

Notes

5 Coveney, *Image of Childhood*, p. 241.

6 James E. Higgins, "'The Little Prince": A Legacy', *Elementary English*, 37/8 (1960), 515.

7 Mavor, *Reading Boyishly*, p. 56.

8 Roland Barthes, *Camera Lucida: Reflections on Photography*, trans. by Richard Howard (New York: Hill and Wang, 1981), p. 5.

9 Christian Boltanski, 'Studio's Visit: Christian Boltanski', *Tate Magazine*, 2 (2002).

10 Larry Wolff, 'When I Imagine a Child: The Idea of Childhood and the Philosophy of Memory in the Enlightenment', *Eighteenth-Century Studies*, 31/4 (1998), 380.

11 Wolff, 'Imagine a Child', 399.

12 Spitz, *Inside Picture Books*, p. 58.

13 Edouard Fournier, *Histoire des Jouets et des Jeux d'Enfants* (Paris: E. Dentu, 1889), p. 94.

14 Marina Warner, 'Out of an Old Toy Chest', *Journal of Aesthetic Education*, 43/2 (2009), 13.

15 Daniel Thomas Cook, 'A Politics of Becoming: When "Child" is Not Enough', *Childhood*, 22/1 (2015), 3.

16 Alphonse Leroy, *Médicine Maternelle, ou l'art d'élever et de conserver les enfants* (Paris: Méquignon, 1803), p. xxii.

17 Spitz, *Inside Picture Books*, p. 31.

18 Walter Benjamin, in Warner, 'Old Toy Chest', 13.

Bibliography

Albaret, Céleste, *Monsieur Proust*, trans. by Barbara Bray (New York: New York Review of Books, 2003).

Alexandre-Bidon/Riché, Danièle/Pierre, *L'enfance au Moyen Age* (Paris: Seuil, 1994).

Apostolidès, Jean-Marie, 'Pinocchio, or a Masculine Upbringing', *Merveilles & contes*, 2/2 (1988), 75–85.

Ariès, Philippe, *Centuries of Childhood: A Social History of Family Life*, trans. by Robert Baldick (New York: Random House, 1965).

Bachelard, Gaston, *The Poetics of Space*, trans. by Maria Jolas (Boston MA: Beacon Press, 1994).

Baker-Sperry, Lori, and Liz Grauerholz, 'The Pervasiveness and Persistence of the Feminine Beauty Ideal in Children's Fairy Tales', *Gender and Society*, 17/5 (2003), 711–26.

Balint, Michael, *Thrills and Regressions* (New York: International Universities Press, 1959).

Bann, Stephen, *The Clothing of Clio: A Study of the Representation of History in Nineteenth-Century Britain and France* (Cambridge: Cambridge University Press, 1984).

Barrie, J. M., *Peter Pan: The Story of Peter and Wendy* (New York: Grosset & Dunlap, 1911).

Barthes, Roland, *Camera Lucida: Reflections on Photography*, trans. by Richard Howard (New York: Hill and Wang, 1981).

—— *Michelet*, trans. by Richard Howard (Berkeley CA: University of California Press, 1992).

—— *Roland Barthes by Roland Barthes*, trans. by Richard Howard (New York: Hill and Wang, 1977).

Bibliography

Barton, Christopher P., and Kyle Somerville, 'Play Things: Children's Radicalised Mechanical Banks and Toys, 1880–1930', *International Journal of Historical Archaeology*, 16/1 (2012), 47–85.

Baudelaire, Charles, 'Morale du joujou (et du pauvre)', *Le Monde littéraire* (1853) (Bibliothèque Municipale de Lisieux electronic collection) *www.bmlisieux.com/litterature/baudelaire/moraljou.htm* (last accessed 9 October 2023).

—— *The Painter of Modern Life and Other Essays*, ed. by Jonathan Mayne, trans. by Jonathan Mayne (New York: De Capo Press, 1964).

Beauvoir, Simone de, *The Ethics of Ambiguity*, trans. by Bernard Frechtman (Secaucus NJ: Citadel Press, 1948).

Bedini, S. A., 'The role of automata in the history of technology', *Technology and Culture*, 5 (1964), 24–42.

Behlmer, George K., and Fred M. Leventhal (eds), *Singular Continuities: Transition, Nostalgia, and Identity in Modern British Culture* (Stanford CA: Stanford University Press, 2000).

Benjamin, Walter, *Illuminations: Essays and Reflections*, ed. by Hannah Arendt, trans. by Harry Zohn (New York: Schocken Books, 1968).

Benson, O. H., 'Four Ages of Childhood', *The Journal of Education*, 107/16 (1928), 470–2.

Benzaquén, Adriana S., 'Childhood, Identity and Human Science in the Enlightenment', *History Workshop Journal*, 57 (2004), 34–57.

Berger, John, *The Success and Failure of Picasso* (London: Penguin Books Ltd, 1965).

Berman, Marshall, *All That is Solid Melts into Air: The Experience of Modernity* (New York: Penguin Books, 1988).

Bernheimer, Charles, 'Degas's Brothels: Voyeurism and Ideology', *Representations*, 20 (1987), 158–86.

Bertelsen, L. K., R. Gade and M. Sandbye (eds), *Symbolic Imprints: Essays on Photography and Visual Culture* (Aarhus: Aarhus University Press, 1999).

Birn, Randi Marie, 'The Windows of Imagination in "A la recherche du temps perdu"', *Pacific Coast Philology*, 5 (1970), 5–11.

Bloch-Dano, Evelyne, *Madame Proust: A Biography*, trans. by Alice Kaplan (Chicago IL: University of Chicago Press, 2007).

Bogue, Ronald, 'Difference and Repetition in Deleuze's Proustian Sign and Time Machine', *Concentric: Studies in English Literature and Language*, 27/1 (2001), 1–28.

Bibliography

Bolt, David, 'Aesthetic Blindness: Symbolism, Realism, and Reality', *Mosaic: An Interdisciplinary Critical Journal*, 46/3 (2013), 93–108.

—— *The Metanarrative of Blindness: A Re-Reading of Twentieth-Century Anglophone Writing* (Ann Arbor MI: University of Michigan Press, 2016).

Boltanski, Christian, 'Studio's Visit: Christian Boltanski', *Tate Magazine*, 2 (2002).

Bonzon, Jacques, *La Réforme du service des enfants assistés* (Paris: Berger-Levrault, 1901).

Brassaï, *Proust in the Power of Photography*, trans. by Richard Howard (Chicago IL: Chicago University Press, 1997).

Breidbach, Olaf, and Irenäus Eibl-Eibesfeldt (eds), *Art Forms in Nature: Prints of Ernst Haeckel* (Munich: Prestel Publishing, 1998).

Broude, Norma, 'Degas and French Feminism, ca. 1880: "The Young Spartans", the Brothel Monotypes, and the Bathers Revisited', *The Art Bulletin*, 70/4 (1988), 640–59.

—— 'Degas's Misogyny', *The Art Bulletin*, 59/1 (1977), 95–107.

Brown, Marilyn R. (ed.), *Picturing Children: Constructions of Childhood between Rousseau and Freud* (Aldershot: Ashgate Publishing Company, 2002).

Brunner, Bernd, *Bears: A Brief History*, trans. by Lori Lantz (New Haven CT: Yale University Press, 2007).

Buffon, Georges-Louis Leclerc, Comte de, *Histoire Naturelle* (Paris: Imprimerie royale, 1749–89).

Burke, Edmund, *Modernity's Histories: Rethinking the Long Nineteenth Century, 1750–1850* (World History Workshop E-Repository eBook, 2004) *www.escholarship.org/uc/item/2k62f464* (last accessed 4 April 2023).

Burton, Anthony, 'Design History and the History of Toys: Defining a Discipline for the Bethnal Green Museum of Childhood', *Journal of Design History*, 10/1 (1997), 1–21.

Butler, Judith, *Gender Trouble: Feminism and the Subversion of Identity* (London: Routledge, 1990).

—— *Undoing Gender* (New York: Routledge, 2004).

Caillois, Roger, *Les Jeux et les Hommes* (Gallimard: Paris, 1967).

Carpenter, Humphrey, *Secret Gardens: A Study of the Golden Age of Children's Literature* (London: Allen and Unwin: 1985).

Carter, Alexandra, 'Blonde, Bewigged and Winged with Gold: Ballet Girls in the Music Halls of Late Victorian and Edwardian England', *Dance Research: The Journal of the Society for Dance Research*, 13/2 (1995), 28–46.

Cartwright, Justin, *White Lightening* (London: Sceptre, 2002).

Bibliography

Cate, Phillip Dennis, and Mary Shaw (eds), *The Spirit of Montmartre: Cabarets, Humor and the Avant-Garde, 1875–1905* (New Brunswick NJ: Rutgers University Press, 1996).

Cendrars, Blaise, *L'homme foudroyé* (Paris: Denoël, 1945).

—— *Shadow*, trans. by Marcia Brown (New York: Aladdin Paperbacks, 1995).

Charles, Albert, *La Révolution de 1848 et la seconde République à Bordeaux et dans le département de la Gironde* (Bordeaux: Editions Delmas, 1945).

Childs, Elizabeth C., 'Big Trouble: Daumier, Gargantua, and the Censorship of Political Caricature', *Art Journal*, 51/1 (1992), 26–37.

Christout, Marie-Françoise, 'Review: *The Dancing Muse of the Belle Époque*', trans. by Barbara Palfy, *Dance Chronicle*, 19/2 (1996), 213–16.

Clabaugh, Gary K., 'Perspectives on Childhood', *Educational Horizons*, 70/1 (1991), 6–7.

Claretie, Jules, *La Vie à Paris, 1881* (Paris: Victor Harvard, 1882).

Clark, Linda L., 'Review of Sylvia Schafer's *Children in Moral Danger and the Problem of Government in Third Republic France*', *The American History Review*, 104/10 (1999), 252–3.

Clement, Russell T., *Four French Symbolists: A Sourcebook on Pierre Puvis de Chavannes, Gustave Moreau, Odilon Redon and Maurice Denis* (Westport CT: Greenwood Press, 1996).

Coe, Richard N., *When the Grass was Taller: Autobiography and the Experience of Childhood* (New Haven CT: Yale University Press, 1984).

Connell, R. W., *Masculinities* (Cambridge: Polity Press, 2005).

Cook, Daniel Thomas, 'A Politics of Becoming: When "Child" is Not Enough', *Childhood*, 22/1 (2015), 3–5.

Cott, Jonathan, *Pipers at the Gates of Dawn: The Wisdom of Children's Literature* (New York: McGraw Hill Education, 1984).

Coveney, Peter, *The Image of Childhood* (Harmondsworth: Penguin Books, 1967).

Crimp, Douglas, 'Positive/Negative: A Note on Degas's Photographs', *October*, 5 (1978), 89–100.

Cross, G., *Kid's Stuff: Toys and the Changing World of American Childhood* (Cambridge MA: Harvard University Press, 1997).

Cunningham, Hugh, *The Invention of Childhood* (London: BBC Books, 2006).

Deleuze, Gilles, *Proust and Signs*, trans. by Richard Howard (New York: Continuum Publishing, 2008).

—— *Proust et les signes* (Paris: Presses universitaires de France, 1964).

Bibliography

Delgado, R., and J. Setfancic (eds), *Critical White Studies: Looking Behind the Mirror* (Philadelphia PA: Temple University Press, 1997).

Descartes, René, *Discours de la méthode*, ed. by J. M. Fataud (Paris: Dessain et Tolra, 1984).

Douglas, Mary, *Purity and Danger: An Analysis of Concepts of Pollution and Taboo* (Oxford: Routledge, 1966).

Duff, C., 'Drugs and Youth Culture: Is Australia Experiencing the "Normalisation" of Adolescent Drug Use?', *Journal of Youth Studies*, 6/4 (2003), 433–46.

Dujardin, Edouard, 'Aux XX et aux Indépendants: Le cloisonisme', *La Revue Indépendante*, (1888).

Durant, Ariel, and Will Durant, *The Story of Civilisation, Volume 10: Rousseau and Revolution* (New York: Simon & Schuster, 1968).

Duval, Henri, *Manuel de l'enfance, ou Petit cours d'éducation physique et morale, suivi d'une nouvelle méthode de lecture* (Paris: Johanneau, 1840).

Dworkin, Andrea, *Woman Hating* (New York: Penguin Books, 1974).

Eisenman, Stephen F., *The Temptation of Saint Redon: Biology, Ideology and Style in the Noirs* (Chicago IL: University of Chicago Press, 1992).

Faunce, Sarah, and Linda Nochlin, *Courbet Reconsidered* (New York: Brooklyn Museum Press, 1988).

Faure, Elie, *André Derain* (Paris: Editions G. Cres, 1923).

Fay, Eliot G., 'The Philosophy of Saint Exupéry', *The Modern Language Journal*, 31/2 (1947), 90–7.

Fevre, Jeanne, *Mon oncle Degas: souvenirs et document inédits* (Geneva: P. Cailler, 1949).

Fineberg, Jonathan (ed.), *Discovering Child Art: Essays on Childhood, Primitivism and Modernism* (Princeton NJ: Princeton University Press, 1998).

Forgione, Nancy, '"The Shadow Only": Shadow and Silhouette in the Late Nineteenth-Century Paris', *The Art Bulletin*, 81/3 (1999), 490–512.

Fortescue, William, *The Third Republic in France 1870–1940: Conflicts and Continuities* (London: Routledge, 2000).

Foucault, Michel, *Abnormal: Lectures at the Collège de France 1974–1975*, trans. by Graham Burchell (London: Verso Publishing, 2003).

—— *The History of Sexuality*, trans. by Robert Hurley (New York: Vintage, 1980).

Fournier, Edouard, *Histoire des Jouets et des Jeux d'Enfants* (Paris: E. Dentu, 1889).

Bibliography

Foyster, Elizaebth, and James Marten (eds), *A Cultural History of Childhood and Family in the Age of Enlightenment* (London: Bloomsbury, 2014).

Freud, Sigmund, *The Standard Edition of the Complete Psychological Works of Sigmund Freud*, trans. by James Strachey, Anna Freud, Alix Strachey and Alan Tyson (London: Hogarth Press, 1953–74).

—— *The Uncanny*, trans. by David McLintock (London: Penguin Publishing, 2003).

Frey, John Andrew, *Les Contemplations of Victor Hugo: The Ash Wednesday Liturgy* (Charlottesville VA: University Press of Virginia, 1988).

—— *A Victor Hugo Encyclopedia* (Santa Barbara CA: Greenwood Publishing Group, 1999).

Fry, Roger, 'Children's Drawings', *The Burlington Magazine for Connoisseurs*, 30/171 (1917), 225–31

—— *Vision and Design* (London: Chatto & Windus, 1920).

Furfey, P. H., 'The Forgotten Age of Childhood', *The Scientific Monthly*, 40/5 (1935), 458–60.

Fuss, Diana, *The Sense of the Interior: Four Writers and the Rooms that Shaped Them* (London: Routledge, 2005).

Galand, René, 'Baudelaire's Psychology of Play', *The French Review*, 44 (1971), 12–19.

Gamwell, Lynn, 'Beyond the Visible: Microscopy, Nature and Art', *Science*, 299 (2003), 49–50.

Garb, Tamar, *The Body in Time: Figures of Femininity in Late Nineteenth-Century France* (Seattle WA: University of Washington Press, 2008).

Gay, Peter, *The Naked Heart* (New York: W. W. Norton, 1995).

Geffroy, Gustave, *La Vie Artistique* (Paris: E. Dentu, 1894).

Gervais, David, 'Hugo and Victor Hugo', *The Cambridge Quarterly*, 28/2 (1999), 116–49.

Gilead, Sarah, 'Magic Abjured: Closure in Children's Fantasy Fiction', *PMLA*, 106/2 (1991), 277–93.

Goldstone, Bette P., 'Views of Childhood in Children's Literature Over Time', *Language Arts*, 63/8 (1986), 791–8.

Gombrich, E. H., *The Story of Art* (London: Phaidon Press Limited, 2007).

Gould, Stephen Jay, *Ontogeny and Phylogeny* (Cambridge MA: Harvard University Press, 1977).

Graham-Dixon, Andrew, *Art in France: This is the Modern World*, BBC Four (2017).

Bibliography

Grant, Richard B., 'Victor Hugo's "Les Deux Archers": Patterns of Disguise and Revelation', *Romance Notes*, 32/3 (1992), 215–20.

—— 'Victor's Hugo's "Le Rhin" and the Search for Identity', *Nineteenth-Century French Studies*, 23/3 (1995), 324–40.

Gray, Jeffrey, '"It's Not Natural": Freud's "Uncanny" and O'Connor's "Wise Blood"', *The Southern Literary Journal*, 29/1 (1996), 56–68.

Grew, Raymond, 'Picturing the People: Images of the Lower Orders in Nineteenth-Century French Art', *The Journal of Interdisciplinary History*, 17/1 (1996), 203–31.

Grossman, Kathryn M., 'Homelessness, Wastelands, and Barricades: Transforming Dystopian Spaces in Les Misérables', *Utopian Studies*, 4 (1991), 30–4.

Guérin, M., *Degas Letters*, trans. by M. Kay (Oxford: Bruno Cassirer, 1947).

Guillard, Maurice (ed.), *Degas: Form and Space* (Paris: Marais-Guillard Editions, 1984).

Halévy, Daniel, *Pays Parisiens*, trans. by Mina Curtiss (London: Vintage Books, 1966).

Halperin, Joan, *Felix Fénéon: Œuvres plus que complètes* (Geneva: Librairie Droz, 1970).

Halsted, Judith Wynn, *Some of My Best Friends are Books: Guiding Gifted Readers from Preschool to High School* (Scottsdale AZ: Great Potential Press Inc., 2009).

Handler, Sophie, 'Redon, Odilon (1840–1916)', *The Routledge Encyclopedia of Modernism* (Oxford: Taylor and Francis, 2016), *www.rem.routledge.com/articles/redon-odilon-1840-1916* (last accessed 4 April 2023).

Hannoosh, Michele, 'The Poet as Art Critic: Laforgue's Aesthetic Theory', *The Modern Language Review*, 79/3 (1984), 553–69.

Hauptman, Jodi, *Beyond the Visible: The Art of Odilon Redon* (New York: The Museum of Modern Art, 2005).

Havens, George R., 'Romanticism in France', *PMLA*, 55/1 (1940), 10–20

Hennequin, Emile, 'Odilon Redon', *Revue Littéraire et Artistique* (1882).

Heywood, Colin, *Growing Up in France: From the* Ancien Régime *to the Third Republic* (Cambridge: Cambridge University Press, 2007).

Higgins, James E., '"The Little Prince": A Legacy', *Elementary English*, 37/8 (1960), 514–15, 572.

Higonnet, M. R., 'Modernism and Childhood', *The Comparatist*, 33 (2009), 86–108.

Bibliography

Hobbs, Richard (ed.), *Impressions of French Modernity: Art and Literature in France 1850–1900* (Manchester: Manchester University Press, 1998).

Hobsbawm, Eric, *The Age of Capital: 1848–1875* (London: Weidenfeld & Nicolson, 1975).

—— *The Age of Empire: 1875–1914* (London: Weidenfeld & Nicolson, 1987).

—— *The Age of Revolution: Europe 1789–1848* (London: Weidenfeld & Nicolson, 1962).

Hoffman, Stanley, Charles P. Kindleberger, Laurence Wylie, Jesse R. Pitts, Jean-Baptiste Duroselle and François Goguel, *In Search of France: The Economy, Society and Political System in the Twentieth Century* (New York: Harper & Row, 1965).

Hogg, James (ed.), *Salzburg Studies in English Literature: Poetic Drama and Poetic Theory* (Salzburg: University of Salzburg Press, 1978).

Holland, Patricia, *Picturing Childhood: The Myth of the Child in Popular Imagery* (London: I. B. Tauris & Co. Ltd, 2006).

Hollein, Max, and Margaret Stuffmann (eds), *Odilon Redon: As in a Dream* (Stuttgart: Hatje Cantz, 2007).

Hollindale, Peter (ed.), *J. M. Barrie: Peter Pan and Other Plays* (Oxford: Oxford University Press, 1995).

Holmes, Diana, and Carrie Tarr (eds), *A Belle Époque? Women and Feminism in French Society and Culture 1890–1914* (New York: Berghahn Books, 2006).

Holmes, Mary, *Gender and Everyday Life* (Oxford: Routledge, 2009).

Hopkins, David, *Childish Things* (Edinburgh: The Fruitmarket Gallery, 2010).

Howard, Richard, 'Childhood Amnesia', *Yale French Studies*, 43 (1969), 165–9.

Hugo, Victor, *Les Misérables*, ed. by Maurice Allem (Edition de la Pléaide: Paris, 1951).

—— *Les Misérables*, trans. by Norman Denny (Harmondsworth: Penguin, 1980).

—— *Les Misérables*, trans. by Isabel F. Hapgood (New York: Thomas Y. Crowell & Co., 1987) (Project Gutenberg eBook), *www.gutenberg.org/files/135/135-h/135-h.htm* (last accessed 4 April 2023).

—— *Œuvres Complètes de Victor Hugo* (Paris: Editions de Nelson, 1911).

—— *Œuvres Complètes: Edition définitive d'après les manuscrits originaux* (Paris: Hetzel-Quantin, 1880–9).

—— *Œuvres Complètes: Les Feuilles d'automne, Les Chants du crépuscule, Les Voix intérieures, Les Rayons et les Ombres* (Paris: Librairie Paul Ollendorf, 1909).

Bibliography

Huneker, James, *Promenades of an Impressionist* (New York: Charles Scribner's Sons, 1910).

Huret, Jules, *Enquête sur l'évolution littéraire* (Paris: Fasquelle, 1913).

Imhoff, Guy F., 'Jeux d'ombre et de lumière dans "Les Misérables" de Victor Hugo', *Nineteenth-Century French Studies*, 29/1 (2001), 64–77

Innes, Christopher, *Avant Garde Theatre: 1892–1992* (London: Routledge, 1993).

Ives, Colta, 'French Prints in the Era of Impressionism and Symbolism', *The Metropolitan Museum of Art Bulletin*, 46/1 (1988), 8–56.

James, William, *The Principles of Psychology* (Cambridge MA: Harvard University Press, 1890) (Project Gutenberg eBook) *www.gutenberg.org/cache/epub/57628/pg57628-images.html* (last accessed 9 October 2023).

Jarry, Alfred, *Ubu Roi*, trans. by Beverly Keith and G. Legman (New York: Dover Publications, 2003).

Jauffret, Louis-François, *Les Charmes de l'enfance, et les Plaisirs de l'amour maternel* (Paris: Didot jeune, 1801).

——'Prix proposé par la Société des Observateurs de l'homme, pour l'an 11', *Magasin encyclopédique*, 4/16 (1801–2), 541–3.

Jay, Martin, *Downcast Eyes: The Denigration of the Vision in Twentieth-Century French Thought* (Berkeley CA: University of California Press, 1993).

Johnson, G. (ed.), *The Merleau-Ponty Aesthetics Reader: Philosophy and Painting* (Evanston IL: Northwestern University Press, 1993).

Jordanova, Ludmilla, 'Reading Faces in the Nineteenth Century', *Art History*, 13/4 (1990), 570–5.

Jullian, Philippe, *The Symbolists* (London: Phaidon Press Limited, 1977).

Jung, C. G., *Memories, Dreams, Reflections* (Waukegan IL: Fontana Press, 1995).

Kandinsky, Wassily, *Concerning the Spiritual in Art*, trans. by Michael T. H. Sadler (Munich: Reinhard Piper, 1911).

Kaplan, Edward K., 'Victor Hugo and the Poetics of Doubt: The Transition of 1835–1837', *French Forum*, 6/2 (1981), 140–53.

Kendall, Richard, 'Degas and the Contingency of Vision', *The Burlington Magazine*, 130/1020 (1988), 180–97, 216.

Kendall, Richard, and Griselda Pollock (eds), *Dealing with Degas: Representations of Women and the Politics of Vision* (New York: Universe Publishing, 1992).

Kernan, Nathan, 'Review: *Shadows of a Hand: The Drawings of Victor Hugo*', *On Paper*, 2/6 (1998), 40–1.

Bibliography

Khanna, Ranjana, *Dark Continents: Psychoanalysis and Colonialism* (Durham NC: Duke University Press, 2003).

King, Constance Eileen, *Jumeau* (Atiglen: Schiffer Publishing, 1983).

Klee, Paul, *Tagebucher von Paul Klee 1898–1918* (Cologne: Verlag M. DuMont Schauberg, 1957).

Klein, Melanie, *The Psychoanalysis of Children*, trans. by Alix Strachey (New York: Grove Press Inc., 1960).

Kofman, Sarah, and Mara Dukats, 'Rousseau's Phallocratic Ends', *Hypatia*, 3/3 (1989), 123–36.

Kristeva, Julia, *Time and Sense: Proust and the Experience of Literature*, trans. by Ross Guberman (New York: Columbia University Press, 1996).

Lanes, Selma G., *Down the Rabbit Hole: Adventures and Misadventures in the Realm of Children's Literature* (New York: Atheneum Books, 1971).

Larson, Barbara, 'Evolution and Degeneration in the Early Work of Odilon Redon', *Nineteenth-Century Art Worldwide*, 2/1 (2003), 1–20.

Leach, Maria (ed.), *Funk and Wagnalls Standard Dictionary of Folklore, Mythology and Legend* (New York: Funk and Wagnalls, 1950).

Lehmann, Arthur C., and James E. Myers (eds.), *Magic, Witchcraft, and Religion: An Anthropological Study of the Supernatural* (Palo Alto CA: Mayfield Publishing Company, 1985).

Leroy, Alphonse, *Médicine Maternelle, ou l'art d'élever et de conserver les enfants* (Paris: Méquignon, 1803).

Lewis, Beatrice E., 'Antique Toys: Vestiges of Childhoods Past', *Children's Environments Quarterly*, 1/1 (1984), 3–6.

Liebermann, Max, and Adrian Stokes, 'Degas', *The Artist: An Illustrated Monthly Record of Arts, Crafts and Industries*, 28/247 (1900), 113–120.

Litvak, Joseph, *Strange Gourmets: Sophistication, Theory, and the Novel* (Durham NC: Duke University Press, 1997).

Lloyd, Jill, *German Expressionism: Primitivism and Modernity* (New Haven CT: Yale University Press, 1991).

Locke, John, *An Essay Concerning Human Understanding*, ed. by John Yolton (London: J. M. Dent, 1993).

Lorber, Judith, *Paradoxes of Gender* (New Haven CT: Yale University Press, 1994).

Lovejoy, Arthur O., *Essays in the History of Ideas* (Baltimore MD: Johns Hopkins Press, 1960).

—— 'The Supposed Primitivism of Rousseau's Discourse on Inequality', *Modern Philology*, 21/2 (1923), 165–86.

Bibliography

Mallarmé, Stéphane, *Oeuvres Complètes*, ed. by Henri Mondor and G. Jean-Aubry (Paris: Gallimard, Bibliothèque de la Pléiade, 1945).

—— *Selected Prose, Poems, Essays, and Letters*, trans. by Branford Cook (Baltimore MD: Johns Hopkins Press, 1956).

Mantz, Paul, 'L'Exposition des œuvres des artistes indépendants', *Le Temps*, (1881), 3.

Marlow, Tim, *Tim Marlow on ... Degas, Sicket & Toulouse-Lautrec*, Channel 5 (2005).

Martens, Lorna, *The Promise of Memory: Childhood Recollection and its Objects in Literary Modernism* (Cambridge MA: Harvard University Press, 2011).

Marx, Roger, 'Une Rénovatrice de la Danse', *Le Musée* (1907).

Masanès, Fabrice, *Gustave Courbet* (Cologne: Taschen, 2006).

Masters, Roger D., and Christopher Kelly (eds.), *The Collected Writings of Rousseau* (Hanover NH: Dartmouth University Press, 1990).

Maurois, André, *Etudes Littéraires II* (New York: Maison Française, 1944).

Mavor, Carol, *Reading Boyishly* (Durham NC: Duke University Press, 2007).

McCarren, Felicia, 'The "Symptomatic Act" *circa* 1900: Hysteria, Hypnosis, Electricity, Dance', *Critical Inquiry*, 21/4 (1995), 748–74.

McMullen, R., *Degas: His Life, Times and Work* (Boston MA: Houghton Mifflin, 1985).

McRobbie, A., and M. Nava (eds), *Gender and Generation* (London: MacMillan, 1984).

Mellerio, André, 'Interview with Odilon Redon', *Mellerio Archive, Art Institute of Chicago* (1891).

—— *Odilon Redon: Peintre, Dessinateur et Graveur* (Paris: Editions Floury, 1923).

Meylan, Valérie, 'La Féticheuse', *Ricochet* (2014) *www.ricochet jeunes.org/livres/livre/52966-la-feticheuse* (last accessed 4 April 2023).

Michelet, Jules, *La Montagne* (Paris: C. Lévy, 1899).

Miller, David C., *American Iconology* (New Haven CT: Yale University Press, 1993).

Milligan, E. E., 'Saint Exupéry and Language', *The Modern Language Journal*, 39/5 (1955), 249–51.

Mills, Winifred H., 'Creative Work with Children in the Field of Puppets', *Junior-Senior High School Clearing House*, 5/8 (1931), 471–3.

Mohr, Richard Drake, 'Knights, Young Men, Boys: Masculine Worlds and Democratic Values', *Noûs*, 25/2 (1991), 202–3.

Bibliography

Moretti, Franco, *The Bourgeois: Between History and Literature* (New York: Verso Books, 2013).

Nichols, Mary, 'Rousseau's Novel Education in the *Emile*', *Political Theory*, 13/4 (1985), 535–58.

Nicolson, Benedict, *Courbet: The Studio of the Painter* (London: Allen Lane, 1973).

Nietzsche, Friedrich, *Beyond Good and Evil*, trans. by Helen Zimmern (2009) (Project Gutenberg eBook) *www.gutenberg.org/files/4363/4363-h/4363-h.htm* (last accessed 4 April 2023).

—— *The Gay Science: With a Prelude in Rhymes and an Appendix of Songs*, trans. by Walter Kaufmann (New York: Vintage Books, 1973).

—— *The Twilight of the Idols: Or How to Philosophize with a Hammer*, trans. by Anthony M. Ludovici (2016) (Project Gutenberg eBook) *www.gutenberg.org/files/52263/52263-h/52263-h.htm* (last accessed 9 October 2023).

Nirdlinger, Virginia, 'Notes on Degas', *Parnassus*, 9/3 (1937), 18–20.

Nochlin, Linda, *Realism* (London: Penguin, 1971).

Nordau, Max, *Degeneration* (London: William Heinemann Publishing, 1895).

Northcote, J., 'Nightclubbing and the Search for Identity: Making the Transition from Childhood to Adulthood in an Urban Milieu', *Journal of Youth Studies*, 9/1 (2006), 1–16.

Nottingham, Theodore, *Hugo: The Strange Life and Visions of Victor Hugo* (Indianapolis IN: Theosis Books, 2011).

Oakley, Ann, *Sex, Gender and Society* (Aldershot: Arena Publishing, 1972).

O'Malley, John W., *What Happened at Vatican II* (Cambridge MA: Harvard University Press, 2010).

Orme, Nicholas, *Medieval Children* (New Haven CT: Yale University Press, 2003).

Osborne, Denise M., 'Bluebeard and its Multiple Layers of Meaning', *Revista Alpha*, 12 (2014), 128–37.

Osborne, Roy, 'Review of *The Principles of Harmony and Contrast of Colors and Theory Applications to the Arts* by M. E. Chevreul', *Leonardo*, 21/1 (1988), 96–7.

Ousselin, Edward, 'Victor Hugo's European Utopia', *Nineteenth-Century French Studies*, 34/1 (2006), 32–43.

Overy, Paul, *Kandinsky and the Language of the Eye* (London: Elek Books Ltd, 1969).

Oxford English Dictionary, *www.oed.com* (last accessed 4 April 2023).

Bibliography

Paechter, Carrie, *Being Boys; Being Girls: Learning Masculinities and Femininities* (Maidenhead: Open University Press, 2007).

Panofsky, Erwin, *Meaning in the Visual Arts* (New York: Doubleday, 1955).

Parry, Linda, *William Morris Textiles* (New York: Viking Press, 1983).

Paterson, Mark, '"Looking on darkness, which the blind do see": Blindness, Empathy and Feeling Seeing', *Mosaic: An Interdisciplinary Critical Journal*, 46/3 (2013), 159–77.

Peel, Ellen, 'Psychoanalysis and the Uncanny', *Comparative Literature Studies*, 17/4 (1979), 410–17.

'Petit Billet de la Semaine: À Miss Loie Fuller', *Le Monde Artiste*, (1892).

Pfeifer, Theresa H., 'Deconstructing Cartesian Dualisms of Western Racialised Systems: A Study in the Colors Black and White', *Journal of Black Studies*, 39/4 (2009), 528–47.

Pollock, Griselda, *Mary Cassatt: Painter of Modern Women* (London: Thames & Hudson, 1998).

—— *Vision and Difference: Feminism, Femininity and Histories of Art* (London: Routledge, 1988).

Pollock, Linda A., *Forgotten Children: Parent-Child Relations from 1500 to 1900* (Cambridge: Cambridge University Press, 1983).

Poster, Mark, *Critical Theory of the Family* (New York: Continuum Publishing, 1988).

Preziosi, Donald, *The Art of Art History: A Critical Anthology* (Oxford: Oxford University Press, 2009).

'Protection of Young Girls', *The British Medical Journal*, 1/1209 (1884), 430.

Proust, Marcel, *Du côté de chez Swann* (Paris: Éditions Gallimard, 1987).

—— *In Search of Lost Time, Volume I: Swann's Way*, trans. by C. K. Scott Moncrieff and Terence Kilmartin (London: Vintage Books, 2005).

—— *In Search of Lost Time, Volume II: Within a Budding Grove*, trans. by C. K. Scott Moncrieff and Terence Kilmartin (London: Vintage Books, 2005).

—— *In Search of Lost Time, Volume III: The Guermantes Way*, trans. by C. K. Scott Moncrieff and Terence Kilmartin (London: Vintage Books, 2000).

—— *In Search of Lost Time, Volume IV: Sodom and Gomorrah*, trans. by C. K. Scott Moncrieff and Terence Kilmartin (London: Vintage Books, 2005).

—— *In Search of Lost Time, Volume V & VI: The Captive and the Fugitive*, trans. by C. K. Scott Moncrieff and Terence Kilmartin (London: Vintage Books, 2005).

—— *In Search of Lost Time, Volume VII: Time Regained*, trans. by C. K. Scott Moncrieff and Terence Kilmartin (London: Vintage Books, 2005).

Bibliography

—— *Les Plaisirs et les jours* (Paris: Librairie Gallimard, 1924).

Rasula, Jed, *Modernism and Poetic Inspiration: The Shadow Mouth* (Reston: AIAA, 2009).

Ré, Paul, 'Review (untitled)', *Leonardo*, 16/2 (1983), 521.

Redon, Odilon, *À Soi-même* (Paris: Editions Floury, 1923).

—— *I am the First Consciousness of Chaos: The Black Album* (Washington DC: Solar Books, 2010).

—— *To Myself: Notes on Life, Art, and Artists*, trans. by Jacob Mira and Jeanne L. Wasserman (New York: George Braziller, 1996).

Reekie, Gail, 'Decently Dressed? Sexualised Consumerism and the Working Woman's Wardrobe 1918–1923', *Labour History*, 61 (1991), 42–56.

Reinhard, Joakim, 'Victor Hugo's Novels I', *The Sewanee Review*, 7/1 (1899), 29–47.

Rhodes, Colin, *Primitivism and Modern Art* (London: Thames & Hudson, 1997)

Richardson, Joanna, *Baudelaire* (London: John Murray Publishers Ltd, 1994).

—— *Victor Hugo* (New York: St Martin's Press, 1976).

Roche, Pierre, 'Une Artiste Décorateur: La Loïe Fuller', *L'art Décoratif*, 10 (1907).

Rousseau, Jean-Jacques, *Confessions*, trans. by J. M. Cohen (New York: Penguin, 1953).

—— *The Confessions of J. J Rousseau: With the Reveries of the Solitary Walker*, vol. 1 (London: J. Bew, 1783).

—— *Emile*, trans. by Barbara Foxley (London: J. M. Dent, 1993).

—— *Emile; or, Concerning Education*, trans. by Eleanor Worthington (Boston: D. C. Heath & Company, 1889).

—— *Emile; or, On Education*, trans. by Allan Bloom (New York: Basic Books, 1979).

—— *Oeuvres Complètes*, ed. by Bernard Gagnebin and Marcel Raymond (Paris: Bibliothèque de la Pléaide, 1959).

Rugoff, Ralph, *The Eye of the Needle: The Unique World of Micro-Miniatures of Hagop Sandaldjian* (Los Angeles CA: Museum of Jurassic Technology and the Society for the Diffusion of Useful Information, 1996).

Ruskin, John, *The Complete Works of John Ruskin*, ed. by E. T. Cook and Alexander Wedderburn (New York: Longmans, Green & Co., 1909).

Safford, Lisa Bixenstine, 'Mallarmé's Influence on Degas' Aesthetic of Dance in his Late Period', *Nineteenth-Century French Studies*, 21/3/4 (1993), 419–33.

Saint-Exupéry, Antoine de, *Le Petit Prince* (Paris: Editions Gallimard, 1999).

—— *The Little Prince*, trans. by Richard Howard (London: Egmont UK Ltd, 2013).

Bibliography

Sandström, Sven, *Le monde imaginaire d'Odilon Redon: Etude iconologique* (Lund: Gleerup Publishing, 1955).

Scarth, Fredrika, *The Other Within* (Lanham MD: Rowman and Littlefield, 2004).

Schafer, Sylvia, *Children in Moral Danger and the Problem of Government in Third Republic France* (Princeton NJ: Princeton University Press, 1997).

—— 'When the Child is the Father of the Man: Work, Sexual Difference and the Guardian State in Third Republic France', *History and Theory*, 31/4 (1992), 98–115.

Schapiro, Meyer, 'Courbet and Popular Imagery: An Essay on Realism and Naiveté', *Journal of the Warburg and Courtauld Institutes*, 4/3–4 (1941), 164–91.

Schiff, Stacy, *Saint-Exupéry: A Biography* (London: Pimlico, 1996).

Schleinzer, Anika, 'Rehearsed Technology: The Definition of Technical Toys in the Early 20th Century', *Icon*, 20/2 (2014), 20–39.

Scholz, Sally J., 'That All Children Should Be Free: Beauvoir, Rousseau, and Childhood', *Hypatia*, 25/2 (2010), 394–411.

Schotsman, H. D., 'Clavaud: Sa vie – son œuvre', *Bulletin du Centre Recherches Scientifiques de Biarritz*, 8/4 (1971), 721, 737, 755.

Schulz, Gerhard, *Novalis Werke* (Munich: Beck Verlag, 1969).

Shinn, Milicent Washburn, *The Biography of a Baby* (Boston MA: Houghton, 1900).

Shumway, Waldo, 'The Recapitulation Theory', *Quarterly Review of Biology*, 7/1 (1932), 93–9.

Smith, Paul, *Impressionism: Beneath the Surface* (Upper Saddle River NJ: Prentice Hall, 1995).

Sommer, Sally R., 'Loie Fuller', *The Drama Review: TDR*, 19/1 (1975), 53 67.

—— 'Loie Fuller's Art of Music and Light', *Dance Chronicle*, 4/4 (1981), 389–401.

Spitz, Ellen Handler, *The Brightening Glance: Imagination and Childhood* (New York: Random House, 2007).

—— *Illuminating Childhood: Portraits in Fiction, Film, and Drama* (Ann Arbor MI: The University of Michigan Press, 2011).

—— *Inside Picture Books* (New Haven CT: Yale University Press, 2000).

Springer, Annmarie, 'Terrorism and Anarchy: Late 19th-Century Images of a Political Phenomenon in France', *Art Journal*, 38/4 (1979), 261–6.

Spyer, Patricia, *Border Fetishisms: Material Objects in Unstable Spaces* (London: Routledge, 1998).

Bibliography

Stallybrass, Peter, 'Worn Worlds: Clothes, Mourning and the Life of Things', *Yale Review*, 81/2 (1993), 183–207.

Stafford, Barbara, and Frances Terpak, *Devices of Wonder: From the World in a Box to Images on a Screen* (Los Angeles CA: Getty Research Institute, 2002).

Stearns, Peter N., 'Challenges in the History of Childhood', *Journal of the History of Childhood and Youth*, 1 (2008), 35–42.

Stearns, Peter N., Michael Adas, Stuart B. Schwartz and Jason Gilbert (eds), *World Civilisations: The Global Experience* (Upper Saddle River NJ: Longman, 2011).

Stemmler, Joan K., 'The Physiognomical Portraits of Johann Caspar Lavater', *The Art Bulletin*, 75/1 (1993), 151–68.

Stendhal, *The Life of Henry Brulard*, trans. by John Sturrock (New York: New York Review Books, 2002).

Stewart, Susan, *On Longing: Narratives of the Miniature, the Gigantic, the Souvenir, the Collection* (Durham NC: Duke University Press, 1993).

Strieter, Terry W., 'Odilon Redon and Charles Baudelaire: Some Parallels', *Art Journal*, 35/1 (1975), 17–19.

Strongheart, Rachel Lynn., '"The Little Prince": My Ally from Asteroid B-612', *The Reading Teacher*, 54/5 (2001), 498.

Sweet, Frederick A., *Miss Mary Cassatt: Impressionist from Pennsylvania* (Norman OK: University of Oklahoma Press, 1967).

Tadié, Jean-Yves, *Marcel Proust: A Life*, trans. by Euan Cameron (New York: Penguin Books Ltd, 2001).

Taine, Hippolyte, *The Origins of Contemporary France: The Revolution*, trans. by John Durand (New York: Henry Holt & Company, 1878).

—— *Philosophie de l'art, leçons professées à l'Ecole des Beaux-Arts* (Paris: G. Baillière, 1865).

Tatar, Maria (ed.), *The Annotated Classic Fairy Tales* (New York: W. W. Norton and Company, 2002).

Thompson, Hannah, *Reviewing Blindness in French Fiction, 1789–2013*, (London: Palgrave Macmillan, 2017).

Timm, Joshua A., and Annette F. Sanborn, *Gender, Sex and the Shaping of Modern Europe: A History from the French Revolution to the Present Day* (Oxford: Berg, 2007).

Trousson, Raymond, 'Victor Hugo juge de Jean-Jacques Rousseau', *Revue d'Histoire littéraire de la France*, 86/6 (1986), 979–87.

Bibliography

Turner, Christopher, 'Art Toys: Through the Eyes of a Child', *Tate Etc.*, 19 (2010), *www.tate.org.uk/tate-etc/issue-19-summer-2010/through-eyes-child* (last accessed 9 October 2023).

Wachelder, Joseph, 'Toys as Mediators', *Icon*, 13 (2007), 135–69.

Walder, Dennis, 'Remembering Rousseau: Nostalgia and the Responsibilities of the Self', *Third World Quarterly*, 26/3 (2005), 423–30.

Walkerdine, Valerie, *Daddy's Girl: Young Girls and Popular Culture* (Cambridge MA: Harvard University Press, 1997).

—— 'Femininity as Performance', *Oxford Review of Education*, 15/3 (1989), 267–79.

—— *Schoolgirl Fictions* (New York: Verso Publishing, 1990).

Wall-Romana, Christophe, 'Mallarmé's Cinepoetics: The Poem Uncoiled by the Cinématographe, 1893–98', *PMLA*, 1 (2005), 128–47.

Warner, Marina, 'Out of an Old Toy Chest', *Journal of Aesthetic Education*, 43/2 (2009), 3–18.

Warner, William Lloyd, *The Living and the Dead: A Study of the Symbolic Life of Americans* (New Haven CT: Yale University Press, 1959).

Webster, Paul, *Antoine de Saint-Exupéry: The Life and Death of the Little Prince* (London: Papermac, 1994).

Weinberger, Eliot (ed.), *Selected Non-Fictions*, trans. by Esther Allen, Suzanne Jill Levine and Eliot Weinberger (New York: Viking, 1999).

Werner, W. L., 'The Psychology of Marcel Proust', *The Sewanee Review*, 39/3 (1931), 276–9.

White, Edmund, *Marcel Proust: A Life* (New York: Penguin Books, 2009).

Williams, Margery, *The Velveteen Rabbit: Or How Toys Become Real* (Scotts Valley CA: CreateSpace Independent Publishing Platform, 2013).

Williams, Rosalind H., *Dream Worlds: Mass Consumption in Late Nineteenth-Century France* (Oakland CA: University of California Press, 1992).

Winnicott, D. W., *The Child, the Family and the Outside World* (London: Penguin, 2000).

—— *Playing and Reality* (London: Routledge, 2005).

Wolff, Larry, 'When I Imagine a Child: The Idea of Childhood and the Philosophy of Memory in the Enlightenment', *Eighteenth-Century Studies*, 31/4 (1998), 377–98.

Yeh, Susan Fillin, 'Mary Cassatt's Images of Women', *Art Journal*, 35/4 (1976), 359–63.

Zipes, Jack (ed.), *Don't Bet on the Prince* (New York: Routledge, 1996).

Bibliography

—— *The Oxford Companion to Fairy Tales* (New York: Oxford University Press, 2000).

—— *When Dreams Came True* (New York: Routledge, 2007).

—— *Why Fairy Tales Stick* (New York: Routledge, 2006).

Zola, Émile, *Au Bonheur des dames* (Montreal: La Bibliothèque électronique de Québec, 1998).

Index of Images

After the Bath
Edgar Degas, *Après le bain* (c.1895), oil on canvas. J. Paul Getty Museum, Los Angeles CA; *www.getty.edu/art/collection/object/108H4X* (last accessed 6 October 2023).

And the Eyes Without Heads Were Floating Like Molluscs
Odilon Redon, *Et que des yeux sans tête flottaient comme des mollusques* (1894), lithograph on *chine appliqué*. Museum of Modern Art, New York; *www.moma.org/collection/works/30124* (last accessed 6 October 2023).

The Ball
Félix Vallotton, *Le Ballon* (1899), oil on wood. Musée d'Orsay, Paris; *www.musee-orsay.fr/en/artworks/le-ballon-8032* (last accessed 6 October 2023).

The Bath. Summer Evening
Félix Vallotton, *Le bain au soir d'été* (1893), oil on canvas. Zürich Kunsthaus, Zürich; *https://collection.kunsthaus.ch/en/collection/item/3031/* (last accessed 6 October 2023).

Blossoming
Odilon Redon, *Éclosion* (1879), lithograph on *chine appliqué*. Museum of Modern Art, New York; *www.moma.org/collection/works/192448* (last accessed 6 October 2023).

Index of Images

Boy with a Toy Soldier
Pierre-Auguste Renoir, *Portrait de Jean de La Pommeraye* (*c*.1875), oil on canvas. Philadelphia Museum of Art, Philadelphia PA; *https://philamuseum. org/collection/object/59197* (last accessed 6 October 2023).

Children's Afternoon at Wargemont
Pierre-Auguste Renoir, *L'après-midi des enfants à Wargemont* (1884), oil on canvas. Alte Nationalgalerie, Berlin; *https://recherche.smb.museum/detail/ 965786/der-nachmittag-der-kinder-in-wargemont?language=de&question= %22Auguste+Renoir%22&limit=15&controls=none&collectionKey=NG*&collection Key=NGAlteNationalgalerie&objIdx=1* (last accessed 6 October 2023).

The Client
Edgar Degas, *Le Client* (*c*.1879), monotype on paper. Museum of Modern Art, New York; *www.moma.org/audio/playlist/27/482* (last accessed 6 October 2023).

Cosette
Émile Bayard (*c*.1879), charcoal and gouache on paper. Maison de Victor Hugo, Paris; *www.parismuseescollections.paris.fr/fr/maison-de-victor-hugo/ oeuvres/cosette-balayant-l-alouette#infos-principales* (last accessed 6 October 2023).

Criminal Physiognomies
Edgar Degas, *Physiognomie de criminal* (1881), pastel on paper. Private collection; *www.sothebys.com/en/auctions/ecatalogue/2015/impressionist-modern-art-evening-sale-l15006/lot.33.html* (last accessed 6 October 2023).

Dancer Fastening her Pump
Edgar Degas, *Danseuse rajustant son chausson* (*c*.1880), pastel and chalk on paper. Private collection; *www.sothebys.com/en/auctions/ecatalogue/2013/ impressionist-modern-art-evening-sale-l13002/lot.19.html* (last accessed 6 October 2023).

Dancers at the Barre
Edgar Degas, *Danseuses à la barre* (*c*.1900), oil on canvas. The Phillips Collection, Washington DC; *www.phillipscollection.org/collection/ dancers-barre* (last accessed 6 October 2023).

Index of Images

Evening Snow at Kambara
Utagawa Hiroshige (1833–4), woodblock print on paper, Metropolitan Museum of Art, New York; *www.metmuseum.org/art/collection/search/56915* (last accessed 6 October 2023).

Fantastical Silhouette
Victor Hugo, *Silhouette fantastique* (1854), ink on paper. Bibliothèque nationale de France, Paris; *http://expositions.bnf.fr/hugo/grand/564.htm* (last accessed 6 October 2023).

The Fifer
Edouard Manet, *Le Fifre* (1866), oil on canvas. Musée d'Orsay, Paris; *www.musee-orsay.fr/en/artworks/le-fifre-709* (last accessed 6 October 2023).

Gavroche at 11 Years Old
Victor Hugo, *Gavroche à 11 ans* (1850), pen and ink on paper. Maison de Victor Hugo, Paris; *www.parismuseescollections.paris.fr/fr/maison-de-victor-hugo/oeuvres/gavroche-a-onze-ans* (last accessed 6 October 2023).

I Plunged into Solitude. I Dwelt in the Tree Behind Me
Odilon Redon, *Je me suis enfoncé dans la solitude. J'habitais l'arbre derrière moi* (1894), lithograph on *chine-collé*. Museum of Modern Art, New York; *www.moma.org/collection/works/97974* (last accessed 9 October 2023).

Is There Not an Invisible World?
Odilon Redon, *N'y a t il pas un monde invisible?* (1887), lithograph on *chine appliqué*. Museum of Modern Art, New York; *www.moma.org/collection/works/62982* (last accessed 9 October 2023).

Jumeau Dolls
A wide variety of *Jumeau* dolls can be viewed online, not least on the doll auction house Theriault's website. Some prominent examples include:

- an early *Jumeau* doll in traditional dress: *www.theriaults.com/events/listing/6515/all-original-french-bisque-bebe-by-emile-jumeau-rare-incised-depose-jumeau-mark* (last accessed 9 October 2023);

Index of Images

- two freestanding *Jumeau* dolls (see comparison with *Pink and Blue*): *www.theriaults.com/events/listing/17748/a-companion-french-bisque-blue-eyed-bebe-jumeausize-2original-costume-and-shoes* (last accessed 9 October 2023);

- an undressed *Jumeau Bébé Phonographe*, revealing the internal mechanisms: *www.theriaults.com/french-bisque-bebe-phonographe-emile-jumeau* (last accessed 6 October 2023); and

- a close-up of a *Jumeau Triste*: *www.theriaults.com/gorgeous-french-bisque-bebe-triste-emile-jumeau* (last accessed 6 October 2023).

In addition, Constance Eileen King's 1983 book *Jumeau* (Schiffer Publishing, Atiglen) includes copious excellent images of dolls from the author's own collection, including further examples of interior mechanisms of the dolls. This book is available for purchase from various online retailers.

The Laundress, Blue Room
Félix Vallotton, *La lingère, chambre bleue* (1900), oil on paper laid on canvas. Dallas Museum of Art, Dallas TX; *https://dma.org/art/collection/object/4009329* (last accessed 6 October 2023).

Little Dancer Aged Fourteen
Edgar Degas, *La petite danseuse de quatorze ans* (1878–81), beeswax, clay, metal, rope, fabric and human hair. Paul Mellon Collection, National Gallery of Art, Washington DC; *www.nga.gov/collection/art-object-page.110292.html* (last accessed 6 October 2023).

Little Girl in a Blue Armchair
Mary Cassatt, *Petite fille dans un fauteuil bleu* (1878), oil on canvas. National Gallery of Art, Washington DC; *www.nga.gov/collection/art-object-page.61368.html* (last accessed 6 October 2023).

The Little Laundry Girl
Pierre Bonnard, *La petite blanchisseuse* (1896), lithograph on paper. Museum of Modern Art, New York; *www.moma.org/collection/works/66744* (last accessed 9 October 2023).

Index of Images

Little Red Riding Hood
Gustave Doré, *Le petit chaperon rouge* (1862), wood engraving print. Bibliothèque nationale de France, Paris; *https://gallica.bnf.fr/ark:/12148/bpt6k855619t/f40.item* (last accessed 6 October 2023).

Octopus
Victor Hugo, *Pieuvre* (1866), pen and ink on paper. Bibliothèque nationale de France, Paris; *http://expositions.bnf.fr/hugo/grand/278.htm* (last accessed 6 October 2023).

Origins
Odilon Redon, *Les Origines* (1883), lithograph on paper. Art Institute of Chicago, Chicago IL; *www.artic.edu/artworks/79343/cover-frontispiece-for-les-origines* (last accessed 6 October 2023).

The Painter's Studio: A Real Allegory Summing Up Seven Years of My Artistic and Moral Life
Gustave Courbet, *L'Atelier du peintre: Allégorie réelle determinant une phase de sept années de ma vie artistique et morale* (1855), oil on canvas. Musée d'Orsay, Paris; *www.musee-orsay.fr/fr/oeuvres/latelier-du-peintre-927* (last accessed 6 October 2023).

Physiognomy
Johann Kaspar Lavater, *Physiognomische Fragmente zur Beförderung der Menschenkenntis und Menschenliebe* (1775–8), book illustrations (woodcut prints). For full book, see *www.deutschestextarchiv.de/book/view/lavater_tragmente01_1775/?hl=phlegmati%C5%Brchen;p=1* (last accessed 6 October 2023). For specific images, see *https://commons.wikimedia.org/wiki/File:Lavater1792.jpg* (last accessed 6 October 2023).

Pink and Blue
Pierre-Auguste Renoir, *Alice et Elisabeth Cahen d'Anvers* (1881), oil on canvas. São Paulo Museum of Art, São Paulo; *www.masp.org.br/acervo/obra/rosa-e-azul-as-meninas-cahen-danvers* (last accessed 6 October 2023).

Index of Images

The Rehearsal of the Ballet Onstage
Edgar Degas, *Répétition d'un ballet sur la scène* (1874), oil on canvas.
Metropolitan Museum of Art, New York; *www.metmuseum.org/art/collection/search/436155* (last accessed 6 October 2023).

Ryukyuan Dancer and Musicians
Miyagawa Chōshun (*c*.1718), ink and colour on silk. Location unknown; *https://en.wikipedia.org/wiki/File:Ryukyuan_Dancer_and_Musicians_by_Miyagawa_Choshun,_c._1718.jpg* (last accessed 6 October 2023).

Shadow
Marcia Brown, *La Féticheuse* (original Blaise Cendrars text) (1982), book illustrations. The book is available for purchase from various online retailers. For example illustrations, see *www.goodreads.com/book/show/356060. Shadow* (last accessed 6 October 2023).

The Snake
Victor Hugo, *Le Serpent* (1856), pen, sepia and gouache on paper. Maison de Victor Hugo, Paris; *www.parismuseescollections.paris.fr/fr/maison-de-victor-hugo/oeuvres/le-serpent#infos-principales* (last accessed 6 October 2023).

Stains with Fingerprints
Victor Hugo, *Taches avec empreintes de doigts* (1865), ink on paper. Bibliothèque nationale de France, Paris; *http://expositions.bnf.fr/hugo/grand/505.htm* (last accessed 6 October 2023).

The Star
Edgar Degas, *L'Étoile* (*c*.1878), pastel on paper. Musée d'Orsay, Paris; *www.musee-orsay.fr/fr/oeuvres/ballet-2084* (last accessed 6 October 2023).

The Stonebreakers
Gustave Courbet, *Les Casseurs de pierres* (1849), oil on canvas. Destroyed due to fire in 1945; *https://commons.wikimedia.org/wiki/File:Gustave_Courbet_-_The_Stonebreakers_-_WGA05457.jpg* (last accessed 6 October 2023).

Index of Images

Strange Flower
Odilon Redon, *Tête à la tige* (1880), charcoal on paper. Art Institute of Chicago, Chicago IL; *www.artic.edu/artworks/90326/strange-flower-little-sister-of-the-poor* (last accessed 6 October 2023).

Study in the Nude of Little Dancer Aged Fourteen
Edgar Degas, *Étude du nu pour la petite danseuse de quatorze ans* (1878–81), pigmented beeswax, plaster, metal and wood. Paul Mellon Collection, National Gallery of Art, Washington DC; *www.nga.gov/collection/art-object-page.66444.html* (last accessed 6 October 2023).

Then There Appears a Singular Being, Having the Head of a Man on a Body of a Fish
Odilon Redon, *Ensuite parait un être singulier, ayant une tête humaine sur un corps de poisson* (1888), lithograph on *chine appliqué*. Museum of Modern Art, New York; *www.moma.org/collection/works/62998* (last accessed 9 October 2023).

The Tub
Edgar Degas, *Le Tub* (1886), pastel on card. Hill-Stead Museum, Connecticut; *www.hillstead.org/degas-alfred-pope-exhibition/* (last accessed 6 October 2023).

Woman with Field Glasses
Edgar Degas, *Femme regardant aux jumelles* (*c.*1866), thinned oil on paper. British Museum, London; *www.britishmuseum.org/collection/object/P_1968-0210-26* (last accessed 6 October 2023).

The Well
Odilon Redon, *Le Puits* (1880), charcoal and chalk on paper. Museum of Modern Art, New York; *www.moma.org/collection/works/35885* (last accessed 9 October 2023).

Index

A

acculturation 8, 34, 61, 75, 122–3,
129, 141, 146, 176
Africa 27–8, 33–5
Ariès, Philippe 3–4, 93, 173
autobiography 18, 37, 54, 92–3,
95, 97, 100, 102, 128
automata 122, 133–4, 136
see also dolls; Jumeau; play;
puppetry; toys
autonomy (of children) 8, 17, 22,
50–3, 83, 136, 140–1, 146–8,
150–3, 155–9, 161, 163,
167–8, 177
avant-garde 2, 22–31, 60, 65,
157–9, 161–2, 164, 167, 175,
177

B

Barrie, J. M. 9, 19, 148, 162–4
see also Peter Pan
Barthes, Roland 18–19, 114, 116
Baudelaire, Charles 7, 22, 24, 39,
76, 86, 96, 150, 154, 166,
176, 179
Bayard, Émile 7, 72–3, 84, 176

bedroom 96, 102–7, 151, 159–60,
164–5, 180
Benjamin, Walter 97, 102, 180
black and white 15–16, 66, 73,
76–7, 82, 85, 87, 108, 125,
130, 156, 160, 165, 178–9
Boltanksi, Christian 20, 178
Bonnard, Pierre 9, 148, 160–1, 167,
177
bourgeoisie 7–8, 27, 74, 76, 78,
92–9, 101–2, 116, 137–9,
148, 150, 176
boyhood 59–60, 83, 96, 101,
124–8, 132–6, 140, 162, 171,
178
see also gender; male;
masculinity
Britain 10, 18, 28, 75, 148
Brown, Marcia 34–6
Buffon, Georges-Louis Leclerc,
Comte de 7, 43–4, 47–8, 175
Butler, Judith 125–8, 131

C

Cassatt, Mary 147, 149–50
Cendrars, Blaise 6, 33–7, 175

Index

Cézanne, Paul 6, 25–6, 37, 175, 179
chiaroscuro 7, 66, 72, 76–7, 84, 87,
 130, 176
child, as
 animal 70–1, 76, 80–4, 86, 176
 artist 29, 18–19, 22–6, 29, 35,
 60–1, 164
 carte blanche 42, 47, 53
 innocent 18, 29, 44, 27, 53 59,
 63, 71–4, 76, 82, 102, 130
 magical 9, 29, 77, 93, 152–4,
 166, 179
 miniature adult 93, 122, 133,
 135–9, 140
 ornament 8, 76, 128, 136–8,
 177
 plant 56–7, 127
 'primitive' 6, 21, 28–34, 37,
 55–6, 70, 175
 toy *see* toy-child
 weak 43–4, 47, 57, 71–3, 76,
 86, 91–2, 99, 116–17, 122,
 136, 146, 150, 158, 166, 172,
 175
 wise 8, 25, 37, 43, 53, 60, 76, 99,
 147, 154, 177, 179
childishness 18, 20, 23, 34, 61, 74,
 78, 104–6, 114–15, 134–6,
 152, 162, 166
Clavaud, Armand 107–11
colonialism 27–8, 31–3, 44, 55–6,
 67, 131, 146, 154
Condillac, Étienne Bonnot de 7,
 42–3, 175
Courbet, Gustave 7, 59–61, 63,
 65, 175
Coveney, Peter 3, 18, 61, 99, 172
curiosité 22, 59

D

darkness 3, 7–8, 33, 50, 56–7, 60,
 62, 66, 68, 70–3, 76–7, 82,
 85–7, 91, 96–7, 99, 101–5,
 109–16, 130, 140, 152–3
degeneration 51, 67, 69–71, 76–7,
 83–4, 86, 110, 112
Deleuze, Gilles 93–4, 96
Degas, Edgar 7, 65–6, 74–82, 84–7,
 149, 176
 The Client 75
 Criminal Physiognomy 81–2
 Dancers at the Barre 78–9
 Dancer Fastening her Pump
 78–9
 Little Dancer Aged Fourteen
 79–80
 *The Rehearsal of the Ballet
 Onstage* 74–5
 The Star 75–6
 The Tub 78
 Woman with Field Glasses 76–7
Denis, Maurice 9, 148
dolls 8, 74, 122, 124, 127–8, 132,
 136–40, 142, 152, 154, 176
 see also automata; play;
 puppetry; *Jumeau*
Doré, Gustave 129–30

E

education 14, 21, 41–52, 55, 57,
 60, 63, 67, 70, 92, 145–6,
 173
embryo 32, 84, 109–16
 see also womb
Enlightenment 1–3, 5, 7, 10, 35–6,
 40–1, 44–7, 54, 57–8, 60, 62,
 145–6, 173–5

Index

ephemerality 91, 32, 34, 148, 157, 159–63, 166–7, 171, 177
evolution 29–30, 44, 56, 68, 84, 109–10

F

fairy tales 8, 96, 105, 123, 128–30, 141, 162, 176
fantasy 18, 75, 128, 141, 151, 154, 162–5, 172, 179
female 49, 52–3, 74–9, 98, 124–8, 131–2, 136, 138–9, 147–50, 160
 see also femininity; gender; girlhood
feminism 8, 129, 132, 147–50, 166, 177
femininity 74, 124, 126–8, 131–2, 136–9, 149–50
 see also female; gender; girlhood
fin-de-siècle 17, 26, 75, 110, 112, 145–6, 157, 167
Foucault, Michel 17, 51
French Revolution 9, 44–5, 52, 67, 176
Freud, Sigmund 19, 26, 45, 106, 138–41, 162
Fry, Roger 19, 22, 29, 37, 61, 68, 179

G

Gauguin, Paul 27, 31
gender 8, 52, 74, 122–33, 136, 141, 147–51, 156, 176
 see also boyhood, female; femininity; girlhood; male; masculinity
Germany 10, 28

girlhood 53, 73–82, 124–32, 136–40, 149–50, 154, 158–9, 161
 see also gender; female; femininity

H

Hugo, Victor 7, 47, 65–6, 72–4, 81–7, 176
 Cosette 72–4
 Fantastical Silhouette 86
 Gavroche 83–4
 Gavroche at 11 years old (artwork) *see* Gavroche
 Les Misérables 72–4, 83–4
 Octopus 85
 The Snake 85
 Stains with Fingerprints 86–7

I

identity (incl. personhood) 8–9, 15, 17, 22–3, 31, 36, 40–2, 53, 56–8, 62, 78–9, 81–3, 102, 124–5, 127–8, 133, 135, 141–2, 148, 150, 176, 178–80
Impressionism 25, 123, 131, 142, 149, 177
industry 31, 56, 94, 108, 124, 133–4
introspection 17–19, 41, 45–6, 53, 92, 97–8, 101, 104–5, 108, 113, 117, 168

J

Japan 70, 134, 149, 159, 161
Jauffret, Louis-François 7, 39, 43–5, 57, 175

235

Index

Jumeau 8, 124, 138–42, 176
 see also automata; dolls; play;
 puppetry; toys
Jung, C. G. 48, 53, 165, 171

K
Klee, Paul 6, 24–5, 37, 175
Klein, Melanie 46, 100, 115,
 151

L
liminality 15–6, 32, 36, 92, 117,
 142, 146, 161, 166–7,
 172–7
Locke, John 42–4, 47, 53

M
masculinity 78, 124–7, 131–3,
 136–7, 150
 see also boyhood; gender;
 male
male 52, 74–5, 78, 125–8, 131–2,
 136, 149–50
 see also boyhood; gender;
 masculinity
Manet, Edouard 8, 135–6
Mavor, Carol 19, 93, 99–100, 102,
 107
memory 2, 18–20, 35–6, 40–2,
 51–4, 57, 62, 68, 93, 97,
 103–4, 153, 161, 167–8, 171,
 178–80
miniature 93, 122, 133, 135–9, 142,
 151–3, 157, 160
modernism 2–6, 10, 14, 20–37, 53,
 61, 63, 147–8, 164, 166, 168,
 174–5, 177

modernity 2, 6, 8–9, 14, 20–2,
 25–9, 31, 36–7, 63, 66, 75,
 79, 108, 110, 112, 122, 129,
 133, 145, 147, 161–2, 166–7,
 172–9
Morisot, Berthe 147, 149–50
mother 8, 19, 52, 57, 69, 92, 94,
 96, 98–103, 106–7, 109–11,
 113–17, 134, 154, 163–4,
 176
 see also womb
Mother Nature 52, 107, 109–11,
 113–14

N
naïveté 22, 25, 40, 53
nature 22, 27, 43–4, 46–52, 54–7,
 59–62, 75–6, 101, 107–16,
 127, 132, 171–2
Nietzsche, Friedrich 22–4
nostalgia 8, 18, 20, 40, 48, 51, 58,
 61, 93, 103, 112, 115, 117,
 129, 137, 163, 171–3, 176,
 178

O
Other (incl. Otherness,
 Otherisation) 2–3, 6–8,
 26–9, 31–2, 34, 41, 54, 57,
 66, 70, 75, 82, 85–6, 88, 91,
 117, 122, 124, 130–2, 136,
 138, 142, 146–8, 157, 161,
 163, 166–7, 172–7
 see also self/Self

P
patriarchy 52, 74, 78, 101, 123–5,
 131–2, 141, 147–50, 177

Index

Perrault, Charles 8, 123, 128–9, 176
Peter Pan 9, 20, 148, 162–3, 167, 177
photography 73, 78, 82, 85, 87, 103, 178–9
Picasso, Pablo 6, 24–5, 28, 37, 175
play 9, 24–5, 29, 44, 62, 76, 86, 107, 122–3, 134–7, 140–2, 145–8, 150–9, 164–7, 177
 see also automata; dolls; Jumeau; puppetry; toys
 shadow (incl. *ombremanie*; shadowgraphy; shadow puppets; shadow theatre) 147–8, 155–7, 167, 177
 toyless 147, 152–5, 164, 167, 177
poverty 7–8, 59, 65–88, 92, 122, 146, 153, 176
Primitivism (artistic movement) 6, 14, 26–8, 175
'primitivism' (incl. 'primitive') 6, 20–1, 27–35, 37, 55–6, 59, 61, 68, 70, 83, 110, 112, 114, 154, 175
Proust, Marcel 8, 91–107, 115–18, 128, 152, 159, 176
 bed/bedroom 95–6, 100, 103–7, 115–16
 child narrator/Marcel 97–101, 103–5, 107
 In Search of Lost Time 93, 97–107
 mother (incl. *drame de coucher*) 92, 94, 96, 98–109, 115, 117, 152
 writing style 93–4, 96, 103–4

puppetry 122, 135, 141, 155–6, 160
 see also automata; dolls; Jumeau; play; toys

R

realism (artistic movement) 7, 21, 58, 59, 63, 175
Redon, Odilon 8, 91–2, 97–103, 106–18, 176
 aquatics 106, 109–11, 113
 And the eyes without heads were floating like molluscs 111
 Blossoming 112
 In the Dream 112
 I plunged into solitude. I dwelt in the tree behind me. 114
 Is there not an invisible world? 111
 microscopy 108–11
 nature (incl. botany) 101, 107–16
 Strange Flower 116
 Symbolism (artistic movement) 101, 108–9, 114
 Then There Appears a Singular Being, Having the Head of a Man on a Body of a Fish 109
 The Well 113
regression 8–9, 17–18, 20–1, 31, 36, 43, 45 53–7, 61, 95–6, 98, 103, 106, 110–11, 115–17, 138, 140, 153, 161, 163, 168, 171–3, 175–6
religion 2, 9, 40, 47, 62
Renaissance 3, 40

Index

Renoir, Pierre-Auguste 8, 133, 135–9
 Boy with a Toy Soldier 133, 135
 Children's Afternoon at Wargemont 136–8
 Pink and Blue 139
Romanticism 1, 5, 7, 10, 40–1, 43–7, 51, 57–8, 60, 62–3, 72, 146, 173, 175
Rousseau, Jean-Jacques 7, 21, 30, 39, 41, 43, 45–63, 88, 91–2, 94, 146, 175
 Confessions 51, 54
 Émile 7, 39, 41, 45–57
 Sophie 49, 52–3

S

Saint-Exupéry, Antoine de 1, 13, 178
self/Self (incl. selfhood) 2–4, 7, 15, 18–19, 22, 32, 34, 36–7, 41, 49, 53–4, 57, 63, 82–3, 85–6, 88, 91–3, 104, 112, 114, 117, 122, 135, 141–2, 146–8, 157, 161, 163, 166–7, 172–5, 177
 see also identity; Other
shadow 3, 9, 15, 33–6, 54, 58, 60, 62, 65–6, 71, 73–4, 76, 79, 82–3, 86–7, 92–3, 96, 102, 105, 107, 113–14, 122, 125, 130, 141, 145, 147–8, 155–67, 175, 177–9
soul 25, 72, 76, 85, 101, 108, 123, 140–1, 150, 153, 157, 165–6
Spitz, Ellen Handler 62, 115, 165, 180
Stewart, Susan 136–7

Symbolism (artistic movement) 9, 101, 108–9, 114, 148, 157–9, 164, 177
 see also Redon, Odilon

T

technology 134–5, 139, 151, 154
Third Republic (in France) 67, 148
toys (incl. playthings) 8, 24, 76, 86, 121–42, 147, 150–6, 158, 160, 164–5, 167, 176–7, 180
 mechanical 134–5, 139–40, 153
 see also automata; dolls; Jumeau; play; puppetry
toy-child 8, 76, 86, 121–5, 132, 134–42, 150, 176–7

U

ukiyo-e 159–61
uncanny 34, 124, 133, 138, 140–2, 163, 168

V

Vallotton, Félix 9, 148, 158–60, 167, 177
 The Ball 158–9
 The Laundress, Blue Room 159
 The Summer Evening Bath 160

W

Walkerdine, Valerie 74, 121, 127
Williams, Margery (incl. *The Velveteen Rabbit*) 145–7, 153–4, 167
Winnicott, D. W. 96, 115, 154–5, 164
Wolff, Larry 3, 13, 178
womb (incl. uterus) 8, 92, 99–100, 102–4, 106–7, 109–17, 176